Benjamin West and

The Valiant Hero

Grand-Style History Painting

Ann Uhry Abrams

New Directions in American Art

Published by the Smithsonian Institution Press, Washington, D.C.

MM

Generous support for this publication has been provided by the Millard Meiss Publication Fund of the College Art Association of America.

The paper in this book meets the guidelines for permanence and durability of the Committee on Production Guidelines for Book Longevity of the Council on Library Resources.

Cover:
Benjamin West, *The Death of General Wolfe,* 1770, oil on canvas. National Gallery of Canada, Ottawa.

Library of Congress Cataloging in Publication Data

Abrams, Ann Uhry.
The valiant hero.

(New directions in American art; v. 1)
Bibliography: p.
Includes index.
1. West, Benjamin, 1738–1820.
2. History in art.
I. Title. II. Series
ND237.W45A827 1985 759.13
84-600329
ISBN 0-87474-206-4 (alk. paper)
ISBN 0-87474-207-2 (pbk.: alk. paper)

Contents

To Eddie

Preface

At the beginning of the nineteenth century, Benjamin West (1738–1820) was unquestionably the world's most famous American-born artist, a recognition earned because he held two significant posts: official history painter at the Court of St. James and president of the Royal Academy of Arts. These honors came to him after he successfully exhibited several grand-style history paintings, most notably *Agrippina Landing at Brundisium with the Ashes of Germanicus*, *The Departure of Regulus from Rome*, *The Death of General Wolfe*, and *William Penn's Treaty with the Indians*, all created between 1765 and 1772, the decisive years of his career. Such works inspired Joel Barlow to place West among the heroes of the new American republic in his epic *Columbiad* of 1807.

> *West with his own great soul the canvass warms,*
> *Creates, inspires, impassions human forms,*
> *Spurns critic rules, and seizing safe the heart,*
> *Breaks down the former frightful bounds of Art;*
> *Where ancient manners, with exclusive reign,*
> *From half mankind withheld her fair domain*
> *He calls to life each patriot, chief or sage,*
> *Garb'd in the dress and drapery of his age.*[1]

This book explores the seminal period of West's career, the years in which he composed the important works praised by Barlow. More than just a survey of paintings, it is a study of processes and choices. What inspires an artist? How does environment, society, or culture influence an artist's aesthetic decisions? By concentrating on a brief but crucial period in West's life, I have taken a close look at the man within the context of two specific areas—the London theater and contemporary British politics—in hopes of opening new fields of inquiry for historians of art and culture. I have also attempted to answer fundamental queries about the origins of "modern" history painting and the neoclassical style, both of which were germinated in English studios during the late 1760s.

One cannot study the life of Benjamin West without realizing that although he was a most accomplished and prolific painter, he remains perplexingly enigmatic. At one moment he was creating mythological roundels for the ceiling of the Royal Academy, at another designing a series of Biblical narratives for the chapel at Windsor, at still another counseling a room full of young American students, and at yet another locked in conversation with the king. West's interests and talents were so broad and so diverse that perhaps the most effective way to study his life and works is by isolating individual segments of his kaleidoscopic career.[2] The most obvious aspect for close scrutiny is history painting, because it was in this discipline that he made his most significant contributions to Western art. West's epic compositions not only established precedents for both the neoclassical and romantic styles, but they also influenced artists ranging from John Singleton Copley, John Trumbull, Washington Allston, and Samuel F. B. Morse to Jacques Louis David and Eugène Delacroix. In different ways, each of these men emulated West's formula for transforming narrative compositions into dramatic allegorical epics. This book is aimed at uncovering that formula and finding out how West developed and shaped the late eighteenth-century concept of history painting.

The first step in such a quest is to provide a clear definition of the term *history painting,* a task that has proven to be much more difficult than one might suspect. Authors who have otherwise demonstrated a perceptive understanding of the subject do not bother to define it, discussing instead the merits of individual works and the orientations of individual artists. One finds the same lack of specificity in dictionaries and encyclopedias. Several actually define history painting by describing West's *Death of Wolfe,* an especially frustrating conundrum for someone trying to discover the concepts that led to creation of that very work.[3]

In attempting to reach some meaningful conclusions about West's contributions to the development of history painting in the eighteenth century, I have considered his compositions as if each were a palimpsest of relevant information. On the outer level the painting appears as pure narrative, an event from ancient or modern history told in the form of an entertaining story. The next level, which reveals data about contemporary issues, lends itself to interpretation as a political and social allegory. At the foundation of the composition one finds innuendoes of the artist's personal concerns, and hints of his artistic goals, his professional interests, even his romantic intentions. Taken together, the symbolic insights convey a composite picture of the late Georgian period, reflected by West through some of his most popular works.

This multilayered analysis approaches a working definition

for history painting in the late eighteenth century: a narrative composition based on an event from ancient or more recent history that may be perceived on several levels. Viewers can appreciate the narrative alone or try to decipher the allegory; they can recognize social issues or perhaps read it as the artist's manifesto. Observing these complex and inviting compositions might require sophisticated knowledge of art history, political acumen, or simply an aesthetic response. The history paintings composed by West during the 1760s and early 1770s are, therefore, both informative and moving; the artist undertook scrupulous research and careful planning to bring together old themes and new attitudes, traditional styles and popular images.

There are several words and phrases to keep in mind while reading this book. The first is *narrative*. As it is imperative that history paintings tell a story, I often use the word *narrative* as a synonym for *history painting*. This designation, of course, implies that the work contains a legible progression of events that observers can "read" by studying the action of figures within the composition. In the eighteenth century, narratives came from a variety of sources: the Bible, classical literature, ancient and recent history. West's paintings encompassed all of these areas, but by necessity I have limited my inquiry only to those that depict subjects with a secular historical base. To place necessary emphasis on the early classical and modern history paintings, which survive today as West's most notable compositions, I have deliberately excluded most of his religious, mythological, and literary works.

The second expression that finds its way into the title and the text is *grand style,* or *grand manner.* The term is usually associated with Sir Joshua Reynolds, who made it a central axiom of his famous *Discourses.* He explained the grand style as an "intellectual dignity" that "ennobles the painter's art" by depicting "some eminent instance of heroic action, or heroic suffering."[4] According to Reynolds, artists who painted in the grand style supposedly elevated viewers through suggestions of the ideal world and "noble" subjects taken from classical and religious history, an elusive goal that Reynolds often talked about but seldom practiced.

"Works of art do not spring into being as isolated phenomena," wrote the late Joshua C. Taylor, "but are created as part of normal human activity, reflecting the judgments, the taste, the human evaluations of the artist who conceived them and often of the time of which they are a part." But, he went on to warn, there is a danger in "becoming so concerned with biography and the historical moment that the fresh direct experience of the work . . . is lost."[5] In this book I have tried to stand between the two extremes that Taylor described, turning my head, Janus fashion, in both directions. I have examined works of art for

their aesthetic contributions but have also considered the paintings in the context of the period in which they were created. The double-edged exploration of art and history is both restricted and comprehensive: it is limited in the sense that I am considering only a few decades of an artist's life, and broad because I draw from these observations evidence of larger patterns found within late eighteenth-century history painting.

Combining art with history requires imaginative leaps that pull both author and reader into the mind of the painter and heart of his or her time. On the rare occasions when historical chronicle and aesthetics merge, one can be suddenly transported into a painting, traveling through time and media to discover new means of perception and better ways of understanding. All writers hope to arrive at the elusive moment when bells ring, blood pressure rises, and the printed word leaps joyfully from the page. At times while writing this book, such wonderful phenomena occurred. I was swept onto the floor of the Roman Senate as imagined by an eighteenth-century artist; I stood on the Plains of Abraham, feeling the symbolic presence of a late Georgian military hero; I sat in a chilly London drawing room, hearing the requests of an aristocratic patron; I was poised before an easel, understanding the beliefs and ideologies that an artist wanted to convey. If I have been able to provide readers with similar glimpses into the artistic past, then I have succeeded in opening a tiny peephole into the rich, fog-shrouded barrier of history.

A.U.A.
Atlanta, July 1984

Acknowledgments

Portions of this book appeared as articles in the *Art Bulletin* and the *Winterthur Portfolio*. Other segments were delivered as papers before meetings of the College Art Association of America, the Comité International d'Histoire de l'Art, and the American Society for Eighteenth-Century Studies; and as lectures at the National Museum of American Art, the National Portrait Gallery, and Independence National Park. I am grateful for the generous support for this publication provided by the Millard Meiss Publication Fund of the College Art Association of America.

Many individuals provided assistance and proffered advice during my four years of research and writing. In Washington, D.C., Linda Ayers and John Wilmerding at the National Gallery of Art; Jean Miller at the Folger Shakespeare Library; Bernard Reilly and Peter Van Wengen at the Library of Congress; and Marion Mecklenburg at the Washington Conservation Studio all helped facilitate my research. In Philadelphia, I received assistance from Peter Parker and Nancy Robardshaw at the Historical Society of Pennsylvania; Ken Finkel, Marie Korey, and Edwin Wolf at the Library Company of Philadelphia; Delores Ziff at the Pennsylvania Hospital; and Frank Goodyear at the Pennsylvania Academy of the Fine Arts. Nearby at Swarthmore College, Constance Cain Hungerford and members of the staff of the Friends Library were most generous with their time; and in Bethlehem, Vernon Nelson helped me find material in the Moravian Archives. I also wish to thank Ann Clapp, Sherry Fowble, Michael Heslip, Nancy Quaile, and Karol A. Schmiegel of the Winterthur Museum and Library; Nancy Shaw of the Detroit Institute of Arts; Shelley Bennett of the Huntington Library; Robert Rainwater of the New York Public Library; Felice Stamfle and Stephanie Wiles at the Pierpont Morgan Library; and Elizabeth Woodworth of the Yale Center for British Art. I also profited from conversations with Robert Folkenflik, Louise Lippincott, Ronald Paulson, Wendy Roworth, Lucy Simler, and many others who shared my interest in the eighteenth century.

In England, Sir Oliver Millar and other officials in the Lord

Chamberlain's office, especially Brigadier David M. Stileman at the House of Lords and Grace Holmes at Windsor Castle, graciously allowed me to view West's many paintings and drawings in the Royal Collection. I am also most grateful to Constance-Anne Parker at the Royal Academy of Arts; Major Moon and Colonel Rubens at the Worshipful Company of Stationers and Newspaper Makers; David Allen at the Royal Society of Arts; Brian Allen at London's Yale Center for British Art; Sarah Lorimer at the Fitzwilliam Museum, Cambridge; and Timothy Stevens at the Walker Art Gallery, Liverpool.

The formative stages of this book took shape in the Office of Research at the National Museum of American Art (then called the National Collection of Fine Arts), where I spent a glorious year as a postdoctoral fellow. For all of the numerous benefits of that opportunity, I wish to thank the helpful individuals in the Smithsonian Institution's Office of Fellowships and Grants and all the knowledgeable people at the National Museum of American Art, National Portrait Gallery, and Archives of American Art. During conversations with Elizabeth Ellis, Monroe Fabian, Garnett McCoy, Ellen Miles, Dennis Montagna, Beverly Orlove, Robert Stewart, and Bill Truettner, I learned a great deal about eighteenth-century art and culture. I also wish to thank William Sturtevant of the National Museum of Natural History who helped me find information about the Indians in West's paintings. Most of all, I owe a special debt of gratitude to Lois Fink, whose constant encouragement and provocative suggestions made my residency at the National Museum of American Art one of the happiest experiences of my career.

A few special people shared my griefs and joys with a personal interest that often provided the necessary boost to keep me going. My close friends and colleagues Elizabeth Johns and Anne Palumbo counseled me through the tribulations of frantic research and provided careful and perceptive reading of the manuscript. There is no way I can properly thank Lillian B. Miller, editor of the Charles Willson Peale Papers, for her constant support, wise guidance, and astute assessment of the text.

My family and friends in Atlanta suffered through these four years of my research and writing. Thanks go to my mother, Alene Uhry, and to my children, Alan and Andy Abrams and Laurie Wexner, for their patience, interest, and assistance. I could not even have begun this project and certainly not completed it without the continued encouragement of my most loyal supporter, chief editor, and severest critic, my husband, Edward M. Abrams.

A Hero for His Time

As thirty-three-year-old Benjamin West was painting *The Death of General Wolfe* (plate VI) in 1770, he was bringing to fruition a thematic and compositional formula he had been developing for years. Even before settling in London in 1763, he had begun experimenting with historical scenes, an unusual pursuit for a young man who had been born and bred in the Pennsylvania wilderness. His efforts were not in vain. In eight short years West had accomplished what no Englishman before him had been able to achieve: he had won the approbation of patrons and the public through history painting, the most exaulted and erudite category of art.

Now as he composed *The Death of Wolfe* he was applying many of the ideas that had been generating for the past decade. The painting was large and dramatic, depicting a climactic moment in recent history when young General James Wolfe died on the Plains of Abraham after Britain's decisive victory over France. In West's interpretation of the event, the wounded general lies in the center of the composition with twelve soldiers and a pensive Indian brave grouped about him. Because the composition tells such a dramatic story, it has spawned several anecdotes that accompany the painting wherever it is shown. One of the earliest—and certainly the most famous—came from West's original biographer, John Galt, in a familiar story that begins with the following episode:

When George III saw *The Death of General Wolfe,* he supposedly told West that he "heard much of the picture, but . . . thought [it] very ridiculous to exhibit heroes in coats, breeches, and cock'd hats."[1] West responded by telling the monarch the following story: One day while he was working on the painting, his patron, Archbishop Robert Hay Drummond, accompanied by Sir Joshua Reynolds, president of the new Royal Academy of Arts, visited his studio. They came, Galt wrote, to warn West not to paint Wolfe's death scene, because taking "so great a risk" could ruin his reputation. The "state of the public taste" in England was such, Reynolds purportedly said, that the painting would prompt either "repulse or ridicule." This could be

avoided, he continued, if West would "adopt the classic costume of antiquity, as much more becoming the inherent greatness of . . . [the] subject than the modern garb of war." West is said to have replied that

the event intended to be commemorated took place on the 13th of September, 1758[2] in a region of the world unknown to the Greeks and Romans, and at a period of time when no such nations, nor heroes in their costume, any longer existed. The subject I have to represent is the conquest of a great province of America by the British troops. . . . If, instead of the facts of the transaction, I represent classical fictions, how shall I be understood by posterity! . . . I want to mark the date, the place, and the parties engaged in the event; and if I am not able to dispose of the circumstances in a picturesque manner, no academical distribution of Greek or Roman costume will enable me to do justice to the subject.

After this explanation, West supposedly told his visitors that because of his respect and friendship for the two men, he would agree that if they still disapproved of the painting when it was finished, he would "consign it to the closet." When the work was completed West invited the men to return to his studio.

They came accordingly, and . . . [Reynolds] without speaking, after his first cursory glance, seated himself before the picture and examined it with deep and minute attention for about half an hour. He then rose, and said to His Grace, Mr. West has conquered. He has treated his subject as it ought to be treated. I retract my objections against the introduction of any other circumstances into historical pictures than those which are requisite and appropriate; and I foresee that this picture will not only become one of the most popular, but occasion a revolution in the art.

As a finishing touch to this episode, Galt added that the king was so pleased with West's explanation that he ordered a copy of the painting for himself, and commissioned the American to create other heroic death scenes for the royal collection. All of these events led King George to appoint West as the official history painter for the Court of St. James.

Whether real or apocryphal, Galt's story spotlights West's *Death of Wolfe* as a landmark in his career. When it was first exhibited in 1771, the dramatic composition elicited two reactions: guarded criticism from doctrinaire academicians and enthusiastic approval by the general public. Young, bold, and anxious to succeed, West undoubtedly welcomed the attention focused upon his epic composition, perhaps smiling if he heard

14

that some observers were disturbed by the "revolutionary" implications of his subject.

One of West's critics was Sir Joshua Reynolds, who was clearly not as enamored with *The Death of Wolfe* as Galt's anecdote would have us believe. Reynolds even made a direct reference to West's interpretation of the "grand style" by advising students of the Royal Academy to avoid filling their narrative compositions with "minute peculiarities of the dress, furniture, or scene of action," because viewers of historical scenes were expected to perceive values of universal significance that could not be found in paintings of contemporary events.[3] His admonition, pronounced in 1771, the year that West's *Death of Wolfe* had been successfully received at the annual Royal Academy exhibition, inferred that history painting should be separated from popular sentimentality.

The notion that history painting was a sacrosanct branch of art had roots in Renaissance Italy. Leon Battista Alberti, a fifteenth-century theorist, originated the term *istoria* to define didactic narrative paintings taken from classical or religious history. Art could parallel poetry, Alberti wrote, if paintings of *istoria* addressed issues of broad aesthetic and ethical dimensions. A perceptible narrative was essential in such works to establish a clear relationship to classical and Scriptural literature. In addition, paintings of *istoria* were expected to contain allegorical references that would elucidate an underlying moral message.[4] Alberti's thesis became the standard definition: history painting must relate a story from ancient or Biblical history that conveyed an instructive lesson concerning universal moral values.

History painting in Europe moved in several directions. During the late fifteenth and early sixteenth centuries, it was usually either allegorical (as best personified by Raphael's Vatican *Stanzas*), or dramatic and descriptive (as seen in Michelangelo's Sistine frescoes or Leonardo's designs for the *Battle of Anghiari*). Renaissance artists often characterized historical figures as contemporary individuals wearing the costumes of their neighbors and friends. Piero della Francesca, for example, filled his *Legend of the True Cross* with a bevy of fifteenth-century Italians. Caravaggio carried this brand of naturalism to such an extreme that he prompted a reaction among the next generation of French and Italian artists. By the late seventeenth century, the tide had turned away from naturalism. Most painters were now placing their historical subjects in imaginary landscapes and dressing them in the robes and peplums of the ancient Greeks and Romans. These ethereal surroundings seemed most appropriate for transmitting moral lessons of universal significance.

15

Nicolas Poussin, perhaps more than any other, created a number of such didactic tableaux, which established a precedent for French academic dogma.

Rules for history painting soon evolved into a set of axioms transcribed in theoretical essays—including Charles Alphonse du Fresnoy's *De Arte Graphica,* Jonathan Richardson's *Theory of Painting,* and Lord Shaftesbury's "Notion of the Historical Draught or Tablature of the Judgment of Hercules"—that became standard instructional material for prospective artists. The seventeenth-century French Academy canonized the history painter as the highest arbiter of culture. In 1669 André Félibien transcribed existing academic regulations into a kind of "rating chart" by ranking acceptable subject matter on a ladder of ascending values. Beginning at the bottom with still-life, he progressed upward to landscape, then animal painting, then portraiture, and finally at the pinnacle rested the highest form of artistic expression: *l'histoire et la fable.* Paintings that fell into this most revered category, the equivalent of Alberti's *istoria,* should blend the grandeur of historical epics with the delicacy of poetry. The subjects, which were ostensibly both enlightening and grandiose, were expected to address questions of cosmic significance. At the same time, artists were entreated to abide by Shaftesbury's "Rule of Consistency," a phrase that implied a balanced mixture of imitation, verisimilitude, universality, didacticism, and classicism.[5]

When painters followed this discipline, they faced a maze of contradictions. Advice to imitate nature was countered by admonitions against overly accurate reproductions of natural objects. The inconsistency of such pedagogy may be noted in the following lines from the 1783 English translation of Fresnoy's *De Arte Graphica:*

> *Vivid and faithful to the historic page,*
> *Express the customs, manners, forms and age:*
> *Nor paint conspicuous on the foremost plain*
> *Whate'er is false, impertinent, or vain;*
> *But like the Tragic Muse, thy lustre throw,*
> *Where the chief action claims its warmest glow.*

Fresnoy then went on to caution against undue accuracy:

> *Yet to each sep'rate form adapt with care*
> *Such limbs, such robes, such attitude and air,*
> *As best benefit the head, and best combine*
> *To make one whole, one uniform design.*[6]

History paintings, Fresnoy counseled, should include only ideal figures appropriately attired in clothing of the ancients, for

classical subjects were believed to embody heroism, honesty, justice, bravery, loyalty, and sacrifice. Instead of portraying actual events, he instructed painters to envision historical scenes in which costumes, settings, and objects conveyed an aura of universal beauty. Utilize "nature's boundless store," he proposed. Then, turning around completely, he criticized those who imitated natural objects by copying them "line for line." On the one hand, painters were told to reproduce "empirical truth," and on the other, they were scolded if their interpretations were not original and imaginative. The disparity between reality and fiction, historical precision and cosmic abstraction, was the very "prejudice" that West was attacking in his supposed encounter with Reynolds. Sir Joshua's subsequent criticism of West's subject matter implied that by not following the academic rules, *The Death of Wolfe* should be "consigned to the closet."

An eighteenth-century history painter was presumed to be a scholarly gentleman whose lofty education distinguished him from the ordinary craftsman. He was expected to have read the classics in Greek or Latin and be able to converse freely about the most sophisticated aspects of European literature, history, and philosophy. Benjamin West was a most unlikely candidate for this elevated position because, despite the king's patronage and West's role as president of the Royal Academy, he was no scholar. His letters and speeches were riddled with spelling and syntactical errors that evidenced his language deficiencies. The lectures he delivered to students at the Royal Academy were awkward and clumsy when compared to the urbane and articulate *Discourses* of his predecessor Joshua Reynolds. Shortly after the annual address of 1794, for instance, King George amused visitors by deriding West for his lack of oratory skills and joking about his pronunciation of the word "Academy" as "Hackademy."[7]

West never denied his inadequacies. "I don't like writeing," he explained in a letter to his cousin Peter Thompson in 1772.

Its as dificult to me as painting would be to you. . . : I could as soon paint you a discription of the things on this side of the water as write. I believe I should have made a Figure in South America in the time of that conquest when we find the natives of that country communicated with each other by Painting the Images of their Amaginations and not in writeing charectors to describe them.[8]

With his admission of verbal shortcomings, West has invited us to consider his painted characterizations instead of his words. The best sources for "reading" the story of his life, there-

Fig. 1 *Self-portrait,* 1756, watercolor on ivory, 2½ × 1¹³⁄₁₆ inches. Yale University Art Gallery, New Haven, Connecticut; The Lelia A. and John Hill Morgan Collection.

fore, should be the self-portraits that he painted at decisive intervals throughout his long career.

The first is a miniature (fig. 1) painted when the artist was less than twenty years old. Presumably composed as a present for one of his Philadelphia girlfriends, the small image pictures a well-groomed young man with a round friendly face and sharp piercing eyes. The same features assume a more whimsical attitude in a little-known charcoal drawing (fig. 2), sketched during West's three-year tour of Italy in the early 1760s. The youthful artist, draped in a baroque cloak, faces an antique head, his right hand resting on a table that holds a book and palette. West's pose resembles that found in Poussin's famous self-portrait painted a century earlier, making the young artist appear to be a master standing jauntily at his easel, full of self-confidence and aplomb. Even in the sparse lines of this casual sketch, one detects a twinkle in his eye and the energetic bravado of an aspiring young painter intent on imitating the classics.

Less than a decade later, West had become a bright light on the London art scene. His rise from being provincial and obscure to having royal and noble patronage was nothing short of miraculous. His often-reproduced self-portrait from around 1770 (fig. 3) hints of his success. Gazing from beneath the wide brim of a black fur hat, West's clean-shaven face is sober and dignified as it rests with ease on his folded right hand. In the version of this painting now in the Baltimore Museum of Art (fig. 4), a canvas in West's left hand contains a portion of the recently completed *Death of Wolfe*. It is, indeed, the image of a handsome young man at the height of his career, satisfied with his world and content with his accomplishments. But a closer examination of the composition discloses a strange phenomenon; dark shadows on the left side of the face divide the regular features into opposing spheres. The light area that supports his folded hand exudes controlled, confident complacency, but the shaded side divulges an expression of pensive melancholy. The combination of self-assurance and introspection reveals both the public and private artist, an intriguing combination that pervades many of his epic paintings.[9]

West further amplified the theme of dual tensions in the portrait of his family painted in 1772 (fig. 5). The left side of the canvas pictures a Georgian parlor, perhaps the couple's home at 14 Newman Street. Seated comfortably in an armchair is the artist's wife, the former Elizabeth Shewell of Philadelphia, holding her new baby, Benjamin; leaning over the upholstered arm of his mother's chair is the older son, Raphael, then a boy of six.[10] Across the room, in Quaker costume, West's father and half-brother sit stiffly in straight-backed chairs. Behind them in the upper righthand corner, the artist placed himself, palette in hand, recording the scene.

Fig. 2 *Self-portrait,* ca. 1762–63, charcoal and chalk on paper, approx. 7 × 6 inches. Friends Library, Swarthmore College, Pennsylvania.

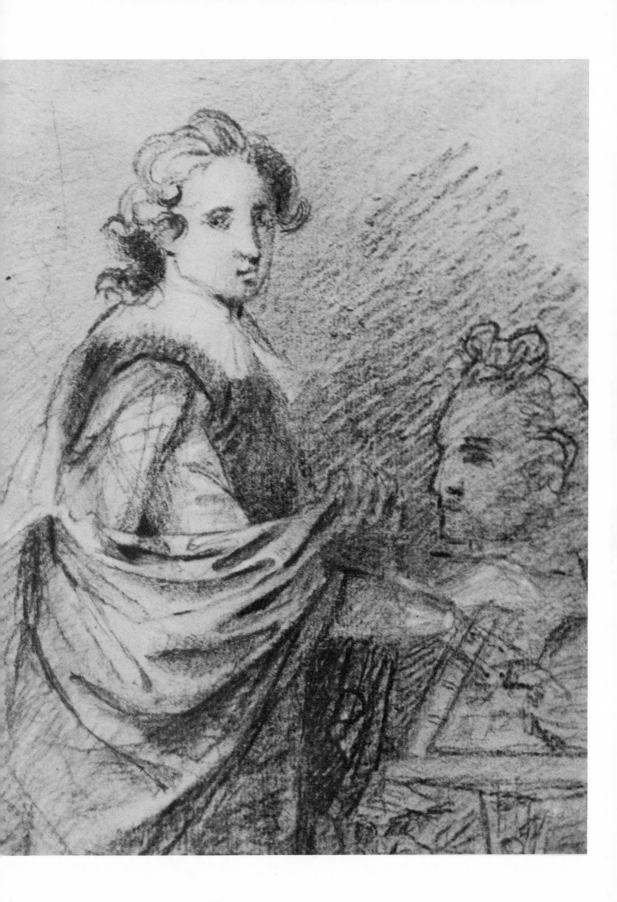

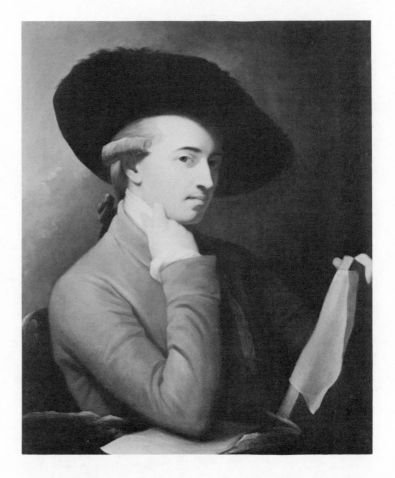

Fig. 3 *Self-portrait,* ca. 1770, oil on canvas, 30¼ × 25⅜ inches. National Gallery of Art, Washington, D.C.; Andrew W. Mellon Collection, 1942.

The group portrait is truly a medley of juxtaposed extremes. Mrs. West with her sons resembles a Renaissance madonna in a plush Georgian interior, with the soft velvet curtain, brocade chair, and paneled door conveying a sense of middle-class luxury. The solemn Quakers, on the other hand, rest warily in stark rigidity. No symbols of wealth or personal comfort, no signs of simple familial pleasures accompany them. They sit erect before a background wall that is as plain and drab as the outfits they wear. Observing them from his perch on the far right is the artist himself. Attired in a gray satin robe with his hair fashionably powdered, his figure appears to be carved from marble. The hint of a smile, however, brings the statue to life. Locked into the corner, observing but not interacting with the figures of his past and present, West dwells partly with his austere Quaker relatives and partly with his animated wife and children. One portion of him delights in the luxuries of material comfort, the other remains serious and subdued. This glimpse into West's personal world discloses that his innermost family circle is divided by private tensions and rewards.

During the next two decades, West gained critical acclaim as a leader of England's art community, his London studio be-

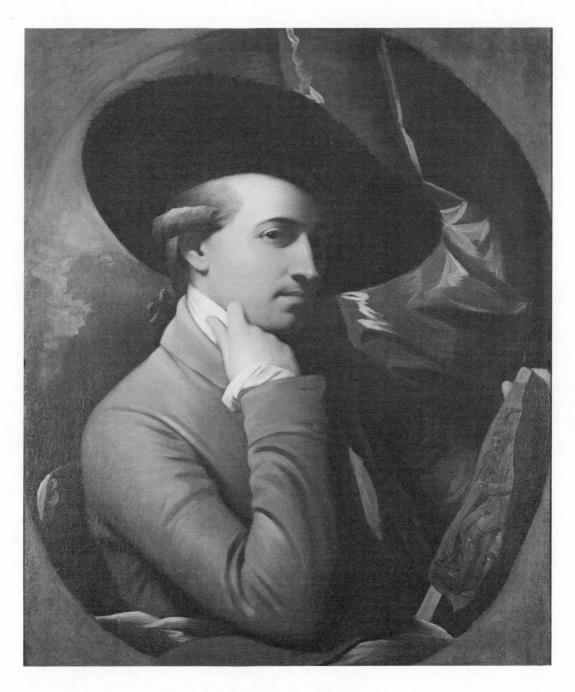

Fig. 4 *Self-portrait,* ca. 1771–76, oil on canvas, 30¼ × 25⅛ inches. The Baltimore Museum of Art, Maryland; Gift of Dr. Morton K. Blaustein, Barbara B. Hirschhorn, and Elizabeth B. Roswell, in memory of Jacob and Hilda K. Blaustein.

coming a magnet for aspiring painters. John Singleton Copley, Charles Willson Peale, Gilbert Stuart, John Trumbull, Samuel F. B. Morse, Robert Fulton, and many other giants of American art and science crossed the ocean to receive instruction from their fellow American who held such a respected position. When Reynolds died in 1792, the American artist was the natural choice for the second presidency of the Royal Academy. Shortly after assuming leadership of that institution, West painted himself seated magisterially at a desk surrounded by books, pens,

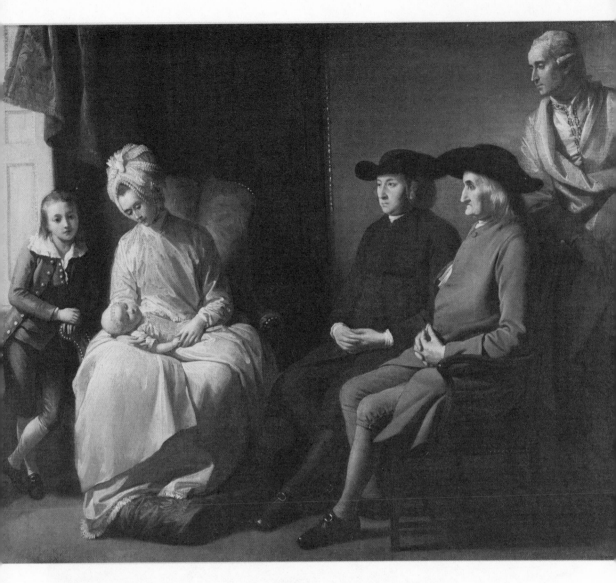

Fig. 5 *The Artist's Family*,
1772, oil on canvas, 20½ ×
26¼ inches. Yale Center for
British Art, New Haven, Con-
necticut; Paul Mellon Collec-
tion.

papers, and the plaster cast of a human torso (fig. 6 and plate I).
In the background he placed Somerset House, home of the
Royal Academy. This is the image of a celebrated master presid-
ing over his domain. Yet within the imposing setting, West ap-
pears dwarfed. The chair seems too large, the desk too
crowded, and the academy in the background awesomely intim-
idating. Even the plaster cast is turned so that its shoulders seem
to bear the weight of presidential responsibilities. Amidst the
signs of his important office, West comes forward as a simple
provincial, cautious yet satisfied, in royal trappings that are
both splendid and meager. The sensitivity and complacency
found in the earlier self-portraits have been redesigned to fit the
new surroundings of cultural leadership.

In another self-portrait from around the same time (see fig.
7), West again referred to his elevated status as president of the

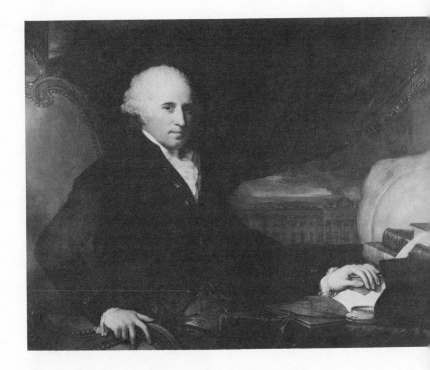

Fig. 6 *Self-portrait,* 1793, oil on canvas, 40 × 52 inches. Royal Academy of Arts, London. Reproduced in color, plate I.

Royal Academy, although here he seems to be more confident in the position. Sitting upright at his desk, he holds a document that reads: "By command Decm^br 10th 1768 Royal Aacademy [*sic*] of Arts, London." Spelling difficulties unfortunately even crept into his paintings at times. His left arm rests on the academy's minute book, and in the background are sources for his most recent paintings: a Bible and the history of England. Opposite the artist in the upper lefthand corner is a bust of George III wearing the costume and laurel wreath of Julius Caesar. Like Caesar, West's principal patron had conquered a crippling bout of illness in 1788–89, and had once more assumed command of his empire. West, too, appeared to be in control of his world, an effective leader presiding over his domain with dignity and assurance.[11]

West's moment of glory was short-lived, however, for by 1803 his fortunes had changed dramatically. The king had lapsed into a renewed and more severe attack of porphyria from which he would never fully recover. For almost two decades the monarch lingered in a long twilight period of withdrawal from the world, a condition that unceremoniously ended West's favored role at court. At the same time, a squabble that had been seething beneath the surface at the Royal Academy broke out in a divisive and acrimonious quarrel. Opposed by several of Britain's most highly respected artists (including his protégé Copley), West suffered numerous abuses when he attempted to defend his leadership qualifications and artistic integrity. As a result of the dispute, West was temporarily removed as president

Fig. 7 *Self-portrait,* ca. 1818 (replica of a self-portrait of 1793–1800), oil on panel, 35³/₈ × 28¹/₂ inches. Fogg Art Museum, Harvard University, Cambridge, Massachusetts; Grenville L. Winthrop Bequest.

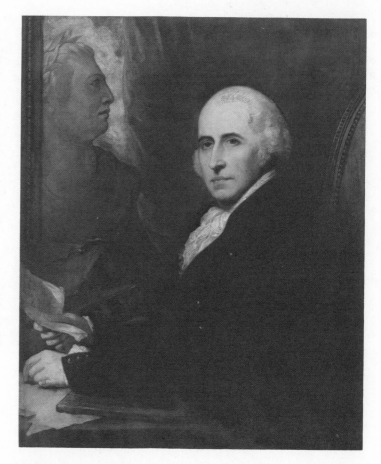

of the academy, and his career as a public figure appeared to be in serious jeopardy.[12] If this were not enough, Mrs. West became gravely ill during those years and narrowly escaped death. Although the troublesome events left irreparable scars, the upshot was not entirely unfavorable for West. He was reelected to office at the academy and his wife recovered from her illness.

In a self-portrait painted around 1806–7 (fig. 8), West alluded to this crisis period. On the right the sixty-eight-year-old artist—with sober, piercing eyes and pressed lips—stands before a life-size portrait of Mrs. West. This "painting within a painting" achieves a clever trompe l'oeil illusion, because the picture of his wife (painted on the same plane as the artist's own image) renders her likeness as "real" as that of her husband's. Was West trying to preserve on canvas a portrait of the wife he nearly lost? Perhaps he was depicting her as robust and hardy when her health actually was declining. Or perhaps he was making a commentary about his ability to duplicate "nature" accurately through his artistic skills. Whatever the explanation, the enigmatic composition is most compelling: the couple stare forward in steadfast determination, their expressions of intensity and vigor seeming to underscore a resolution to survive in a world

Fig. 8 *Self-portrait (with Portrait of Mrs. West),* ca. 1806–7, oil on canvas, 36 × 28 inches. The Pennsylvania Academy of the Fine Arts, Philadelphia; Gift of Mrs. Henry R. Hallowell.

24

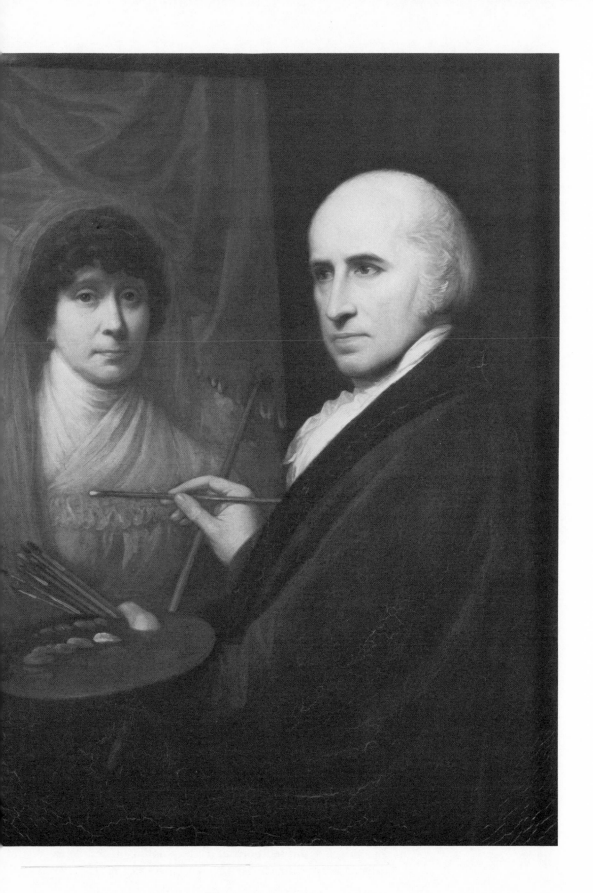

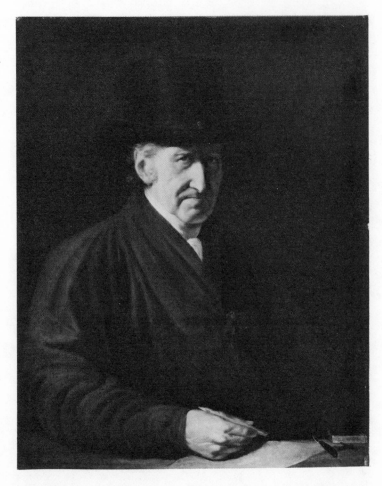

now overshadowed by physical threats and emotional challenges.

West's last self-portrait (fig. 9), dated 1819, a year before his death, shows the crusty exterior of a man who exchanged his youthful bombast for the wisdom and melancholy of old age. Although only faint echoes of the cocky, energetic young artist remain, the last self-image is as strong and complex as his portrait in the black fur hat painted a half-century earlier. Dressed in a simple brown cloak and high black top hat, he stares at the viewer with an octogenarian's haunting comprehension. The objects around him are few: a brush, a piece of blank paper, and a box of charcoal. On the table, he has placed a knife with its blade pointing toward him—a hint, perhaps, of approaching death. In spite of the somber mood, this is not a painting of despair, for West's set jaw and penetrating stare announce his determination to hold onto life, even though his wife had died five years earlier. The empty sheet of paper on the table and the brush in his hand further emphasize his will to live. In fact, a comparison of this self-portrait with a painting of West done around the same time by Sir Thomas Lawrence (fig. 10) reveals

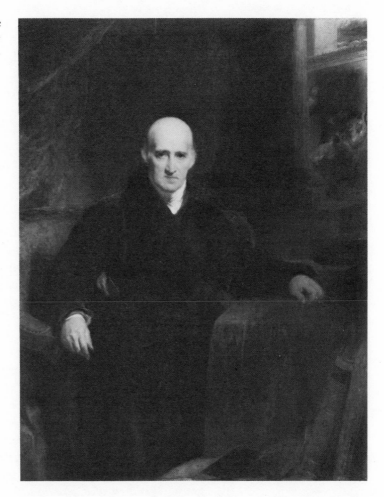

that West has made himself appear years younger than Lawrence saw him. The last self-portrait is a remarkable document because it records that at age eighty-one West was mentally agile and creatively robust. It is, indeed, a fitting epitaph for a productive lifetime.

When West died in 1820 a galaxy of dignitaries attended the large funeral at St. Paul's Cathedral, but only days after the burial the floodgates of abuse, which had been precariously closed since the 1803–4 rift at the Royal Academy, broke open to unleash a flood of criticism. His most devoted students and friends—many of them then well-established artists in Britain and America—were unable to stem the tide.[13] The derogation was often petty and personal, inspired partly by jealousy of West's role as the academy's president, partly by scorn for his provincial speech and homespun manner, and partly by dislike of his formal painting style.

In his multivolumed history of British art written in 1831,

Allan Cunningham stated: "[West] wanted fire and imagination to be the true restorer of that grand style which bewildered Barry and was talked of by Reynolds. Most of his works—cold, formal, bloodless, and passionless—may remind the spectator of the sublime vision of the Valley of dry bones, when the flesh and skin had come upon the skeletons, and before the breath of God had informed them with life and feeling." But Cunningham added condescendingly that "West was injured by early success, he obtained his fame too easily—it was not purchased by long study and many trials—and he rashly imagined himself capable of anything. But the coldness of his imagination nipped the blossoms of history."[14]

Throughout the next few generations, West's reputation continued to plummet, so that less than a century after Britons had heaped such lavish praise upon *The Death of General Wolfe* his works found few admirers. In an influential study of British artists, first published in 1866, Richard and Samuel Redgrave expressed thorough disapproval of West's painting style.

West only attained to an imitative facility and a barren power that enabled him, during a long life, to cover acres of canvas with much that is insipid and mediocre, leaving him no time to produce one work, hardly one figure, evidencing intense feeling or keen perception. This very facility led him to a painty and mechanical execution which repels the spectator, makes him long for less respectability and more vigour, and, if at the cost of a little coarseness, for something to find fault with or something to praise. West drew well, cast his draperies well, painted his picture satisfactorily throughout; but no part excites us to admiration or enthusiasm, or invites our special attention.[15]

In 1866, when the Redgraves advanced their acid judgment, popular artists of the day were often bohemians working against the grain of bourgeois society. For middle-class patrons the sentimentality of Victorian genre scenes or medieval fantasies was in vogue, while classicism as interpreted by West and his generation was passé. Perhaps, as Cunningham allowed, West's greatest failing was early success. Another was excessive productivity, especially in his later years. The sum total of his prolific career is so overwhelming that it defies even the most scrupulous scholarly documentation.[16] Until well into the twentieth century, most of West's early works lay hidden in private estates and royal palaces, leaving only the paintings of his later years to be viewed by the public. It is little wonder, therefore, that the Redgraves, knowing little about his earlier endeavors, were so harsh.

In the first years of the twentieth century, West's best works lay in dusty attics or hung unnoticed in dark hallways, familiar

only to a few antiquarians and scholars. The situation began changing, however, shortly after World War I, when some of West's early history paintings entered public and private collections in the Western Hemisphere. In 1921 the Philadelphia Art Alliance held a memorial exhibition, followed a year later by one at the Brooklyn Museum. Interest in the colonial period and the revival of many previously forgotten American artists prompted the Philadelphia Museum of Art to mount a major exhibition in 1938, the two-hundredth anniversary of West's birth. Although response to the show was generally favorable, it did little to reestablish West as a dynamic figure in American or British art.[17] But the exhibition accomplished an important task by spotlighting the original *Death of Wolfe,* loaned by the National Gallery of Canada, where it had been housed for two decades. This composition and *William Penn's Treaty with the Indians* were the best examples of West's early epic history paintings included in the exhibition, as most of the show consisted of his later works and paintings from his childhood that had been assembled for their first major viewing. While the Philadelphia exhibition gave only a slight boost to West's reputation, it did prompt scholarly interest. A number of the most perceptive articles about his work date from these years and shortly thereafter. In keeping with prevailing attitudes of the mid-twentieth century, authors investigated art of the past with one eye on the evolution of modernism. The most "revolutionary" fact they could attach to Benjamin West was his defiance of academic norms when painting *The Death of Wolfe,* an iconoclastic gesture that had a special appeal to scholars of the late 1930s and early 1940s.[18]

Today the appraisal of Benjamin West remains much the same. He has entered the pages of history as the "rebel" who painted *The Death of Wolfe* and influenced several generations of younger American artists. For the most part, however, his paintings are still out of favor. "Much of West's work for the King seems today dull and fustian stuff," wrote Sir Oliver Millar in 1969, "but in patronizing him the King was encouraging those who hoped to see a flourishing school of History painting in England."[19]

To make West's works come alive, one must pay special attention to the early part of his career, the years before 1771 when he was developing his mature style. Each of his major history paintings preceding *The Death of Wolfe* demonstrate how the artist addressed certain fundamental questions that intrigued and fascinated him. As documents of his evolving formula for history painting, each reveals the wide range of his creative imagination. These were the works that captured the attention of London critics, patrons, and royalty. West was a superb draftsman and a perceptive interpreter of his surroundings; his

early works were splendid examples of the latest trends in painting, as new and vital as any of those created by his English and Continental contemporaries. In fact, West was a most "modern" artist during the 1760s. It is this young man, cocky and energetic, ambitious and sensitive, who fills the following pages.

John Galt and the Legendary Origins of Benjamin West

John Galt published *The Life, Studies, and Works of Benjamin West, Esquire* in two volumes: one issued in 1816, four years before West's death, and the other in 1820, shortly after the artist died. Although the biography survived for more than a century and a half, scholars have long recognized its inaccuracies and exaggerations. Most have dismissed the account as pure fiction, yet there are still some who treat the text as if it contained accurate information about West's youth and later career.[1] Few, however, have realized that the biography is probably an attempt by the elderly artist to create his own apotheosis at a time when his reputation as a leader in the British art world was rapidly declining.

Galt readily admitted that West played an active role in writing the biography, actually dictating most of the text. "The whole of materials were derived from him," Galt wrote,

and it may be said to have been all but written by himself. The manuscript of the first part he carefully corrected; the second was undertaken at his own request when he was on his deathbed, and nearly all the last proof in the printing submitted to him.

To bolster the claim of West's coauthorship, Galt elaborated on their working arrangement. "My custom," he continued, "was to note down those points which seemed important in our own conversations, and from time to time to submit an entire chapter to his perusal; afterwards, when the whole narrative was formed, it was again carefully read over to him."[2] If this statement is correct, and we have no contradictory information to discredit it, then Galt's *Life of West* is tantamount to an autobiography.

No one knows why the elderly West chose Galt to transcribe his image for posterity. When the two men began their collaboration in 1816, the thirty-eight-year-old Galt was an unsuccessful hack writer from Scotland, having previously published a travelogue of his tour of the Continent with Lord Byron and a biography of Cardinal Wolsey. The books were sensa-

tional flops, criticized for being "awkward, affected and desti-tute of taste." Galt's attempts to write dramas based on themes from Shakespeare, Euripides, and Aeschylus were equally disap-pointing. Sir Walter Scott went so far as to appraise them as "the worst tragedies ever seen."[3] Galt's luck changed, however, with publication of the first volume of *The Life of West* in 1816. Re-ception of the book when it first appeared was surprisingly fa-vorable, even though one reviewer commented caustically about the author's "dashing manner and propensity to theorize and dramatize." The biography nevertheless captured enough atten-tion to enhance the Scottish author's literary career.[4]

A string of colorful stories interspersed throughout Galt's text contributed to the book's popularity. Many of them had al-ready been published in biographical essays about West, an indi-cation that the anecdotes probably originated with the artist himself. Galt merely applied literary license, enlarging the story line and retelling the incidents in metaphorical terms. Galt ad-mitted that the anecdotes in the biography "have an interest in-dependent of the insight they afford into the character to which they relate." "Nature," he continued, endows the artist "with the faculty of perceiving a fitness and correspondence in things which no force of reasoning, founded on the experience of oth-ers, could enable them to discover."[5] Here Galt implies that art-ists and/or authors should fabricate and embellish factual mate-rial in order to better interpret their subjects. For the researcher, the biographer's admission suggests that his anecdotes are puz-zles waiting to be solved. Contained in his obvious exaggera-tions and inflated rhetoric must be clues to a better understand-ing of West's ancestry, youth, and orientation in the world of eighteenth-century art.

The first volume of Galt's biography begins with a fanciful jux-taposition of fact, fiction, and symbolic suggestion, a bizarre conglomeration even for an age accustomed to inflated prose. In the opening paragraph the reader is told that West's lineage could be traced "in an unbroken series to the Lord Delawarre, who distinguished himself in the great wars of King Edward the Third, and particularly at the battle of Cressy, under the imme-diate command of the Black Prince."[6] The validity of his state-ment is impossible to prove or disprove because no verifiable records trace West's ancestry back to the days of Edward III. The story, however, did not originate with Galt; it appears in every biography of West written during his lifetime. One must assume that the artist believed that he was descended from Lord Delawarre, even though twentieth-century researchers have found that West's immediate ancestors were middle- and lower-class yeomen farmers, soldiers, and craftsmen.[7]

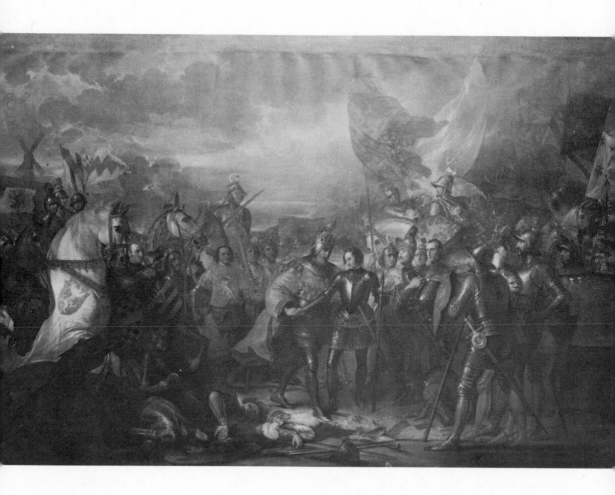

Fig. 11 *Edward III with the Black Prince after the Battle of Crécy,* 1788, oil on canvas, 113 × 176 inches. Her Majesty Queen Elizabeth II. Reproduced in color, plate II.

Evidence that West believed he was a legitimate member of the Delawarre family is cleverly concealed within his own series of paintings that commemorate the military victories of Edward III. Among these canvases are two compositions, *Edward III with the Black Prince after the Battle of Crécy* (fig. 11 and plate II) and *The Institution of the Order of the Garter* (fig. 12). In the first, which depicts a meeting between King Edward and his son after the same battle that Galt cites in the text, a knight in the crowd wears the heraldry of the first Lord Delawarre. The second painting is even more revealing, for in the upper lefthand corner, among the lords and ladies witnessing England's most famous knighting ceremony, West has placed a portrait of himself and his wife (fig. 13).

A page of West's sketchbook (fig. 14), now in the collection of Swarthmore College, provides an explanation of why the artist thought he should be represented among noblemen attending the Order of the Garter ritual. On this scrap of paper we find a coat of arms crowned by a hawk; around the edges are notations of colors; and at the bottom is scribbled: "Thoˢ West— Lord De la Ware knight of the Garter Installed anno. 1549." From the drawing and its label we learn that the family name of

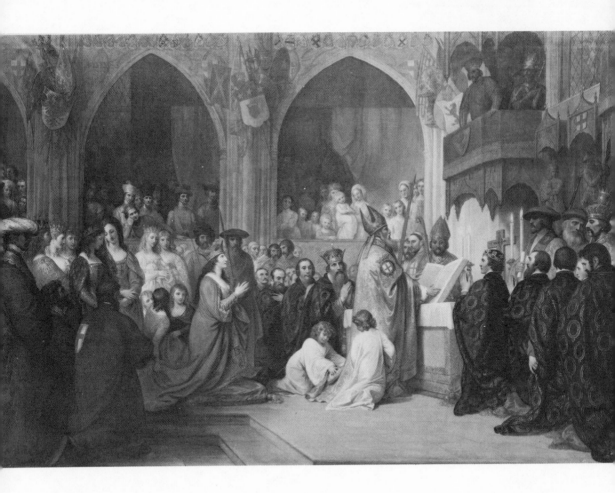

Fig. 12 *The Institution of the Order of the Garter,* 1787, oil on canvas, 113 × 177 inches. Her Majesty Queen Elizabeth II.

Lord Delawarre was West. To further corroborate West's claim to noble lineage, the seat of the Delawarre domain is Buckinghamshire, the ancestral home of the artist's own family. Such evidence motivated West to tell his biographer that he was descended from the Delawarre line.[8] In his painting *The Institution of the Order of the Garter,* therefore, West projected himself through time to participate in his own investiture.

Finding that West chose to paint himself in the presence of former kings and noblemen suggests that the artist aspired toward elevation to the peerage, a rank that Sir Joshua Reynolds attained as president of the Royal Academy. Galt, to the contrary, indicated that West declined a similar opportunity for knighthood because "he had already earned by his pencil more eminence than could be conferred on him by that rank." By pairing West's rejection of a title with references to his noble forebearers, Galt presents a composite picture of the artist as a regal but humble man. Ties with Lord Delawarre endowed West with ancestral legitimacy in royal circles, while refusal to be known as "Sir Benjamin" kept him on equal footing with his American students and associates. As an answer to frequent jokes about West's awkward speech and homespun accent, the opening

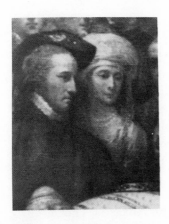

Fig. 13 Detail (West and his wife) from *The Institution of the Order of the Garter.*

statement in Galt's biography justifies West's presence at the Court of St. James. The American artist was both aristocrat and backwoodsman, with a mixture of sophistication and simplicity that appealed to eighteenth-century ideas of "noble savagery." West enjoyed this designation, frequently reminding others that even though he socialized with courtiers and kings, he had been raised in the Pennsylvania wilderness.[9]

An even greater mix of anecdote and allegory emerges from Galt's description of West's immediate ancestry. The biographer portrayed West's father, John, as a planter who frequently conducted business trips to the Caribbean. On one such visit, Galt wrote, John West was admonished by a Quaker minister because he owned a slave. Affected by the clergyman's reprimand, the senior West supposedly vowed to free his slave and become an active participant in the abolitionist movement. Scholars have dismissed this tale as pure fantasy, for the simple reason that John West was never a planter but operated a tavern in rural Pennsylvania.[10] Yet the anecdote, which provides valuable information about a possible connection between the West family and the abolitionist movement, should not be totally rejected. The first clue to its possible validity is found in a frayed, unsigned letter, dated October 10, 1819 (Benjamin West's

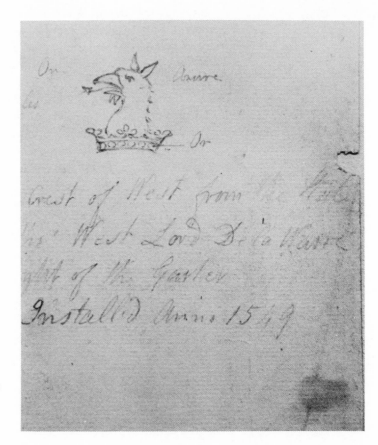

Fig. 14 *The Delawarre Crest,* date unknown, crayon on paper (from sketchbook), image: approx. 4 × 4 inches. Friends Library, Swarthmore College, Pennsylvania.

eighty-first birthday), that has been long buried in the archives of the Historical Society of Pennsylvania. Among the fragmented sentences is the statement: "All the Negroes say that John West is still alive,—even more now, than exactly hundred years ago, when he went to America and began the task of the abolition of that trade which not till now has been finished."[11]

The antislavery activities of colonial Pennsylvania have been well documented with no mention of John West's name, but on this basis alone he cannot be automatically precluded from having participated. The covert nature of the movement required certain liaisons—especially tavern owners who received transient traffic—to remain anonymous. So little is known about John West that such speculation is not without grounds. In fact, details of his early life and of his arrival in America remain shrouded in mystery. In the late seventeenth century his parents had immigrated to Pennsylvania as followers of William Penn, bringing with them their two oldest sons but leaving John, the youngest, with relatives in England. Roughly twenty years later John did the same: when his first wife died during childbirth, he left his own son, Thomas, in the care of English kinsmen and ventured off to sea. For about two years he toured the Caribbean before finally finding his parents and brothers in Pennsylvania. Did he become involved with abolitionists during the extended voyage? Was it at that time, perhaps, that he encountered the minister described in Galt's tale? These are questions that may never be answered, but they do pose an interesting scenario, for which the fragmentary letter at the Historical Society of Pennsylvania provides a shred of documentary proof.

Benjamin West's connections with the antislavery movement can be more easily verified. During the latter decades of the eighteenth century, American and British members of the Society of Friends led an undercover campaign to end the slave trade. Although West never openly admitted his participation in the movement, one of his students recalled that West allowed a secret meeting of Quaker abolitionists to be held in his Newman Street studio. In 1783 he went even further by agreeing to deliver a Quaker antislavery petition to Queen Charlotte at St. James Palace, an episode that is documented in an archival source.[12] By necessity, that mission would have been conducted under the utmost secrecy, owing to the controversial nature of the abolitionist movement during the late 1780s. West could not have disclosed his participation in these maneuvers because too many influential Englishmen were then profiting from the sale of Africans.

By the time Galt wrote his text in 1816, however, Parliamentary legislation had ended the slave trade. Support for humanitarian causes had become so fashionable among young intellectuals and aristocrats that Galt had ample reason to tuck the

story about West's father into the opening chapter of the biography. Not only did the anecdote imply that the artist came from a liberal background, but it also established his roots in Quaker altruism, now that support for the abolitionists was considered to be a favorable asset. Approval of this kind would have been especially important for West during the later years of his life when his opponents so often criticized him for being conservative and "old fashioned."

Woven through the opening chapter of Galt's biography is a similar web of information about West's mother. Shortly before Benjamin's birth, Sarah West supposedly attended a lecture by the Quaker orator Edmund Peckover. At the climax of his sermon, wrote Galt, as the minister shouted fearsome pronouncements about "the future greatness of America," Sarah West was "taken with the pains of labour," which "nearly proved fatal both to the mother and the infant." After her baby was born, Galt continued, Peckover told John West that "a child sent into the world under such a remarkable circumstance would prove no ordinary man."[13] By linking West's birth with a sermon concerning the glorious promise of America followed by a prediction of the artist's magnificent career, Galt endowed West's entrance into the world with the sanctity of a spiritual mission.

Not surprisingly, the anecdote differs markedly from the documented facts. First of all, Sarah West had not been a Quaker for two decades preceding the birth of her last child, Benjamin, although her parents had been pious followers of William Penn. In 1717, at age twenty, she had actually been "read out of meeting" for what was bluntly recorded in one Chester County archival source as "fornication." Although Quaker regulations provided the young woman with an opportunity to plead her case and thus retain her membership in the Society of Friends, she never appeared at the specified meeting to defend her reputation, because, the records indicate, she had been "absconded."[14] Was John West her kidnapper? We cannot help but wonder, for it was just around this time that they married and started their large family of ten children. Because of Sarah's dismissal from meeting, her offspring were denied membership in the Society of Friends.

The discovery of Sarah West's real circumstances not only discredits many of Galt's stories about West's Quaker boyhood and Sarah's pious devotion to the tenets of Quaker practice, but actually calls into question the authenticity of the entire biography. Why, indeed, were these anecdotes such an integral part of the opening chapter of a book that West presumably authorized?

A circuitous course through the pages of colonial history again supplies a possible answer. Edmund Peckover did not arrive in America until 1743, five years after Benjamin West was born. But in 1739, when the artist was still an infant, the well-

known Methodist evangelist George Whitefield toured Chester County, winning thousands of converts with his hypnotic oratory. In fact, Whitefield's tour troubled Pennsylvania leaders because so many former Quakers joined his crusade.[15] Additional speculation, then, can be raised about Sarah West. Was it the fiery Methodist and not the sedate Quaker who caused her to become emotionally overwrought? The passionate atmosphere of the Great Awakening could well have inspired a woman shunned by her own faith to follow a charismatic evangelist.

While our conjectures about the underlying meanings of Galt's tales must remain pure speculation, the anecdotes do convey an intriguing pattern. Together, the two legends about West's parents comprise a dramatic overture for an unfolding historical epic. One might imagine that because of Sarah's disgrace, John West would have been a persona non grata in Quaker Pennsylvania and, therefore, might have been an ideal liaison for the underground abolitionists. We can also understand the gravity of Sarah's banishment when we realize its effect on her husband. Loyalty to her kept him from formally affiliating with the Quakers during his wife's lifetime. But in 1759, three years after her death, John West rejoined the Society of Friends. When he returned to England in 1764 to accompany the future wife of his son Benjamin, he became reacquainted with his Quaker relatives, especially his eldest son, Thomas.

The intensity of West's feelings about his association with the Society of Friends is shown in his family portrait of 1772 (fig. 5), in which he placed himself behind his father and half-brother instead of across the room with his wife and children. Throughout his English career West boasted of his Quaker heritage, even though he and his wife attended Anglican services. Nonetheless, in the family portrait of 1772 he clearly allied himself on the "side" of the Quakers. In light of his mother's disgrace, West's obvious concern with emphasizing his Quaker roots in the family portrait becomes more understandable. In one sense it was an apology, in another a rationale.

Taken as a whole, the tales of West's background—the saintly birth, divine prophesy, aristocratic parentage, his father's altruism and mother's piety—disclose scraps of illustrative material. Beneath the hyperbole lie hints of John West's rebellious independence and Sarah West's passionate nature. Set in Galt's framework of improbable fantasy, the anecdotes about the artist resemble imaginative prologues that preceded Georgian theatrical productions. The "audience" first learns about West through a series of colorful masques designed to establish a mood for the approaching drama.

In the remainder of the first chapter of *The Life of West,* Galt

transforms the artist's childhood into a heroic odyssey in which West emerges as a young Hercules forging through the primeval wilderness of Pennsylvania in relentless pursuit of the fame and fortune promised by Peckover's legendary prediction. The saga begins with the often-quoted anecdote about the fledgling genius's first encounter with art. West was only seven, Galt reported, when his sister left him in charge of his infant niece. As he viewed the sleeping baby, he was supposedly moved to sketch the child's fleeting likeness. When his mother and sister returned, they praised his handiwork, prompting the boy to volunteer to make a second drawing, of the flowers they had gathered during their outing. With superb craftsmanship Galt wove a metaphor of the blossoming young genius by describing how the sleeping baby awakened to become the productive child, the flowers symbolizing his "blooming" talent.[16]

In one preposterous anecdote after the other Galt fashioned the image that young West grew up as a child of nature with products of the wilderness as his utensils. From local Indian herbs and roots he was said to have created red and yellow pigments; from his mother's indigo he made blue; and from the tip of his cat's tail he devised a brush. Yet West's biographer admitted that such stories were not to be taken literally. The "mythologies of antiquity furnish no allegory more beautiful," he explained, "and a Painter who would embody the metaphor of an Artist instructed by Nature, could scarcely imagine anything more picturesque."[17] Allusions to West's homespun education established the artist as an innovative pioneer, a companion of the natives who roamed the woods in search of subjects to paint. In later years West often referred to his past in such romantic terms, encouraging—if not promoting—the image of himself as an innocent product of the wilderness.[18]

West happily spent the early years of his idyllic childhood drawing and painting with his primitive supplies, Galt continued, until a distant relative, Edward Penington, visited Chester County and marveled over the boy's talents. Upon his return to Philadelphia, Penington sent Benjamin "a box of paints and pencils, . . . several pieces of canvass [sic] prepared for the easel, and six engravings by Grevling."[19] The boy was so enamored with his new treasures, he supposedly became a truant from school in order to remain at home and paint. Perhaps the tales about West's devotion to artwork rather than to studies were a rationale for his never having received an elementary education, for although Galt indicated that West attended classes near his home, there is no documentation to confirm his enrollment in any Pennsylvania school.[20] Hence the stories in the first part of the biography serve as both a cover-up and an explanation for West's difficulties with grammar and spelling.

Penington's gift was supposed to have included engravings

by "Grevling," but this story may also be apocryphal, for no artist by that name has been identified. Perhaps, as art historians have suggested, Galt (or West) was referring to either Hubert François Gravelot or Simon Gribelin. In later years West used prints by both of these French artists as sources for various compositions, although he never acknowledged that he had borrowed from their works.[21]

One of the most interesting anecdotes in the biography concerns West's first visit to Philadelphia when he was nine years old. West must have dictated this story to Galt, because in a letter written in 1810 the artist described an identical incident, using the same language and the same sequence of events that appears in the biography. Galt described how Samuel Shoemaker, a neighbor of West's relative Edward Penington, admired a landscape that young Benjamin had painted and agreed to introduce the boy to the English artist William Williams. When their meeting took place, the English painter was so impressed with the boy from Chester County that he immediately befriended him, offering to lend him several books written by Jonathan Richardson and Charles du Fresnoy, the great theorists of European art.[22]

A slight but significant difference exists between West's version of the encounter and that found in Galt's biography. The nuance of difference not only changes the meaning of the anecdote itself, but it also explains why Galt told the story of an artist's childhood as if it were a segment from Homer's *Odyssey*. In his version of the conversation with Williams, West wrote that the English artist asked him if he had ever read "the great Masters of Painting," to which West purportedly replied that the only "great men" he knew were "those in the Bible and New Testament." Galt, on the other hand, did not mention the "great Masters of Painting," saying only that West told Williams that his boyhood heroes were "Adam, Joseph, David, Solomon . . . whose actions were recorded in the Holy Scriptures."[23]

Both Galt and West mention that Williams loaned the young artist books by "Richardson and Fresnoy," which were so welcome, West wrote, that they became "my companions by day, & under my pillow by night."[24] If, in fact, the nine-year-old artist had kept the turgid essays by Richardson and Fresnoy under his pillow, he would not have rested easily; with his meager education, he would have found such highly sophisticated essays to be diffuse and confusing. Reference to the writings of Richardson and Fresnoy, however, reveal more about the adult West than they do about the boy. The very suggestion that West had studied these hallowed theorists at a very tender age gave him a stamp of legitimacy in Britain's art community.

The composite picture—created by Galt's first few pages and West's own version of his experiences in Philadelphia—

forms a theatrical allegory. The curtain opens on little Benjamin standing firmly at the threshold of his preordained artistic mission, equipped with a library of "sacred" documents to prepare him for initiation into his chosen profession of history painting.

Galt may have neglected to mention the "great Masters of Painting" in conjunction with West's childhood because, as the artist's biographer, Galt was attempting to imitate the very essays that Williams had advised his protégé to read. At the conclusion of the second volume of the biography, completed after West's death, Galt admitted that his purpose had been to place West in the pantheon of artistic deities. "As an artist," he wrote,

[West] will stand in the first rank. His name will be classed with those of Michel Angelo and Raphael; but he possessed little in common with either. As the former has been compared to Homer, and the latter to Virgil, in Shakespeare we shall perhaps find the best likeness to the genius of Mr. West. He undoubtedly possessed, but in a slight degree, that peculiar energy and physical expression of character in which constitutes the charm of Raphael's great productions. But he was their equal in the fulness [sic], the perspicuity, and the propriety of his compositions.[25]

Galt clearly had a specific mission that extended far beyond transcribing a mere biography. At a time when West's reputation was suffering from the scorn of his colleagues and the disrespect of a younger generation having new artistic goals, Galt was asked to create an apotheosis. His ultimate purpose was to correlate West's life with those of the great Italian masters, providing the American with a prototypically English position in the galaxy.

In their catalytic study *Legend, Myth, and Magic in the Image of the Artist* written in 1934, Ernst Kris and Otto Kurz demonstrated how painters from Giotto to Goya were similarly endowed with supernatural characteristics. Authors of artists' biographies, they concluded, used anecdotes to tap "the realm of myth and saga" and thereby transport "a wealth of imaginative material into recorded history."[26] In Renaissance Italy, biographers were charged with elevating painters above the ranks of mere craftsmen, the lowly position they had occupied during the Middle Ages. Thus, biographers of Renaissance painters were obliged to legitimize their subjects by endowing them with the mystique of an artistic calling. The lives of painters were usually heralded by cascades of chubby angels announcing God's creative inspiration and by bearded sages who would usher the brilliant neophytes upward over the pitfalls of mundane education to an elevated place beside the "great Masters." Among the

many legends that Kris and Kurz found to be duplicated in artists' biographies were stories of self-education ("autodidactism"), predestination, creative genius, precocity, aristocratic patronage, and numerous other ingredients also found in the Galt/West account.[27]

The quintessential mythmaker was Giorgio Vasari, whose *Lives of the Artists* of the mid-sixteenth century stands as a classic example of anecdotal biography. Vasari's prose was so widely accepted that it established a precedent for subsequent biographers who merged fact with fiction and implanted deep-rooted fairy tales within the absorbent soil of art historical scholarship. If we compare Galt's *Life of West* with any one of Vasari's "lives" the parallels are intriguing: Michelangelo and Alberti were said to have descended from a noble line; Ghirlandajo was always found making sketches as a child; Titian left his provincial home to live in Venice with his uncle, who introduced him to Bellini, his first teacher; and Donatello and Mantegna were discovered by wealthy merchants in the city.[28] Almost all of the Italian masters were described as child prodigies and most of them became the court painters of noblemen, bishops, and kings, just as West had risen from a provincial background to be George III's official history painter.

What Galt (and probably West) did was to incorporate portions of these apocryphal tales into *The Life of West*. Such an apotheosis was rarely necessary in the eighteenth century, for artists of Georgian England (unlike those of Renaissance Italy) no longer needed to establish themselves as superheroes in order to achieve posthumous approval. West, however, was different. He *was* from the provinces and he *did* have problems convincing his artistic colleagues of his legitimacy, especially during the latter years of his life. Galt's task, therefore, was akin to Vasari's in that each was commissioned to write both an apology and an apotheosis.

The rationale for Galt's biography is clarified—and, indeed, illuminated—by the following anecdote: Shortly after returning from his first trip to Philadelphia, young Benjamin reportedly met a classmate trotting on his horse down a country road. When the boy asked West to join him, and pointed to a place behind him on the saddle, the young artist, "full of dignity of the profession to which he felt himself destined, answered that he never would ride behind anybody." His friend conceded, and Benjamin sat in front. During the ride the classmate commented that he would someday become a tailor, which prompted West to respond that he planned to become a painter. In disbelief, the boy is said to have exclaimed:

"What sort of a trade is a painter? I never heard of such a thing."
"A painter," said West, *"is a companion for Kings and Emperors."*

"Surely you are mad," replied the boy, "for there are no such people in America." "Very true," answered Benjamin, "but there are plenty in other parts of the world."

Unabashed, the classmate reaffirmed his ambition to become a tailor, whereupon West jumped from the horse, announcing: "Then you may ride by yourself, for I will no longer keep your company."[29]

In the context of West's life, the anecdote may be interpreted as an intriguing allegory comparable to the best in Vasari's *Lives*. First, the story denounces manual labor as being beneath the dignity of a history painter, clearly separating art from craft. Second, it establishes the natural nobility of the future president of the Royal Academy, who was not a boorish backwoods oaf to be ridiculed by sophisticated Londoners. Most important, it suggests that West envisioned his own life as an emulation of the "great Masters of Painting." If Leonardo, Michelangelo, or Raphael could obtain royal and clerical patronage, so could he. Galt's story, therefore, describes West's ambitions. As a boy he had read about the "great Masters of Painting" and from them deduced that success in the world of art meant association with "Kings and Emperors." From his provincial perspective, Vasari became the reality. Surely, it was Vasari's *Lives,* not Richardson and Fresnoy, that lay beneath young Benjamin's pillow at night.

West hired Galt to write his apotheosis in an era when heroic biographies abounded. Parson Weems created the mythical image of George Washington and, as we shall see, writers of the 1760s similarly deified General Wolfe. Napoleon, Franklin, Jefferson, and Garrick all received the same treatment. The most remarkable quality of Galt's biography is its endurance. While the other eulogistic accounts have long been accepted as mythic constructions, *The Life of West* is still quoted in all manner of scholarly studies, often as authentic documentation. Whether credulous or skeptical, most researchers have failed to realize that they have been caught in the artist's cleverly baited trap. The image of the homespun, provincial painter who could interact with kings was a scenario, written and acted by none other than the star performer—Benjamin West. The final script for the compelling drama was Galt's *Life of West,* which wrapped up all the prevailing legends and captured them for posterity.

CHAPTER THREE # The Birth of American History Painting

Around 1756 West completed his first history painting, *The Death of Socrates* (fig. 26), a remarkable accomplishment for a youth of eighteen. Not only does the work represent West's first historical epic and the only signed painting of his colonial career, but it is also one of the first classical narratives by any native-born American. When viewing the complex and compelling canvas, one cannot but wonder where West learned the technical skills and classical orientation necessary to create such a composition. Clearly he had been exposed to more cultural advantages than suggested by Galt.[1] To best understand the many strains that come together in *The Death of Socrates* and West's subsequent history paintings, one must follow his progress from his first art lesson in Philadelphia to the eve of his departure from America.

A varied cast of characters contributed to the process: the young English artist William Williams, who introduced West to painting; the sober Moravian minister John Valentine Haidt, who taught him how to envision an integrated narrative; the gunsmith William Henry, who provided West's first exposure to the classics; the volatile William Smith, who prescribed a strong dose of politics, theology, and theatrics; and finally, the English artist John Wollaston, who taught West how to finish his paintings in the European manner. All of these men added parcels to the visual and intellectual baggage that would accompany West for the remainder of his career.

People were only one part of West's coming of age; places and events were equally as significant. The French and Indian War on the nearby frontier, theatrical performances in Philadelphia, and classical education with religious overtones all helped form West's visualization of the world he inhabited. His early perceptions provided a multifaceted foundation upon which he would build his career as a history painter. European art and culture would someday polish the rough edges of his colonial experiences, but the initial impressions—carved deeply into his young mind—would never disappear entirely.

The journey into West's childhood begins in colonial Phila-

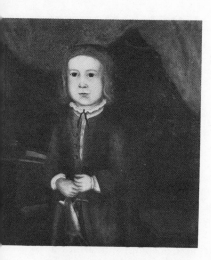

Fig. 15 *Robert Morris*, ca. 1753, oil on canvas, 18 × 17½ inches. Chester County Historical Society, West Chester, Pennsylvania; Gift of Moses W. Cornell and Josephine Cornell Oas, 1984.

delphia when the artist first arrived there with his cousin, Edward Penington. West recalled that he was then only nine years old, so the year would have been 1747. At that time, the town was undergoing a spurt of tremendous growth spawned by a thriving mercantile trade. As young West toured the wharfs and docks, he would have stumbled over the bricks and boards of a burgeoning economy. To the boy from Chester County, the provincial capital must have looked like a huge and bustling metropolis, although twentieth-century observers would see it as scarcely more than a busy country village. Few streets were paved, garbage lined the alleys, fire protection was minimal, and vandalism was rampant. Despite crude conditions, the population was growing so rapidly that between 1743 and 1760 the city almost doubled in size.[2]

In the middle of the eighteenth century, Philadelphians were far too busy developing commerce and building a city to waste time on cultural pursuits. Besides, such luxury had little place in a Quaker center, where stringent restrictions, enforced by legislative action, forbade Pennsylvanians from enjoying concerts or theatrical performances. By the time West visited the city in 1747, however, the cultural climate was changing, owing to an influx of immigrants from Western and Eastern Europe. With Anglican, Lutheran, Presbyterian, Hugenot, Moravian, and Jewish settlers came the rich musical, artistic, and literary traditions of their homelands.[3]

At booksellers along Walnut and Market streets, young Benjamin would have found a wide variety of engravings taken from paintings by Europe's finest artists. The printed copies of works by Raphael, Poussin, Rubens, Rembrandt, and dozens of other masters were stock items in the libraries of Philadelphia's leading citizens. So were paintings. If West accompanied his cousin Edward Penington into estates of prosperous merchants, he would have been able to study original compositions by the recognized colonial artists John Smibert and Robert Feke, both of whom worked in Philadelphia during the 1740s. Distinguished for their finely crafted portraits, the two artists came to the Pennsylvania city to render likenesses of its leading citizens. No doubt young West saw many of their portraits, and he also may have been able to study their history paintings. Both are known to have created classical and religious narratives, although none survive today.[4]

In the drawing rooms of Philadelphia mansions, the paintings by Smibert and Feke very likely hung beside those of the colony's best-known resident artist, Gustavus Hesselius, an accomplished Swede who had spent several decades in the city working as a jack-of-all-trades. There is no way to know whether West ever met the elder Hesselius, but given the small size of Pennsylvania's art community, it is quite possible that the

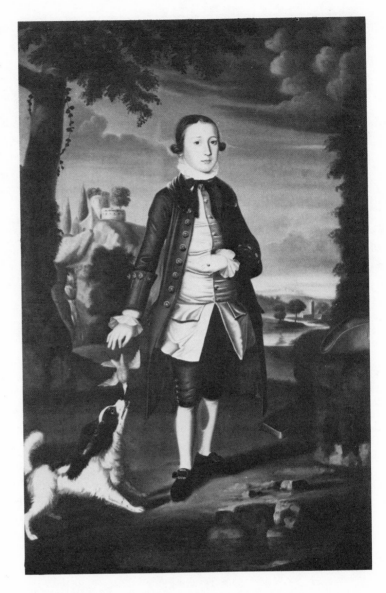

Fig. 16 William Williams (ca. 1710–1790), *David Hall,* 1766, oil on canvas, 70⅞ × 45⅞ inches. The Henry Francis du Pont Winterthur Museum, Delaware.

ambitious lad from rural Pennsylvania was familiar with the works of the versatile Swedish artist and his son, John, who was then beginning his own career as a painter. That being the case, young West might have seen two narrative compositions by Gustavus Hesselius—*Bacchus and Ariadne* and *The Bacchanalian Revel*—then hanging in the family home. As two rare surviving examples of mythological painting in colonial America, the unusual canvases blend familiar symbols with a pastiche of traditional poses and allegorical representations. If young West saw the works, he would have learned how to borrow themes and forms from engravings and to reinterpret such images by employing his imagination.[5]

While we cannot be certain whether he ever met Hesselius, we do know that West was well acquainted with the English

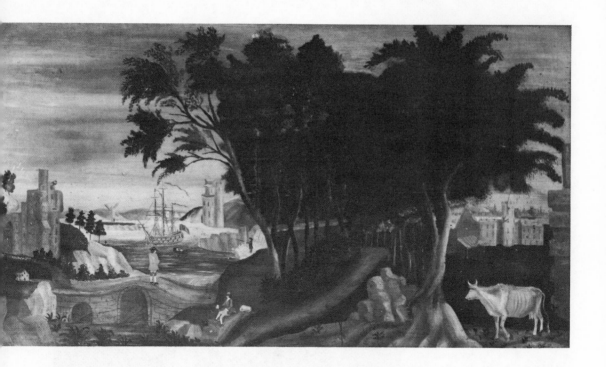

Fig. 17 *Landscape with Cow,* ca. 1747–52, oil on cedar panel, 26 × 49½ inches. Pennsylvania Hospital, Philadelphia.

painter William Williams, the only artist of colonial Pennsylvania mentioned in Galt's biography. Then a young man in his early twenties, the Englishman must have been an ideal companion for the boy from Chester County. In a letter written in 1810, West admitted as much. His memories of his former friend and instructor were so imbued with warmth and admiration that it is easy to imagine the boy browsing through Williams's collection of prints and books, soaking up knowledge about European painting, and listening to fanciful yarns about the Englishman's adventures at sea and among Caribbean natives. The friendship with Williams undoubtedly made West's first formal exposure to art a pleasurable mixture of companionship, discovery, and storytelling.[6]

West's earliest paintings—portraits of two children, Jane and Robert Morris—evidence Williams's influence.[7] Although both paintings have suffered the ravages of time, *Robert Morris* (fig. 15) still retains much of its initial freshness. Holding a tiny, stiff rabbit, the little boy (presumably a Chester County neighbor) stares at the viewer with large, wistful eyes. The pose of the child and the stylized animal in his hand are copied directly from Williams, whose portrait of David Hall (fig. 16) has the same round eyes, fixed stare, and outlined features. The tiny bird in the Hall boy's hand is as rigid and lifeless as the rabbit in West's *Robert Morris.*

West's first landscape (fig. 17), which he described as containing "ships, cattle & other things which I had been accustomed to see," is actually a panel crowded with three castles, a

Fig. 18 William Williams (ca. 1710–1790), *Imaginary Landscape,* 1772, oil on canvas, 16 × 18 inches. The Newark Museum, New Jersey; Gift of Miss Clara Lee, 1922.

windmill, a footbridge, a waterfall, a large sailing ship, a wooded path, three tiny figures, and a distinctive white cow with extended ribs.[8] Painted with bright, opaque patches of pure color defined by small intricate brushstrokes, the composition is delightfully naïve. The same castles, ships, and ornate foliage appear in the background of Williams's portrait of David Hall and in his *Imaginary Landscape* (fig. 18), an indication that West's composition may well have been painted in the Englishman's Philadelphia studio. The work is composed with a pattern of colorful patches that makes it a playful and entertaining tableau. Very likely it was originally an overmantel, one of the narrow wooden panels that decorated the walls above eighteenth-century hearths.

West's panoramic landscape is reminiscent of stage scenery, and this, too, he may have learned from Williams, who designed backdrops for Philadelphia theatrical productions. Although young West soon abandoned the decorative painting technique that Williams taught him, the love for color and detail became a fundamental part of his artistic vocabulary.

Sometime around 1755 West traveled to Lancaster to paint portraits of the local citizens. It was to be one of the most productive periods of his colonial career. At age seventeen he had improved his painting techniques, although little is recorded by Galt or others about the artistic training West received during his early adolescence. The visit to Lancaster was important for

two quite different reasons: it was there that he painted *The Death of Socrates,* and there that he obtained his closest exposure to the French and Indian War.

At that time, Lancaster's largest industry was the new ironworks, then supplying firearms for the British and colonial armies fighting along the nearby frontier. West would have been familiar with the munitions factory because he stayed at the home of William Henry, who earned his living by manufacturing arms. Henry and his new wife, Ann, must have talked of events in the Pennsylvania Assembly, where the question of disbursing weapons to the soldiers had prompted a heated debate between the pacifistic Quakers (who refused to authorize funds for arming the troops) and supporters of the proprietary government (who argued for increased defense spending). During West's first weeks in Lancaster, British forces were suffering a series of setbacks. Not only had troops been unable to protect the frontier communities from destructive raids by Indians under French command, but in July 1755 a long-planned maneuver by General Edward Braddock ended in a humiliating defeat that took the lives of the general and many of his men.

Galt described how West served briefly in a local militia and
acted as the "commandant" of a "little corps" of volunteers that
trained in Lancaster. While verification of the artist's military
service is lacking, documents indicate that his older brother, Sa-
muel, a captain in the army of General John Forbes, took part in
the grizzly task of recovering the remains of Braddock and his
ill-fated forces. West planned to use this expedition as the sub-
ject for a "modern" history painting, Galt related, but the work
was never completed.[9] Stories of the French and Indian War
were probably included in Galt's biography to demonstrate how
important the conflict had been during West's boyhood. We need
only consider the sensitive way he depicted the war's climactic
battle in his masterpiece *The Death of Wolfe* to realize that he
felt deeply about the people and events of the hostilities that
took place so close to his childhood home.

West was quite prolific during his Lancaster visit, executing
a number of portraits, including those of Mr. and Mrs. George
Ross and Mr. Ross's sister, Catherine; William and Ann Henry
(figs. 19 and 20); and Dr. and Mrs. Samuel Boudé (figs. 21 and
22). He is also reported to have completed a painting of a

51

Fig. 21 *Dr. Samuel Boudé,* 1755–56, oil on canvas, 35⅝ × 30⅛ inches. National Gallery of Art, Washington, D.C.; Gift of Edgar William and Bernice Chrysler Garbisch, 1964.

mother and child, a landscape, a self-portrait, several tavern signs, and *The Death of Socrates,* although only the latter painting and the portraits survive.[10] West's Lancaster paintings differ markedly from his earlier works, and thus we can infer that he had taken lessons from someone other than Williams. Gone are the clear, opaque colors and decorative details; in their place we find a somber palette, more subtle shading, and a greater awareness of anatomical structure.

Clearly, something beyond natural development had caused West to change so dramatically, but neither the artist nor his biographer provide any explanation. A clue to the missing link in West's colonial education appears in the diary of Joseph Farington, who recorded that when West was a boy in Philadelphia he studied with a German artist named "Mr. Hide."[11] The name is apparently an Anglicized version of "John Valentine Haidt," pronounced "Hite" but easily remembered years later in West's uncertain spelling as "Hide."

Haidt had come to America from his native Germany in 1754. Trained as a metal engraver under his father, the principal goldsmith at the Prussian court of Frederick I, he decided at a relatively young age that he would devote his life to the Moravian church. His duties as a lay preacher and religious painter

Fig. 22 *Mrs. Samuel Boudé,* 1755–56, oil on canvas, 35⅝ × 30⅛ inches. National Gallery of Art, Washington, D.C.; Gift of Edgar William and Bernice Chrysler Garbisch, 1964.

took him first to England and finally to America, where he settled into the Moravian community of Bethlehem, Pennsylvania. Shortly after his arrival, he was formally ordained as a minister and assigned to the church in Philadelphia. Because West told Farington that he had received his instruction from "Mr. Hide" in the provincial capital, we can assume that their association took place there between 1754 and 1755, the only year Haidt lived in Philadelphia.[12] The lessons, therefore, would have occurred shortly before West journeyed to Lancaster.

In Haidt's studio the boy from Chester County would have discovered portraits, allegories, and highly intense Biblical narratives (see fig. 23) painted by the prolific minister. Later in his career West, too, would explore these diverse areas, incorporating much of the same spiritual energy into his many religious paintings (see figs. 133 and 134). He would also later borrow elements from Haidt's best-known composition, *The First Fruits* (fig. 24), an allegory about Moravian converts from around the world. In the foreground, Haidt placed an American Indian, draped in a loincloth and posed as the Greek statue *Doryphoros;* other chiefs and braves in the composition also resemble various well-known examples of antique sculpture. When composing such paintings as *The Death of Wolfe* and *William Penn's*

53

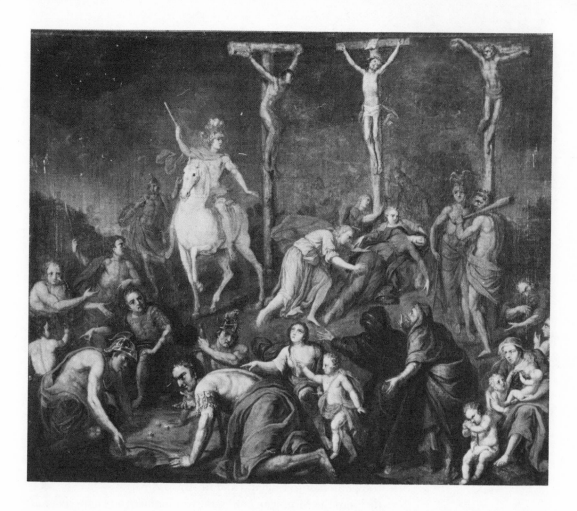

Fig. 23 John Valentine Haidt (ca. 1700–1780), *Crucifixion,* date unknown, oil on canvas, 24¹/₂ × 30 inches. Moravian Historical Society, Nazareth, Pennsylvania.

Treaty with the Indians (plates VI and VII), West followed this convention by modeling the Indians after classical statues.

In West's portraits of Lancaster residents, one also finds evidence of the German's teachings. Haidt's Moravian women (see fig. 25) sit upright with their bodies slightly turned and shoulders sloping. In West's portraits of Lancaster women, especially Ann Henry and Mrs. Boudé, one detects many of the same characteristics, together with the use of perceptible outlines and dark earth tones, which are also distinguishing features of Haidt's work.[13]

The Death of Socrates (fig. 26), more than any other of West's colonial paintings, demonstrates Haidt's profound influence. Stylistically and iconographically it prefigures West's approach to history painting. Composed of predominantly warm earth tones balanced by occasional greens, yellows, and hazy reds, the 34-by-41-inch canvas demonstrates the skillful dexterity of its youthful creator. In the center a bearded Socrates holds the cup of hemlock as soldiers in plumed helmets and suits of mail plead with him to reconsider his fatal decision. Behind the philosopher, mourners display their grief with exaggerated ex-

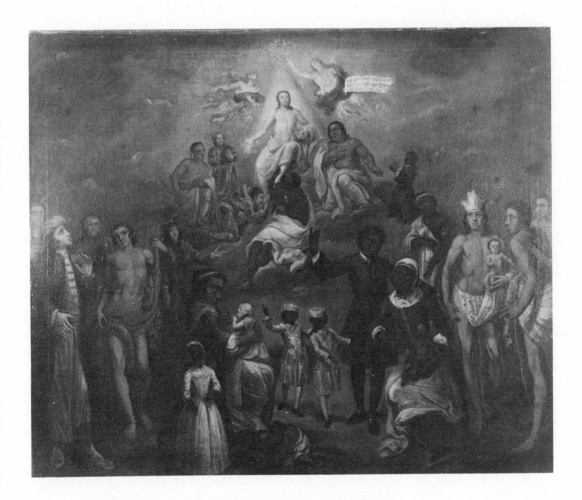

Fig. 24 John Valentine Haidt (ca. 1700–1780), *The First Fruits*, date unknown, oil on canvas, 41½ × 50½ inches. Archives of the Moravian Church, Bethlehem, Pennsylvania.

pressions of despair and anguish.

Galt explained that West's initial inspiration for this unprecedented composition came from his host, William Henry, who read him the story of Socrates from "the English translation of Plutarch" and requested a painting of the scene. According to Galt, West reluctantly agreed, adding that having never worked from a live model, he was unprepared to depict the half-nude slave who presented the poison to Socrates. Brushing aside the boy's objections, Henry supposedly asked one of his workmen to pose for the figure.[14]

Galt's apocryphal account contains several flaws. The probable source for West's first history painting was not Plutarch's *Lives* but volume 4 of the 1738–39 edition of Charles Rollin's *Ancient History,* which still remains in the library of William Henry's descendants. We can see from the book's frontispiece (fig. 27), engraved by J. P. Le Bas after Hubert François Gravelot, that West copied its figure of Socrates, the man weeping on the far right, and the slave behind Socrates, supposedly modeled after Henry's workman. West even borrowed the arched vault and barred window from Gravelot's composition,

Fig. 25 John Valentine Haidt (ca. 1700–1780), *Anna Maria Lawatsch,* 1756–57, oil on canvas, 25½ × 19½ inches. Archives of the Moravian Church, Bethlehem, Pennsylvania.

incorporating the features into the background of his painting.[15]

The physical structure of the men, however, does not come from Gravelot. Instead, the faces, costumes, and bodies in West's *Death of Socrates* recall the figures of Haidt's narrative compositions (see, for example, fig. 23). In West's painting, a linear rhythm creates independent patterns within the drapery, playing dark inner creases against highlighted outer folds; in Haidt's many narrative scenes, the painted fabric is filled with similar stark contrasts. The exaggerated facial expressions of the men around Socrates—their brows furrowed, their mouths turned downward—recall the intense emotion that distorts the faces of Haidt's religious subjects. Because Haidt often copied poses from engravings of Roman statuary, his work is linear rather than painterly, the muscles and tendons on his figures looking as though they had been carved in stone. West, too, relied heavily upon engravings to construct the figures in his *Death of Socrates:* the bodies are modeled as if their original three-dimensional shapes had been reduced to a series of contrasting planes.[16]

West was indebted to Haidt for the style of his Lancaster paintings, but the mood and concept of *The Death of Socrates* point to radically different influences. West's first history painting reveals, for example, a surprising awareness of recent interpretations of the classics and of contemporary trends in European art. Surely his sophisticated notions did not emanate from Chester County; nor were they likely to have been the legacy of the deeply religious Haidt. Where, then, did West garner such knowledge? One source was undoubtedly William Henry, who was well versed in classical and modern literature and familiar with new European developments in art. Henry would have realized that Voltaire had recently revived the legend of Socrates with special emphasis on the death scene, and that Denis Diderot had outlined a drama centered around the philosopher's imprisonment and execution. In fact, the Socrates legend was so popular in eighteenth-century Europe, it had even appeared on the London stage.[17]

Henry quite likely described these performances to West because the composition of his *Death of Socrates* resembles a play, with the figures highlighted from the front to simulate theatrical illumination. The same devices appear in history paintings by Sebastiano Ricci, Giovanni Battista Tiepolo, and other early eighteenth-century Venetians, who treated the rectangular canvas as if it were a stage with "actors" grouped around a leading protagonist. Although theatrical narratives could be found in contemporary Europe, the subject of West's painting had few precedents in art. Only scattered examples from the Renaissance and Baroque periods exist, and two or three decades would elapse before the theme would become a favorite of French and

British neoclassicists, making West's endeavor all the more remarkable.[18]

Jacques Louis David painted his well-known *Death of Socrates* (fig. 28) in 1787. Two years later, the French monarchy toppled and the artist became an active participant in the revolutionary government. The painting, therefore, has long been read as a call to arms. The subject of the ancient philosopher's choice of death in defense of free speech certainly echoes eighteenth-century concepts of noble sacrifice for a righteous cause. West may well have had similar motivations. In his youthful painting, as in David's more urbane masterpiece, one finds a stirring defense of personal liberty in opposition to threats of official suppression. Perhaps his choice of subject matter was prompted by

Fig. 26 *The Death of Socrates,* ca. 1756, oil on canvas, 34 × 41 inches. Private collection.

The DEATH of SOCRATES.

Publish'd June 1st 1739 by J.& P. Knapton

Fig. 27 Jacques Philippe Le Bas after Hubert François Gravelot, *The Death of Socrates,* engraving from frontispiece of Charles Rollin, *Ancient History,* vol. 4 (London, 1738–39). Prints Division, The New York Public Library, Astor, Lenox and Tilden Foundations.

political tensions akin to those that inspired David. In Pennsylvania during 1756, war was intensifying along the frontiers, and many colonists were harboring deep-seated resentment of Quaker legislative restraints. As a youth of eighteen imbued with the liberal teachings of his young mentor William Henry, West may well have designed his painting as a plea for individual rights and freedom of speech.

The Death of Socrates can be interpreted another way, too. Surrounded by his disciples as he waits in prison for armored soldiers to enforce the edict of execution, Socrates resembles a saint awaiting his execution. Authors in eighteenth-century France, in fact, often drew parallels between the martyrdom of Socrates and the crucifixion of Christ.[19] Their interpretation added an extra dimension to the stoic theme of a martyred death. For an aspiring young history painter steeped in Haidt's religious fervor and Henry's respect for the classics, there could be no more timely and edifying subject than Socrates' choice of death over silence.

Although experiences in Europe would further mold and cultivate West's painting style, *The Death of Socrates* was certainly the seedbed of his future history-painting formula. The painting, which still hangs in the home of Henry's descendants, is a landmark of early American art and a critical guide to understanding West's colonial education. It essentially demonstrates that the young artist envisioned a scene from classical history as if it were a drama unfolding on the stage, one filled with lessons of sacrifice and valor, courage and selflessness.

William Smith, the dynamic and controversial provost of the College of Philadelphia (now the University of Pennsylvania), dominated a large portion of West's remaining education in the colonies. Galt wrote that during a visit to Lancaster in 1756, Smith, who was then only twenty-nine, was so impressed by West's *Death of Socrates* that he invited the young artist to study with him in Philadelphia. Galt's story, however, may be yet another confusion of facts and dates: the didactic nature of *The Death of Socrates* reflects many of Smith's ideas, thereby suggesting that West had contact with the provost before, not after, he completed the painting.[20] As a classical scholar, Anglican minister, and political activist, Smith introduced West to a unique blend of Greek and Roman literature, missionary zeal, and mercantile politics. The Scottish-born Smith had come to Pennsylvania in the early 1750s after his foresighted writings on education captured the attention of Benjamin Franklin and other trustees of what was then the Philadelphia Academy. From the outset, the young minister invited polemical responses, using his pulpit to defend Pennsylvania's controversial proprietor,

Fig. 28 Jacques Louis David (1748–1825), *The Death of Socrates,* 1787, oil on canvas, 51 × 77¼ inches. The Metropolitan Museum of Art, New York, New York; Catharine Lorillard Wolfe Collection.

Thomas Penn, and to denounce the policies of the Quaker-dominated legislature.

Affiliation with the so-called Proprietary Party brought Smith into direct confrontation with his former sponsor, Benjamin Franklin. In 1758 their escalating public quarrel moved to the floor of the Pennsylvania Assembly, then dominated by Franklin and his Quaker allies. The issue was Smith's public defense of William Moore, an outspoken critic of the Friends and their policies. When the dispute came before the Quaker-dominated assembly, Smith was accused of sedition and sentenced to three months in jail. From his prison cell Smith held classes (which West may have attended) and wrote angry essays condemning the assembly for suppressing free speech—the very issue that underlies West's *Death of Socrates.*

Upon his release from prison Smith continued his battle against Franklin and the Pennsylvania Assembly, traveling to England to receive an official pardon from the king. In the meantime, Franklin channeled his efforts into a campaign designed to end proprietary government in Pennsylvania. For several years he petitioned British authorities to substitute a royal

charter for Penn's nominal rule of the colony, although his efforts eventually proved to be futile. The controversy—which colored all aspects of Pennsylvania politics during the late 1750s—form a dramatic background for West's last years in America.[21]

Smith's active role in the political arena never seemed to interfere with his duties as an educator, for most students and colleagues remembered him as a charismatic teacher and pioneer of modern instructional methods. Galt described how the provost created a special program that excused West from "grammatical exercises" and other classes that he believed were irrelevant to the training of a history painter. The biographer commented that Smith advised the aspiring artist to master only "those passages of antient [sic] history" that would "make the most lasting impression on the imagination of the regular-bred scholar."[22] While Galt may have included this information to further justify West's scholarly deficiencies, Smith is on record for advocating curricula tailored to fit individual needs. He outlined his views on education in an essay, "The College of Mirania," which described an institution that taught not only pupils entering the professions but those pursuing "mechanical" careers as well. His was a revolutionary plan during the 1750s, when most colleges offered only classical and religious subjects. For West, with his limited early education, such a specifically designed program would have been far more suitable than the conventional instructional methods of the day. Despite Galt's description, however, no school records substantiate West's official enrollment in the College of Philadelphia, although there are indications that he was informally connected with the institution between 1757 and 1759.[23]

Smith held impassioned opinions about so many topics of current interest that an impressionable young man from a rural background could not have escaped constant exposure to his fervent oratory. Much of it, in fact, resounds beneath the surface of West's later paintings. One recurring theme, for example, was the protection and preservation of British ideals, a topic Smith explored in his address to the first graduating class of the college in 1757. "Let the World know that LIBERTY is your unconquerable Delight," he exclaimed, expounding at length about man's duty to defend God, king, and country.[24] The trio of obligatory loyalties was a constant refrain in Smith's orations. To him, service to the state carried all the commitment of a religious crusade. In opposition to the secularism of Franklin and other urbane philosophies, Smith placed heavy emphasis on divine guidance; and unlike the pacifistic Quakers, he insisted that men fight openly to defend their political convictions. A like philosophy appears in West's classical and modern history paintings, in which subjects, such as Socrates, choose to face death

rather than compromise fundamental principles.

In addition to his political and educational interests, Smith pursued a peculiar kind of religious anthropology. His writings indicate that he was fascinated, if not obsessed, with the American Indians—their customs, habits, costumes, artifacts, and beliefs, especially concerning protection of their souls. Like so many British immigrants in colonial America, his attitudes toward the Indians were inconsistent. He described them sometimes as "fierce Savages" "hounding forth" from "dark lurking places brandishing their murderous knives"; at other times he depicted them as innocent children unable to resist the evil grip of alcohol that had been forced upon them by wicked French conspirators. Convinced that Britons and Christians were obligated to "civilize these our Pagan Friends," he conducted frequent missions into Indian territory, comparing his work with the civilizing efforts of "Heroes of Antiquity" who "purchased immortal Renown," by rescuing the "Teutonic tribes" from "Barbarity."[25] Again we are reminded that a distinct feature of West's later paintings was the classical depictions of Indians.

Most of Smith's opinions appeared as essays in the *American Magazine,* a remarkable journal published by the College of Philadelphia between the autumns of 1757 and 1758. Its contents ranged from articles about earthquakes and the eclipses of Jupiter to inquiries into the habits of sea animals and more domestic topics such as the "progress of love." Each issue contained poems by students, reports on colonial affairs, and accounts of the frontier war. West, who was studying at the college

Fig. 29 Unidentified artist, wood engraving for cover illustration of *American Magazine,* 1757–58. Rare Books Room, Library of Congress.

PRÆVALEBIT ÆQUIOR.

during the year the *American Magazine* was published, was mentioned in two poems in the journal and may have had a hand in composing the cover illustration (fig. 29). In this wood engraving, an Indian brave, leaning on his rifle, stands between an Englishman on the left holding a book and a Frenchman on the right offering a tomahawk. There is good reason to believe that West designed the drawing for the cover, because the facial features and poses correspond with similar pictures in his colonial sketchbook (see fig. 30). Placement of the three figures also resembles *The Choice of Hercules* (fig. 54), which West painted in 1764. If we apply the traditional iconography of this topic (Hercules standing between Vice and Virtue) to the *American Magazine* cover drawing, we see that it illustrates Smith's beliefs about British valor and the necessity to "civilize" the natives: the Englishman who promises education symbolizes Virtue while the Frenchman who offers a gun stands for Vice.[26]

Among the students contributing frequently to the *American Magazine* were Francis Hopkinson, Jacob Duché, and Thomas Godfrey. With slight variations in spelling, Galt mentioned these men (together with Joseph Reed) as West's comrades at the college. All four later became distinguished in their fields: Duché was a popular local minister; Godfrey (who died in 1763) was a promising poet and playwright; Reed became one of Philadelphia's leading physicians; and Hopkinson, perhaps the most famous, was a renowned lawyer and signer of the Declaration of Independence.[27] He also wrote original music and poetry, with a good many of his verses devoted to various aspects of the French and Indian War.

When General James Wolfe and his armies landed in French Canada in 1758, Hopkinson celebrated the event with a poem entitled "On the Late Successful Expedition against Louisbourg," which praised the "brave Deeds" and "never dying Fame" of General Wolfe and his men. By extending the nation's territorial wealth, he wrote, the courageous soldiers demonstrated extraordinary "British Valour."[28] Daily reports in the press followed the progress of Wolfe's army as it moved toward Quebec. Then, in September 1759, came the bittersweet triumph on the Plains of Abraham—the final defeat for France and the death of General Wolfe. An effusive poetic tribute to Wolfe in the *Pennsylvania Gazette* was probably also written by Hopkinson; not only do the style and tone appear to be his but the names Duché and Godfrey are mentioned in the following excerpt from one of the stanzas. Most notably the poem contains much of the same imagery that West would later incorporate into *The Death of Wolfe.*

> Thy merits WOLFE, *transcend all Human Praise*
> The Breathing Marble, *or the Muses Lays*

Fig. 30 *Sketch of a Man,* ca. 1757–59, charcoal on paper (from sketchbook). Historical Society of Pennsylvania, Philadelphia.

Art is but vain, the Force of Language weak,
To paint thy Virtues, or thy actions speak
Had I Duché's or Godfrey's magic skill
Each Line to raise and animate at will.
To rouse each Passion dormant in the soul,
Point out its object, or its Rage control

.

These were the words that clos'd the Warrior's Breath
'My Eye-Sight fails!—but does the Foe retreat?
If they retire, I'm happy in my Fate!'
A gen'rous Chief, to whom the Hero spoke,
Cry'd 'Sir, they fly!'—their Ranks entirely broke,
'Whilst thy bold Troops o'er slaughter'd Heaps advance,
And deal due Vengence on the Sons of France'
'I'm satisfy'd'—he said—then wing'd his way
Guarded by Angels to Celestial Day.[29]

The poem's images, current in the American press in November 1759, suggest that West had reason from the outset to visualize Wolfe's last moments in terms of a dramatic spectacle, replete with a "gen'rous Chief" and the French armies retreating in the background. Eleven years later he would revive these impressions in his epic masterpiece.

❧

Most critical issues of the eighteenth century found their way into verse. Because hardly a person or event was not at some time commemorated in rhyme, it is not surprising that West's work was the subject of two poems in the *American Magazine.* The verses are most valuable as a research tool because they constitute the only printed documents from colonial Pennsylvania that contain the artist's name. Without them we would have little more than Galt's unreliable text and a few letters to prove that West lived and worked in Philadelphia between 1757 and 1759.

The first, published in the February 1758 issue, was entitled "Upon Seeing the Portrait of Miss**—**by Mr. West" and was signed "Lovelace," a pseudonym for Joseph Shippen, West's future traveling companion to Italy. The poem itself tells nothing about West, describing only the beauty of his sitter. But an introductory footnote contributed by the editor, probably William Smith, is most informative.

We are glad of this opportunity of making known to the world, the name of so extraordinary a genius as Mr. West. He was born in Chester County in this province, and without the assistance of any master, has acquired such a delicacy and correct-

ness of expression in his paintings, joined to such a laudable thirst of improvement; that we are persuaded, when he shall have obtained more experience . . . he will become truly eminent in his profession.[30]

The second verse about West in the *American Magazine,* written by Francis Hopkinson, connects West with the English painter John Wollaston, who was then working in Philadelphia. The poem is primarily about Wollaston, but it ends with the following stanza:

> *Nor let the muse forget thy name O WEST*
> *Lov'd youth, with virtue as by nature blest:*
> *If such the radiance of thy early Morn*
> *What bright effulgence must thy Noon adorn?*
> *Hail sacred Genius! May'st thou ever tread,*
> *The pleasing paths your Wollaston has led*
> *Let his just precepts all your works refine,*
> *Copy each grace, and learn like him to shine.*
> *So shall some future muse her sweeter lays,*
> *Swell with your name, and give you all his praise.*[31]

Drawing on Hopkinson's poem and the stylistic parallels between West's and Wollaston's paintings, it is safe to assume that West was instructed by Wollaston during his last years in Philadelphia.[32] West's surviving paintings from this period are all portraits of young Philadelphians, each bearing a strong resemblance to similar canvases by Wollaston. The muted palette and severe mood of West's Lancaster paintings of only a few years earlier have now been replaced by bright colors, luminous surfaces, and a variety of textures. Whereas the Lancaster portraits have precise outlines and very little modeling, the later Philadelphia canvases have refined shading, with darks and lights shifting so gradually that the linear structure is barely visible. Most noticeably, the faces and figures of West's Philadelphia subjects have characteristics found in portraits by Wollaston (see fig. 31). His *Jane Galloway* (fig. 32), for example, sits in a slightly turned, three-quarter pose; her protruding eyes have heavy lids, and her chin recedes. In the shimmering satin of her dress, jagged white highlights balance the shaded folds. All of these are characteristics found in Wollaston's paintings of the same period.

In addition to these portraits, West is known to have completed several history paintings during his last years in America, although none have been found.[33] Drawings of angels and imaginary gods (see fig. 33), which fill the pages of his colonial sketchbook, suggest that West was gathering details for narrative compositions. Galt describes a few such works, making spe-

Fig. 31 John Wollaston (active 1749–67), *Mrs. Lucy Parry, Wife of Admiral Parry,* 1745–49, oil on canvas, 50⅛ × 40 inches. National Museum of American Art, Smithsonian Institution, Washington, D.C.; Museum purchase.

cial mention of *The Trial of Susanna,* an ambitious project that contained more than forty figures taken from "living models."[34] An ink, wash, and chalk drawing, *Rebecca at the Well* (fig. 34), now in the collection of the Pierpont Morgan Library, appears to be a preparatory drawing for another narrative painting. Its inscription reads: "One of the first attempts of historical composition by Benj. West while in Philadelphia, 1757."[35] The remarkable work, with Rebecca and her attendants meeting Eleazer and his party at the well, is delicately integrated and acutely balanced; the figures, many of them quite complex, move freely in three-dimensional space. If West created *Rebecca at the Well* at age nineteen as the inscription indicates, the drawing remains as convincing testimony that the young artist had developed a skillful hand and practiced eye before ever leaving America.

One of the most striking features of West's *Death of Socrates* and *Rebecca at the Well* is the theatricality of the compositions. In visualizing his historical narratives as if the participants were actors on a stage, West was following a "modern" trend in Euro-

Fig. 32 *Jane Galloway,* ca. 1757–59, oil on canvas, 49³/₄ × 39¹/₄ inches. Historical Society of Pennsylvania, Philadelphia.

pean painting which, as noted earlier, is a surprising innovation in the work of a young, mid-century, provincial artist. Equally impressive is the dramatic content of West's characterizations, which may well have resulted from exposure to stage productions in Philadelphia. During the colonial period, Quaker prohibitions made it extremely difficult for touring British actors to schedule performances in the City of Brotherly Love, even though the persistent efforts of William Smith and other anti-Quaker activists enabled a few acting companies to bypass the stringent legislation and present repertories of popular plays for limited but well-attended seasons.

Among the favorite dramas appearing in Philadelphia during West's youth were Joseph Addison's *Cato,* considered to be one of eighteenth-century England's most effective political allegories, and Nicholas Rowe's *Tamerlane,* a mixture of Lockean philosophy and Whig foreign policy. The plays, which were repeated by every visiting company, blended ancient characters with current political issues, often recalling contemporary situations in Pennsylvania politics. Addison's *Cato,* for example, could be interpreted as a criticism of Quaker prohibitions against free speech.[36] The allegorical underpinnings of such

plays form the ideological foundation for some of West's later didactic paintings.

West is sure to have attended James Thomson's *Masque of Alfred* when the students of the College of Philadelphia produced it in 1757. His friends Hopkinson, Duché, and Godfrey not only collaborated with Smith to modernize the oratory and make it relevant to Pennsylvania audiences, but they also played the leading roles. The revised script spoke of liberty's triumph over oppression and virtue's victory over sin, questions close to Smith's heart. Interspersed within the lines were suggestions of local issues, especially the war with France. Jacob Duché, who played King Alfred, delivered the epilogue, which alluded to the British troops fighting along the nearby frontier. The following exerpt from that speech illustrates the parallel:

> *For lo! to cheer our Hope and bring Relief*
> *Glad o'er th' Atlantic comes the Gallant Chief*
> *Before whose Arm our Foes have often fled*
> *And black Rebellion hid her gory Head!*
> *Be you but BRITONS, as an ALFRED he,*
> *And War and Rapine soon shall cease to be.*[37]

Scenes from The *Masque of Alfred* must have remained fresh in West's memory, for two decades later he created a series of paintings based on the apocryphal history of the Saxon ruler (see figs. 35 and 36).

In 1759, West's last year in America, colonial Philadelphia experienced its hottest confrontation between a troup of British

Fig. 33 *Sketch of an Angel* and *Sketch of Mercury,* ca. 1757–59, charcoal on paper (from sketchbook). Historical Society of Pennsylvania, Philadelphia.

of the first attempts at historical composition by Benj.t West. exhibited in Philadelphia 1754.

Fig. 34 *Rebecca at the Well,* 1757, ink and wash over black chalk, 13⁵/₁₆ × 20⁵/₈ inches. The Pierpont Morgan Library, New York, New York.

actors and the traditional Quakers. The conservatives who had tried to stop earlier productions were irate when David Douglass's company made arrangements to build a new playhouse south of the city limits on Society Hill. Accusations that "blasphemous Passions" and "filthy Jests" on the stage would bring Armageddon to Philadelphia failed to stop the projected season, which opened as scheduled for a six-month run in June 1759.[38] Among those embroiled in the controversy was West's friend and teacher William Williams, who was paid more than one hundred pounds "to paint a new set of Scenes for the said Theatre."[39] Settings for the plays were apparently quite elaborate. In *Theodosius,* for example, the backdrop consisted of a "transparent Alterpiece, shewing the Vision of Constantine the Great, before his Battle against the Christians, the bloody Cross in the Air Inscrib'd about it [in] Golden characters *In hoc signo Vinces.*"[40] Whether or not West helped Williams with the sets must remain a matter of speculation, but in all probability he attended some of the plays during the six-month repertory season.

Smith's outspoken ideas often filtered into the scripts that were redrafted for local audiences. For instance, the prologue delivered by Francis Hopkinson for the season's opening play,

69

Fig. 35 *King Alfred Sharing His Last Loaf with the Pilgrims,* 1777–78, oil on canvas, 20 × 26½ inches. The Worshipful Company of Stationers and Newspaper Makers, London.

the old favorite, *Tamerlane,* echoes the provost's philosophy. Addressing the continuing Quaker criticism of theatrical productions, Hopkinson ended his speech with the following lines:

So may each scene some useful moral show
From each performance sweet instruction flow.
Such is our aim—your kind assent we ask,
That once obtain'd we glory in the task.[41]

Hopkinson's message is clear. The real purpose of such dramas was to uplift the audience by emphasizing universal values. West would follow such advice in his classical history paintings executed during the 1760s by employing theatrical themes to provide instruction in "useful morals." His dramas were didactic scenes from Greek and Roman history, with actors delivering orations about bravery, courage, and sacrifice, many serving as cleverly disguised commentaries on current issues. For West, as for Smith and Hopkinson, Christ's teachings were synonymous with antique values of justice, benevolence, and loyalty. Such presumed absolutes, they all believed, could be demonstrated

most convincingly in the persuasive and compelling atmosphere of a theater. In the plays that were performed during his youth in Philadelphia, West found much of the essential framework for his later classical paintings: drama, morality, and theatrics.

The final act of West's Pennsylvania career occurred in late 1759 or early 1760, when the wealthy merchant and landowner William Allen agreed to sponsor the artist's journey to Italy aboard one of his cargo ships. He was to be accompanied by Allen's son, John, and one of the merchant's young relatives, Joseph Shippen. Allen instructed his London bank to supply West with an allowance, which the artist was to repay by copying recognized masterpieces and sending them back to Philadelphia. To insure West easy access to the necessary art collections, Allen told his agents in Italy that they should help the "ingenious painter" in every way possible because in Philadelphia he had displayed "the Character of a very deserving young man."[42]

Thus ended West's colonial education. He was now prepared to put the finishing touches on the ideas and techniques he had learned during his first twenty-two years. The young man who set sail that day in April 1760 carried with him a pastiche of high art and popular culture that was as varied as the men who instructed him. Williams, Haidt, Henry, Smith, Wollaston, and many others taught the boy from Chester County to blend Christian morality with classical imagery, to insert political issues into theatrical settings, and to merge European styles with American concerns. The young man who sailed from Pennsylvania in April 1760 was part rural and part urban, part Quaker and part Anglican, part sophisticate and part innocent. In essence, he was the talented product of an evolving culture.

Fig. 36 J. B. Michael, *William de Albanac Presenting Three Daughters (Naked) to Alfred, the Third King of Mercia,* 1782, engraving after a 1778 painting by Benjamin West. Department of Prints and Drawings, The British Museum, London.

CHAPTER FOUR Apprentice in Arcadia

Tales of West's three-year stay in Italy constitute an American legacy as familiar to students of art history as George Washington's legendary encounter with the cherry tree. In Galt's apocryphal biography, fact and fiction are so closely interwoven that it is impossible to follow West's progress with any degree of accuracy. The following passage is a prime example of such myth-making:

In America all was young, vigorous, and growing,—the spring of a nation, frugal, active, and simple. In Rome all was old, infirm, and decaying,—the autumn of a people who had gathered their glory, and were sinking into sleep under the disgraceful excesses of the vintage.[1]

It is this kind of hyperbole that has caused scholars to discredit Galt's description of West's Italian experiences. Yet we cannot ignore it altogether because certain anecdotes in *Life of West* do contain nuggets of relevant material. The image of West as an innocent provincial encountering the jaded urbanity of Rome probably does have validity, although not in the cosmic proportions that Galt described.

The well-known story of West's first meeting with the noted collector and antiquarian Cardinal Alessandro Albani is an example of how fanciful exaggeration can disguise fragments of salient information.[2] When presented with his young American visitor, the nearly blind cardinal is said to have asked, " 'Is he black or white?' " Upon being told that West was fair, Albani responded, " 'What as fair as I am?' " This amused visitors to his villa, Galt explained, for Albani's "complexion was of the darkest Italian olive, and West's was even of more than the usual degree of English fairness."[3] On the surface, Galt's tale can be interpreted as a joke about European naïveté regarding the racial origins of Americans. But if read as a commentary on West's youthful "fairness" (or innocence) compared to Albani's gnarled "darkness" (or perversity), the anecdote has greater significance. The cardinal was a worldly individual who kept company with

several illustrious mistresses and a mixed cadre of questionable associates.

To procure his renowned collection of ancient artifacts, Albani was rumored to have engaged in shady dealings with archaeologists in nearby Pompeii and Herculaneum. In addition, the cardinal was known to have participated in an undercover espionage maneuver with Sir Horace Mann, the British minister in Florence. The two men corresponded for many years, ostensibly to discuss their art collections and mutual British acquaintances, but this enterprise was merely a cover for their real mission—passing information about the exiled Jacobite Pretender, who was then living in Rome under Vatican protection. During frequent exchanges of antiquities with members of the Hanoverian court, Albani promised to help top British officials guard against a possible Jacobite insurrection. The wily old cardinal thus used his privileged position in the church hierarchy to keep the Stuart heir and his son under constant surveillance by surreptitiously transmitting his findings to Mann in Florence.[4]

In the ample halls and terraces of his sumptuous Roman villa, Albani often assembled an illustrious array of scholars, artists, and dilettantes. The star among them was Johann Joachim Winckelmann, the cardinal's secretary and librarian, whose recently published *Gedanken über die Nachahmung der Griechischen Werke* was considered to be one of the finest commentaries on ancient art then in existence. West may have spoken with the German scholar while visiting Albani, for he clearly shared Winckelmann's passionate conviction that Greek sculpture epitomized aesthetic perfection. While there is no clear indication that the two men ever met, they did have several mutual acquaintances, most notably the German painter Anton Raphael Mengs who taught West while he was in Rome.[5]

During the time West studied with him, Mengs was working on a ceiling mural for Albani's new villa near the Porta Salaria. The project included a large mythological painting, *Parnassus* (fig. 37), which is today considered a landmark of early neoclassicism. Constructed to create the illusion of balanced harmony, the composition centers on the figure of Apollo, surrounded by nine muses and their mother, Mnemosyne. The pose of the youthful god is that of the *Apollo Belvedere* (fig. 38), the antique statue that Winckelmann had so lavishly praised. Mengs designed his painting to be both an allegory of Albani's court (a "parnassus" of art and culture) and a commentary on the cardinal's romantic interests. It is said that he gave Albani's youthful features to Apollo, while portraying several of the old man's mistresses as the different muses.[6]

West observed many characteristics in Mengs's paintings that had been stressed by his Pennsylvania instructors. Like West's first German teacher, John Valentine Haidt, Mengs mod-

eled figures after antique sculpture and incorporated allegory into the composition; and, like Smith and Henry, he demonstrated great reverence for ancient Greece and Rome. But Mengs's work was far more sophisticated than anything West had encountered in the colonies because, following the advice of Winckelmann, the German painter was experimenting with novel ways to imitate classical forms. Eager to adapt the most recent innovations, West learned from Mengs how to make skin textures resemble the marble of statues and to structure his compositions on a shallow horizontal and vertical grid.

West's mature painting style probably owed most to Gavin Hamilton, a Scottish artist who had lived and worked in Rome since 1748.[7] From archaeological sites at Pompeii and Herculaneum, Hamilton had acquired a rare collection of artifacts that he used as models for figures in his paintings. His innovative interpretation of classical forms made a lasting mark on West, James Barry, and other British artists who saw his work in Rome. Although West acknowledged that he had known Hamilton in Italy, Galt's biography does not reveal how extensively West emulated the Scottish artist. One of the anecdotes subtly reveals, however, that West shared Hamilton's interest in classical literature. The story concerns an incident at a Roman coffee-house. In excessively ornate prose Galt describes how a blind singer named Homer serenaded West and Hamilton with a long ballad that forecast West's stellar future as an "instrument chosen by heaven" to elevate "American taste" to new heights.[8]

While the anecdote is essentially another of Galt's flowery metaphors of West's exalted destiny, the singer's name, Homer, points to a series of six paintings that Hamilton had begun at the time.[9] West probably saw *Andromache Bewailing the Death of Hector* and *Achilles Lamenting the Death of Patroclus,* the two works in this series that had been completed by 1761. In each of these paintings, Hamilton employed the horizontality of stage settings and the dramatic diagonals of baroque paintings to compel the viewer's attention to the prone body of the martyred hero. Like Mengs, Hamilton borrowed from Poussin, combining the severe classicism of his French predecessor with the homespun sentimentality of eighteenth-century genre paintings. The pathos, somber coloring, heavily contrasted lighting, and heightened drama found in West's paintings from the 1760s indicate how closely the American must have studied the works of Gavin Hamilton while he was in Rome.

Of all Galt's anecdotes none is more revealing than the famous story of West's first impressions of the *Apollo Belvedere.* Shortly after the young American arrived in Rome, he supposedly accompanied Cardinal Albani and a group of his Italian friends on a tour of the Vatican. They led him through the vast art collection, finally stopping before the *Apollo.* When asked

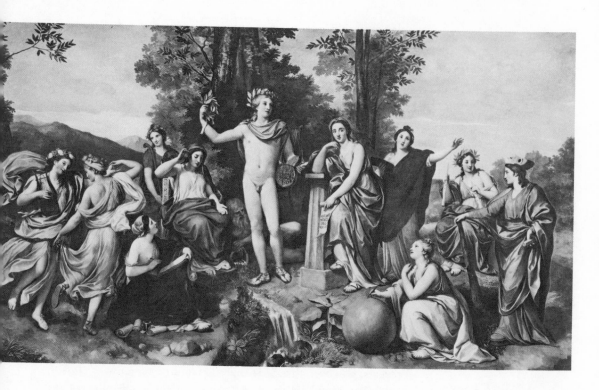

Fig. 37 Anton Raphael Mengs (1728–1779), *Parnassus,* 1761, fresco. Villa Albani, Rome/Alinari.

Fig. 38 Unidentified artist, *Apollo Belvedere,* date unknown, marble, 87⅓ inches high. Vatican Museum/Alinari.

his opinion of the sculpture, West is said to have exclaimed, "My God, how like it is to a young Mohawk warrior!" The Italians, Galt wrote, were "excessively mortified to find that the god of their idolatry was compared to a savage." Puzzled by their reaction, West assured Albani and his friends that Mohawks were agile, brave, and competent with bow and arrow. The explanation so delighted the Italians that they purportedly agreed "no better criticism" had "been pronounced on the merits of the statue."[10]

The anecdote is truly a gem of metaphorical prose. In one sense it parodies Winckelmann, who had designated the *Apollo Belvedere* as the "highest ideal of art." "His stature," he wrote, "is loftier than that of man, and his attitude speaks of the greatness with which he is filled. . . . There is nothing mortal here, nothing which human necessities require."[11] West obviously shared Winckelmann's reverence for the *Apollo,* as evidenced by his crayon drawing (fig. 39), which he probably sketched while in Rome. Although Winckelmann's exuberant tribute to the Roman statue provides the conceptual framework for Galt's anecdote, it does not fully explain the painting.

Closer examination reveals that the story is actually a commentary on one of West's own compositions, a work known until recently only through a reference made in Joel Barlow's *Columbiad,* written in 1807. In one passage, the author explained that West had

staggered the connoisseurs in Italy while he was there, by his pic-

76

ture of The Savage Chief taking leave of his family on going to war. This extraordinary effort of the American pencil on an American subject excited great admiration at Venice. The picture was engraved in that city by Bartolozzi before either he or West went to England.[12]

In recent years the original canvas of West's *Savage Chief,* or *The Indian Family* (fig. 40), has been discovered hanging unidentified in the London College of Surgeons. It mirrors the engraving by Bartolozzi (fig. 41) that served as the frontispiece for *Storia degli stabilimenti europei in America,* the Italian translation of William and Edmund Burke's *Account of the European Settlements in America,* published in Venice in 1763. Discovery of the painting and print fills an important gap in our knowledge of West's early career.[13]

As Barlow indicated, the painting was created for a specific purpose, revealed in a letter written by Joseph Shippen, West's traveling companion from Pennsylvania. Shippen wrote that John Murray, the British minister in Venice, needed a painted

Fig. 39 *Apollo Belvedere,* ca. 1760–62, crayon on paper, image: 11⁵/₁₆ × 8⁷/₈ inches. Friends Library, Swarthmore College, Pennsylvania.

Fig. 40 *The Savage Chief (The Indian Family)*, ca. 1761, oil on canvas, 23³/₅ × 18⁴/₅ inches. The Trustees of the Hunterian Collection and Council of the Royal College of Surgeons of England, London.

Fig. 41 Francesco Bartolozzi (1727–1815), *The Savage Chief (The Indian Family)*, 1763, engraving after a painting by Benjamin West. Department of Prints and Drawings, The British Museum, London.

description of "an Indian Warriour in his proper dress & accoutrements" accompanied by a squaw. For this assignment, West's instructions were quite precise: the work was to be on canvas with figures at least eighteen-inches high so that "the particulars of dress may be plainly distinguished." In addition, the "Warriour's face should be painted"; he should wear a "Feather in his Head"; and he should carry "his gun, Tomhawk [*sic*] and Spear." Shippen further advised West not to show a dog accompanying the brave, because the Indian should appear to be prepared for fighting, not hunting.[14]

West followed Shippen's directions to the letter. His painting depicts an Indian brave—with painted face, gun, and tomahawk—standing beside a squaw cradling her baby. Behind them is a stylized wilderness, replete with corn and gourds; in the

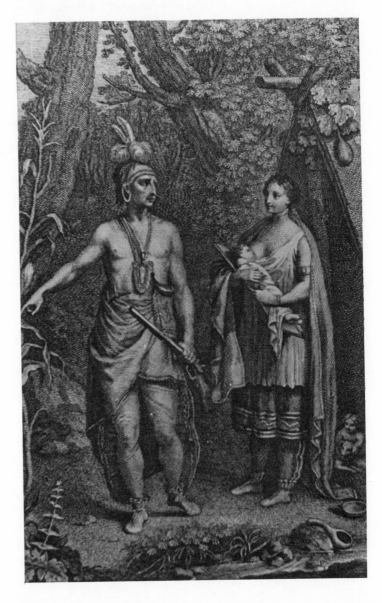

background a dog is being restrained by a puttolike child so that the animal will not interfere with the warrior's departure for battle. The Indian's headdress, powder horn, and other items (which appear to be Iroquois, not Mohawk) are precisely as Shippen decreed, down to the most trivial particulars. Many of the specifics were included in an Italian description of the Indian's costumes and artifacts that accompanied the engraving when it was published.[15]

Despite its attempted anthropological accuracy, the painting is as much a product of West's new European discoveries as of his American memories. Without a doubt the composition displays the artist's familiarity with antique sculpture. The squaw is a classical Venus/Madonna, dressed in a pastiche of a Greek peplum and a patterned woven skirt, her face, hair, and drapery modeled from ancient forms, the baby at her breast wrapped in the swaddling cloth of the infant Jesus.

The muscular brave, with his right arm extended and torso slightly turned, stands in the *contropposto* pose of the *Apollo Belvedere*. West, indeed, had transformed Winckelmann's hallowed statue into the very "Mohawk warrior" that Galt mentioned in the anecdote. West did not originate the idea of posing contemporary subjects as the *Apollo*. As we have seen, Mengs had modeled the central figure of his *Parnassus* fresco after the statue, and several years earlier Allan Ramsay and Joshua Reynolds had painted modern British "warriors" in the same stance (see fig. 53). Because of his provincial background, West was conditioned to interpret classical sculpture more pragmatically than were more urbane European painters. His Indian *Apollo* became a visual document, designed to provide salient information about the dress and habits of native Americans. Smith and Haidt had taught him to merge antique forms with popular imagery, and now he was merely carrying their lessons one step further by modeling the requested Indian brave after Europe's most celebrated artistic icon. Galt's often-repeated anecdote is, therefore, more than just a metaphor: it describes one of the most significant paintings that West completed during his stay in Italy.

A leg infection requiring surgery forced West to interrupt his Italian tour during the winter of 1761–62. Although the painful ailment and lengthy confinement were no doubt discouraging, he was fortunate to have had the operation in Florence, where he could spend his months of slow recovery copying masterpieces in the Uffizi and Pitti collections.[16] In Florence at that time, a community of young artists were similarly reproducing works of the masters and experimenting with paintings that incorporated classical forms. Among them was the Swiss-born

Angelica Kauffmann. Although rumors of a romance between West and Kauffmann cannot be confirmed, their mutual affection does seem apparent in the portraits they sketched when together in Florence and later in Rome. West drew Kauffmann draped in the costume of a Greek maiden with a palette in her hand (fig. 42), alluding to their common interest in art and antiquity. She, in turn, pictured him in Renaissance costume (fig. 43) and as an English nobleman wearing an elegant, fitted jacket. Kauffmann's drawings, executed with Spartan simplicity, display her mastery of the linear technique associated with the new classical style. During the next few decades their paths crossed often, as both became recognized artists in London. Each continued to paint narratives that incorporated the classical poses and severe settings they had discovered during their Italian studies.[17]

When he was convalescing in Florence, West also became acquainted with Horace Mann, the well-known British minister and connoisseur. As a diplomatic official and purchasing agent for English collectors, Mann remained in constant touch with a variety of political and cultural leaders, whom he frequently entertained at his Florentine villa. During those years, British residents in Italy had a "network" of mutual assistance that began with the consular personnel and stretched to Cardinal Albani and other Vatican officials. Visiting noblemen relied upon the network for accommodations, transportation, escorts, and entertainment; collectors depended upon it for assistance and advice about art; and students needed it for introductions to famous libraries, studios, and galleries. Because most of the contacts professed to have a scholarly familiarity with the arts, many made substantial profits by selling antiquities and masterpieces to touring Englishmen.[18]

Planning to move from one designated contact to another, West embarked on a journey to Bologna, Parma, Mantua, Verona, Padua, and Venice accompanied by the British merchant and antiquarian Henry Matthews.[19] At each stop, they tapped the Italo-British network for assistance and entertainment. One of their hosts was John Murray, the English minister in Venice, who had earlier requested the painting *The Savage Chief*. In Venice, West painted Murray's portrait and that of his wife (Lady Northampton) "in the Character of a Madonna, with her Child in her Arms."[20] Through Murray, West met Richard Dalton, an enigmatic dealer and entrepreneur, who had come to Italy several years earlier to purchase paintings and other collectable items for Lord Richard Grosvenor. When George III became king in 1760, he appointed Dalton as his royal librarian and keeper of the royal art collection. To the young artist from Pennsylvania, Dalton must have appeared highly impressive, especially when he promised to buy one of West's history paintings

for the new monarch. Yet the royal commission not only failed to materialize, but Dalton probably had little to do with West's eventual introduction to the king. Contact with the royal librarian was not entirely in vain, however, for from Dalton, West surely gained information about the habits and foibles of noble collectors, especially George III and Grosvenor, who both later became his most important patrons.[21]

West's tour of Italy was filled with fortunate encounters. Among the many names dropped by Galt were Thomas Jenkins, the influential and erratic artist and antiquarian; the future Sir John Dick, the British consul at Leghorn; Thomas Robinson (West's close friend and escort), who would someday sit in the House of Lords as the second Baron Grantham; the wealthy merchant Oliver Hope, whose son Henry became one of West's future patrons; the British author and scholar Joseph Wilcocks, who sat for a portrait by West; the Abbé Peter Grant, a prestigious and knowledgeable connoisseur; and a Mr. Crispigne (or Crispin), a mysterious individual who entertained an array of notable Italians and Englishmen.[22] West had become, indeed, the fair-haired child of Italy. Arriving at the right moment in his-

Fig. 42 *Angelica Kauffmann,* ca. 1763, crayon and pen and ink on paper, 6 × 4³/₄ inches. Friends Library, Swarthmore College, Pennsylvania.

tory, when the Italo-British network was experiencing a jolt of incentive and activity, West found himself among the elite. His affable nature attracted many friends, and his Pennsylvania origins provided just the right amount of romantic exoticism to inspire gossip, curiosity, and admiration.

Social encounters were only the dressing on West's Italian experience; the real purpose of his journey was to master painting skills. Part of his education came from Mengs, Hamilton, and other contemporary artists, and part from copying the old masters. Not only did West hope to learn painting techniques when he labored over each reproduction, but he also had an assignment to complete. As funds from William Allen had underwritten his entire tour, even helping to finance his surgery, the artist felt deeply obligated to send the promised paintings back to Pennsylvania. The shipments, which occurred at various intervals throughout his three-year sojourn, contained copies of works by Titian, Guido Reni, Correggio, and other accepted

Fig. 43 Angelica Kauffmann (1741–1807), *Benjamin West,* 1763, chalk on paper, 16¹/2 × 12¹/2 inches. National Portrait Gallery, London.

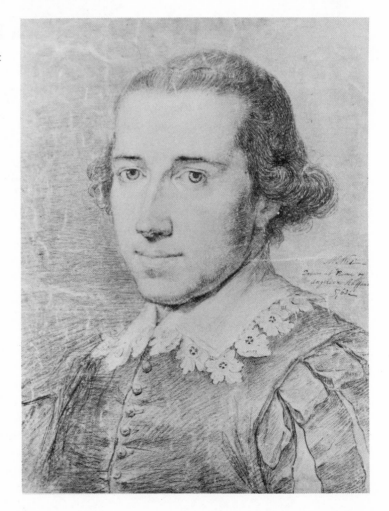

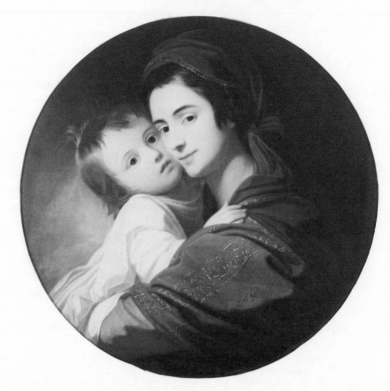

Fig. 44 *Mrs. Benjamin West and Her Son Raphael,* ca. 1773, oil on canvas, 26½ inches in diameter. Yale Center for British Art, New Haven, Connecticut; Paul Mellon Collection.

masters. Three small sketchbooks (now at the Royal Academy) are filled with drawings of architecture, details of sculpture, and portions of paintings, indicating that West spent arduous hours working in churches, palaces, and galleries.

In later correspondences West cited Raphael, Michelangelo, Correggio, and Titian as the artists whose works he found most instructive. Raphael, he said, should be studied for interpretations of individual characters and for groupings of figures within the composition. During West's first years in England his paintings were often compared to those by the Umbrian master, and in one instance he was called an "American Raphael," a designation that obviously pleased him. His wish to maintain that association extended into his personal life: he named his first son Raphael, and painted a portrait of his wife and the boy (fig. 44) modeled after the Italian Raphael's *Madonna della Sedia,* one of the paintings West had copied in Italy.[23]

West's studies of Michelangelo survive in finely wrought and sensitive drawings of figures from the Sistine Ceiling and the *Last Judgment* (figs. 45 and 46). West wrote that he admired the great sculptor for allowing "Philosophy" to direct his "Genius" and simultaneously convey the "internal beauties" of a subject by manipulating two-dimensional surfaces to create an illusion of volume.[24]

Correggio, a favorite among eighteenth-century painters, figured prominently in West's later recollections. The Pennsylva-

nian not only copied several of Correggio's works, including *St. Jerome* and *Venus Lamenting over the Body of Adonis*, but also painted his own version of the latter (fig. 47), using Correggio's composition as a model. Years later West spoke of Correggio's paintings as if they possessed the ultimate answers to foreshortening, facial expression, lighting, and application of paint. In an address at the Royal Academy, he elevated the master of Parma to veritable sainthood by telling students that Correggio had "received his tuition in painting from the angels," because his "figures seem to belong to another race of being than man, and to have something too celestial for the forms of earth to have presented to his view."[25] Such excessive praise indicates that the delicate brushwork and supple modeling that West later

Fig. 45 *Figures from Michelangelo's Deluge, Sistine Chapel,* 1760–63, pen and ink with chalk on paper, 17³⁄₈ × 23 inches. The Pierpont Morgan Library, New York, New York.

Fig. 46 *Michelangelo's Adam from the Creation of Eve, Sistine Chapel,* 1760–63, chalk on paper, 17¹⁄₄ × 22⁷⁄₈ inches. The Pierpont Morgan Library, New York, New York.

achieved came from assiduous scrutiny of Correggio's canvases.

Copying Titian's famous *Venus of Urbino* at the Uffizi in Florence, West came to admire the artist for his bold and incandescent coloring. He became so obsessed with discovering the Venetian's "secret" of pigmentation that he constantly sought ways to duplicate Titian's deep and luscious hues.[26] While West advised students to study Titian, Veronese, and other Venetian artists for composition and coloring, he never acknowledged his debt to more recent painters of that city. Yet he obviously benefited from firsthand observation of works by Sebastiano Ricci, Tiepolo, and other eighteenth-century painters of Venice who were experimenting with history paintings based on theatrical themes. Having already used a theatrical setting for *The Death of Socrates,* West would have found their dramatic compositions directly relevant to his interests.

After his tour of northern Italy, West returned to Rome in early 1763, inspired to create his own narrative paintings. For subjects he chose two mythological stories: Cymon and Iphigenia from Giovanni Boccaccio's *Decameron,* and Angelica and Medoro from Lodovico Ariosto's epic poem *Orlando Furioso.* Both legends had been rewritten for the theater: Cymon and Iphigenia into a play by John Dryden, and *Orlando Furioso* into Italy's favorite puppet show.[27] His choice of topics indicates that instead of interpreting obscure literary sources, as one might suspect, West was actually exploring familiar and popular themes. *Angelica and Medoro* (fig. 48)—the only one of the two paintings that survives—features the two lovers of the title

Fig. 47 *Venus Lamenting the Death of Adonis,* 1768, oil on canvas, 64 × 69½ inches. Museum of Art, Carnegie Institute, Pittsburgh, Pennsylvania; Museum purchase, 1911.

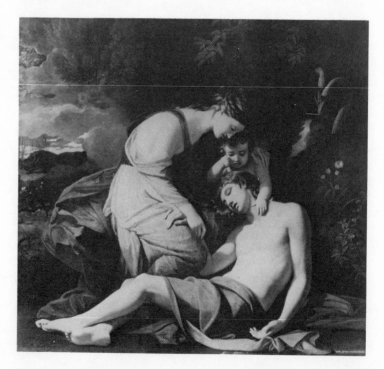

Fig. 48 *Angelica and Medoro,* 1763–64, oil on canvas, 36¼ × 28¼ inches. University Art Gallery, State University of New York at Binghamton.

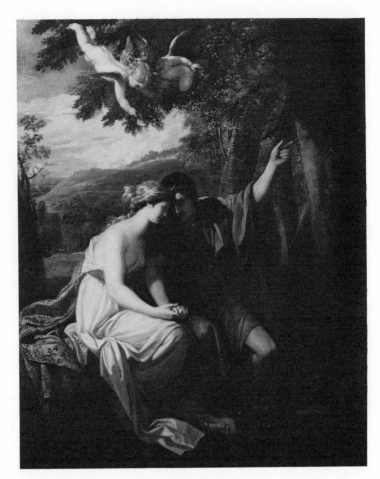

lounging in a wooded landscape. Perhaps, as some have speculated, West chose the scene as a tribute to Angelica Kauffmann. In Ariosto's original story, Angelica encounters Medoro after he has been wounded, thereby alluding to the meeting of West and Kauffmann in Florence during West's convalescence. Most telling is West's depiction of Angelica with the same delicate features, upswept hairstyle, and shawl that he gave Kauffmann in the portrait drawn in Italy around the same time (fig. 42).[28]

Angelica and Medoro is a fitting graduation thesis for West's Italian education, for it incorporates elements from the classics, the old masters, and contemporary culture. The figures are modeled after antique sculpture; she is a Venus, he a seated Apollo with an outstretched arm. Furthermore, the flying putti and precise landscape of the background resemble analagous features in works by Raphael and Correggio. From these and other artists West learned the intricate brushwork and subtle shading necessary to produce the shimmering surface of Angelica's richly patterned silk shawl. The entire composition reflects a refinement of technique, a sharper honing of the finished line, and a greater dexterity with compositional devices—all benefits

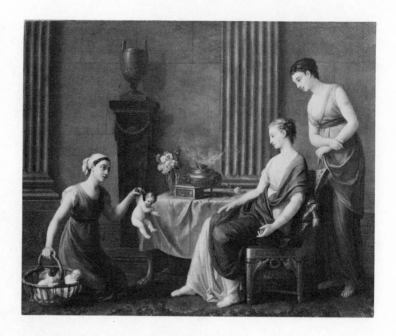

Fig. 49 Joseph-Marie Vien (1716–1809), *La marchande d'Amours,* ca. 1763, oil on canvas, 37²/₅ × 42¹/₂ inches. Fontainebleu Chateau / Giraudon.

that West reaped from his three-year tour of Italy.

With *Cymon and Iphigenia* and *Angelica and Medoro* in his baggage, West left Rome in the early summer of 1763, planning to journey across northern Italy to France with a brief stop in England before his scheduled return to America. Dr. William Patoun, one of the many connoisseurs and dealers who escorted Englishmen around the Continent, accompanied him as they moved northward through Parma, Genoa, Turin, Lyons, and eventually Paris.[29] Only fragmentary descriptions exist of West's first visit to the French capital in July 1763. Galt wrote more about the degenerate state of Parisian society than about West's impressions of the artwork he found there. We must assume, nevertheless, that the American studied the paintings and drawings he saw in the royal collection and in private palaces around the city.[30]

The great event at the end of that summer was the annual Salon of the Académie Royal de Peinture et Sculpture. Although West and Patoun probably missed the exhibition, they undoubtedly saw many of the works in their tour of Parisian estates and studios. If so, they viewed an impressive array of paintings, which were appraised by Diderot in his review of the 1763 Paris Salon as the most instructive collection of French art amassed in the past hundred years.[31] With canvases by rococo painters François Boucher and Claude Joseph Vernet, there were also works by Joseph-Marie Vien and Jean Baptiste Greuze, said to exemplify new trends in the use of theatrical devices and stories with compelling moral messages.

Vien's *La marchande d'Amours* (fig. 49), which hung in the exhibition, has been cited as a significant precursor of the neoclassical compositions that found full fruition in the later works of David and Ingres. In this painting, exhibited in 1763, Vien placed his "actors" on a shallow stage and told his story through the interaction of principal characters. Although the composition still contained much of the rococo lightness and subtle eroticism that marked his earlier paintings, Vien connected the elements to a more severe and classical structure, which he borrowed from an engraving of a Roman painting recently discovered in Herculaneum. Greuze's exhibition piece of that year was *La Piété Filiale* (see engraving, fig. 50), a vignette of a provincial patriarch's deathbed. Noted for its melodramatic overtones, the painting combines a modern sentimental narrative with the universality of a sermon on filial piety. Diderot praised it as a persuasive and appealing lesson in human behavior. "Ought we not be satisfied," the critic asked, "to see it [morality]

Fig. 50 Unidentified artist, *La Piété Filiale,* ca. 1763, engraving after a painting by Jean Baptiste Greuze (1725–1805). Department of Prints and Drawings, The British Museum, London.

competing at last with dramatic poetry in moving us, teaching us, correcting us and encouraging us in virtue?"[32]

West must have shared Diderot's sentiments as he observed paintings in Paris during the summer of 1763. Surely, he was delighted to discover that modern French art combined the didacticism of his Pennsylvania education with the classicism of his Italian studies. We need only consider the moral overtones and dramatic settings of his historical canvases of the late 1760s to appreciate West's debt to Greuze, Vien, and their contemporaries.

West crossed the English Channel in August 1763, planning to learn as much as possible about British art and culture before his scheduled return to America. His tour of England involved the same rigorous routine of examining paintings and consulting with dignitaries that had marked his visits to Italy and France. In keeping with his characteristic good fortune, West was greeted in London by several of his most important Philadelphia friends and patrons. William Smith was in England, raising money for the College of Philadelphia and campaigning against Franklin's plan to change Pennsylvania's government; William Allen was there, enjoying the countryside and working with Smith to preserve Thomas Penn's proprietorship; and two younger Philadelphians, Samuel Powel and John Morgan, had stopped briefly in England before embarking on a tour of the Continent. Only weeks before West's arrival, Thomas Penn had arranged for Powel and Smith to hold an audience with George III. Their discussion concerned royal support for both the College of Philadelphia and Penn's continued rule of the colony.[33]

While it behooved West to keep abreast of events that involved his patrons, political matters were not his major concern. His primary aim was to discover the best of Britain's art treasures before returning to Pennsylvania. His tour of the private estates and royal collections of southern England began with a stop at Hampton Court to see the famous cartoons by Raphael. These designs for Belgian tapestries obviously made an impression on the American, because his paintings of the next few decades utilized many of the same primary colors, sharp contrasts, and horizontal compositions.[34] From Hampton Court, West proceeded to Oxford, Blenheim, Bath (where he visited William Allen), and finally Stourhead, the estate of Henry Hoare. Strolling down the picturesque paths that circled through Stourhead's classical gardens designed by Capability Brown, West saw vistas of temples, pantheons, and Palladian bridges that resembled paintings by Claude and Poussin. The picture collection at Stourhead contained one of Hoare's most recent acquisitions, *Caesar and Cleopatra* by Mengs (fig. 51), completed only

shortly before West had worked with the German artist in Rome. Also there was Poussin's *Choice of Hercules* (fig. 56), which was surely on West's mind several months later when he began work on the same subject.[35]

Sometime before the end of 1763, West took lodgings in London's Covent Garden and immediately contacted two of Britain's best-known painters: Joshua Reynolds and Richard Wilson. Reynolds had managed to complete an impressive number of portrait commissions since he had returned from Rome several years earlier. His successes were the stuff of West's dreams. Within an amazingly short time West would be following the path Reynolds blazed: finding hospitality in the same regal palaces, boasting of the same aristocratic patronage, and eventually presiding over the same academy. It is surprising, then, that this man who so profoundly affected West's life provided him with no formal instruction. Conversely, Wilson allowed the American to work in his studio but left relatively little trace on West's work, either in terms of technique or choice of subject matter. Only a shared admiration for Rome and the classical tradition united the two men. The older landscape painter was helpful, nevertheless, in introducing West to London's artistic community and in providing advice on how he should finish the two canvases he had begun in Rome.[36]

Reynolds and Wilson were part of an elite group of British artists who had enhanced their knowledge of art and culture by studying in Italy. Through association with these men, West found himself part of that circle. While the term *avant-garde* is anachronistic in regard to the eighteenth century, it does apply to the Italian-trained painters, sculptors, and architects who were working considerably in advance of English taste. They were, in fact, responding to new continental ideas that British collectors steadfastly ignored. Conservative Englishmen generally felt more secure purchasing narrative paintings by safely dead French and Italian artists and commissioning British painters solely for portraits. For this reason, success in England meant mastery of "face painting," a secret Reynolds learned early in his career. He was clever, though, using his Italian training to incorporate classical design, poses, and settings into the traditional portrait. Wilson, too, utilized his knowledge of the classics to create Greek and Roman landscapes in the manner of Claude and Poussin. But for the kind of classical history painting West had learned from Mengs and Hamilton, there was little encouragement in the British Isles.

One formidable obstacle confronted the would-be classical painters and sculptors in mid-century London: the pervasive authority of William Hogarth, the grand patriarch of English art at the time. When West first observed the inner workings of the British art world in 1763, the feisty satirist was still fulminating

Fig. 51 Anton Raphael Mengs (1728–1779), *Caesar and Cleopatra,* 1760, oil on canvas, 118 × 83½ inches. The National Trust, Stourhead, England.

angrily against imported training and foreign ideas. Hogarth also dominated English education in studio arts, because the closest thing to an academy was his St. Martin's Lane school, which West attended during the autumn of 1763. Small and informal though it was, the school offered a place for the city's artists to meet and exchange ideas. West often joined fellow students and teachers at the end of the day at Turk's Head Tavern in Soho. A few years earlier, meetings of this kind had culminated in a plan for a royal academy of art, similar to those that had long existed on the Continent. Even though the proposal failed to win the approval of George II, it pointed out the absence of a British institution charged with sponsorship of regular exhibitions and a formal program of art education.[37]

The picture had brightened considerably by the time West reached London in 1763. Three years earlier, the Royal Society of Arts (an organization devoted to promoting native artistry,

manufacturing, and commerce) had agreed to sponsor the first exhibition of British painters and sculptors. Although this monumental event of 1760 had been a tremendous success, the alliance of artists lasted less than a year. In 1761 two rival associations were formed to sponsor separate annual exhibitions: the Society of Artists of Great Britain at Spring Gardens, Charing Cross; and the Free Society of Artists on Maiden Lane.[38] With names as illustrious as William Hogarth, Thomas Gainsborough, Joshua Reynolds, Richard Wilson, Francis Hayman, Thomas Hudson, and Joseph Highmore among the exhibitors, the Spring Gardens show far outshone its competitor, establishing a precedent for quality and variety that was to continue until 1768, when the new Royal Academy was launched. Within a year after West's arrival Hogarth died and other older artists, such as Hudson and Highmore, no longer exhibited at Spring Gardens. They were gradually being replaced by new talents, including Johann Zoffany, Gavin Hamilton, George Stubbs, and Joseph Wright of Derby.[39]

In 1764 West's name would be listed among the exhibitors at Spring Gardens, for now he had graduated from his apprenticeship and was prepared to compete with the modern masters. As his stay in London stretched from a few weeks to several months, he was slowly becoming integrated into the British art establishment, leading to a decision that was to shape the course of his future career.

The Choice of Hercules

CHAPTER FIVE

The creative process is so elusive, involving so many disparate ingredients, that one can only surmise what sights, smells, feelings, and sounds are present when the painter stands before a canvas. Even though the magic balance of color, line, composition, and inspiration determines the real success of a painting, one should never overlook the many social and cultural influences crowded into the artist's consciousness as he plans his work. Because of his diverse background, West's creative abilities were tempered by reflections from Pennsylvania, Italy, and England, all of which transformed his paintings into prisms that refracted the changing colors of eighteenth-century culture. Like all artists, West had to select subjects and styles that fulfilled his personal needs and yet would appeal to his patrons and to the entire art community. From his first days in London, West had to choose which artists to imitate and which ones to ignore, which precedents to incorporate and which to avoid. It was most important for an artist of the mid-eighteenth century to maintain a delicate balance between past and present.

West demonstrated his mastery of contemporary trends in a portrait he painted in early 1764 (see engraving, fig. 52). His sitter was Major General Robert Monckton, Wolfe's top-ranking brigadier during the Battle of Quebec. Because of the notoriety connected with this post and subsequent victories in the Caribbean, Monckton had become a local hero.[1] West's full-length portrait captures Monckton's heroic stature, as the general stands beside his tent with scenes from the battle of Martinique—his great Caribbean triumph—in the background. The obvious pose for a military celebrity in the mid-eighteenth century was that of the *Apollo Belvedere* (fig. 38). Reynolds had used it in 1753 when he depicted Commander Keppel on a stormy shore (fig. 53), a setting that suggests Keppel's victories at sea, and West himself had used it for his *Savage Chief* (fig. 40), painted in Italy. The pose was, therefore, a natural one to be used in his portrait of General Monckton, because it reinforced West's alliance with the "modern" artists who were reviving classical forms. When he displayed the portrait in his studio,

95

a number of established artists, including George Romney, Wilson, Gainsborough, Reynolds, and Wright of Derby came to view the work.[2] For West, the commission brought another reward. He could talk in person with a hero of the Quebec campaign, an encounter that later insured a prominent position for Monckton in West's "modern" epic *The Death of General Wolfe.*

At the suggestion of Reynolds and Wilson, West decided to enter the Monckton portrait together with *Angelica and Medoro* (fig. 48) and *Cymon and Iphigenia* in the Spring Gardens exhibition of 1764. The show that opened in April to a flurry of advance publicity included portraits by Gainsborough, Reynolds, and Pine; landscapes by Wilson; theatrical pieces by Zoffany; and "a lion seizing a horse" and five other sporting scenes by Stubbs. Among the history paintings exhibited were *The Death of Abel* by George James, *The Head of Pompey Shown to*

Caesar by Samuel Wale, and *The Death of General Wolfe* by Edward Penny (fig. 100), a work that surely must have interested West.[3]

The 1764 Spring Gardens exhibition was both exhilarating and disconcerting for West. Before the show opened, publicity about the young American artist had been laudatory. West's reputation as a sparkling new talent had even inspired a verse in London's *Public Advertiser,* dedicated to "Mr. West, a celebrated painter . . . known in Italy by the name of the American Raphael." The flowery verse that followed began with the stanza:

> *Thou, who canst make the canvas live,*
> *Great Master! now thy pow'rs disclose;*
> *And let my eyes from thee receive*
> *The lovliest sight that nature knows.*[4]

With such a glorious prelude, critics were understandably cautious. A columnist in *Gentleman's Magazine* who signed his name "Connoisseur" commented that despite several minor flaws in the construction of the figures, he found West's work to be "very good and pleasing."[5] The commentator for the *Public Advertiser,* however, was less enthusiastic, submitting this candid appraisal:

This Gentleman (whose merit is certainly considerable) has had the good Luck of setting out in his Profession, countenanced by the best and greatest judges: May true merit always meet with such Success! Tho' no one entertain a higher Sense of this artist's most promising Abilities than myself, yet I must say, his sanguine Friends have been too lavish of their Praises, and by their exaggerated accounts of the Powers of his Pencil, rather diminished than added to his Reputation; for until Mr. West exhibits some more striking Performances than those he has already done, surely the glorious Title of the American Raphael can never be, without Irony, bestowed on him.[6]

The acerbic Horace Walpole also believed that West had been praised too highly, and wrote in his notebook that the history paintings exhibited by the American were "much admired but . . . very tawdry, after the manner of Barroccio."[7]

Such comments—from the lavish verse that preceded his first public showing to the sobering remarks that followed—placed West's name in the spotlight. Only eight months after his arrival he was forced to assess his goals and aspirations. Should he remain in England where he would have to compete with highly trained professionals? Or should he return to Pennsylvania where he would shine as the most worldly of all American

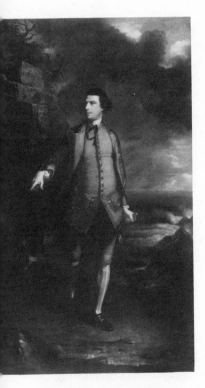

Fig. 53 Sir Joshua Reynolds (1723–1792), *Commodore Keppel,* 1753–54, oil on canvas, 91⁷/₁₀ × 57¹/₂ inches. National Maritime Museum, Greenwich, London.

artists? With such uncertainties about where to practice his art, West also had to decide what kind of work he would produce. Should he pursue the high and difficult road of history painting, which had claimed more casualties than triumphs in the English-speaking world? Or should he follow the easier path of portraiture, with its better promises of patronage? In addition to professional concerns, West also pondered over personal matters.

Four years earlier, in 1760, he had courted Elizabeth (Betsy) Shewell in Philadelphia, and now he wished to make her his bride. With his newly acquired English celebrity, his prospects for supporting a family through a career in art were better in London than in Philadelphia, where he would probably be forced to paint signs, design stage sets, or engage in other commercial ventures to survive. Yet Pennsylvania was home, holding the promise of warm friends and loving relatives who would welcome him as a returning hero. With both William Smith and William Allen in London to remind him of the benefits across the ocean, and his new British sponsors suggesting career advantages if he remained in England, West was faced with major decisions.

Confronting one of his life's most critical crossroads in mid-1764, West resorted to the means of expression he knew best. If he could not describe his dilemma in words, he could certainly do so with paint. The result was *The Choice of Hercules* (fig. 54), one of the most profound autobiographical statements of his career.[8] The relatively small canvas, based on a legend from Xenophon, depicts Hercules poised between two women, one symbolizing virtue, the other vice or pleasure. The young god frowns in bewilderment as he wonders whether to pursue the rigorous path of righteousness or the more pleasurable one of debauchery. Virtue, in her white tunic and dark blue robe, points heavenward to indicate that her elevated route is the correct one for Hercules to follow. Opposite her, Vice lounges seductively, a pink gown falling from her fleshy shoulder to expose voluptuous breasts. The subject and its iconography certainly did not originate with West; he merely borrowed the familiar theme to make a declaration about his artistic, personal, and perhaps even political concerns. ·

West's special interest in *The Choice of Hercules* possibly began in the colonies with the cover illustration for the *American Magazine* (fig. 29). In that drawing, an Indian is choosing between an Englishman (Virtue) and a Frenchman (Vice). Examples of the traditional theme could be found elsewhere in America. Not only had John Smibert painted it in the early eighteenth century, but engravings of the subject were quite popular in the colonies. As West toured Italy, he would have found

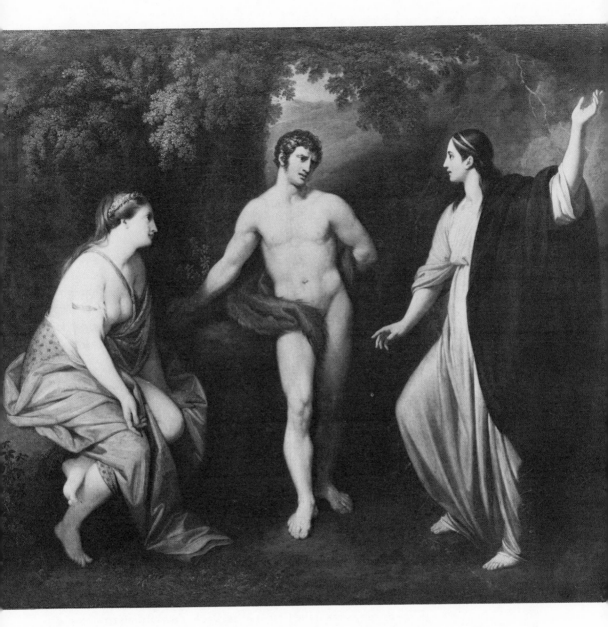

Fig. 54 *The Choice of Hercules,* 1764, oil on canvas, 40 × 48 inches. The Victoria and Albert Museum, London.

differing interpretations of Hercules' dilemma. They ranged from a Roman relief at the Villa Albani to more recent versions of the subject by Sebastiano Ricci, who painted *The Choice of Hercules* (fig. 55) at the Palazzo Marucelli-Fenzi as part of a fresco cycle that illustrated Virtue's triumph over Vice. In England, West saw Poussin's *Choice of Hercules* (fig. 56) when he visited Stourhead. The subject had even been recently reinterpreted on the stage as both an opera and a masque.[9] Thus when West sat down to compose his painting of 1764, his selection of an often-reproduced topic was conscious and deliberate.

The subject, in fact, had become a kind of manifesto for history painters. During the Renaissance, European artists from Annibale Carracci to Lucas Cranach had chosen the ancient

Fig. 55 Sebastiano Ricci (ca. 1659/60–1734), *The Choice of Hercules*, 1706–7, fresco, approx. 310 × 382 inches. Palazzo Marucelli-Fenzi, Bologna/Giraudon.

theme to advance ideas of self-determination. In the late seventeenth century the iconography for "Hercules at the Crossroads" settled into a compositional formula in which Hercules was depicted standing or sitting between the two goddesses. Recognizable emblems identified their attributes: Hercules held a club to signify strength and courage, Virtue wore a helmet and carried a lance to symbolize perseverance, and Vice was pictured amidst objects of silver and gold to represent her debauched life.[10]

In 1713 Lord Shaftesbury analyzed the symbolic references in his "Essay on Painting Being a Notion of the Historical Draught or Tablature of the Judgment of Hercules," a section of his philosophical opus *Characteristicks*. At first glance the treatise appears to be an instructional manual for artists, but when we consider it in conjunction with Shaftesbury's other writings, it is clear that the essay encapsulates the philosopher's basic ideas about aesthetics. Shaftesbury believed that the fundamental purpose of a painting was to convey a moral message, especially one relating to the deeper dimensions of conflicting "human Passions," and he advised artists, therefore, to address subjects that touched on man's long struggle to overcome temptations and vice. "Hercules at the Crossroads" was an ideal vehicle for transmitting this lesson because it featured a youthful hero caught between pleasures of the past and uncertainties of the future. To convey the full impact of Hercules' decisive moment, Shaftesbury instructed artists to simplify their compositions and subordinate all superfluities so that the didactic purpose of the painting would predominate. Every expression, gesture, color, and object should be planned to repeat the moral message with clarity of design and intensity of action. Artists, he wrote, must reject "false Ornaments of *affected Graces, exaggerated Passions, hyperbolical* and *Prodigious Forms; which* equally with the mere *capricious* and *grotesque,* destroy the *Simplicity* and *Unity,* essential in a PIECE."[11]

For the visual manifestation of his analysis, Shaftesbury commissioned the Italian artist Paolo de Matthais to create a painting that would later be engraved by Simon Gribelin as the frontispiece for the treatise (figs. 57 and 58). Although Matthais carefully adhered to the description in Shaftesbury's essay by placing Hercules in the center between a seated Vice on the right and a standing Virtue on the left, the Italian artist added the allegorical symbols and decorative drapery that Shaftesbury had criticized.

West undoubtedly used Matthais's painting (probably viewed through Gribelin's engraving) as a model for his composition. Like Matthais, West depicted Hercules between a standing Virtue and seated Vice, but the American artist was far more faithful to Shaftesbury's text than his Italian predecessor had been.[12] First, West included no symbols. Except for a mere sug-

gestion of a club hidden beneath Hercules' hand, the painting is devoid of all superfluous objects, an important omission in light of then-current artistic trends.[13] The absence of symbols places West in the school not only of Shaftesbury but of Mengs and Hamilton as well. The didactic purpose of the painting is transmitted not through the specific objects that accompany the figures, but by the part the individuals play in the larger allegorical narrative.[14] The emphasis on human action is the most innovative aspect of West's *Choice of Hercules,* as it established a precedent that he would incorporate into later paintings.

West also differed from Matthais and most earlier artists in the way he placed Pleasure on the left and Virtue on the right. He may have deliberately reversed the figures to ally his painting with a similar composition by Reynolds, who cleverly alluded to the "Choice of Hercules" theme in *Garrick between Comedy and Tragedy* (fig. 59). In Reynold's painting, the actor strides between a giddy, young Comedy (Pleasure) and a stern, classical Tragedy (Virtue), but Reynolds altered the traditional European pattern by reversing the position of the women, placing Pleasure on the left and Virtue on the right, a configuration West would

Fig. 56 Nicolas Poussin (ca. 1593/94–1665), *The Choice of Hercules,* ca. 1637, oil on canvas, 35¾ × 28¼ inches. The National Trust, Stourhead, England.

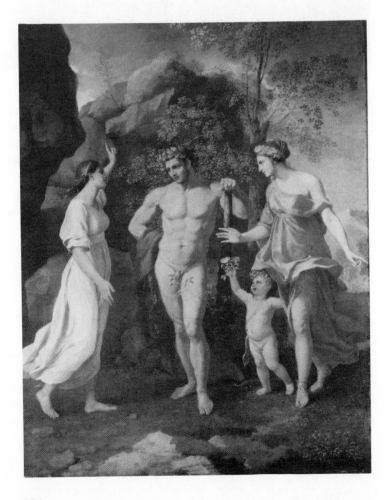

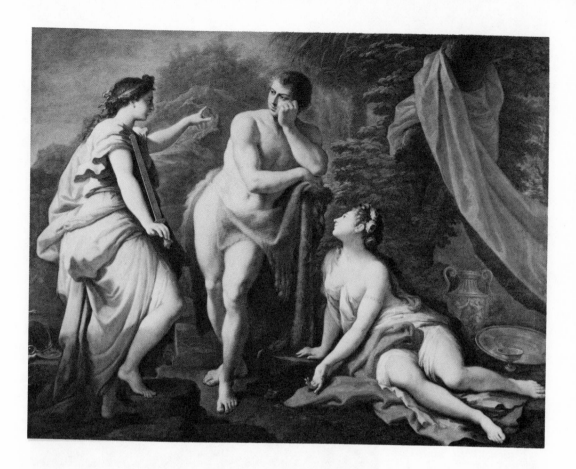

Fig. 57 Paolo de Matthais (1662–1728), *The Judgment of Hercules,* 1712, oil on canvas, 78 × 101 inches. Ashmolean Museum, Oxford, England.

later imitate.[15] Although West's painting lacks Reynolds's subtle humor, it is far less conventional than one might initially surmise. By making the figures synonymous with their own symbolic function, West's *Choice of Hercules* was extremely "modern."

To underscore his reverence for classicism, West patterned the body of Hercules after the recently unearthed *Belvedere Torso,* an obvious selection when one realizes that several years earlier Winckelmann had identified that fragment of antique sculpture as "the trunk of Hercules."[16] The central god is, therefore, a paradigm of classicism, a simple and naturalistic personification of the Greek ideal. West's Virtue, on the other hand, is a mixture of English and antique references. Her aquiline features and Greek robe are decidedly classical, but her left hand pointing upward is distinctly British because her pose is an exact replica of Reynolds's "Tragedy." By giving his classical goddess this stance, West claimed his place among the select cadre of English artists who had studied ancient art in Rome.

The plump figure of Pleasure makes yet another commentary about art, for she is as stocky, pink, and voluptuous as any of Rubens's maidens. Depiction of this emblem of debauchery in a "baroque" frame of reference further underscores West's deci-

sion to avoid all temptation to employ the artistic "vice" of former generations. If Virtue represents the cool, clear purity of a modern culture, Vice symbolizes the "sinful" excesses of the artistic past.

All such innuendos transform West's *Choice of Hercules* into an artistic treatise ladened with philosophical and cultural implications. As Shaftesbury's disciple, West endowed his painting with a clearly defined lesson about man's lifelong struggle to overcome his baser instincts; as a protégé of Mengs and Hamilton, he told his story through the action of the figures, not through antiquated emblems; and as a British subject, he borrowed the setting and details of the pose from one of England's most respected artists. In this way, he was defining his intentions to establish himself as a painter of historical subjects.

In his personal life West was Hercules at the crossroads, contemplating whether or not to assume the responsibilities of a wife and family. He solved the problem, Galt explained, after conferring with his Philadelphia mentors, Smith and Allen. Following the path of Virtue, West decided to marry his American sweetheart, Betsy Shewell, arranging for her to cross the ocean accompanied by his father, John (now a widower), and Betsy's cousin, Matthew Pratt, who became West's first American student. After the wedding in August 1764, West settled down to the life of a family man in their new home on Castle Street, Leicester Fields, where in 1766 their first son, Raphael, was born. Although West continued to paint portraits to support his family, he concurrently began to compose didactic history paintings according to Shaftesbury's instructions.

A political message may also underlie West's *Choice of Her-*

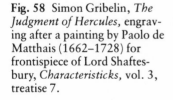

Fig. 58 Simon Gribelin, *The Judgment of Hercules,* engraving after a painting by Paolo de Matthais (1662–1728) for frontispiece of Lord Shaftesbury, *Characteristicks,* vol. 3, treatise 7.

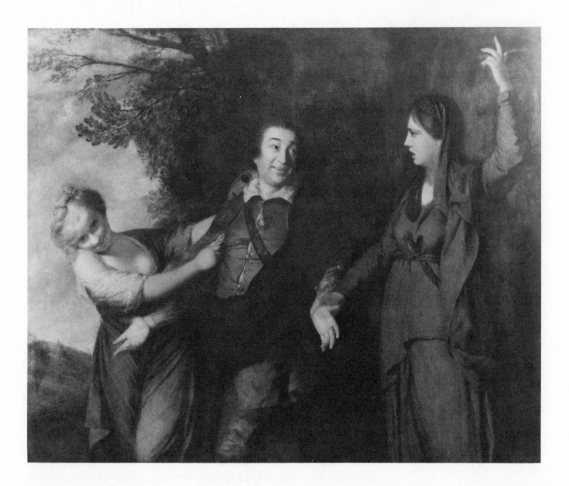

Fig. 59 Sir Joshua Reynolds (1723–1792), *Garrick between Comedy and Tragedy,* 1760–61, oil on canvas, 58³/₁₀ × 72 inches. Private collection.

cules, for shortly after George III became king in 1760, he issued a proclamation encouraging piety and virtue in place of the "Vice, Prophaneness and Immorality" that he believed to be rife in the kingdom. The naïve assumption that a king could legislate morality with a simple document reveals the political innocence of the young monarch. Within a few years the king's idealism was shattered by the realities of court politics and public opinion. The first blow came when he was forced to dismiss his close friend and principal minister, Lord Bute; the second, when the controversial M.P. from Aylesbury, John Wilkes, published inflammatory and often pornographic attacks on the court. Addressing both issues, artists and writers invented new and devastating satirical jibes that charged the government with unwarranted suppression of liberty and free speech.[17]

To defenders of the Crown, Wilkes's sardonic pen represented unadulterated vice, while the king's proclamation epitomized untarnished virtue, adding yet another dimension to West's *Choice of Hercules.* If West, however, hoped to please the king and influence public opinion with this composition, he was destined for disappointment. As far as we know, King George never saw the painting, at least not in 1764. In subsequent years

it was never displayed in a public exhibition, and an engraving was not published until 1811. Nor was it sold during the artist's lifetime. When the auctioneers surveyed West's collection after his death, they found the original painting, still hanging where it had always been, in the artist's picture gallery.[18]

In 1764 West's *Choice of Hercules* would have had a very limited appeal among English patrons and connoisseurs. Average observers could scarcely understand the subtlety and severity of its conventional theme shorn of symbolic trappings. Few would realize that the painting should be interpreted as West's personal manifesto. Virtue's jagged course loomed darkly ahead, for history painting in Britain promised few rewards apart from commendation by a select group of colleagues and possible patronage by one or two sophisticated collectors. Under these circumstances West considered himself to be an aesthetic pioneer dedicated to the elusive goal of didactic history painting.

※

While West's chosen path had few travelers in 1764, there was reason to hope that a journey over the rocky terrain might succeed. His decision to become a history painter grew in part out of a realization that the time was ripe. There is no question that he had much in his favor. For many years Britons had been engaged in an ongoing love affair with narratives of all kind. British culture had long been characterized by a strong literary tradition in which clearly defined stories took precedence over more abstract poetry or prose. Portrait painters were aware of England's penchant for narrative when they included an array of objects to describe the lives, possessions, and concerns of their subjects. Hogarth certainly understood the attraction of a good story when he wove a continuing tale through separate illustrations of *A Harlot's Progress, A Rake's Progress,* and *Marriage à la Mode.* A central plot with several subplots forces the viewer to "read" these compositions as if they were chapters in a book.[19]

Hogarth's narratives told stories of the new capitalist class that had transformed the British isles from a rural to an industrial economy. By the middle of the eighteenth century, industrialists were infiltrating the upper ranks of nobility, rivaling the old aristocratic lines by building stately homes filled with treasures of ancient and recent art. Hogarth mirrored the economic and social changes when he both ridiculed and admired the affluent bourgeoisie. His heroes were industrious workers and generous employers, his villains profligate aristocrats and indolent paupers. The novels of Henry Fielding, Samuel Richardson, and Tobias George Smollett similarly exposed a new kind of bourgeois protagonist.

Nowhere was the middle-class hero better received than on the London stage. Under the innovative guidance of actor David Garrick, who had himself risen from simple origins to attain wealth and fame, British theater thrived. Bourgeois audiences at Drury Lane were delighted to watch Garrick portray ordinary folk facing everyday situations. Instead of imitating courtiers and kings, leading men and women of the 1760s played bumbling factory owners, ambitious tailors, and inquisitive old aunts—familiar characterizations for London audiences of those years. Even when Garrick produced the ever-popular classical dramas, he endowed Roman fathers and Greek maidens with values of the British middle class.

By mid-century the theater had become a favorite subject for painters. Their interpretations fell into two categories: the popular actor's or actress's portraits in their favorite roles (Zoffany's *Garrick as the Farmer Returned from London* or Francis Parsons's *Miss Davies in the Character of Maude in "Love in a Village"*), and vignettes taken from actual performances (Edward Penny's *Scene from Jane Shore* or Christopher Barber's *Selima Imploring Bajazet to Spare Her Life* from Rowe's ever-popular *Tamerlane*).[20] A comparison of such paintings with French or Italian works from the same years points to clear differences in interest and orientation. While Continental artists created the ambiance of a theater by treating their compositions as if they were boxlike stages with highly contrasted lighting and tilted perspective, British painters rendered actual performances with as many particulars as they could illustrate. British canvases offered reports of specific plays, replete with contemporary actors and actresses. Viewers were not only expected to follow the action "on stage," but also to recognize the different players. If they failed to do so, the artist clarified any mistaken identities by giving the work a long, explanatory title.

A similar specificity and fascination for narrative detail characterizes the paintings of English history. During the early 1760s, artistic interest in Britain's past was increased when the Royal Society of Arts offered premiums for the best paintings of scenes based on the history of England. A number of accomplished artists entered the annual competitions. In the judging of 1763, for example, Robert Edge Pine won the first place for *Canute the Great Reproving His Courtiers for Their Impious Flattery.* The same jury awarded Pine's protégé John Hamilton Mortimer second place for *Edward the Confessor Spoiling His Mother at Winchester* and George Romney third place for *The Death of General Wolfe.* The latter painting, now lost, appears to have been one of the earliest attempts by a British artist to capture the event that inspired West's masterpiece. The compositions by Pine and Mortimer are of special interest because they were overtly political. Mortimer's *Edward the Confessor Spoil-*

ing His Mother, for example, was meant as an allegory of Lord Bute's alleged romance with the dowager princess.[21] Because paintings with obvious references to contemporary political events were finding ready acceptance, there is ample reason to suppose that West was doing the same. Not only did his *Choice of Hercules* hint at the king's current dilemma, but in the next few years his most successful classical narratives would make similar allusions to recent happenings.

A third kind of narrative painting found in the early exhibitions at Spring Gardens and Maiden Lane were nautical battle scenes, such as Samuel Scott's *Taking of Quebec* or Richard Paton's *Action of Admiral Boscawen, off Cape Lago on the Coast of Portugal.* These meticulous compositions were akin to journalistic accounts of recent sea battles, except that the artists rarely witnessed the events they portrayed. Because they relied on descriptions by participants and reports of the scene in the newspapers, their works combined the mood and drama of Dutch marine paintings with the topographical particulars found in prints of American and British port cities. Scott and his colleagues, however, added minute information about ships, men, and the action of battle, allowing the viewer to actually "read" about a specific military engagement.

British genre paintings, with their deep literary roots, satisfied the same kind of curiosity by providing glimpses into the private lives of lower- and middle-class English families. Scenes of ordinary folk painted by Hogarth, Hayman, Highmore, Marcellus Laroon, and many other eighteenth-century artists were often based on expository passages in novels, plays, or poems. English genre paintings, in contrast to those by Continental artists, contained fewer symbolic references and were a great deal more graphic and interpretative.

The popular conversation pieces were also literary, in the sense that most were group portraits that told stories about families or other closely associated individuals. Perhaps they are best compared to a novel of manners, which studied a select segment of British society.[22] Sporting scenes contained the same kind of specificity, especially those that presented an intricate delineation of a nobleman's livestock holdings, racing horses, or hunting exploits. Like conversation pieces, these documentary paintings catered to a sophisticated voyeurism that enabled viewers to peer into the lives of others. The common denominator tying together the varied narrative paintings was the British penchant for verbal rather than visual gratification. To meet the demand, artists had to fill their works with enough specific information to hold the attention of a public conditioned by newspaper reports, broadsides, dramatic performances, and novels of the day. Continental critics and patrons might debate the aesthetics of line, color, or composition; Britons wanted their paint-

ings and prints to tell stories.[23] The most successful English artists were those whose paintings could be reproduced in engravings that middle-class collectors on both sides of the Atlantic could study to obtain information about people and events.

West had such an uncanny ability to absorb the society and culture around him that his paintings might be best interpreted as sponges designed to soak up dominant themes found flowing through the environment of mid-century London. His sensitive eye and skillful hand soon brought rewards, as William Allen wrote to Benjamin Chew in January 1764.

My Lady Juliana Penn called upon us to go and see our Country man Wests Painting. he [sic] *is really a wonder of a man and has so far out-stripped all the painters of his time as to get into high esteem at once, whereas the famous Reynolds was five years at work before he got into Vogue, as has been the case with all the others who generally drudged a longer time before they had any thing of a name.*[24]

As Allen's remarks suggest, West's progress in London was little short of meteoric. Five months after his arrival, he had already begun to outshine his peers in the art world. In the staid British capital, West's unusual blending of colonial innocence with his facility for the new classical style made him a remarkable novelty.

Pivotal to West's success as a history painter was his ability to obtain patrons in high places and to win the approval of London art critics. The two were not unrelated. His acceptance by influential people caused writers to notice his work and begin to evaluate it seriously. From all accounts, West was a perfectionist, and his skillful, innovative canvases deserved attention from thoughtful collectors and perceptive critics. He eventually obtained both.

Among the first people to commission history paintings from West were Anglican bishops, who may have first discovered West through William Smith when the provost was touring Britain in search of clerical backing for the College of Philadelphia. Although the clergymen were welcome patrons, West was more cautious when it came to politicians, taking care not to accept favors from controversial individuals. Galt described how West turned down a large commission from the Marquis of Rockingham, leader of one faction within the government, because he was advised that the affiliation might jeopardize his chances for broader patronage.[25] West also avoided partisanship in American political controversies. Benjamin Franklin, who

first called on West and his new wife in early 1765, was in London to campaign against William Smith and Thomas Penn, both known to be friends of the artist. Franklin might have hoped initially to solicit West's aid in his attempt to change the government of Pennsylvania, but as far as can be detected, West remained neutral, maintaining close relationships on both sides of the controversy.[26]

By 1765 West had become a member of the prestigious Royal Society of Arts and a director of the Incorporated Society of Artists, the group that sponsored the Spring Gardens exhibitions.[27] During his first year of residency in England, West also launched his career as a teacher. Beginning with his first pupil, Matthew Pratt, in 1764, West's studio became a meeting place for young English and American artists. Informal gatherings there found students copying paintings by the masters or sketching from plaster casts of antique sculpture. Always known as a generous and amiable instructor, West impressed his protégés with his cheerful willingness to provide constructive and precise criticism. Visitors often recalled his unselfish, courtly manner and solicitous hospitality. "Never did I hear him Speak evil, or judge uncharitably," wrote one caller. "You perceive in Him nothing proud, conceited, puffed up or envious."[28] So many pupils and acquaintances echoed these sentiments that it is easy to envision the self-assured, genial artist as he escorted strangers through his picture collection, invited them to tea, told anecdotes about his work, and joked about the adventures of his students.

In the press, verses dedicated to West continued to be panegyrical. An anonymous pamphleteer of 1766 praised West's entries in Spring Gardens with what by then appeared to be an almost standard poetic tribute.

> *Virgilian West, who hides his happy Art*
> *And Steals, through Nature's inlets, to the Heart*
> *Pathetic, Simple, Pure, through every part.*
>
> .
>
> *Thou long expected, wish'd for Stranger, hail!*
> *In Britain's bosom make thy loved Abode*
> *And open daily to her raptured Eye*
> *Thy mystic wonders of thy Raphael's school.*[29]

The road to acceptance as a history painter was not always a steady uphill climb. Some critics, notably the columnist for the *Public Advertiser,* found fault with certain aspects of West's work. He wrote in 1765: "There is a Glow in his Colouring which gives a Kind of unnatural Varnish to his Pictures. There seems also to be a Sameness in his Figures," he continued, "which if not carefully avoided, will obtain the Artist the Name

of a Mannerist." In his conclusion, the writer criticized West for attempting to exhibit "Forms *more beautiful* than those of nature."[30]

The following year, a cautious columnist for the same paper wrote a similarly candid appraisal. The coloring, he observed, is "rich, and yet not delicate," the drawing "good, but not graceful" and the designs "original, yet not pleasing." But he added with a note of optimism: "When a few years have lost these Luxuriances and Imperfections, . . . we may then expect to see something great indeed." Another viewer who signed himself simply as "Crito," wrote that although West's history paintings of 1766 lacked "Energy," they were "very happy" in their coloring.[31]

By 1767 the criticism had become almost as positive as the poetry. The columnist for the *Public Advertiser* was now not only satisfied with West's entries in the Spring Gardens exhibition, he was most enthusiastic. When referring to his two mythological canvases (*Jupiter and Semele* and *Venus Relating to Adonis the Story of Hippomenes and Atlanta*), the critic used the phrases "Gracefulness of the Attitude," "Beauty," "Naturalness," "Antique Grace," and the like. In writing about West's religious painting *Elisha Raising the Shunamite's Son,* the columnist commended its "great Dignity united with peculiar Simplicity" and he expressed admiration for West's two historical narratives *Pyrrhus When a Child Brought to Glaucias, King of Illyria, for Protection* and *The Fright of Astyanax*. His conclusion must have made West very happy indeed.

Upon the Whole Mr. West promises to make a great Painter, the first in his walk, our Country has produced. Nature and the Antique, which are indeed nearly synonymous Terms and Expression, which is the Soul of History-painting, shine throughout his Pictures. I hope some more able Critic will inform him more particularly of his Faults, and that he, unaffected with the Vanity of excelling his Countrymen will cultivate his Talents to the Utmost in that great Stile of Painting which he has chosen, and to which he seems equal, and will find all the Encouragement he may deserve.[32]

There was now little doubt that West was well on his way to becoming one of England's most successful history painters. His Herculean choice had proven to be the right one; virtue seemed to have its rewards. Despite help from a number of influential friends, West's rapid progress in less than four years required more than good fortune. A dense palimpsest of experiences underlay his gifts: a preacher's sense of right and wrong, an archaeologist's reverence for ancient forms, an actor's intuition for drama, a novelist's compulsion to tell a story—and most

of all a painter's keen eye and dexterous hand. Now that Hercules had conquered the temptation to devote his life to lesser pursuits, he could continue his upward climb toward perfection of his grand-style history-painting formula.

Color Plates

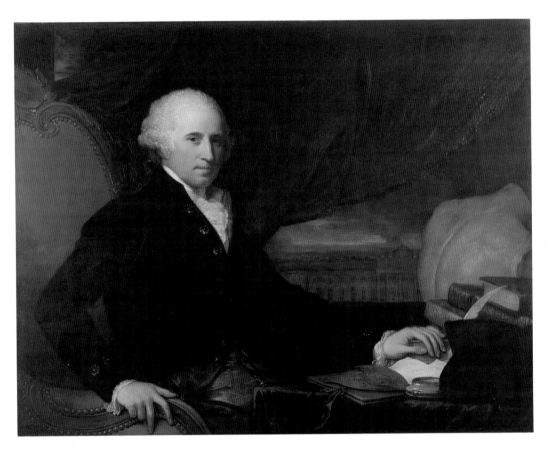

Plate I *Self-portrait*
1793, oil on canvas, 40 × 52 inches
Royal Academy of Arts, London

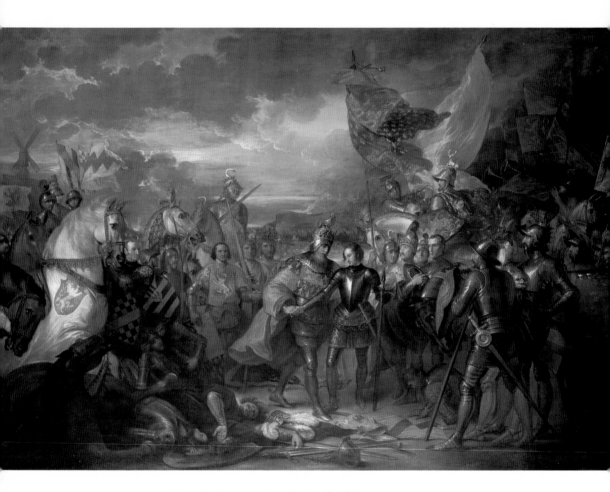

Plate II *Edward III with the Black Prince after the Battle of Crécy*
1788, oil on canvas, 113 × 176 inches
Her Majesty Queen Elizabeth II

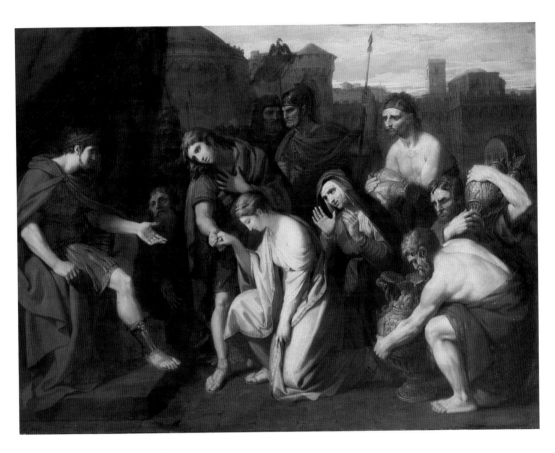

Plate III *The Continence of Scipio*
1766, oil on panel, 39½ × 52½ inches
The Fitzwilliam Museum, Cambridge, England

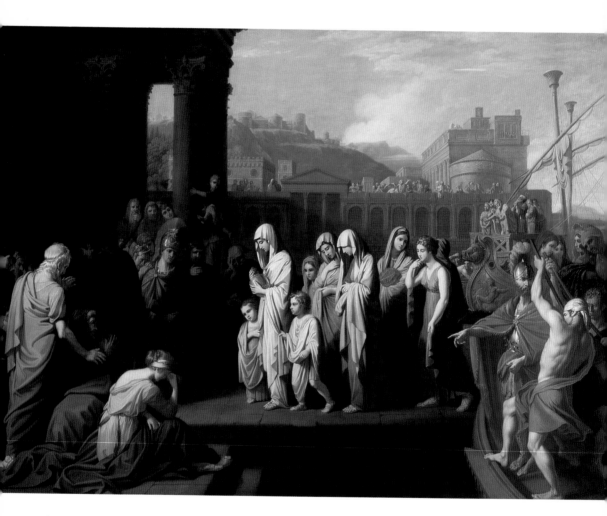

Plate IV *Agrippina Landing at Brundisium with the Ashes of Germanicus*
1768, oil on canvas, 64½ × 94½ inches
Yale University Art Gallery, New Haven, Connecticut
Gift of Louis M. Rabinowitz

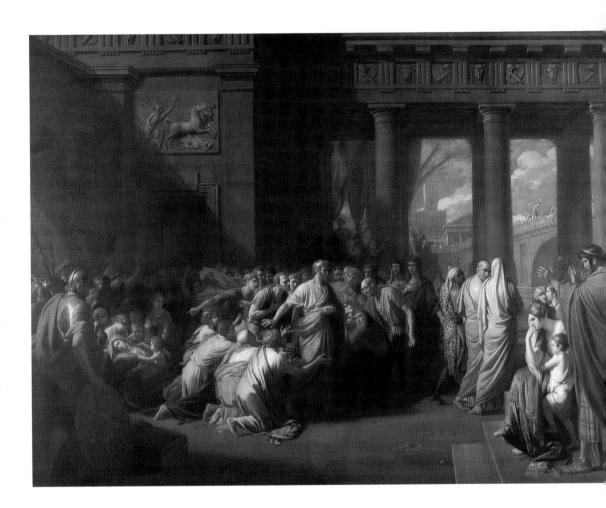

Plate V *The Departure of Regulus from Rome*
1769, oil on canvas, 88¹/₂ × 120 inches
Her Majesty Queen Elizabeth II

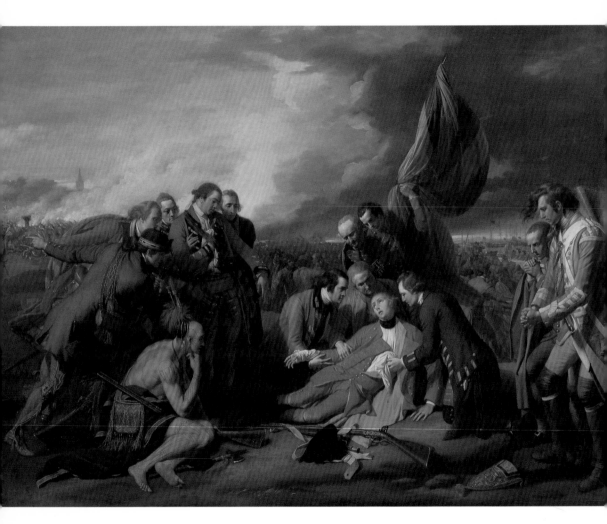

Plate VI *The Death of General Wolfe*
1770, oil on canvas, 59½ × 84 inches
National Gallery of Canada, Ottawa
Gift of the Duke of Westminster

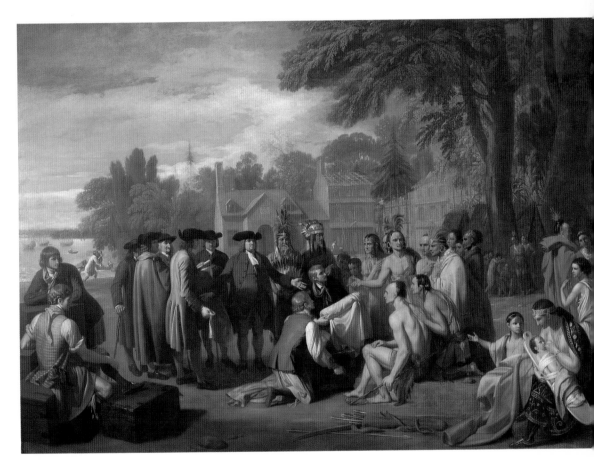

Plate VII *William Penn's Treaty with the Indians*
1771, oil on canvas, 75½ × 107½ inches
The Pennsylvania Academy of the Fine Arts, Philadelphia
Joseph and Sarah Harrison Collection

Drama, Politics, and Evolution of the Neoclassical Grand Style

The theater season of 1767 opened at Drury Lane with a "dramatic romance" entitled *Cymon,* a musical extravaganza loosely based on John Dryden's *Cymon and Iphigenia.* The score by Michael Arne had been published in advance of the production, and well before the scheduled opening rumors circulated that the elaborate scenery was being designed by the Italian artist Giovanni Battista Cipriani. As Londoners talked of Garrick's new production, West submitted *Cymon and Iphigenia* to the 1766 Spring Gardens exhibition, the second time in two years that he had shown the work. It surely was no accident that the exhibition of West's painting preceded Garrick's revival of the Dryden play. Unfortunately it is impossible to compare West's work with the script of *Cymon* because the original canvas has been lost. But the title and a written description of the painting indicate that the pastoral scene, taken from the Boccaccio love story, included the figures of Cymon, Iphigenia, and two flying cupids. Garrick's play, in contrast, scarcely resembled Boccaccio's tale. In place of the simple romance, the flamboyant actor-entrepreneur staged a spectacular fantasy that included such characters as Merlin and Fatima, neither of whom had a part in the original legend. In addition, Iphigenia (a central figure of Boccaccio's story and West's painting) made no appearance in Garrick's play.[1]

Differences of the sort were typical. West's classical history paintings of the 1760s were based very often on episodes that had been produced on stage, but the theatrical versions of the stories differed markedly in mood and content from West's compositions. Playwrights made imaginative departures from the classics; West, on the other hand, usually adhered closely to the original literary or historical material, often to the extent of taking his poses and compositions directly from the illustrations that accompanied the texts. For the most part, West selected topics for his classical paintings of the 1760s from older plays that had been in constant production for more than a half-century, and he rarely took themes from newly staged performances. When West borrowed from the Augustan dramatists for

Fig. 60 W. Byrne, engraving after a drawing by Benjamin West for cover of *The New English Theatre*, vol. 7, 1777. Department of Prints and Drawings, The British Museum, London.

his narrative compositions he often inserted veiled references to contemporary political issues.

The option to make such suggestions was open to West because as an artist he was exempt from regulations prescribed by the Licensing Act of 1737. This law, which required theater managers to submit new scripts to government officials for approval, prohibited authors of plays and librettos from alluding to contemporary controversies. There were, however, several ways that playwrights circumvented the legal restrictions. One method was to include gentle references to social and political issues in the prologues and epilogues written for each play. Another way was to plant subtle political messages within the

scripts of older allegories, such as Addison's *Cato* or Rowe's *Tamerlane,* which were known to have controversial implications but were not subject to censorship. As London theaters revived the popular productions year after year, managers and directors made slight changes in the venerable scripts to hint at recent happenings.[2] Perhaps remembering his boyhood, when the same classical dramas were produced to suggest topical problems in Pennsylvania, West structured his Greek and Roman history paintings of the 1760s on theatrical themes that paralleled events in contemporary London. In essence, he and other artists took over the editorial functions once exercised by the dramatists.

By basing his classical paintings of the 1760s on the same kind of stories that interested the Augustan playwrights, West was performing his own kind of artistic revisionism, patterned after the lessons he had learned from Mengs and Hamilton. He kept abreast of recent developments on the London stage and occasionally illustrated published editions of current and older plays (see engraving, fig. 60). Theatrical themes were then so popular among Continental painters that young artists were often advised to duplicate stage settings in their compositions. The following passage from Daniel Webb's widely read manual of 1761 is an example:

History painting is the representation of a momentary drama: We may therefore, in treating of compositions, borrow our ideas from the stage; and divide it into two parts, the scenery, and the drama. The excellence of the first consists in a pleasing disposition of the figures which comprise the action.[3]

West's *Pylades and Orestes Brought as Victims before Iphigenia* (fig. 61) and *The Continence of Scipio* (fig. 62 and plate III) were "borrowed from the stage" just as Webb had instructed. As companion pieces in the 1766 Spring Gardens exhibition, the two paintings match in size, composition, scope, and underlying message. Both are constructed as if the figures were "actors" on a shallow, horizontal platform, with the major participants highlighted against a dark background. Processions of suppliants enter from the right "wings" and cross before the audience to face an authority figure positioned on the left. Although West had used the theatrical format in *The Death of Socrates,* his ability to recreate the ambiance of a stage had greatly improved since he left America. From Hamilton and others he had learned to light the surfaces in the foreground of the picture plane so they would contrast dramatically with the darker background areas, making the painting appear as if light were flickering from the hooped chandeliers that hung over the acting area, or from candles that lined the platform.[4]

Fig. 61 *Pylades and Orestes Brought as Victims before Iphigenia,* 1766, oil on canvas, 39½ × 49¾ inches. The Tate Gallery, London.

With fewer artistic precedents and a more subtle moral message, *Pylades and Orestes* is the more imaginative of the two.[5] Taken from Euripides' *Iphigenia among the Taurii,* the painting shows the two friends Pylades and Orestes standing before the high priestess of Taurus awaiting their execution. Unknown to the two men, the priestess is really Iphigenia, sister of Orestes, who had been imprisoned in Taurus since childhood. West chose to illustrate the moment when Iphigenia realized that the condemned man was her brother, a discovery that ultimately caused her to save the prisoners' lives and facilitate her own escape from captivity.

To demonstrate his ties to the original Greek story, West patterned the partially nude figures of Pylades and Orestes after the Roman statue *Castor and Pollux* (fig. 63). He selected this particular piece for the muscular frames and short curly hair of

124

his own two heroes for a reason: Winckelmann had recently announced that *Castor and Pollux* had been mislabeled and should be identified correctly as Pylades and Orestes at the tomb of Agammemnon. For the costume and pose of Iphigenia, West chose the *Farnese Flora* (fig. 64), sometimes called the *Capitoline Flora,* as his model. Like *Castor and Pollux,* this popular Roman attraction had been reproduced in plaster casts, and both statues could be found in the gardens and halls of English stately homes.[6]

The characters of Pylades, Orestes, and Iphigenia were familiar to eighteenth-century audiences, for all three had appeared in a number of recently staged pseudoclassical productions. Best known, perhaps, was Lewis Theobald's opera, *Orestes,* of 1731, so loosely based on the Euripides drama that only a skeleton of the original story remained. Theobald added a vast number of gods, goddesses, villains, and heroes to expand the Greek tale and provide it with hints of contemporary political issues. West, on the contrary, adhered closely to Euripides' original, maintaining the theatrical sobriety of the Greek drama

Fig. 62 *The Continence of Scipio,* 1766, oil on panel, 39½ × 52½ inches. The Fitzwilliam Museum, Cambridge, England. Reproduced in color, plate III.

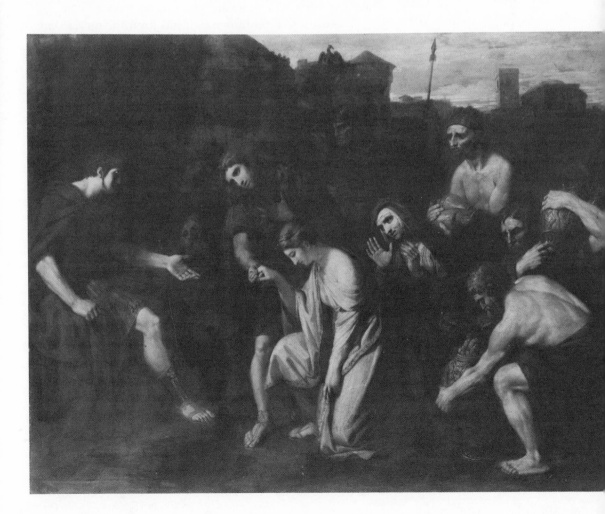

125

Fig. 63 Unidentified artist, *Castor and Pollux,* date unknown, marble, 61³/₅ inches high. The Prado, Madrid/ Alinari.

by utilizing a horizontal composition and illuminating the figures from the front edge of the picture plane. Significantly, West's deliberate choice of the theatrical format meant he was "staging" the original Greek drama—not Theobald's opera—in a contemporary London playhouse. By so doing, he was allying his history paintings with those by artists who maintained the intrinsic "purity" of the classics that Winckelmann advocated.

The compositional structure of West's *Pylades and Orestes* also resembles the setting of a British satirical engraving, those comical, pungent, and often bawdy prints that parodied social and political issues of the time. To fully understand the messages of graphic satires, eighteenth-century readers had to know the details of Greek mythology and Roman history, for legendary gods, goddesses, senators, and sages often symbolized leading officials of British government. Today such references are extremely difficult to decipher, their subtleties lost, their symbolism forgotten. Not only are the prints couched in antiquated rhetoric, but identification of the key figures is often partially concealed by omitted letters and other devices employed to soften the accusatory blows and elude the libel laws.[7]

References to little-known incidents from ancient Greece and Rome do seem archaically obsolete in our own age of blatant political indictments, yet the twentieth century has its own version of the popular political and cultural allegory. Remember how the Broadway tune "Camelot," for example, came to represent John F. Kennedy's administration. To admirers of the late president, the popular melody that suggested the idyllic conditions of King Arthur's legendary court served as a welcome vehicle for expressing a complex package of ideas and emotions. In the same vein, Pablo Picasso's *Guernica,* designed around the artist's personal impressions of the Spanish Civil War, denote a decisive moment in European history. Remove the painting from the context of night bombings in northern Spain and it becomes merely a collection of distorted bodies and fragmented objects. Although *Guernica* will always retain its strength as an evocative painting, its real meaning is contingent upon the viewer's understanding that the symbols represent a tragedy that haunted the artist in an especially impassioned manner, a subtlety that may well be forgotten in two hundred years.

Eighteenth-century observers undoubtedly found the same kind of contemporary relevance in West's classical paintings of the 1760s. For instance, the figure of Iphigenia in *Pylades and Orestes* suggests Britannia, usually depicted in a Greek gown, with long flowing hair topped by a laurel wreath (as in fig. 65). Such allegorical representations, which appear in satires directed against the Stamp Act, criticize Parliament for its attempt to tax the American colonies. If eighteenth-century Britons, prepared by long habit of translating these visual puzzles, recog-

126

nized Iphigenia as Britannia in West's painting, they would be able to "modernize" the message of liberation suggested by the story of Pylades and Orestes. Read as an allegory, the dramatic rescue of Orestes represented America's salvation from unwanted taxation, and reunification of brother and sister implied a reconciliation between England and her colonies—another image often found in cartoons of the period (see figs. 66–68). Londoners of the 1760s needed no explanation of such unspoken suggestions. In fact, open exposure of these subtleties might call attention to the political nuances and thus ruin the delicate nature of West's sensitive portrayal.

In *Pylades and Orestes* we find, therefore, the basic recipe for West's classical history paintings: beginning with the raw ingredients of a "pure" Greek or Roman source, he added a large helping of theatrical staging, spicing it with the pungent aroma of contemporary political issues. It was the mixture West had learned in the colonies from Haidt, Smith, and Henry, only to improve it by studying the history paintings of Hamilton, Mengs, and Greuze. In this way, *Pylades and Orestes* synthesized West's own artistic and educational experiences and the prevailing trends of London during the 1760s.

The same blend of ancient forms and contemporary culture characterizes its companion piece in the 1766 Spring Gardens exhibition, *The Continence of Scipio* (fig. 62 and plate III), another lesson on the triumph of righteousness over needless sacrifice. In this case, however, it is the authority figure, Scipio, whose personal largesse saves others from tragedy. The legend, taken for the most part from Valerius Maximus and Livy, concerns the Roman general shortly after he conquered Carthage. Upon becoming ruler of the captured African nation, Scipio fell in love with a beautiful Spanish princess, a prisoner of the victorious Roman campaign. Although consumed with desire for the maiden, Scipio relinquished her, untouched, after discovering that she was betrothed to a prince from her homeland. To signify his benevolence, Scipio contributed lavish gifts to her dowry, thereby demonstrating to the conquered Carthaginians that their new Roman commander would treat them fairly.[8]

West chose the Scipio theme for the same reason that he had picked the "Choice of Hercules" two years earlier. It was the tested favorite of a long string of European masters and, as in the *Hercules,* his interpretation of the subject was an austere theatrical tableau without the extravagant embellishments found in works of his predecessors.[9] West's composition (fig. 69) is a deliberate amalgamation of seventeenth- and eighteenth-century sources, ranging from Rubens and Poussin to Sebastiano Ricci (see figs. 70 and 71). Paintings by the latter—with their tilted perspective and horizontal placement of figures—strongly suggest a stage setting.[10]

Fig. 64 Unidentified artist, *Farnese Flora (Capitoline Flora),* date unknown, marble, 133 inches high. Museo Nazionale, Naples/Alinari.

127

In spite of its dramatic overtones, West's *Continence of Scipio* bears little resemblance to the best-known eighteenth-century theatrical interpretation of the legend: Charles Beckingham's *Scipio Africanus,* first performed at Lincoln's Inn Fields in 1718. With its large cast of characters, intricate subplots, and a long complex story of intrigue and romance, Beckingham's drama typified early eighteenth-century extravaganzas.[11] On stage, the tormented Scipio was motivated by lust, not charity, relinquishing the girl only because he realized she would be unmanageable if he forced her to stay. "By your freedom I'll regain my own," he cried in exhausted relief, worn down by a barrage of insults from the maiden and her lover.[12] Beckingham's lonely hero, defeated by his passions and bending to expediency, scarcely resembled the generous and courageous ruler portrayed by three centuries of European artists. As in *Py-*

128

lades and Orestes, West recreated a dramatic setting in order to retell the original story in its stark dignity. At the same time, he deliberately emphasized the somber ethical substance that the dramatists had ignored.

The Continence of Scipio also hinted of current controversies. Six years after assuming power, young King George was earnestly attempting to personify moral decency by demonstrating exemplary conduct as a devoted husband and father. He was being forced, meanwhile, to render weighty decisions that tested his own moral fiber. Pressured to dismiss his close friend and adviser, Lord Bute, and acquiesce to demands for repeal of the Stamp Act, the king, like Scipio, had to make unwanted compromises and sacrifices.[13] Eighteenth-century observers immediately would have made this connection, because in current publications the name of Scipio was used to signify a paradigm of beneficence, a ruler who exhibited extraordinary qualities of "wisdom" and "moderation."[14]

As a sequel to *The Choice of Hercules,* West's *Continence of Scipio* was also a statement of West's greater artistic intentions. Employing a similar popular theme, he combined a theatrical format, suggestions of contemporary issues, the coloring of Gavin Hamilton, and the compositional structure of Poussin. The result was a dramatic tableau that merged moral edification with antique dignity. It was the association of classical art with modern ideology that the critics recognized and admired, even as they remarked about West's need to improve certain technical and conceptual aspects before patrons would appreciate his efforts to modernize history painting.[15]

Art and drama were cautious bedfellows during the 1760s, creating a sparring friendship that was whimsically suggested by David Garrick in the following lines from his 1766 prologue for *The Clandestine Marriage:*

129

Poets and Painters, who from Nature draw
Their best and richest Stores have made this Law
That each should neighborly assist his Brother
And steal with Decency from one another.[16]

An even more specific reference to the close ties between stage and studio appeared in the *Public Advertiser*. When describing a nurse in West's *Fright of Astyanax* (exhibited at Spring Gardens in 1767), the columnist observed: "Perhaps Mr. West caught the Idea of the Expression in her Countenance from Mr. Garrick, for she has a strong Resemblance of that inimitable Actor."[17] His observation rivets our attention to a striking parallel in the London theater season of 1767: Abrose Philips's *Distrest*

Fig. 69 *The Continence of Scipio,* ca. 1766, chalk and pen and wash on paper, 15⅝ × 21⅜ inches. National Galleries of Scotland, Edinburgh.

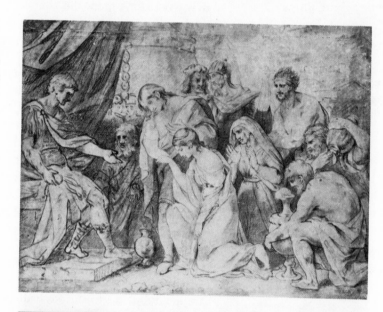

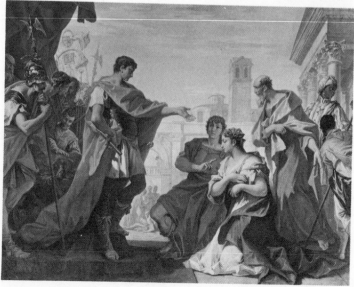

Fig. 70 Sebastiano Ricci (ca. 1659/60–1734), *The Continence of Scipio,* 1706, oil on canvas, 55 × 71½ inches. The Art Institute of Chicago, Illinois; Preston C. Morton Memorial Purchase Fund for Older Paintings.

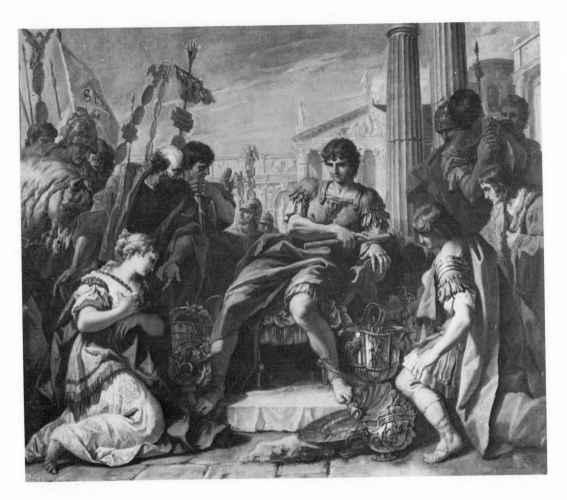

Fig. 71 Sebastiano Ricci (ca. 1659/60–1734), *The Continence of Scipio*, date unknown, oil on canvas, 54 × 56³/10 inches. Her Majesty Queen Elizabeth II.

Mother was playing at Garrick's Drury Lane at the same time that the annual exhibition was in progress at Spring Gardens. The leading characters in the popular drama—Astyanax, Andromache, Pylades, Orestes, and Phyrrus—also "starred" in West's paintings from the same years.

The Fright of Astyanax, mentioned by the columnist, is known today only through a segment of the original that West included in the background of his portrait of Thomas Newton, bishop of Bristol (see engraving, fig. 72).[18] The fragment appears to depict the Trojan hero, Hector, departing from his wife, Andromache, and child, Astyanax, shortly after the Trojan armies had been defeated by the Greeks. The portion of the composition that can be seen in the Newton portrait (see fig. 73), shows Andromache restraining Hector from lifting the child from the arms of another female—probably the nurse mentioned in the *Public Advertiser* commentary. If West were following the text of Homer's *Iliad*, he was depicting the moment when Hector prepared to hurl his son from the walls of Troy to prevent his capture by the conquering Greeks.

In Garrick's revival of Philips's *Distrest Mother* (taken from

131

Fig. 72 Richard Earlom (1743–1822), *The Right Reverend Thomas Newton, D.D.*, 1767, engraving after a painting by Benjamin West. Department of Prints and Drawings, The British Museum, London.

Racine's *Andromaque* of 1667), the concept of classical heroism and sacrifice reverses the story of Homer's *Iliad*.[19] Astyanax was never flung from the walls of Troy, but was captured by the Greeks and taken prisoner by King Phyrrus of Epirus. The play, which begins with the landing of Pylades and Orestes in Epirus, involves a complex love entanglement between Orestes, Hermione, Andromache, and Phyrrus, and ends with Andromache's resolve to restore her son to his rightful place on the throne of Troy. The story of intrigue surrounding an exiled prince was familiar to seventeenth- and eighteenth-century audiences. Racine had probably intended to suggest the Stuart restoration in Britain or the then-current French dispute with Spain over inherited lands; Philips's play probably alluded to the first Jacobite Pretender. His recent death brought him once more into the spotlight, which explains why Garrick thought the drama worth reviving in 1767.[20]

West's other historical narrative in the Spring Gardens exhibition of 1767, *Phyrrus When a Child Brought to Glaucias, King of Illyria, for Protection,* is also lost and thus known to us only through a preliminary sketch and engraving (fig. 74).[21] The composition parallels its companion piece, *The Fright of Astyanax,* quite specifically: the story concerns a royal child threatened with either death or exile, a characterization also found in Philips's *Distrest Mother.* In classical literature two kings of Epirus are named Phyrrus: one is a legendary figure of the Trojan War era, the other a Greek general who fought against Roman occupation in the third century B.C. *The Distrest Mother* tells a story about the former; West's painting, about the latter. West chose his theme from a story in Plutarch's *Lives* that describes how emissaries from the court of Epirus persuaded King Glaucias of Illyria to provide asylum for the infant Phyrrus, thereby protecting the young prince for his future heroic mission.[22]

West's *Fright of Astyanax* and *Phyrrus Brought to Glaucias* worked in tandem to present a complex allegory of displaced royal infants and to reverse the contemporary theater's interpretations of the classical legends. The cleverly conceived use of ancient stories to illustrate modern events reveals West's highly developed sensitivity to the subtleties of his surroundings. In the *Iliad,* Astyanax was condemned to death, never experiencing the refuge of exile provided in Philips's eighteenth-century reinterpretation, whereas in Plutarch's *Lives,* Phyrrus survived his exile to become a hero. The opposite fates of the two infant princes mirrored recent British history of West's day. Like Phyrrus, George III's great-grandfather had been reared on foreign soil

Fig. 73 Richard Earlom (1743–1822), after Benjamin West, detail ("The Fright of Astyanax") from *The Right Reverend Thomas Newton, D.D.*

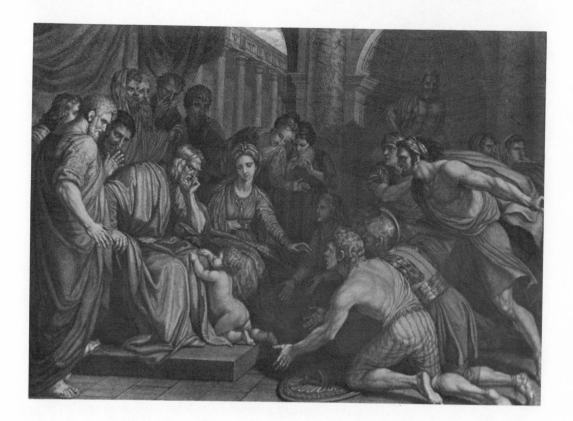

Fig. 74 Richard Earlom (1743–1822) and John Hall, *Pyrrhus Brought to Glaucius,* 1769, engraving after a painting by Benjamin West. Department of Prints and Drawings, The British Museum, London.

but entered Britain as the triumphant leader. The Stuart heirs, on the other hand, resembled the unfortunate Astyanax, for they had been figuratively hurled from the city walls, never to claim the throne.

Without the original paintings it is difficult to assess the full impact of the composition or coloring, but from the available scraps of visual material and documentary comments by observers, we can see that the companion pieces of 1767 were more comprehensive and forceful than West's earlier narratives. In *Phyrrhus Brought to Glaucias* and *The Fright of Astyanax* he was taking a currently popular story from the contemporary stage and restructuring it according to the original source. At the same time, he alluded to the popular theatrical hybrid in order to coordinate his pictorial observations into a complete statement. It was his skillful blending of drama, classicism, and political suggestion that established West's reputation as London's most creative history painter.

West brought together stylistic, theatrical, and allegorical innovations in *Agrippina Landing at Brundisium with the Ashes of Germanicus* (plate IV), commissioned by Robert Hay Drummond, archbishop of York, in 1766.[23] Galt tells us that the fortuitous meeting occurred during a dinner at the archbishop's

London residence. Following the meal, Drummond purportedly read West a story from the *Annals* of Tacitus, saying that he believed it would make a fitting subject for a history painting. On the following day, Galt wrote, West returned with a sketch that so pleased the archbishop that he asked West to complete the painting "without delay."[24]

The story that Drummond purportedly read concerns Agrippina, wife of Germanicus, the Roman general distinguished by his victorious campaigns in Germany and the East. His military triumphs and reputation for bravery and generosity made Germanicus the object of both love and envy. His greatest foe was his own uncle, the emperor Tiberius, who feared that Germanicus's popularity could be a threat to his imperial power. During a triumphant tour of duty in Syria, Germanicus contracted a mysterious illness that ultimately proved fatal. Convinced that her husband had been poisoned by Tiberius and his agents, Agrippina vowed to avenge his death by returning with his ashes to Rome.

West's painting depicts the widow descending from her ship at the Roman port, carrying the urn that bears her husband's ashes. Around Agrippina and her two small children, crowds gather in silence to mourn.[25] Although the subject has few precedents in art, two other interpretations of the scene appeared about the same time that West was working on his composition for Drummond. One was an engraving after Gravelot (fig. 75) that shows Agrippina disembarking from a boat leading two children, wearing a similar hood, and holding an urn.[26] During the 1760s Gavin Hamilton also painted a scene of Agrippina landing at Brundisium (fig. 76) as a commissioned work for the Earl of Spencer. His composition, like those by West and Gravelot, contains a hooded Agrippina carrying an urn and leading two small children.[27] These similar renditions of the same incident, all from the 1760s, leaves one to wonder why the theme had such an appeal at the time.

West painted two versions of *Agrippina*. One (fig. 77), painted in 1770 after the original sketch of 1766, is now at the Philadelphia Museum of Art; and the larger, finished canvas of 1768 (plate IV) is now at the Yale University Art Gallery. Both paintings are larger than any of West's previous works, the Yale version being 5' 4 1/2" high and 7' 10 1/2" wide.[28] The compositions are almost identical, the most striking difference being in the head and hands of Agrippina. As in West's earlier history paintings, *Agrippina* is structured like a drama, with actors crossing the stage. But a much stronger three-dimensional illusion distinguishes this work from his previous ones. Planes are more distinctly separated, with the movement from foreground to background more gradual and clearly defined. The lighting is also strikingly different from earlier works: the canvas sparkles

Fig. 75 St. Aubin, *Agrippine arrivant à Brindes avec l'Urne qui contient les Cendres de son Epoux,* engraving after Hubert François Gravelot (1699–1773) in *Tibere ou les Six Premiers Livres des Annales de Tacite . . .,* vol. 2, 1768. The New York Public Library, New York.

with a balanced gradation of tones that give the colors a rich vibrancy. Such departures from his earlier work—in size, depth, and lighting—had direct parallels to developments on the London stage.

The typical playhouse of the period was divided into three parts: a proscenium, or platform, which extended into the audience; the middle stage behind the curtain; and the scenes in back consisting of matching pairs of wings and shutters. The arrangement differed from the later Victorian plan, which is still used today, because the projecting proscenium served as one of the theater's principal acting areas. Audiences in eighteenth-century playhouses surrounded the extended platform and thus witnessed the performance in close proximity to the actors and actresses (as pictured in fig. 78).

West brought the structure of the theaters into *Agrippina* and subsequent epic canvases by duplicating the tripartite scheme through his foreground, middle ground, and background, even including an audience viewing the performance from either side of the proscenium. He accomplished this illusion by placing figures facing the action as if they occupied the peripheral seating section of the playhouse. As was customary in the informal atmosphere of eighteenth-century theaters, audiences so near the stage interacted with the players—conducting conversations, shouting invectives, and often even touching the

Fig. 76 Gavin Hamilton (1723–1798), *Agrippina Landing at Brundisium with the Ashes of Germanicus,* exhibited 1772, oil on canvas, 71³/₄ × 101¹/₄ inches. The Tate Gallery, London.

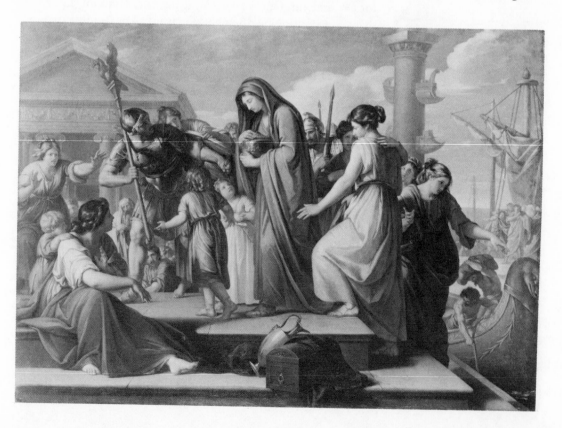

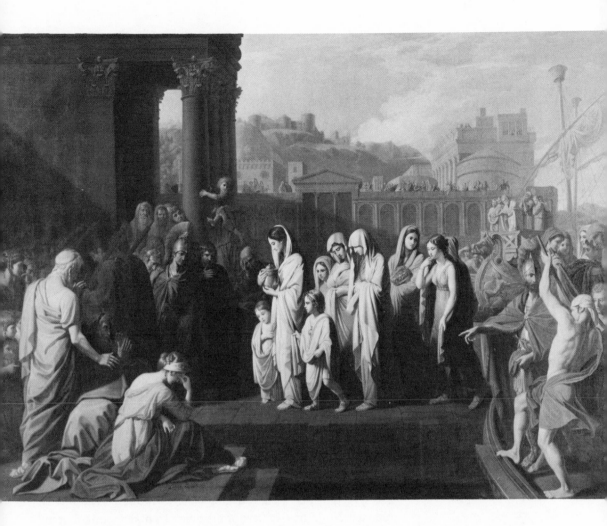

Fig. 77 *Agrippina Landing at Brundisium with the Ashes of Germanicus,* 1770 after 1766 sketch, oil on canvas, 63 × 94 inches. Philadelphia Museum of Art, Pennsylvania; The George W. Elkins Collection; Museum purchase.

actors and actresses while the play was under way.[29] It was the atmosphere of audience participation that added a lighter element to West's otherwise somber Roman epic. The spectators in *Agrippina*—mourners on the left and boatmen on the right—are literally seated around the sides of the drama, interacting with the cast members as they recite their lines.

A luminary "revolution" on the London stage accounts for the innovative lighting in *Agrippina*. In 1765 Garrick visited the Comedie Français and returned to London with plans to imitate modern French methods of illuminating a much greater portion of the performing space. In short order, he completely transformed the lighting scheme of Drury Lane by replacing the old hooped chandeliers that hung over the front edge of the stage with groups of candles and perpendicular oil lamps attached to posts or frames placed strategically throughout the acting area. Within two years, both Covent Garden and the Haymarket theaters followed Garrick's lead by illuminating full sections of the background scenery once relegated to the shadows. Although stages were still relatively dark by today's standards, and the

Riot at Covent Garden Theatre, in 1763, in consequence of the Managers refusing to admit half-price in the Opera of Artaxerxes.

flickering candles caused sharp contrasts, the scope and intensity of the lighted arena increased dramatically. The spread of lighting over a wider area also prompted sensational departures in scenery, because wings and flats, once hidden, were now visible. As the 1760s progressed, theater managers began hiring skilled artists to paint more sophisticated set designs, which greatly improved the quality of the pictures seen behind the actors and actresses.[30]

West incorporated the innovations in lighting and scenery by brightening his background, providing it with more details, and spreading his "actors" over a wider surface. In *Agrippina* he retained the dramatic effect of the older, frontal lighting, but in subsequent history paintings he began to move his light source away from the front and into the center and sides of the "stage" area.

The costumes of West's players and the scenery in *Agrippina* (and even in several of his earlier classical paintings) corresponded to the simultaneous trend toward historical accuracy in theatrical productions. Before mid-century, costumes on both stage and canvas combined eighteenth-century and classical apparel, but by 1760 the Romans were represented on stage in accurate togas, cloaks, sandals, and helmets—all copied from archival material and new, illustrated books about the ancient world. West borrowed deliberately from such sources when he designed *Agrippina,* taking the central procession from the relief sculpture on the Roman monument *Ara Pacis,* and the background architecture from Diocletian's palace at Spalato.[31]

In order to fully appreciate the place of the Agrippina legend in mid-eighteenth-century society, we must return to that evening

when West dined with Archbishop Drummond. Imagine the young artist and his aging patron as they sipped their brandy and talked about what sort of classical painting would speak most effectively to their contemporaries. They would discuss not only Tacitus's original story, but how it had been misused by dramatists, cartoonists, and pamphleteers.

The key that unlocks the hidden meaning of *Agrippina* is West's deliberate omission of a principal character in the classical legend: the ominous Sejanus, Tiberius's adviser, believed to have plotted the murder of Germanicus and the subsequent deaths of his allies. The best-known theatrical rendition of the story was Ben Jonson's *Sejanus,* rewritten by Francis Gentleman in 1752 but probably never performed.[32] Garrick refused to produce the play at Drury Lane because he said it contained "too much Declamation in it to succeed on the stage." In the prologue, Gentleman revealed the play's polemical intentions.

The same Soil which was blessed with a BRUTUS, a CATO and a GERMANICUS, was cursed with a SEJANUS: BRITAIN who feels herself happy in an ORRERY, a CHESTERFIELD and had in the Person of her late generally and justly lamented PRINCE OF WALES, all that ROME boasted in her GERMANICUS, knows not what SEJANUS may rise in future Times to wound her Peace.[33]

As the statement indicates, the author had a specific "Sejanus" in mind. In the emblematic language of the period, it could have been none other than the infamous Lord Bute, chief adviser to the royal family. In the press, Bute's image was synonymous with a sinister array of villains, from Roger Mortimer (traitor to Edward II and lover of his wife, Queen Isabella) to the Earl of Essex, who was charged with wooing the young Queen Elizabeth in a base attempt to wield political influence.[34] But the most commonly used epithet was "Sejanus." Often depicted as an evil conspirator, Bute was repeatedly pictured whispering traitorous messages to his protégé the king, conducting a lewd and illicit affair with the dowager princess, or conspiring to humiliate the nation through a disgraceful peace with France (see figs. 79 and 80). Handsome, cultured, and arrogant, Bute was a perfect target for such public scorn. Hatred of him was so widespread that the scurrilous campaign intensified after the king expelled him from court in 1763, and new accusations about his behind-the-scenes manipulation continued to occupy the attention of the satirists.[35]

As the campaign against Bute grew more intense, an especially troublesome detractor (later identified as the Reverend James Scott) began to publish satiric letters and pamphlets signed "Anti-Sejanus." The well-circulated complaints about

Fig. 79 Unidentified artist, *Sawney Below Stairs,* 1763, engraving. Department of Prints and Drawings, The British Museum, London. All the characters identified with Lord Bute are grouped around him. "Sejanus" is on the far right.

Fig. 80 Unidentified artist, *The Scotch Colossus . . . ,* 1762, engraving. Department of Prints and Drawings, The British Museum, London.

King George's court inspired a spate of new engravings (such as fig. 81) that referred directly to Scott's letters and thus firmly linked Bute's name with that of the legendary Roman traitor. By the late 1760s, association of the hated Bute with the character of Sejanus was so pervasive that an intricate parody of Tacitus's original story had evolved. Not surprisingly, an anonymous playwright attempted once more to revive Jonson's *Sejanus,* this time under the more obvious title of *The Favorite,* a direct allusion to Bute. Again the drama was denied production, but the

Fig. 81 Unidentified artist, *The Statue, or the Adoration of the Wise-Men of the West,* 1766, engraving. Department of Prints and Drawings, The British Museum, London. James Scott, author of the "Anti-Sejanus" pamphlets, is being worshiped by Cabinet ministers and other government officials.

Fig. 82 Unidentified artist, *Nero Fiddling, Rome Burning, Pompaja & Agrippina Smiling,* 1770, engraving for *Oxford Magazine.* Department of Prints and Drawings, The British Museum, London.

published version of the play (which was dedicated facetiously to Bute) repeated the story of Sejanus's treachery and conspiracy.[36]

The satirical lexicon connected with the Sejanus legend contains a full cast of characters that included Agrippina, frequently represented as the king's mother, the Dowager Princess Augusta. The reason for the allegorical association was threefold: (1) Augusta's husband Frederick, like Agrippina's husband Germanicus, died suddenly before he could assume his designated role as king; (2) there had been open rivalry between Frederick and his father, George II, just as there was between Germanicus and his uncle, Tiberius; (3) Agrippina's son, Caligula, succeeded Tiberius as emperor, and her daughter (also named Agrippina) was the mother of another emperor, Nero. The latter association was most appealing to King George's enemies, who enjoyed suggesting that he was fiddling while London burned around him (see fig. 82).[37]

Again we must return to Drummond's parlor as he instructed West to paint a work that would emphasize Agrippina's heroism, suggesting that the subject was especially appropriate in light of the continued defamatory publicity directed against the dowager princess. The Earl of Spencer apparently had a similar aim when he commissioned Hamilton to depict the identical incident. It was time, indeed, for responsible citizens to set the story straight. The king had long decried the acrimonious attacks against his mother, and wrote Bute as early as 1756: "I will remember the insults, and never forgive anyone who shall venture to speak disrespectfully of her."[38] He apparently kept his vow, making his disgust known whenever the slanderous satires appeared.

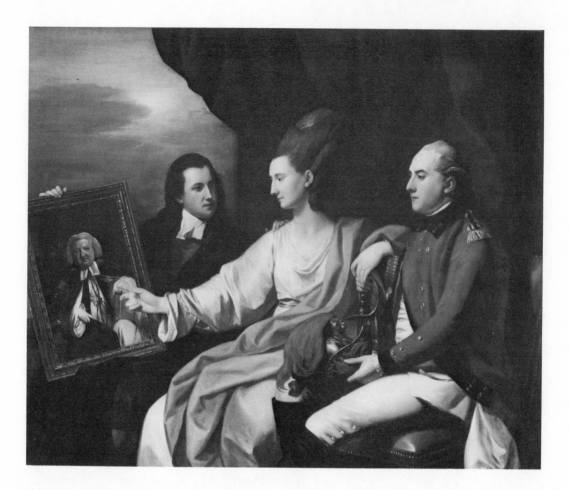

Fig. 83 *Portrait Group of the Drummond Family,* ca. 1776, oil on canvas, 60 × 72 inches. The Minneapolis Institute of Arts, Minnesota; The William Hood Dunwoody Fund. Relatives of Robert Hay Drummond stand with a portrait of the deceased archbishop.

West's patron, Drummond (see fig. 83), was in an especially vulnerable position, for he counted the king as well as his ministerial opponents among his friends. On the one hand, he had served the monarch in several official capacities, but he also sat in the House of Lords through an inherited family peerage. During George II's reign he had spoken out frequently in favor of Whig policies, gaining the admiration and close friendship of the Duke of Newcastle, leader of the strongest Whig faction in Parliament. After the disarray that marked George III's first decade of rule, Drummond retired gracefully from political life, although his friend Newcastle remained in the fray, often expressing his disgust with the ministerial leaders. In their ongoing correspondence, the archbishop admonished the elderly Newcastle for showing favoritism, and advised him to maintain nominal loyalty to the king.[39] The ensuing political calm brought by the ministry of Newcastle's ally Lord Rockingham must have made Drummond realize that the time was ripe for conciliation between the king and his former adversaries. Thus he directed his young American protégé to suggest a highly controversial contemporary issue in the didactic disguise of a Roman history painting.

West's interpretation, therefore, went beyond mere redemption of a Roman legend from contemporary abuse. By emphasizing Agrippina's serene determination to defend her husband's honor and protect her children's rights, he attempted to replace negative connotations with a strong positive image. The courageous heroine was, indeed, a lady of dignity and fortitude, a loyal wife, and a loving parent. If cartoonists had debunked the king's widowed mother by accusing her of adultery and conspiracy, West elevated her Roman equivalent to new heights of extraordinary bravery and integrity.

As the mature fulfillment of West's history-painting formula, *Agrippina* was a landmark. He had juggled drama, allegory, and history to produce a unique balance—a re-creation of ancient Rome as seen though eighteenth-century British eyes. But more than that, *Agrippina* captured the essence of a late Georgian theatrical performance. Viewing the large, elegant canvas we feel the excitement of actors and actresses reciting their lines, of tension building in the developing plot, of audiences applauding in the boxes around the periphery as the curtain falls. It was, indeed, a spectacle capable of winning high rewards, perhaps even the commendation of a king.

The Road to Royal Patronage

In eighteenth-century London, influential patronage often determined an artist's success, and West was unusually adept at winning the support of prominent individuals. While this does not mean that his paintings were unduly influenced by the wishes of his benefactors, his sensitivity to each patron's special needs did play a significant role in his interpretations of specific subjects. It may, in fact, explain why he became the official history painter for the Court of St. James. Galt's detailed description of West's initial meeting with the king is unfortunately the most thorough existing documentation of that historic encounter.[1] Acceptance of the biographer's account, however, must be tempered by realization that it portrays West's ascent to royal patronage as if it had been an easy walk up a well-carpeted stairway.

West's introduction to King George occurred sometime in 1768, the same year in which *Agrippina* hung in the Spring Gardens exhibition together with four more paintings by West: two full-length portraits of gentlemen, one religious painting (*Jacob Blesseth Joseph's Two Sons*), and one mythological subject (*Venus and Europa*). It was to be the last time the American would show in that annual exhibition; one year later a newly founded Royal Academy would overshadow and eventually replace its predecessor. Before *Agrippina* made its public debut, Galt tells us, Drummond invited noted "artists and amateurs" to express their opinions of the work. The archbishop was so thoroughly "satisfied by the approbation which they all expressed," that he deemed the painting fine enough to present to King George. In a lengthy discussion with the monarch, Drummond supposedly disclosed "all the circumstances connected with the history of the composition; and on what principle he had always turned his conversations with Mr. West to excite an interest for the promotion of the arts in the minds of his family."

No one will ever know what Galt intended this abstruse prose to mean. Was he implying that Drummond had to spell out West's hidden message? In all likelihood the very literate and cultured monarch would have been sensitive to the painting's

underlying implications, and would have required little explanation. We can only guess what transpired behind the closed doors of the king's chamber, but the result is legend. As Galt phrased it: "The curiosity of the King was roused, and he told the Archbishop that he would certainly send for the Artist and the picture."[2]

According to Galt's colorful description, the initial meeting between West and George III was a smashing success. The king first took the painting around to various court apartments to examine it in different lights. Then he summoned the queen, "to whom he introduced the Artist with so much warmth, that Mr. West felt it at the moment as something that might be described as friendliness." The royal couple studied the canvas, Galt related, the king commenting that he "understood the same subject has seldom been properly treated."[3] " 'There is another Roman subject which corresponds to this one,' " King George supposedly remarked, " 'and I believe it also has never been well painted; I mean the final departure of Regulus from Rome. Don't you think it would make a fine picture?' " When West agreed, the monarch purportedly replied: " 'Then . . . you shall paint it for me.' " Ringing for an attendant to bring "the volume in Livy in which the event is related," King George read the passage to West, and commanded the artist to "come with the sketch as soon as possible."[4]

The narrator now shifts from Galt to the American artist Charles Willson Peale, who was studying with West at the time. In his autobiography, written many years later, Peale recalled that on the day West departed from his studio to take the sketch of *Regulus* to the king, he wore a "small sword" because he considered formal dress to be correct for attendance at court. Upon his return West told Peale "that he put his drawing on a chair in an anti-chamber [sic] and shortly the queen came in and kneeled down to examine" it. When King George arrived, Peale wrote, "he said, 'hah! West, I see you have chosen the Doric order for the Buildings and, that is my favorite order of architecture.' "[5] Thus began West's professional affiliation with the royal family of Britain.

After receiving the king's commission, West proceeded to create *The Departure of Regulus from Rome* (fig. 84 and plate V), the largest and most complex narrative he had ever painted. It depicted a scene in the life of the Roman consul Marcus Atilius Regulus, a hero of the First Punic War, who had been captured and held prisoner by the Carthaginians. After five years in enemy custody, Regulus was allowed to return home, on the condition that he would promise to negotiate a peace treaty and arrange an exchange of prisoners with his colleagues in the Roman Senate. But Regulus, who remained loyal to his homeland, advised the Senate to reject the Punic offer, an act that would

146

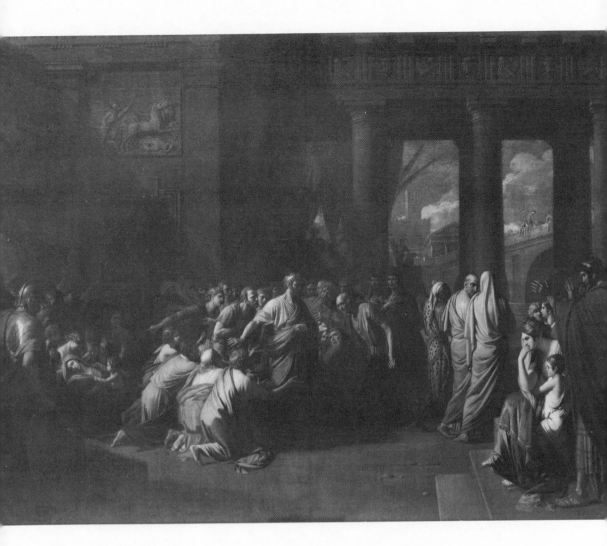

Fig. 84 *The Departure of Regulus from Rome,* 1769, oil on canvas, 88½ × 120 inches. Her Majesty Queen Elizabeth II. Reproduced in color, plate V.

spell his own death at the hands of his enemies. He had promised, nevertheless, to return to Carthage. Despite the entreaties of friends and family, he honored his word, leaving the safety of Rome to face his execution.

West's *Departure of Regulus* is set in the porticoed antechamber of the Roman Senate. As in *Agrippina,* an "audience" sits and stands in "boxes" on both sides of the foreground; groups of spotlighted figures occupy the "stage," and a detailed panorama fills the background. By reversing and expanding the scope and direction of the central procession, West has enhanced his formula for history painting. On the far left in a highlighted area Regulus's wife falls into a faint as her two children watch; toward the center, in a larger, lighted area, a crowd of individuals stand and kneel around a tall, bearded man in a rich, rose-colored toga. He holds out his hand as if to pacify the crowd and detain them from following the three men walking away on the right.

In creating one small and two large focal points and pulling

the viewer across and into the heart of the action, West has intensified the dramatic quality of his composition. But by devising this complex arrangement, he has also created a dilemma. We are left without knowing which man in the composition is supposed to be Regulus, the subject of the drama. Is he the balding man who is departing on the right, or is he the bearded figure in the center? The title would suggest that Regulus is the man who is leaving with the group on the right. All diagonal lines, however, all the arms and heads, point not to the exiting men with their backs toward the "audience," but to the central figure whose noble stance and clear command over the crowd endow him with a hero's mantle.

One might suppose that the riddle could be solved by examining a variety of art historical precedents, but a survey of paintings from the centuries preceding West's epic composition has produced few clues.[6] Literary and theatrical selections, on the other hand, have proven far more rewarding. Galt is actually inaccurate in designating Livy as the Roman historian chosen by the king as the source for West's composition. More likely it was either Silius Italicus's *Punica,* Cicero's *De Officiis,* or Horace's *Ode III.* West himself may have added Charles Rollin's *Ancient History,* which provided so many ideas for his history paintings. These texts, especially *Punica,* might have rendered the "plot" for West's *Departure of Regulus,* but the setting and character portrayals have direct roots in two recent stage productions: Pietro Metastasio's *Attilio Regolo,* an opera first produced in Italy during the 1750s; and William Havard's *Regulus,* which played at Drury Lane in 1744 with Garrick in the title role.[7]

Although the cast of characters in the opera, play, English history, and the Roman texts differs markedly, each source specifically mentioned the Carthaginian ambassadors and members of Regulus's family. Also in Havard's tragedy are Regulus's wife, Marcia, and a villain named Corvus who schemed against Rome by supporting the Carthaginian peace treaty. So it would seem that West borrowed the major characters from Havard's play and some of the minor ones from Metastasio's opera (the African ambassador dressed in all of his finery and the "chorus" of pleading women, senators, and plebians).[8]

Four principal sources—Rollin's *Ancient History, Punica,* and the two stage productions—all contain clues to the identity of Regulus. If he is the departing figure on the right, as the title of the painting suggests, who then is the imposing bearded man in the center of the canvas? Perhaps he is intended to be the consul Manlius, who appears in three of the sources: the play, the opera, and Rollin's history. In each, Manlius supports the return of Regulus to Carthage, and aids his friend by restraining fellow Romans from attempting to stop his departure. If West were interpreting the scene according to these sources, then he would

have placed Manlius in the center of the composition, holding back the angry crowd to prevent them from interfering with Regulus's departure for Carthage. Within the accepted confines of eighteenth-century expectations, however, West would not have deliberately yielded center stage to a supporting actor while relegating his star to the periphery.

In the logic of the period it is most likely that the "departure" of the title refers not to Regulus's actual leave-taking but to the more dramatic moment when he announced his intention to renounce the safety of Rome in favor of dying as a hero. This would be the moment when fellow citizens comprehended the full measure of his sacrifice. The scene naturally would be fraught with dramatic conflict and heightened emotions. The actual departure would be a less momentous and, indeed, an anticlimactic, incident. At least that is the way it is described by Silius Italicus.

How the Senate debated, and how Regulus at last addressed the sorrowing house. . . . When he entered, all eagerly called on him with voice and gesture to take his wonted seat and former place. He refused and declined the seat of honour that once was his. None the less they gathered round, all seeking to grasp his hand and begging him not to deprive his country so great a general. . . .

Thus he spoke and at once gave himself up again to the anger of Carthage. Nor did the Senate reject a warning so serious and so honest, but sent off the Carthaginian envoys, who made haste for home, vexed by their failure and threatening their prisoner.[9]

Regulus's courageous act is that of the hero's victory over base duplicity. In West's composition, only the spotlighted figure in the center assumes such an attitude of triumph. The shadowy figure on the right, his back turned to the audience, suggests something very different. Who, then, is *this* person, the balding man usually identified as Regulus? The most likely candidate is the evil Corvus, who conspired with the Carthaginians in Havard's play, greatly facilitating the traitorous peace treaty. Although the Corvus character does not appear in Silius Italicus's *Punica*, he does play a major role in Garrick's restaging of Havard's *Regulus* at Drury Lane in 1744.

As the first painting for King George, *The Departure of Regulus* was an essential commission for West, requiring careful planning and scrupulous consideration of his didactic responsibilities. Not only was it expected to be highly moral in tone, but it was actively to promote public virtue in a strong, positive, and unambiguous manner. The theme of the quintessential hero relinquishing his life for his country's honor conjured up images of selfless patriotism, a theme that Londoners of the late 1760s closely identified with the character of Regulus. His name was

so widely accepted as a synonym for personal courage that when a writer for the *Political Register* engaged in the risky business of promoting electoral reform, he signed his columns "REGULUS."[10]

The story of Regulus was linked to a person of much greater notoriety, however, for the public issue that overshadowed all others at that time was the case of John Wilkes. After being expelled from Parliament in 1764, Wilkes had fled to Paris to escape arrest and imprisonment. Now, four years later, he had returned to England, where he risked possible punishment in exchange for the public acclaim that he had not received in exile. Always intent on making a spectacle, Wilkes returned with great fanfare to solicit support for reelection to his seat in Commons. Instead of reappearing as a humble and contrite supplicant in the manner of Regulus, he crossed the Channel bent on attaining vindication for his censure by the government. Undaunted by an initial rebuke from old supporters in London, he turned to his home district of Middlesex, where he was able to tally enough votes to reclaim his former seat. The victory prompted a series of raucous demonstrations in London that Wilkes heartily endorsed. By the time Parliament opened in May 1768, the crowds had become so unruly that a gathering in St. George's Fields produced a confrontation with government troops resulting in several deaths and a number of serious injuries.

In hopes of quelling the disruptive demonstrations, the ministry decided to arrest Wilkes for inciting a riot. Although in previous trials, the clever politician had been able to win acquittal, this time he could not. In June 1768, Lord Mansfield sentenced him to twenty-two months in King's Bench Prison, a move that actually strengthened Wilkes's cause. Now supporters of the acerbic publisher lauded him as a veritable Cicero being denied his rightful voice in the senatorial chambers. Among his many champions was a poet who equated Wilkes with Regulus captured by the Carthaginians.

> *Thus faithful to his Country's Good,*
> *Unmov'd the menac'd Roman stood*
> *At all the Punic Rage;*
> *Bravely he met the Death he dar'd*
> *Nor fear'd the cruel Pains prepar'd*
> *Their Malace to assuage.*[11]

Such adulation was only temporary. By the autumn of 1768, the initial intensity of Wilkes's supporters had mellowed, and the anger of his captors subsided. Perceptive Britons had begun to question the true meaning of sacrifice, liberty, and national service. Many may have remembered an epilogue spoken

twenty-four years earlier by a then-young David Garrick as the curtain fell on Havard's *Regulus*.

> *To night fam'd Regulus appear'd before you,*
> *Brimful of Honour and his Country's Glory:*
> *So fraught with virtue and with Patriotic zeal*
> *He laid down Life to serve the Public weal.*
> *Bless me! was ever Man so wildly frantick?*
> *We have no patriots now are so Romantick;*
> *We've no State Quixots as they had Yore*
> *Our Patriots huff; 'tis true, and rant and roar*
> *And talk of this and that—but nothing more.*[12]

The same questions were echoed in January 1769 in a letter signed "A True Briton" that appeared in the *Public Advertiser*. The author asked, "What would have become of the Roman Commonwealth had it been blessed with such a set of Patriots as had been our Lot for a Number of Years past?" Questioning whether they would have been locked in an eternal squabble, the author concluded:

On the contrary, the Roman Nobles and Senators . . . [had] no other View than that of raising their Republic to the Utmost Grandeur, spurned at every private lucrative Emalument. When they had rendered the State the most essential Service, and filled the World with an Admiration of their patriotic Virtues, the utmost of their Wishes as the Reward of all their Toil and Merit, was the Approbation and Applause of a brave and generous People.[13]

It was to this chorus that West composed his *Departure of Regulus* in late 1768 or early 1769. As in Havard's play from two decades earlier, the conspiring Corvus became part of the narrative. The man hurrying away with the Carthaginian ambassador and a hooded figure (a traditional symbol of death) was the villain Corvus, satirically characterized as John Wilkes. His flattened face, irregular eyes and receding hairline are the features found in contemporaneous portraits of Wilkes (see fig. 85). Conversely, the noble Regulus, with his tall, fearless stance and proud carriage, is a composite of mid-eighteenth-century heroic ideals. Gesturing to the departing trio, he indicates that he will follow them to the ships that are waiting to transport him to inevitable death.

The message of West's *Departure of Regulus* would not have been ambiguous to an observer of 1769. It spoke of courage standing firm, of a patriot willing to face execution rather than betray his country. The underlying message is symbolized by the group of observers that West placed in the right fore-

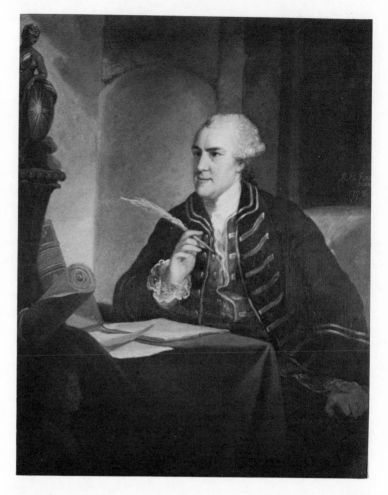

ground: a seated woman, a tall man, and a child. She is the pensive Britannia, pondering the fate of the nation in the same pose that had appeared in so many satirical engravings of the period (such as fig. 86); shielding her from behind is a standing Roman senator, and beside her a young boy.[14] Together the trio represents past, present, and future. Through their unity, Rome and Britain are joined as they observe a drama that tells of valor, sacrifice, and national service.

The theatrical framework of West's *Departure of Regulus* did not go unnoticed. One correspondent wrote to the *Public Advertiser:*

West's Regulus *is a striking Instance of the Powers of the Pencil in this way. You cannot glance your Eye upon the Canvas without being insensibly led to examine the Story, and you derive the same Pleasure from a view of the whole Performance as you do from a well wrought Tragedy, where all the Passions are excited and kept alive by a fine Climax.[15]*

The real-life drama was far less stirring. After remaining in

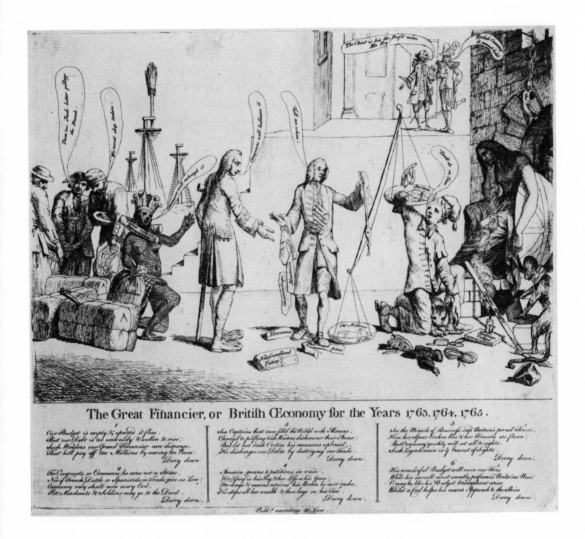

The Great Financier, or British Œconomy for the Years 1763. 1764. 1765.

Fig. 86 Unidentified artist, *The Great Financier, or British OEconomy for the Years 1763, 1764, 1765, 1765,* etching. Department of Prints and Drawings, The British Museum, London. Britannia is in the shadows on the far right; the Indian, a symbol of America, kneels on the left.

the public spotlight for several months more, Wilkes was released from prison and allowed to return to Parliament. Eventually, he became a conforming member of British middle-class society, joining the very adversaries he had once so strongly opposed. Tensions within the government continued even though the appointment of Lord North to lead the ministry brought a temporary end to much of the domestic disorder. North, however, was no Regulus; he was not willing to sacrifice his life for the sake of the nation. Britannia's lament, therefore, was hauntingly prophetic, for within less than a decade the troubles in London would be dramatically overshadowed by the war with America.

West's skillful weaving of ancient history, current events, and universal values transformed *The Departure of Regulus* into a classical masterpiece. It marked the perfection of his dramatic history-painting formula and the beginning of his long associa-

tion with George III. One of the first responsibilities of his new role as a favorite of the court was to act as the king's emissary in the founding of the new Royal Academy of Arts. This institution rose from the ashes of the Incorporated Society of Artists (sponsor of the Spring Gardens exhibitions), which had been consumed by the flames of professional jealousies. In 1768 George III yielded to the prodding of several friends and authorized four men connected with the court to design preliminary plans for a British counterpart to the academies of France, Prussia, and Italy. West was on that committee, together with the royal architect Sir William Chambers, the portrait painter Francis Cotes, and the king's former drawing master George Michael Moser.[16]

By December 1768 the so-called instrument that chartered the new Royal Academy had been approved, and Joshua Reynolds had agreed to serve as its first president. Negotiations progressed with relative ease, but the birth of the academy was not without pain. Because the founders limited the membership to forty, many artists and architects were excluded and understandably angry. The printmaker Robert Strange, for instance, wrote an irate pamphlet denouncing the academy for denying membership to engravers, suggesting that fear of competition rather than concern for excellence had motivated the founders.[17]

Another person incensed by policies that prohibited him from joining the nascent academy was the amateur artist George Townshend, who in November 1768 designed and sold two satirical prints ridiculing the new academicians. Townshend was one of those oddly omnipresent individuals who played a decisive role in the Battle of Quebec under General Wolfe and since then always seemed to turn up as the subject of polemical debates in Parliament. In 1768 it was the academicians who angered him. His first cartoon to satirize them, entitled *The secret Councel of the Heads* (fig. 87), shows a gathering of academy members at Turk's Head Tavern, symbolized by a head with a turban. In the center is a caricature of Samuel Johnson's head attached to his dictionary, a satirical reference to the academy's charter, which Dr. Johnson helped to prepare. Around the room, groups of artists are seen gossiping about being chosen by the king and boasting of their eventual knighthood. Although one of the figures was surely meant to represent West, Townshend did not succeed in capturing a sufficiently close likeness to allow us to identify him. West is found more easily, however, in the second of Townshend's satires, *A Scene of a Pantamime Entertainment lately Exhibited* (fig. 88), which depicts a stage upon which an eight-headed Hydra is being stabbed by two assailants. Each "head" of the beast represents a leader of the new academy, most of them commenting on the inadequacies or attributes of the infant organization. The one identified as West is

Fig. 87 George Townshend (1724–1807), *The secret Councel of the Heads,* 1768, etching. Department of Prints and Drawings, The British Museum, London.

Fig. 88 George Townshend (1724–1807), *A Scene of a Pantamime Entertainment lately Exhibited,* 1768, etching. Department of Prints and Drawings, The British Museum, London. The head of the Hydra identified as West is the third from the left.

lamenting his exclusion from the peerage, an issue of public interest after Joshua Reynolds was knighted in 1769.[18]

With much fanfare the first exhibition of the Royal Academy opened on April 26, 1769.[19] West entered only two paintings, *The Departure of Regulus from Rome* (fig. 84 and plate V) and *Venus Lamenting the Death of Adonis* (fig. 47), both well received by the press. The commentator for the *Public Advertiser* was especially complimentary, referring to West as "our charming History Painter," and asking rhetorically if any other British artist could equal him in

the Correctness of his Composition, the Harmony of his Stile, or the Delicacy of his Colouring? Let it be remembered [he continued] . . . that he has ventured to walk in a Path unmarked by the Traces of any British Painter. . . . But the Town has given the Painter that Applause to which his modest merit entitles him. His

155

Fig. 89 *The Oath of Hannibal,* 1770, oil on canvas, 88¼ × 119¾ inches. Her Majesty Queen Elizabeth II.

Majesty is to have the Picture and Mr. West is no Doubt happy in such a Mark of Approbation from the best of Monarchs.[20]

It was, indeed, an accomplishment for the boy from Chester County, for the first royal commission was followed shortly by a second: *The Oath of Hannibal* (fig. 89, and see figs. 90 and 91), requested by the king around 1770 as a companion piece to hang with *Regulus* in the Warm Room at Buckingham House. Like *Regulus,* West's *Hannibal* speaks of patriotic sacrifice, in this case that of the future Carthaginian hero who at age nine swore his allegiance to defend his homeland regardless of the risk. According to legend, the boy had begged his father, Hamilcar, to take him along on a military expedition into Spain; Hamilcar agreed, but only if Hannibal would first pledge his enmity to Rome in the temple. The story was told by several ancient writers including Livy and Polybius, but West apparently based his painting on the long passage in Silius Italicus's *Punica,*

the source he had already mined for the composition of *Regulus*. Here we find a complete account of the event with a full description of the temple and its gods.

Hannibal was conceived on the same grand scale as *Regulus,* equaling it in size and drama. Spotlighted on a raised platform in "center stage" is the pagan altar containing the gruesome body of a slain ox, and above it, in the shadows, is a gigantic figure of a local god. Before the awesome shrine stands nine-year-old Hannibal and his father, Hamilcar. The usual "audience" fills the corners and, just as in *Regulus*, the observers on the right represent three generations: an old Carthaginian pointing out the spectacle to a mother and her children.[21]

While *Hannibal* matches *Regulus* in scope and composition, there are no known theatrical equivalents of the former. Quite possibly the king wanted West to illustrate the Hannibal episode from ancient history because it concerned a son's deter-

Fig. 90 Valentine Green (1739–1813), *The Oath of Hannibal,* 1770, engraving after a painting by Benjamin West. Department of Prints and Drawings, The British Museum, London.

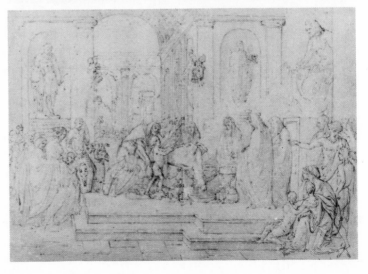

Fig. 91 *The Oath of Hannibal,* ca. 1770, crayon on paper. Archives, Windsor Castle.

157

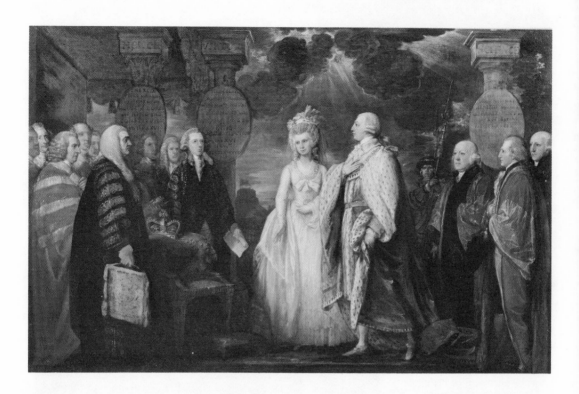

Fig. 92 *His Majesty George III Resuming Power in 1789,* ca. 1789, oil on canvas, 20⁷/₁₆ × 30¹/₄ inches. Hirschl and Adler Galleries, Inc., New York, New York.

mination to avenge his father's enemies, a situation paralleled in the monarch's own history. Theoretically, George III had pledged his life at a sacrificial altar when he became Prince of Wales at age thirteen, vowing to protect the nation despite attempts by his father's adversaries to undermine his authority. Like Hannibal, King George had prevailed over seemingly insurmountable obstacles to defeat his long-standing foes, so that in 1770, when he commissioned West, the ministry under Lord North promised a period of long-absent stability. The story of the young Carthaginian hero could be interpreted, therefore, as an allegory of King George's successful execution of his youthful promise to triumph over enemies of the court.[22]

The king paid West £420 (an impressive sum in those days) for *Regulus* and probably an equal amount for *Hannibal.* When the works were exhibited the following year, Horace Walpole commented about the high prices West was able to command for "a piece not too large to hang over a chimney." "He has merit," Walpole caustically remarked, "but is hard and heavy, and far unworthy of such prices."[23] West, however, was pleased with his success. He expressed his sense of achievement in a letter to John Green, an old friend from Pennsylvania. Awkward spelling and grammar aside, the message was clear.

In reguard to the arts hear in England this seems to be the Augustan Age. Tho this is a nation so long faim^d for her greatness yet the arts never apeared hear till the Reighn of George Third which

158

is owing to his Tast and Munifisiance and under his Patronage London bids faire to vie with Rome *and* Paris. *The Exhibitions hear have drove men to pursue defirent departments in the art of pinting—by which means I have removed that long received opinion that That was a department in the art that never would be incourage in this Kingdom. But I can say I have been so fare successfull in it that I find my pictures sell for a prise that no living artist ever received before. I hope this is a Circumstance that will induce others to do the same; for the great necessity a man is under hear to have money in his Pokt often directs the studies of youths contreary to theire geniuses.*[24]

For the next two decades West was a frequent guest at Buckingham House and St. James Palace; and at Windsor, where he obtained a residence for his family in the shadow of the castle, he was more than a casual visitor. Among his many paintings in the Royal Collection are portraits of King George, Queen Charlotte, and their large brood. He was officially the king's history painter, and in compliance with this position he completed a number of epic scenes to hang in the royal chambers. In the mid-1780s, few doubted that West would spend the remainder of his life under the Crown's comfortable protection. But fate played cruel tricks. In 1788 the king suffered a debilitating attack of porphyria, which rendered the once-able leader to a state of helplessness and confusion. When, a year later, he surprised doctors with a full recovery, West celebrated the event in both a painting and drawing (figs. 92 and 93). The optimism inherent in these compositions was short-lived, however, for early in the nineteenth century the attacks of porphyria became more severe, and it soon became apparent that George III would never again command court affairs.[25]

Fig. 93 *Allegory on the Illness of King George III,* ca. 1789, wash, pen and ink on paper. Archives, Windsor Castle.

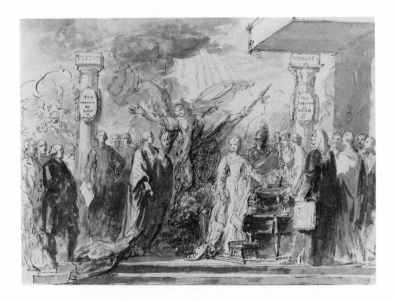

Serving as regent in his father's stead, the Prince of Wales (eventually George IV) rejected West's services in a series of stinging rebuffs that removed the American painter from the royal payroll. The greatest disappointment was final cancellation of the promised commission for paintings to fill the chapel at Windsor. Although West completed most of the compositions, he was never able to convince court authorities that the king had initially approved the project.[26]

In the long run, West's commitment to grand-style history painting also suffered from the monarch's patronage because compositions that followed the dictates of a royal benefactor often lacked spontaneity and imagination. The spark ignited by competition was extinguished by royal demands. In retrospect, one cannot help but wonder about that fateful first meeting between the young American artist and King George. Did they, perhaps, engage in a Faustian bargain in which West exchanged his artistic soul for a chance to become a "companion for Kings and Emperors"?

The Apotheosis of General Wolfe

Without question, West's most famous painting is *The Death of General Wolfe* (fig. 101 and plate VI), first displayed to the public at the Royal Academy exhibition of 1771. Even before that event occurred, West boasted to Charles Willson Peale that the canvas had brought him "great Honour."[1] Whatever commendation the painting received before its first public showing was multiplied tenfold after the work made its debut at the academy's Pall Mall gallery to an appreciative crowd. An anecdote concerning Garrick's visit to the academy exhibition underscores the theatrical appeal of the painting. When a female admirer asked Garrick if he thought the face of General Wolfe accurately captured the expression of a dying man, the actor supposedly responded by flinging himself into the reclining pose of Wolfe. The look on Garrick's face, so the story goes, turned out to be identical to the artist's rendition, causing visitors in the gallery to burst into applause. Others, however, responded to West's characterization with less enthusiasm. Lord Chatham purportedly objected to the painting because there was "too much dejection, not only in the dying hero's face, . . . but in the faces of the surrounding officers." Such despondence, Chatham continued, was inappropriate for a British hero because Englishmen "should forget all traces of private misfortunes when they had so grandly conquered for their country."[2] While no doubt exaggerated, such stories provide further proof that the painting operated as both a historical document and a theatrical tableau.

The stories also reveal how thoroughly the British public had "canonized" the slain general since his death twelve years earlier on the Plains of Abraham. In all corners of the empire, England's triumph over France that resulted from the Canadian conflict inspired outbursts of patriotic fervor and national pride.[3] Indeed, the Wolfe mythology that had sprouted after the Battle of Quebec was gradually burgeoning into an apotheosis of Biblical magnitude. Poets, columnists, and orators had pronounced so many effusive tributes that the legend of Wolfe's heroism was more vigorously alive in 1771 than it had been a de-

Fig. 94 George Townshend (1724–1807), *"Ah, Monsieur le General . . . ,"* 1758–59, crayon on paper, 10⁴/₅ × 8 inches. McCord Museum, McGill University, Montreal, Canada.

Fig. 95 George Townshend (1724–1807), *"Grâce, mon General . . .,"* 1758–59, crayon on paper, 10¹/₅ × 7⁷/₁₀ inches. McCord Museum, McGill University, Montreal, Canada.

Fig. 96 George Townshend (1724–1807), *"Quelle Profondeur a cette Latrine . . .,"* 1758–59, crayon on paper, approx. 10¹/₂ × 8 inches. McCord Museum, McGill University, Montreal, Canada.

cade earlier.

Wolfe had not always been so highly regarded. During his lifetime he was just an ordinary soldier, chosen to lead British forces in Canada because he had created no disturbances during previous tours of duty. The appointment angered fellow officers, however, since at age thirty-two Wolfe had far less military experience than any of his colleagues. Unfortunately for the young commander, his most vocal critics were two of his three brigadiers, George Townshend and Robert Murray, both of whom felt entitled to preferment over the man they believed to be a bourgeois upstart. From the beginning of the Quebec campaign, the two officers opposed every decision Wolfe made, charging that poor tactical planning had resulted in unnecessary losses of military and civilian lives.

The choleric Townshend let his dissatisfaction be known in several ways. As an amateur artist—the same one who would later vent his rage in satiric drawings of the Royal Academicians (see figs. 87 and 88)—he drew sardonic caricatures of the general, some sketched during the Canadian campaign and some following Wolfe's death (see figs. 94–96). When Townshend returned to England in 1760, he resumed his diatribe against Wolfe, hoping to discourage Britons from eulogizing the deceased general. But such criticism reached deaf ears, for most Englishmen refused to accept any negative assessment of their hero. Instead, Townshend himself became the target of public ire. One of his most adamant opponents, the Earl of Albemarle, even published a condemnatory pamphlet demanding that the

officer either retract his criticism of Wolfe or face a duel. Townshend accepted the challenge, but the fight was canceled when King George intervened.[4]

As Albemarle's angry reaction indicated, Townshend's accusations hit a raw nerve. No amount of derogation could stem the outpourings of sentiment inspired by the Wolfe legend. Early newspaper reports of the battle described Wolfe's courageous determination to fight beside his men, despite serious injuries. They told how, mortally wounded, he rallied to inquire about the British offensive, clung to life until he knew the French retreat was certain, and then willingly departed, his duty done. The legendary events became part of the hagiography that made its way into every literary treatment of the Quebec victory.

The playwright George Cockings reiterated the scenario in a "historical tragedy" of 1766 entitled *The Conquest of Canada*. Although records indicate that the play was probably never produced in London, it survives as a fine example of the Wolfe apotheosis. In the preface, Cockings equated the Canadian campaign with a classical confrontation between liberty and enslavement, stating that he had "endeavoured to display . . . a Representation of real and genuine Facts, great in themselves, as any in our Times, and amply worthy of being registered in the annals of Fame, as rival actions of those Patriotic Deeds of the so much admired ancient *Greeks* and *Romans!*"[5] Among the real and imaginary characters in the cast are the allegorical figures Britannicus and Leonatus, several Scottish grenadiers, and the French commander Marquis Louis Montcalm with his lieutenants.

By bringing together symbolic figures and real-life participants in the event, Cockings endowed his play with an aura of mythological universality. Following customs of the time, the playwright included choruses of trumpets, frequent darkening of the stage, and a number of loud "huzzas" to signify victory. The five acts ascend toward the melodramatic conclusion that resembles an epic clash between good and evil. Before departing for his final battle, the pathetic villain, Montcalm, tells his aides: "Death, or Victory; shall Be mine. This Day, the Fates weigh *Britain* against Gaul: *Wolfe,* then must bleed, or flee, or I will nobly fall." He exits to drumbeats.

Wolfe's final speech is equally momentous, incorporating the entire lexicon of emotions associated with an ancient hero's redemptive death.

> *The glorious Tumult of the War, has Charms*
> *To stay my flitting Soul some short Moments!*
> *And the bright Implements of Death shall give*
> *New Day to my benighted Eyes, and light*
> *Me where to snatch at Victory with my dying Grasp!*

After the officer rushes in to report the French defeat, Wolfe dies, uttering the following epitaph:

> My Glory's Race is run!—my Country's serv'd!
> Quebec is conquer'd!—Great George is Victor!
> I wish no more; and am compleatly satisfy'd

The most remarkable aspect of the dramatization by Cockings is that very little was original. Rather, like West's painting of four years thereafter, it was a compilation of the prevailing Wolfe mythology.

Poetry was a natural vehicle for conveying the emotions associated with Wolfe's "sacrifice," and during the 1760s there were numerous tributes in rhyme. One of the earliest was an anonymous poem entitled "Daphnis and Menalcas: A Pastoral Sacred to the Memory of the Late General Wolfe." Its classical references and patriotic ardor typified the laudatory rhetoric that the Wolfe legend inspired. One verse, for instance, included the following stanza:

> All Hail, AMERICA! the age of gold
> Which Greece and Italy enjoy'd of old.[6]

Another of these eulogies written in 1761 by Thomas Young similarly equated Wolfe with the gods of antiquity:

> He'll like Achilles conquer, like him fall;
> O! read this tragic page, and then compare,
> How much alike our direful fortunes are,
> Nor need new Iliads paint the bloody scene,
> For there is Hector, here Achilles seen.
>
> .
>
> But O my soul! might the celestial powers
> But crown the day, and make the battle ours,
> No Lydian, Carthaginian spoils,
> Cou'd raise such trophies, or reward such toils.[7]

In addition to the many verses, there were several prose accounts, the best known being *The Life of General James Wolfe*, published in 1760. Author Sir John Pringle, who was physician to George III in 1774, claimed to have written a biography. Instead, he created the most melodramatic of all the eulogistic tributes. Here, for example, is a typical passage:

> If Britons were now asked the Question, which of their Generals they love best; they would answer without Hesitation, WOLFE; because the Conduct of his whole Life was invariably the same,

great and good, and Death authenticated and ratified this Great-
ness and Goodness, by affixing her Seal to it with an indelible Im-
pression. Other Generals . . . are then the mere Man, and not the
Hero. . . . Death often seized upon them in the Midst of their
Havock and Outrages. . . . Not so with WOLFE: *Without Ambi-*
tion, Avarice, or any other Vice, . . . with which the Rights and
Liberties of Europe *are intimately connected: As another* Judas
Maccabeus, *he fought.*

In another section, Pringle endowed Wolfe with the charac-
teristics of a Roman conqueror. In spite of his "dangerous Fit of
Illness," Pringle wrote, "he was present in Person, active, dili-
gent and indefatigable . . . thus fulfilling, in his whole Manner,
the Character of *Caesar.*"[8] Countering Townshend's critical ap-
praisal, Pringle's apotheosis transformed the Heights of Abra-
ham into a kind of Calvary upon which an Achillean Wolfe sac-
rificed his life to save Britain.

❧

On November 22, 1759, the House of Commons unanimously
passed a resolution to erect a monument to Wolfe in Westminster
Abbey. A number of sculptors entered the competition, but two
designs were clearly favored: one (fig. 97) created by the French-
man Louis François Roubillac, the other (fig. 98) by the British
sculptor Joseph Wilton. The striking difference between the two
proposed memorials establishes the framework for interpreting
West's masterpiece. Roubillac designed a grand spectacle. On
the pinnacle, the uniformed general slumps into the arms of a
winged female, probably meant to represent victory; beneath
them, on the pedestal, rests the symbolic figure of Liberty sur-
rounded by an eagle (strength or wisdom), a shield (war), a lau-
rel wreath (peace), and the club of Hercules (courage). At the
base, the British lion presses his paw upon the head of a Gallic-
style "savage." In contrast, Wilton's simple classicism appears
neither allegorical nor ornate. Grouped before a battlefield tent,
two British officers in full dress attend the dying Wolfe, who is
clothed only in scanty drapery; an angel flies beside them; and
two naturalistic lions guard the base below.[9]

Even though the designs by both Roubillac and Wilton
were theatrical, the two men approached the project from oppo-
site directions. One envisioned the monument in allegorical
terms, the other created a religious and classical apotheosis. In
the French manner, the elder Roubillac conceived his sculpture
within the context of seventeenth-century European symbolism,
using female figures and their accepted emblematic accompani-
ments to represent victory, liberty, courage, and other abstract
principles. His hero, clothed in modern uniform, transcended
the earthly domain through the symbols that surrounded him,

his human quality subordinated to the artistic representatives
that commemorated his sacrifice.

Wilton, on the other hand, avoided such baroque conven-
tions, for like West, he had been trained in Italy, and thus envi-
sioned his work within the parameters of classicism. Symbolic
abstractions, a product of Christianity, did not exist in antiquity.
Instead, Greek and Roman sculptors used the human form to
convey the message—through natural positioning of the body
and significant facial expressions. Wilton depicted Wolfe with-
out clothing to emphasize the universality of his sacrifice; set
him among his officers to suggest the atmosphere of a battle-
field; placed an angel above him to represent divine interven-
tion; and added the lions beneath him to personify British patri-
otism. In this way he designed a modern statue that embodied
the late eighteenth-century interpretation of the classical ideal.

As discussion continued in Parliament over choice of the
sculptor, various writers expressed their opinions about the
competition. Pringle ended his eulogistic biography with a nine-

stanza verse entitled "A Monument INSCRIPTION, Latin and English, To perpetuate the Memory of General Wolfe." The underlying message of his effusive poetry was that the memorial to Wolfe should be founded on classical principles.

The anonymous author of the poem "Daphnis and Menalcas" similarly described his plan for the Wolfe memorial.

> *Raise to his memory and deathless name,*
> *The sculptur'd tomb; and monument of fame.*

Fig. 98 Joseph Wilton, *General Wolfe Monument,* 1772, Westminster Abbey, London.

Now show the sad reverse; the Hero lies
As if in pleasing slumbers; clos'd his eyes
That martial ardor still, in death, express'd . . .
Plant armies, senates, Princes, weeping round
By golden armour, and a radiant crest
And martial portrait, distinguished from the rest,
Place noble GRANBY, AMHERST, TOWNSHEND there
Mourning their Friend, and Brother of the War.[10]

The poet's inclusion of Townshend's name is ironic, for Wolfe's former brigadier would hardly have agreed with the sentiments surrounding construction of the memorial. In fact, a widely circulated satirical print entitled *A Living Dog Is Better Than a Dead Lion* (fig. 99) bears the stamp of Townshend's vitriolic pen.[11] Needless to say, the black humor of the drawing was endorsed by few Englishmen. The majority demanded that

Fig. 99 George Townshend [?] (1724–1807), *A Living Dog Is Better Than a Dead Lion,* 1760, engraving. Prints and Photographs Division, Library of Congress, Washington, D.C.

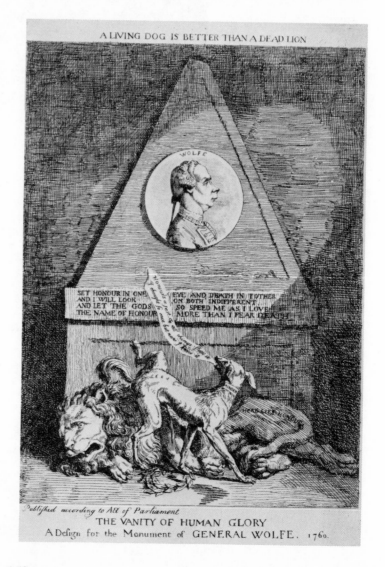

168

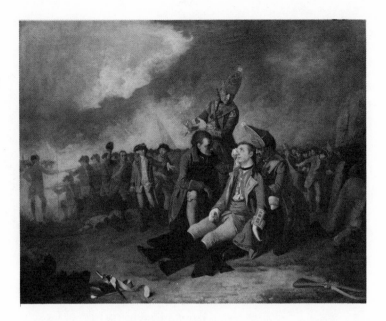

Fig. 100 Edward Penny (1714–1791), *The Death of General Wolfe,* 1763, oil on canvas, 39 × 47 inches. Ashmolean Museum, Oxford, England.

the Westminster Abbey monument glorify the late general without stint or qualification.

To no one's surprise, Wilton received the commission. Roubillac had died shortly after submitting his design, but even had he lived, his proposal doubtless would have lost the competition. Not only was Wilton's classical model more closely akin to the newer artistic ideals, but imagine the uproar if Parliament had authorized a French artist to commemorate the British victory!

During the thirteen years between announcement of the competition and completion of the monument, painters in London were designing their own memorials to Wolfe. George Romney had won a medal from the Royal Society of Arts for his painting of the subject done in 1763, and Edward Penny had exhibited his composition a year later at Spring Gardens. The present location of Romney's work is unknown, although two versions of Penny's *Death of Wolfe* remain. Both depict the wounded general seated upright in the arms of an officer with two other men in attendance. The second painting (fig. 100) is the more interesting, however, because it includes a messenger running from the battlefield to inform Wolfe of the French defeat, a feature repeated in West's composition.[12]

Relative to the other artistic and poetic tributes to Wolfe, Penny's painting can be classified neither as classical nor symbolic; rather, in the British tradition, it is tied to the written word, best understood as a visual equivalent of detailed newspaper reports. Such fidelity to verbal description made it impossible for Penny to create an acceptable apotheosis. Instead of glorifying the deceased hero through the effusive emotional fervor evoked by the poetic eulogies, Penny faithfully interpreted

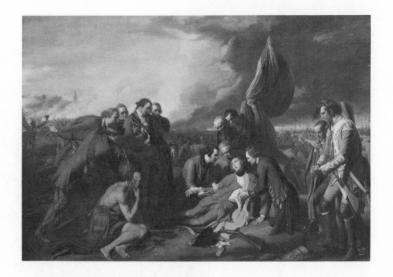

Fig. 101 *The Death of General Wolfe,* 1770, oil on canvas, 59½ × 84 inches. National Gallery of Canada, Ottawa; Gift of the Duke of Westminster. Reproduced in color, plate VI.

the documentary accounts. Because this kind of accurate translation of expository prose lacked monumentality in scope or concept, Penny failed to win the public acclaim that West would later enjoy.

West painted four large versions of *The Death of Wolfe.* The original (59½ by 84 inches; fig. 101 and plate VI) was later purchased by Lord Richard Grosvenor. His heir (the Duke of Westminster) donated it in 1918 to the Canadian government, so that it now hangs in the National Gallery of Canada at Ottawa. The second, still larger version (60 x 96 inches; fig. 102), which West painted for George III, remains in the Royal Collection; an even larger copy (65⅛ x 96¼ inches; fig. 103), created for the family of Robert Monckton, is now in the Royal Ontario Museum in Toronto; and the largest (74½ x 109½ inches; fig. 104), now at the William L. Clements Library of Ann Arbor, Michigan, was originally painted for the Prince of Waldeck. Except for the increasing sizes and varying background details, the four paintings are almost identical.[13]

From the moment the original version of the painting was first exhibited in 1771, viewers realized that the composition represented something different. One will never know whether Reynolds and other leaders of the academy reacted as dramatically as Galt has described, but the issue of West's iconoclasm did appear in the popular press long before Galt published his biography, and has remained part of the painting's legacy up to this very day.[14]

The question of the contemporary setting and "modern" costume in *The Death of Wolfe* has become so essential to interpreters of the painting that it overshadows all discussion of the work's aesthetic and iconographic merit. The issue of West's

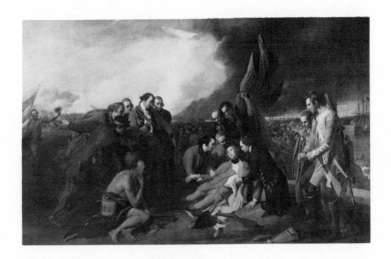

Fig. 102 *The Death of General Wolfe,* ca. 1771, oil on canvas, 60 × 96 inches. Her Majesty Queen Elizabeth II.

"revolution" has prompted several excellent studies, beginning with Edgar Wind's seminal article of 1938. In his provocative analysis Wind concluded that West's *Death of Wolfe* had popular appeal because it corresponded with contemporaneous literary and journalistic curiosity about exotic, distant places, and conformed with similar "revolutionary" innovations in theatrical costuming and scenic design. West and his American colleagues working in England could defy academic regulations, Wind implied, because they were free to express "democratic ideas" eschewed by their European colleagues. Six years after Wind's article appeared, Charles Mitchell took a slightly different approach. Rather than depict West as a "revolutionary," Mitchell concluded that the American artist revived traditional patterns by combining classical and Christian iconography with familiar popular imagery. Subsequent authors have written variations of Wind's and Mitchell's opinions, filling the pages of scholarly journals with frequent articles about the origins and content of West's *Death of General Wolfe*.[15]

Like the veritable inchworm measuring the marigolds, researchers have dissected West's provocative painting in minute detail. From intricate investigations of the background to studies of the origins of each uniform, they have scrutinized every aspect of the composition and iconography. Military historians have been especially concerned about West's placement of the officers, documenting those present at the death scene and amassing elaborate evidence to prove that most of the men West pictured were not there when Wolfe died. Some scholars have traced art historical and cultural influences, others have sought to discover the painting's political and social significance. Recent art historians agree that West emulated traditional models, one interesting parallel being the equation of Wolfe's prone figure with the antique statue *Dying Gaul*.[16] West did seem to borrow from many sources—Rubens, Poussin, Sebastiano Ricci,

171

and even Penny, from whom he copied the messenger and the cloud formations.

An artist's depiction of current events has so many precedents that West's treatment could hardly be construed as "revolutionary." As early as 1440, the Florentine painter Paolo Uccello had celebrated a recent victory when he portrayed contemporary armies in *The Battle of San Romano,* while in seventeenth-century Spain, Diego Velázquez and others illustrated Hapsburg military triumphs by painting comprehensive battle panoramas. Several generations later West and his colleagues merely modernized this kind of epic by providing the participants with eighteenth-century trappings.

Another frequent comment concerns the religious implications of West's *Death of Wolfe.* Several authors suggest that Wolfe's pose resembles that of Christ in a Deposition or Lamentation scene. Although elevation of a British officer to heights of religious martyrdom might appear to defy eighteenth-century standards of artistic and social decency, this too had contemporary precedents in European art. A century earlier, Poussin had apotheosized Greek and Roman heroes in the same manner, and in West's own day Greuze and other French genre painters were portraying the final moments of ordinary folk in a similar moralistic and theatrical vein (see, for example, fig. 50). As a religious allegory, then, *The Death of Wolfe* was extremely orthodox. At a time when deists and other eighteenth-century reformers were highly critical of traditional Christian beliefs, the painting implied that greater rewards existed in heaven, and recalled, therefore, an earlier system of religious ideals.[17]

As the scholarly debate continues, the most important fact of all has been often overlooked. West's *Death of General Wolfe* is a breathtaking painting, a symphony of color, pageantry, and design. The cleverly contrived tripartite composition, precisely staged to create a dynamically unified whole, consists of several

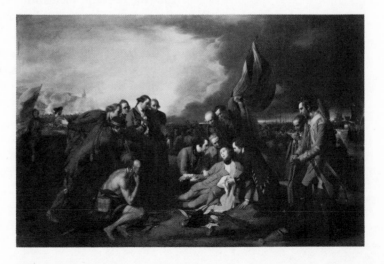

Fig. 103 *The Death of General Wolfe,* 1772–80, oil on canvas, 65^{1}/$_{8}$ × 96^{1}/$_{4}$ inches. Royal Ontario Museum, Toronto, Canada; Canadiana Department.

172

geometric formations. One is a series of three pyramids graduated in concentric triangles to the prone figure of Wolfe. Superimposed over the triangular configuration is an elliptical patterning, bound on either side by the two groupings of figures posed around the central axis and moving inward toward the wounded general. All lines point toward Wolfe: the flag, clouds, weapons, heads, arms, and legs are all aligned diagonally, like spokes on a wheel riveted to the hub. Well-placed spots of red, white, and blue move rhythmically among the geometric forms to give the painting a self-contained motion of brilliant intensity. Syncopation and deliberate manipulation of the senses—not the artist's borrowings and iconoclasms—make West's *Death of Wolfe* a masterpiece.

The combination of visual delights in West's *Death of Wolfe* contains few startling artistic departures. Essentially, the painting offered his contemporaries a familiar subject, executed in a traditional style and conceived within the confines of a conventional composition. The critics and scholars generally agree that West made little effort to recreate an accurate historical record, even though he portrayed authentic uniforms and a modern battlefield. That in itself was West's real "revolutionary" maneuver; instead of creating a documentation of the event, he staged an operatic performance. To accomplish his goal, he moved Wolfe's death scene from its actual setting in a secluded hollow near the battlefield to the proscenium of a modern stage, and changed the small party of soldiers in attendance from a few insignificant lieutenants to an entire chorus of admirers.

Clearly, none of the officers in West's painting were ministering aid to their dying comrade. Rather, they were posed around the slain hero as if grouped for the final act of Cockings's play. One can almost hear the offstage drumbeats and mournful choruses. Thus it is not surprising that observers inter-

Fig. 104 *The Death of General Wolfe,* ca. 1772–80, oil on canvas, 74½ × 109½ inches. William L. Clements Library, The University of Michigan, Ann Arbor.

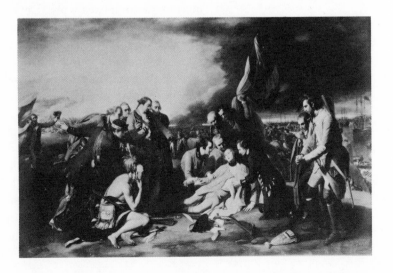

173

preted facial expressions, character interactions, and all kinds of personal communications just as if they were responding to a live drama. It was precisely this "audience reaction" that made the painting so popular. All of the elements that West had skillfully developed during the 1760s—staging, lighting, figural arrangement, and allegorical suggestion—merged to distinguish *The Death of Wolfe* as a living memorial, comparable to Wilton's monument in Westminster Abbey, which was under construction at that time. If Garrick's performance at the Pall Mall gallery did actually occur, it must have pleased West tremendously. Indeed, it was just the kind of theatrical response that he had hoped to elicit.

When viewed as a drama, West's *Death of Wolfe* becomes two paintings. One is the stage upon which actors kneel around the dying general; the other is the background scenery that pictures the conquest of Quebec. The cast, with its mixture of ages, races, and nationalities, succeeded so well that West saw no reason to alter the composition in the three subsequent renditions. The background, on the other hand, varies in each of the later versions. An obvious change is in the messenger who bears news of the French defeat; his size increased as the canvases grew larger. Perhaps West altered and expanded the detailed battle scenery to satisfy his patrons, or perhaps he made corrections to rectify certain errors that had been brought to his attention. The complexity of action in the background battle substantiates the thesis that the panorama represents an allegory of the entire Canadian campaign.[18]

An ink and watercolor drawing of *The Death of Wolfe* (fig. 105), recently purchased by the National Gallery of Canada, is dated 1765, indicating that West had long been planning his epic composition. The sketch contains the same number of figures in approximately the same configuration as the finished painting. Yet there are striking differences between the preparatory drawing and the completed work. Details in the background of the painting are far more complex than those in the drawing, and the placement of objects on and around the assembled soldiers have been moved about in the final composition. The greatest variation is found in the faces of the men. Some portraits in the drawing are entirely different from those in the painting, a discovery that leads to several interesting speculations. Perhaps West made the drawing before he decided which soldiers to include, or perhaps he had been unable to have the designated officers sit for their portraits before he completed the sketch. Or, as some have suggested, he might have had a financial motive for including different men from those in his original plan. A few of West's contemporaries accused the artist of requiring the individual soldiers to pay before their likenesses could be placed in the tableau. Such a maneuver, they implied, prompted

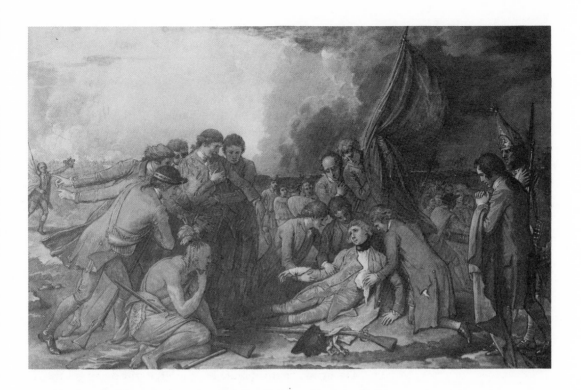

Fig. 105 *The Death of General Wolfe,* 1765, ink and watercolor on paper, 17 × 24 inches. National Gallery of Canada, Ottawa.

changes in portraits of the attending officers. While radiographs as well as infrared and ultraviolet photographs of the original painting reveal virtually no alterations in the faces of the participants, the disparity between the portraits in the sketch and those in the painting do add credence to the allegation that West might have been paid to include certain people.[19]

Only a few officers were with the general when he died, so West must have had some rationale for selecting an entourage of thirteen observers to witness Wolfe's death. Six of them were identified in a key published in 1776 to accompany William Woollett's engraving (figs. 106 and 107). The most famous was Isaac Barré (centered above Wolfe), who had been badly wounded during the capture of Canada. By 1770, when West was composing his painting, Barré was well known as an adamant supporter of American rights in the House of Commons, and thus had become quite popular in the colonies. Other figures labeled in the 1776 key were Captain Hervey Smyth (to the left of the dying general), Wolfe's aide-de-camp, who supposedly sketched a portrait of his commanding officer during the Canadian campaign; Adam Williamson (standing above Barré), who had served with General Braddock's ill-fated forces at Fort Duquesne during West's youth and was subsequently wounded at Quebec; and a surgeon identified merely as "Adair" (kneeling at Wolfe's right), who could have been either John Adair, a doctor with the armies in Canada, or his brother Robert, a prominent physician in London. The latter was a frequent visitor to the

175

court of George III, where he may have met West, who perhaps asked him to pose for the painting in his brother's stead.

Identified in the center of the group on the left is Robert Monckton, Wolfe's second in command, whose portrait West had painted several years earlier (see engraving, fig. 52). He holds a handkerchief over his heart to signify the wound received during the capture of Quebec. Looking over Monckton's shoulder is the engineer Hugh Debbieg, Wolfe's assistant quartermaster in Canada. In a more extensive key published during the 1920s, the man leaning forward on the far left (wearing the green jacket of an American Ranger) was said to be William Howe, the British commander of forces during the American Revolution, but this designation is probably incorrect. Examination of the canvas discloses an inscription on the powder horn that reads: "Sr. Wm. Johnson." This well-known Indian negotiator was then older than the man portrayed by West, although the figure does resemble his nephew Guy (also known for his fair dealings with the Indians), whom West painted five years later in a composition that also contains an Indian chief (fig. 108).[20]

The pensive native, seated to the left of the dying general, is perhaps the most enigmatic figure of all. While many of the men in the tableau were identifiable by their portraits, the Indian appears to be purely allegorical. In one sense he stands for the Mohawk and Delaware natives who helped British forces in Pennsylvania during West's boyhood; in another, he suggests those numerous tribes that assisted the enemy in the French and Indian War.

For West, the native chief was synonymous with the American wilderness. Depiction of natives modeled after classical

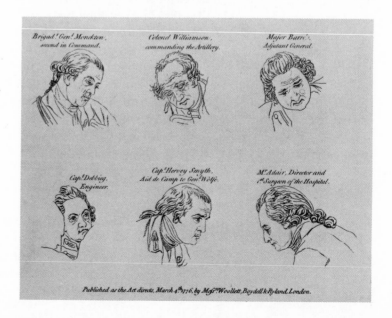

Fig. 106 William Woollett (1735–1785), engraving, key to accompany *The Death of General Wolfe,* 1776. Department of Prints and Drawings, The British Museum, London.

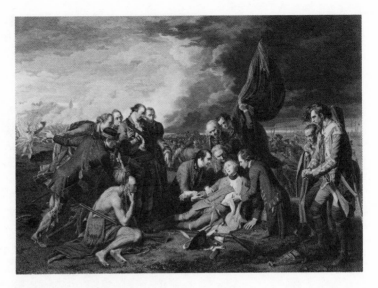

statues had by now become part of his artistic vocabulary. In Italy he had painted the "Mohawk brave" (see fig. 40) in the pose of the *Apollo Belvedere,* and in 1765 he had utilized his knowledge of the Pennsylvania Indians to produce two illustrations, *The Indians Giving a Talk to Colonel Bouquet* and *The Indians Delivering Up the Captives to Colonel Bouquet* (figs. 109 and 110), for a book by William Smith. In the drawings he pictured muscular braves draped in cloaks and togas, children who resembled chubby Renaissance putti, and mothers modeled after Italian madonnas.[21]

The Indian in *The Death of Wolfe* repeated West's now-familiar juxtaposition of traditional models and native American costumes. Just as Wilton had replaced obsolete emblems with descriptive human forms, West followed the same classical convention by placing a stately chief in the composition to personify America. The Indian, who for two centuries had symbolized the American continent in a variety of prints, paintings, and statues, was clearly the most logical and poignant emblem of Britain's conquest.[22] In the same sense, the two men on the right, a grenadier and an enlisted man, have an allegorical function. In essence, they parallel "Britannicus" and "Leonatus" in Cockings's play. Like the "audiences" in West's classical paintings, the figures in the corners are compositional devices intended to symbolize the underlying meaning of the narrative and to pull viewers into the drama.

The absence of Townshend and Murray in the grouping of officers is also a significant allegorical statement, for it would have been a sacrilege to place Wolfe's most vocal critics among the men paying homage. Instead, it is Monckton, the highest ranking brigadier, who occupies the most prominent position in the composition. In the staff of officers directing the Canadian

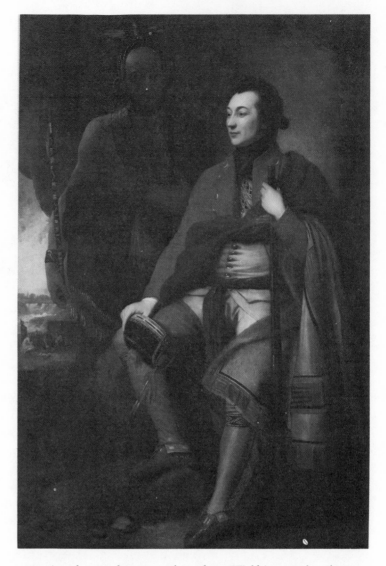

Fig. 108 *Colonel Guy Johnson,* 1776, oil on canvas, 79³/4 × 54¹/2 inches. National Gallery of Art, Washington, D.C.; Andrew W. Mellon Collection, 1940.

campaign, he was known to have been Wolfe's most loyal supporter. Monckton's place of honor explains why West selected certain officers and omitted others. Following the classical precedent that required actual people, not symbols, to convey moral messages within a work of art, the individuals in the painting were chosen because each played a specific role. West obviously realized that his memorial to Wolfe must include only those men who deserved to attend the slain hero. It mattered not if the officer had been absent at Wolfe's death scene, but it was imperative that he had remained loyal to the general during and after the battle.

Although the precise likeness of each officer gave West's *Death of Wolfe* an element of human interest, the use of portraiture in an epic painting was certainly not "revolutionary." Eighteenth-century conversation pieces were similarly staged, as were Italian Renaissance *sacra conversazione* and Dutch guild por-

 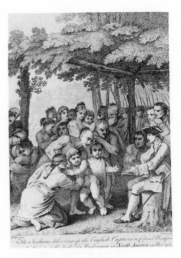

Fig. 109 *The Indians Giving a Talk to Colonel Bouquet,* engraving from William Smith, *An Historical Account . . . Under the Command of Henry Bouquet,* London, 1766. Rare Books Room, Library of Congress, Washington, D.C.

Fig. 110 *The Indians Delivering Up the English Captives to Colonel Bouquet,* engraving from William Smith, *An Historical Account . . . Under the Command of Henry Bouquet,* London, 1766. Rare Books Room, Library of Congress, Washington, D.C.

traits. West merely modernized these venerable traditions by placing carefully crafted portraits into a theatrical tableau.

For the face of General Wolfe, West utilized four known portraits: one an anonymous painting owned by George Warde of Squerryes; another attributed to Joseph Highmore; a posthumous profile (fig. 111), probably created by J. S. C. Schaak, from Hervey Smyth's sketch; and another (fig. 112) drawn by Townshend at Quebec. In all of these, Wolfe is shown with a receding cleft chin, large protruding eyes, a small mouth, and a long turned-up nose. West's image is a composite of these features, cleverly rearranged into a three-quarter view to minimize the unflattering profile.[23]

West may have noticed that Wilton had also chosen a similar pose in his Westminster Abbey memorial then under construction. That monument may well have served as a model for West because it embodied two cardinal rules of eighteenth-century classicism: the use of realistic human figures in place of emblematic abstractions, and the portrayal of a hero in the guise of an antique god. In this contemporary manner, Wilton depicted the chief protagonist as a modern reincarnation of an ancient hero. The British miniaturist Nathaniel Marchant repeated this characterization several years later when he designed a relief medallion (fig. 113) to commemorate the death of General Wolfe. Even though Marchant's sculpture is a subtle parody of West's painting (Wolfe reclines in the same pose, accompanied by an In-

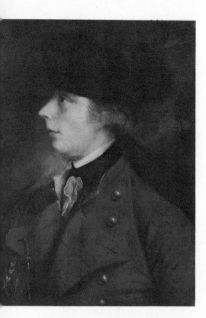

Fig. 111 Attributed to J. S. C. Schaak, *James Wolfe,* ca. 1760, oil on canvas after a sketch by Hervey Smyth. National Portrait Gallery, London.

Fig. 112 George Townshend (1724–1807), *General James Wolfe,* ca. 1758–59, watercolor and chalk on paper. McCord Museum, McGill University, Montreal, Canada.

dian wearing the same headdress and a soldier carrying the same flag), there is one striking difference: the hero is nude. Perhaps this was Marchant's deliberate attempt to rectify what he saw as a glaring error in West's composition. An artist working in the "grand manner" was expected to portray a national hero without clothing to demonstrate that the subject exemplified the ancient ideals of courage, valor, and strength.[24]

It was this very issue that lay at the core of the controversy over the use of modern dress in *The Death of Wolfe.* The painting was "revolutionary" not because the supporting cast of officers were dressed in contemporary clothing but because Wolfe himself was depicted as an ordinary mortal. No one seriously objected when Penny pictured the same general fully attired, because his pictorial corollary to journalistic reports did not aspire to be a grand-style or classical epic. West, on the other hand, created a large-scale exhibition piece of traditional proportions. When he dressed Wolfe in a modern uniform he not only broke rules that Fresnoy, Richardson, Shaftesbury, and theoreticians of the past had sanctioned, but he also defied the teachings of Winckelmann and other neoclassicists. By moving his epic narrative from the Roman forum to the Plains of Abraham, West had written new specifications for glorifying a modern hero.

This unorthodox interpretation was explained and justified in an appraisal of the painting written in 1793 by West's friend Reverend Robert Bromley. Devoting six pages of his *Philosophical and Critical History of the Fine Arts* to a laudatory appraisal of West's *Death of Wolfe,* Bromley described the painting as an allegory, citing the Indian, the costumes of the officers, and the background battle scene as evidence that West had combined accurate research with dissemination of an elevated moral message. "Had he taken facts merely as they stood," Bromley wrote, he would not have reached "any one passion of the heart." The real meaning, he explained, lay in the figure of Wolfe: "We behold him a hero in death; not by struggling against it, or shewing any contumacy of mind, but by that placid serenity which great minds only can possess, and which must be inseparable from him whose sense of duty and of service to his country had found themselves in that instant so gloriously accomplished."[25]

What the review reveals is that West's apotheosis of Wolfe reversed current practices. Instead of utilizing a classical setting to comment on a contemporary social or political issue, he used a recent event to preach a sermon on universal moral values. Courage, loyalty, patriotism, sacrifice—all pillars of the Roman ethos as then perceived—were captured in his composition. Wolfe did not need to resemble a Greek or Roman hero in outward appearance as long as his death could be understood as the expiration of a classical or Biblical figure.

West's *Death of Wolfe* soon became the most important icon in the deification of General Wolfe, spawning a legacy that began with its first exhibition in 1771. The painting's celebrity probably influenced Lord Richard Grosvenor to spend the large sum of four hundred pounds to purchase the work. While no documents in the Grosvenor Estates provide sufficient proof that Lord Richard actually commissioned the painting, the very polished preliminary drawing (fig. 105), with its fine highlights and distinctive shading, suggests that West could have prepared the finished sketch for a patron's approval.[26]

Around that time, Grosvenor (pictured in fig. 114) had just won a well-publicized divorce suit against his wife of six years. Although he had been successful in proving that she had committed adultery, the long, tedious trial became a favorite subject for gossip columnists because Lady Grosvenor's lover was none other than the Duke of Cumberland, the younger brother of King George. Even without the notoriety occasioned by the

Fig. 113 L. Schiavonetti, *The Death of General Wolfe*, ca. 1780, engraving after a relief miniature by Nathaniel Marchant. Rare Books Room, Library of Congress, Washington, D.C.

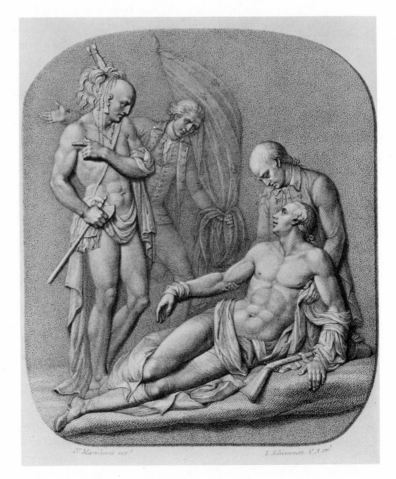

181

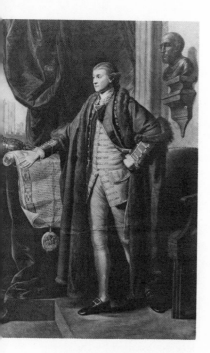

Fig. 114 W. Dickinson, *Lord Richard Grosvenor,* ca. 1774, engraving after a painting by Benjamin West. Department of Prints and Drawings, The British Museum, London.

scandal, Lord Grosvenor was famous in his own right. As scion of an affluent noble line, his baronial estates included all of Mayfair, Belgravia, and much of Cheshire. Besides holding substantial and strategic lands, the marquis was a debonair socialite, found frequently at the most fashionable gatherings in England. Grosvenor was also a collector of great renown. In his younger years he devoted a great deal of time and money to amassing stables full of prize race horses, but his interests changed during the 1760s when he developed an interest in art. Commissioning Richard Dalton as his purchasing agent in Italy, Grosvenor began to fill his estates with a rich assortment of works by old and modern masters.

Grosvenor may well have chosen *The Death of Wolfe* because he had a personal interest in the victory at Quebec. Shortly after the peace of 1763, he had sponsored an investigation into the commercial possibilities of investments in Canadian land and raw materials. As a result of his efforts, the king rewarded him with territories in East Florida.[27] West's allegory of the Canadian victory, therefore, marked not only a heroic episode in British history but also an event that enabled Grosvenor to increase his own territorial holdings.

Profits were also realized from William Woollett's engraved copy of *The Death of Wolfe,* published by John Boydell in 1776. Sale of the print in England, France, and America netted fifteen thousand pounds for Boydell, almost seven thousand pounds for Woollett, and a large but undisclosed amount for West.[28] The popularity of Woollett's engraving was not only a testimony to West's skill but a splendid indication that the Wolfe apotheosis had become one of England's most appealing legends. In fact, when James Barry followed in the long succession of artists to illustrate the scene in his painting of 1776, the subject still commanded the respect and attention of England's leading artists and patrons. West himself addressed the Wolfe legend once more when Lord Grosvenor asked him to paint a portrait of the general as he might have looked when he was a boy (fig. 115). By the end of the century, West's Canadian epic was so familiar that the composition itself was symbolic, as evidenced by James Gillray's cartoon of 1795 (fig. 116), which used the same configuration to lampoon British government officials.

A significant document in the ongoing Wolfe legend was written in 1775 by Thomas Paine. His eulogy to the long-dead general indicates how thoroughly the Wolfe mythology had become integrated with ancient history and literature in the minds of all British subjects, transcending the polemics that were swiftly carrying England and America to the brink of war. Paine's poetry, in fact, summarizes the conceptual substructure of West's *Death of Wolfe.* As a "last word" in the composite Wolfe apotheosis, the verse presents a superb example of the

way classicism and imperial pride were jumbled in the British psyche.

> *In a mouldering cave where the wretched retreat*
> *Britannia sat wasted with care*
> *She wept for her Wolfe, then exclaim'd against fate*
> *and gave herself up to despair,*
> *The Walls of her Cell she had sculptur'd around*
> *with exploits of her favourite Son,*
> *And even the Dust as it lay on the ground*
> *was engrav'd with some deeds he had done.*

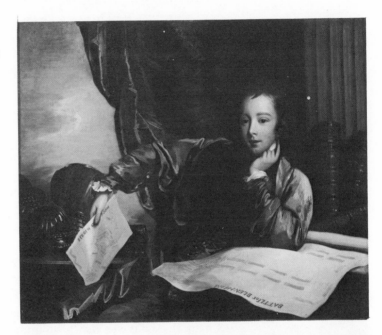

Fig. 115 *Wolfe as a Boy,* ca. 1778, oil on canvas, 15½ × 19 inches. His Grace the Duke of Westminster, D.L.

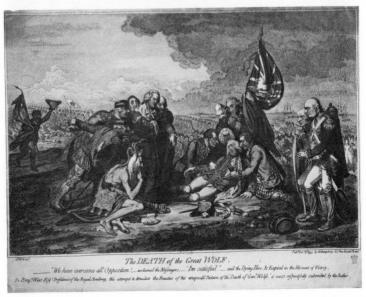

Fig. 116 James Gillray (1757–1815), *The Death of the Great Wolf,* 1795, engraving. Department of Prints and Drawings, The British Museum, London.

The Sire of the Gods from his crystaline throne
beheld the disconsolate Dame
And mov'd at her Tears he sent Mercury downe
and these were the Tidings that came,
Britannia, forbear—not a sigh—not a Tear
for thy Wolfe so deservedly lov'd,
Your grief shall be chang'd into triumphs of Joy,
for Wolfe is not dead—but remov'd:

The Sons of the Earth, the proud Giants of old,
have broke from their darksome abodes,
And such is the News, and in heaven 'tis told,
They're marching to war with the Gods.
A Council was held in the Chamber of Jove,
and this was the final decree,
That Wolfe should be called to the Armies above
and the Charge was entrusted to me.

To the Plains of Quebec with the orders I flew,
he beg'd for a moment's delay,
And cried, O forbear,—let me Victory hear,
and then the Command I'll obey.
With a dark'ning Cloud I encompass'd him round,
and convey'd him away in an Urn
Lest the fondness he bore, for his own native shore
Should tempt him again to returne.[29]

Paine's verse should be read as a poetic corollary to West's *Death of Wolfe.* Both are timely reflections of prevailing beliefs and attitudes. The painting was popular yet classic, theatrical yet natural. And it was also "revolutionary," not so much in its costume and setting, but because the composition merged contemporary concepts of classicism with elements from modern life. West had finally created a tribute to America that his colleagues, patrons, and the general public could admire.

CHAPTER NINE # Epitaph

The drama and pathos of West's *Death of Wolfe* captured the mood and temper of that pregnant interval when Western culture sat poised on a narrow ridge between an era of scientific positivism and one of romantic passion. Writers and orators of an earlier generation had been convinced that the world functioned according to fixed laws, with man as a stationary link within a universal 'chain of being'. By the 1760s, however, the complacency and optimism of the recent past had eroded, leaving poets and playwrights to experiment with subjective topics in place of the more formal, universal ones of the earlier years. Whereas in the 1690s John Dryden had formed precise heroic couplets to defend specific Whig leaders and their ideologies, a half-century later Thomas Gray would compose a churchyard elegy to evoke the mystery and melancholy of death.

Samuel Johnson and most older intellectuals continued to believe that a system of rational laws controlled mankind, but younger scholars were reminding their readers that irrational sensibilities also existed in the universe. Edmund Burke's *Philosophical Enquiry into the Origin of Our Ideas of the Sublime and Beautiful,* which first appeared in 1756, presented a new aesthetic theory by postulating terror as a primary link between man and the sublime. Alexander Pope had extolled nature as the "one clear unchang'd and universal Light" in his *Essay on Criticism,* published in 1711. Less than five decades later, Burke equated the "sublime in nature" with "that state of the soul, in which all its emotions are suspended, with some degree of horror." If the word "delight" suggested world harmony to Pope, it implied impending danger to Burke.[1]

The ideological differences between generations is perhaps easiest to perceive in architecture. The Earl of Burlington's Chiswick House, built in the 1720s, symbolized the balanced precision of the early eighteenth century. Its Palladian façade with matching stairwells and simple geometric proportions epitomized an age of stability and certainty. In contrast, Horace Walpole's Strawberry Hill, begun in 1748, was a hodgepodge of Gothic asymmetry. These two landmarks, designed only twenty

years apart, were signposts of the rapidly changing tastes that marked the period.

The dramatic ambiance that made West's *Death of Wolfe* so powerful suited that moment in history. Only the most prophetic of savants could have foreseen the end of British hegemony in the thirteen colonies below the Canadian border. It looked in 1771 as if settlement of the Stamp Act crisis several years earlier had ended all friction between America and her "mother." West's personal feeling of pride in this reconciliation undoubtedly prompted him to use his Canadian battlefield drama to transmit the pathos and sentimentalism that he must have felt. Translating Burke's concept of the sublime into layman's language, West captured that elusive sense of wonder and awe, that element of passion, that secular yet spiritual link with powers greater than man. Despite his ability in future years to tap the edges of what would be defined as "romanticism," in his early works West never lost his toehold on rationalism. His firm linear style, the clearly wrought narrative, the utilization of authentic portraiture and uniforms all gave his epic canvas a sense of dignity and balance. Perhaps *The Death of Wolfe* could be best defined as a mirror of a frozen moment—not the moment that Wolfe actually died, but the one West inhabited when he planned and executed the painting.

The dynamic impact of *The Death of Wolfe* made it a prototype for West and for a number of his students and colleagues, establishing the conceptual framework for what might be most aptly described as a "death tableau." West made his next attempts at this kind of composition during the early 1770s with *The Death of Chevalier Bayard* and *The Death of Epaminondas* (figs. 117 and 118), both commissioned by King George to hang with *The Death of Wolfe* in Buckingham House. These depictions of the battlefield deaths of historical warriors are compatible with *The Death of Wolfe*. They are equally as didactic, treating a military hero's demise as a personification of national loyalty and selfless sacrifice. The death of Epaminondas was often paralleled with the last moments of General Wolfe because the ancient Thebian general died inquiring about the status of his armies. Similarly, the medieval French knight Bayard asked that his enemies be forgiven as he lay mortally wounded after a crucial battle in Provence. Bayard supposedly expressed pity for his foes because they had suffered the ignominy of betraying their king while he was provided the honor of dying for his country.[2]

Even though *Bayard* and *Epaminondas* were conceived within the same melodramatic framework as *The Death of Wolfe,* neither express the sense of passion and lyrical movement found in West's Canadian epic. Both compositions are vertical,

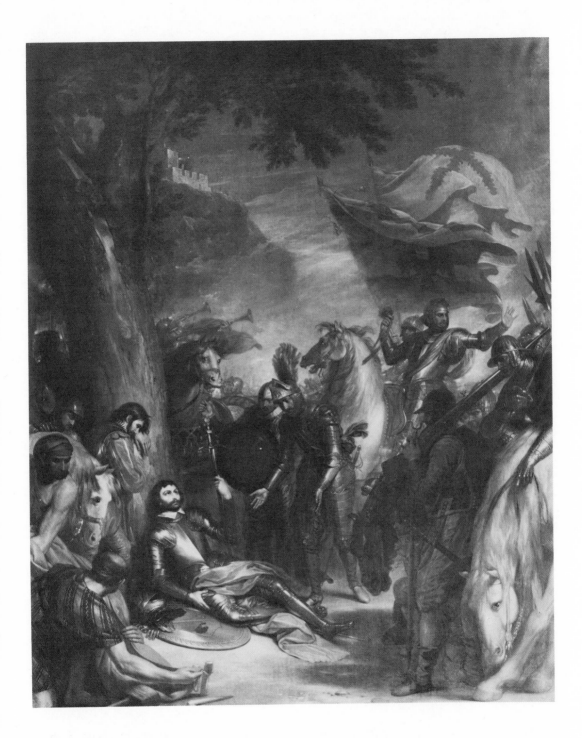

Fig. 117 *The Death of Chevalier Bayard,* 1772, oil on canvas, 87¼ × 70½ inches. Her Majesty Queen Elizabeth II.

with the dying heroes lying in the lower third of the canvas. Perhaps West shifted from the wide horizontal vista of *The Death of Wolfe* to the crowded narrower format of *Bayard* and *Epaminondas* to conform with the king's spatial requirements. But the structural change disturbs the dramatic impact and creates an atmosphere of stilted uncertainty. Instead of imparting the emotional pathos of an operatic finale, the actors in the

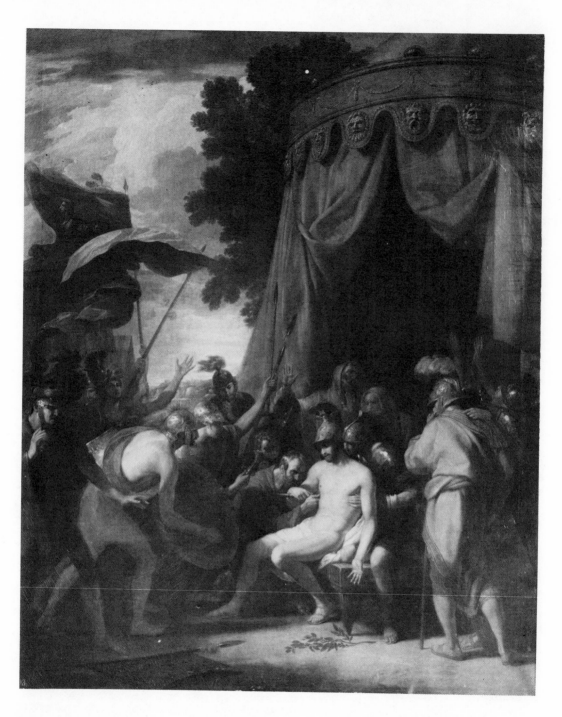

Fig. 118 *The Death of Epaminondas,* 1773, oil on canvas, 87½ × 70⅝ inches. Her Majesty Queen Elizabeth II.

paintings appear to be unconcerned about the hero's death they are witnessing. West clearly lacked the personal attachment to these historical figures that he had felt for the hero of Quebec. Nevertheless, the original paintings (both still in the Royal Collection) are impressive. Brilliant shades of crimson and blue lend excitement. In addition, observers in the corners and the diagonal thrust of the flags direct our attention toward the heroes lying prone near the bottom of the composition.

188

A similar blend of dramatic line and vibrant color characterizes one of West's most poignant death tableaux, *The Death of the Earl of Chatham* (figs. 119 and 120). The small canvas (fig. 119) is the study for a larger epic that was never completed. Many have speculated that West lost interest in the project when his talented American colleague, John Singleton Copley, decided to paint the same subject. It was a timely topic with all the dramatic innuendos of a heroic finale. Lord Chatham, the elder William Pitt, had collapsed in the House of Lords after delivering an impassioned defense of the American colonies. The painting's title is deceptive, however, for Chatham did not die until three weeks after his dramatic collapse. Nevertheless, West and Copley decided to capitalize on the theatrical and symbolic implications of his departure from the political arena by depicting the episode as if the famous orator had succumbed at the conclusion of his fiery speech.

As one of the most colorful and enigmatic figures in government circles, Chatham was known for his vociferous support of both British imperialism and partial autonomy for the American colonists. While his outspoken championship of individual rights endeared him to the public, especially in America, he was often at odds with the king, whom he had served in various ministerial capacities. For West, an apotheosis of Chatham in the manner of General Wolfe posed a serious dilemma. Had he painted a large exhibition piece to eulogize the controversial minister, his relationship with King George might have been jeopardized. For this reason, he relinquished the subject to Copley, who responded with a large epic representation of the dramatic scene (fig. 121).[3]

A comparison of West's *Death of Chatham* with Copley's reveals crucial information about how West transmitted the grand-style formula for death tableaux. Both compositions are theatrical: figures occupy a narrow stage, highlights come from the front of the picture plane, observers watch from both corners of the foreground, diagonals point to the ailing hero, and spots of red, white, and deep blue denote a subject of national worth. In each painting, the stricken minister, surrounded by his constituents, sits slumped on the right, while at a table across the room on the left, Lord Mansfield (one of Chatham's principal opponents) soberly observes the proceedings.

Even though Copley and West designed their paintings along the same compositional lines, and both used carefully researched portraits to add historical credence, the two paintings differ considerably. West's grouping of figures is more intimate, with fewer actors and a more compact spatial arrangement. Whereas Copley's Chatham appears as a virtual corpse, his face wan and waxy, West's figure looks as if he were in the throes of pain, his ailing legs wrapped in bandages, his face revealing the

189

Fig. 119 *The Death of the Earl of Chatham*, 1778, oil on canvas, 28 1/8 × 36 1/4 inches. Kimbell Art Museum, Fort Worth, Texas.

Fig. 120 *The Death of the Earl of Chatham*, ca. 1777–78, black, white, and red chalk on blue paper, 5 1/4 × 6 1/2 inches. The Henry E. Huntington Library and Art Gallery, San Marino, California.

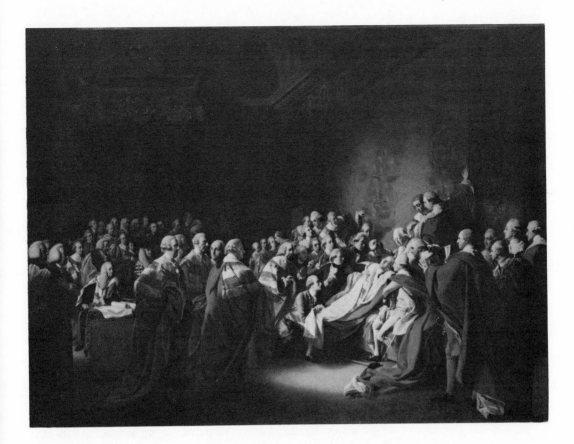

Fig. 121 John Singleton Copley (1738–1815); *The Collapse of the Earl of Chatham in the House of Lords, 7 July 1778,* 1779–80, oil on canvas, 90 × 121 inches. The Tate Gallery, London.

anguish of his illness. Horace Walpole remarked favorably about West's more naturalistic portrayal.

Mr. West made a small sketch of the death of lord [sic] Chatham, much better expressed and disposed than Copley's. It has none but the principal persons present; Copley's almost the whole peerage, of whom seldom so many are there at once, and in Copley's most are mere spectators. But the great merit of West's is the principal figure, which has his crutch and gouty stockings, which express his feelings and account for his death. West would not finish it not to interfere with his friend Copley.[4]

Copley had borrowed and amplified West's formula for the dramatic narrative, including more portraits and enlarging the theatrical framework to encompass a greater array of players. But when Copley emulated the way West manipulated color and line to produce an operatic finale, he also copied one of his fellow American's weaknesses—excessive documentation. Too many portraits and overly accurate detail distract from the dramatic impact. It was a mistake West would also make in years to come.

The "death tableau" with its aura of an operatic finale repre-

sents the last stage in the evolution of dramatic grand-style narratives. Shortly after exhibiting *The Death of Wolfe* in 1771, West began to experiment with slight changes in his history-painting formula. The impetus came from Thomas Penn, who commissioned him to paint an epic composition of his father William's legendary peace conference with representatives of the Lenni Lenape (or Delaware) tribes under the great elm at Shackamaxon.[5] The result was *William Penn's Treaty with the Indians* (fig. 122 and plate VII), a transitional work in West's career. As he had done in his classical history paintings, West used the theatrical setting with its "audience" observing in both foreground corners, a heroic figure surrounded by his admirers, and a horizontal alignment of participants. But several components of this narrative differ in composition and concept from his earlier grand-style narratives.

The swirling lines and diagonals of *The Death of Wolfe* have been replaced by a balanced, rectilinear composition; the vivid colors of the battlefield drama supplanted by muted earth tones that reproduce the somber atmosphere of a Quaker meeting. The composition, therefore, might be called more "panoramic" than "dramatic." Whereas West's dramatic paintings describe the courageous act of a single performer, the panoramic ones are documentaries that display large groups of people signing treaties, fighting battles, or participating in other events of national significance. The dramatic paintings are emotional, the panoramic ones intellectual; one conveys the moralizing of a sermon, the other the factual information of a textbook.

What categorizes *Penn's Treaty* as the first of West's panoramic paintings is its theme. William Penn's peace mission did not make him a hero in the classical sense; he suffered no loss and performed no selfless deed. It would have been demeaning, in fact, to depict the intrepid founder of Pennsylvania as a melodramatic actor. Therefore, to comply with Thomas Penn's wishes, West designed a historical panorama in which events, not individuals, played the starring roles.

When he commissioned West, the elderly Thomas Penn was administering the colony from the comfortable confines of his English estate, leaving the day-to-day managerial tasks to an appointed governor and to his allies in the provincial assembly, many of them leaders of Philadelphia's thriving mercantile trade. As we have seen, this form of government was at the heart of a local controversy in which Penn's opponents criticized everything from his fiscal and legislative policies to his absentee proprietorship. The furor created by Franklin's crusade to replace Penn's rule with a royal government was troublesome for the ailing proprietor, especially when Franklin's most influential allies were descendants of the very Quakers his father had led to America eighty years earlier.

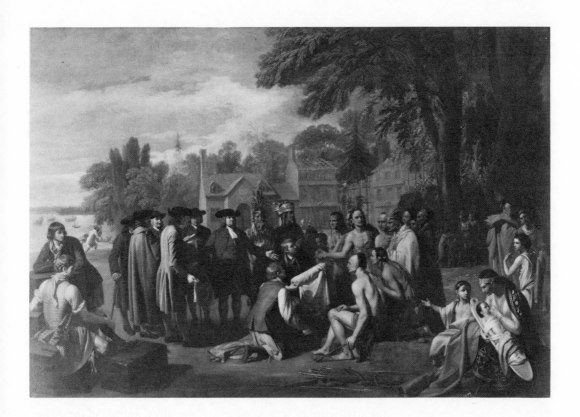

Fig. 122 *William Penn's Treaty with the Indians,* 1771, oil on canvas, 75½ × 107½ inches. The Pennsylvania Academy of the Fine Arts, Philadelphia; Joseph and Sarah Harrison Collection. Reproduced in color, plate VII.

By 1771 the political atmosphere in the colony had changed considerably. Franklin's campaign to replace the proprietorship had failed to win royal approval, and a recent peace conference at Fort Stanwix between representatives of the proprietary government and tribal leaders had produced a treaty that ended decades of fighting between colonists and Indians.[6] On the surface it looked as if the proprietary government had brought peace at last to the troubled province, but the treaty did not please all of the colonists. In the course of negotiations, the chiefs assembled at Fort Stanwix had released their lands east of the Ohio River to the Pennsylvania government, an arrangement that not only displaced numerous tribes from their ancestral homes, but also brought substantial financial gains for the Penn family. Franklin's allies in the Pennsylvania Assembly eagerly seized this issue as the center of their continuing criticism of the proprietary government, causing even further consternation for Thomas Penn.

Despite the flow of angry rhetoric bandied back and forth between opponents in the ongoing colonial squabble, the legacy of William Penn retained its persuasive power. During the long years of arguments over whether or not to arm the colony, each side used the apocryphal confrontation between Penn and the Indians to evoke nostalgic memories of a bygone era when peace and harmony reigned. Quakers reminded Pennsylvanians that William Penn was a pacifist who would never have allowed

Fig. 123 Joseph Richardson, Sr., *Peace Medal*, reverse, 1757, silver, 1³/4 inches in diameter. The American Numismatic Society, New York, New York.

Fig. 124 *The Battle of La Hogue*, 1778, oil on canvas, 60¹/8 × 84³/4 inches. National Gallery of Art, Washington, D.C.; Andrew W. Mellon Fund, 1959.

armed battles against Indian tribes; supporters of the proprietary government spoke of Penn's fatherly protection, suggesting that he would never have left frontier settlements unarmed and vulnerable to Indian attack. The image of the portly founder as the progenitor of harmony and fair dealing carried the same degree of emotive power in Pennsylvania that suggestion of Wolfe's sacrificial death did in England: it was symbolic, sacrosanct, and commanding, the perfect combination for a "modern" history painting.

Faced with the challenge of using this revered legend to suggest peace and tranquility under the fruitful leadership of William Penn's son and chosen successor, West composed his painting around a network of symbols, the most obvious being the hallowed meeting between Penn and the Indians. It was, in fact, a familiar image in Pennsylvania, for pictures of the legendary encounter could be found on the "peace medals" (see fig. 123) that were given periodically to tribal leaders in exchange for Indian lands. The discarded quiver of arrows and peace pipe are other customary symbols of peace, just as the two young men kneeling in the center to offer gifts to the Indians represent the alliance between the Penn proprietorship and Philadelphia's leading merchants. The men with their rolls of silk and trunks filled with unknown treasures are actually conducting the peace

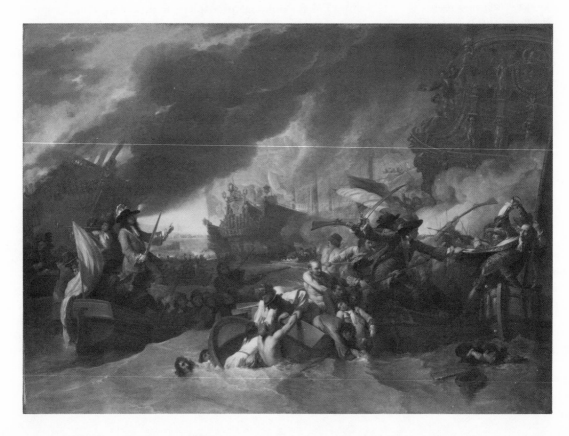

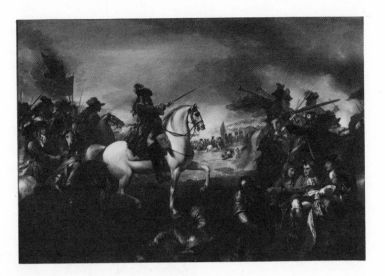

negotiations; the passive Quakers appear to be merely witnessing the event.

Portraits, which became an essential component in West's "modern" history paintings, add a personal touch because the artist identified his father, John, and half-brother, Thomas, both seen standing at Penn's left. West allegedly included his own self-portrait as the young man leaning on a crate in the left foreground.[7] All of these various symbols add up to an image of peace and colonial harmony under the benign protection of the Penn family. Trade appears to be flourishing: Indians, Quakers, and merchants mingle happily in the idyllic surroundings of the Pennsylvania wilderness.[8]

Today West's *Penn's Treaty* has become such an icon of American history that few people realize it was planned as an allegory of provincial politics and not as an artistic depiction of an actual event. Its array of human symbols dramatically imparts a multilayered message that suggests Thomas Penn's interests as proprietor, West's own background, and the legend of William Penn's peaceful, protective guidance, which had become the ideological glue of colonial Pennsylvania.

After *Penn's Treaty,* West's panoramic paintings became larger and more comprehensive, containing fewer associations with the artist's personal life. Two well-known examples are *The Battle of La Hogue* and *The Battle of the Boyne* (figs. 124 and 125), both commissioned by Grosvenor in the late 1770s. While the works are conceptually related to *Penn's Treaty* in that they illustrate a significant moment in history instead of a hero's dramatic death, they are far less theatrical than the Pennsylvania narrative. In these epic battle panoramas, West removed his ac-

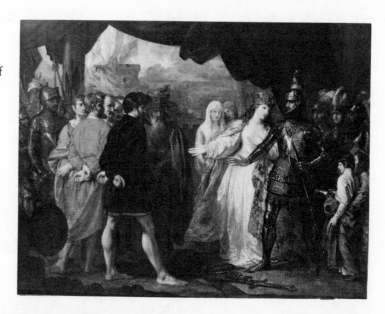

Fig. 126 *Queen Philippa Interceding for the Lives of the Burghers of Calais,* 1788, oil on canvas, 39½ × 52¼ inches. The Detroit Institute of Arts, Michigan; Gift of James E. Scripps.

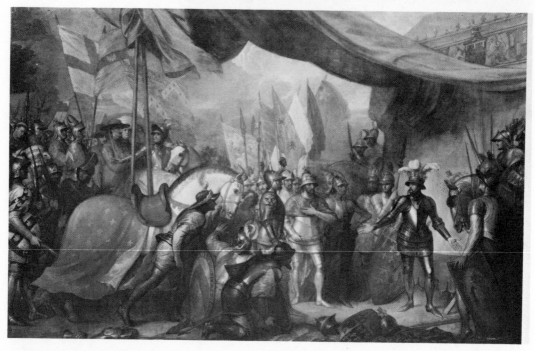

Fig. 127 *The Black Prince with King John of France after the Battle of Poitiers,* 1788, oil on canvas, 113 × 177 inches. Her Majesty Queen Elizabeth II.

tors from the footlights and staged them out-of-doors. No foreground audience witnesses the action; no single hero falls in center stage to expire valiantly for a noble cause. Instead, the viewer is thrown into a vast and complex military encounter with no intimate vignette to evoke sympathy, pathos, or a sense of individual participation. Without a star performer the abstract concepts of victory and national pride seem hollow. In essence, these epics of decisive British victories resemble news reports designed to inform but not to captivate. If the

swashbuckling narratives are ineffective as dramatic finales, they are powerful as documentaries. In each, the costumes are historically accurate, and portrayals of every ship and sailor, soldier and herald, are carefully researched down to the finest details.

Verisimilitude of this sort became a hallmark of West's later historical epics, whether the subjects were from modern, classical, or medieval history. The episodes were well researched, the scope broad, and the emphasis usually intellectual rather than emotional. Among the better-known examples of West's panoramas are seven canvases (including figs. 11, 12, 126, and 127) illustrating the victorious campaigns of Edward III. The series, commissioned by King George in the late 1780s for his audience room at Windsor, is noted for its meticulous accuracy. To prepare for the compositions, West investigated a variety of archival sources, searching for the proper armor, helmets, banners, and coats of arms.[9] What he achieved in documentation, however, was lost in aesthetic persuasion. The figures appear to be contrived and awkward, the compositions crowded and uneven, and the overall effect bland and mechanical.

Although they lack the coherence and dramatic impact of *The Death of Wolfe* or *Penn's Treaty,* West's history paintings of the 1770s and 1780s possess salient features that make them innovative and unique. Such narrative compositions as *Charles II Landing at Dover* (ca. 1783), *Cromwell Dissolving the Long Parliament* (fig. 128), *Anthony Revealing the Body of Caesar* of around 1774, or *Alexander III of Scotland Rescued from the Stag* of around 1785 (see engravings, figs. 129 and 130) tell compelling stories that can be "read" with interest. Figures move about the canvas with dramatic intensity, and the sense of historical reality is often quite convincing.

Fig. 128 *Cromwell Dissolving the Long Parliament,* 1782, oil on canvas, 60 × 84 inches. Montclair Art Museum, New Jersey; Museum purchase, 1960.

By the end of the 1770s, West's world was rapidly changing; war in America tore his affinities between past and present. Although the artist made no public announcements of preference for either side, two of his paintings refer indirectly to the Revolution. The most pointed is *The Allegory of Britannia Receiving the American Loyalists,* seen now only in the background of the portrait of John Eardley-Wilmot (fig. 131) and in the engraved frontispiece of Eardley-Wilmot's *Report of Losses and Compensations to the American Loyalists.* In this allegorical composition, an oversized Britannia welcomes a varied assembly of Americans (including blacks and Indians) into her protective covenant. West expressed his own sympathy for his patron's efforts to aid Americans who fled to England during the Revolution by portraying himself and his wife in the composition, standing on the right under Britannia's shield.

Fig. 129 Valentine Green (1739–1813), *Anthony Revealing the Body of Caesar,* 1781, engraving after a painting by Benjamin West. Department of Prints and Drawings, The British Museum, London.

Fig. 130 Unidentified artist, *Alexander III of Scotland Rescued from the Stag,* ca. 1786, engraving after a painting by Benjamin West. Department of Prints and Drawings, The British Museum, London.

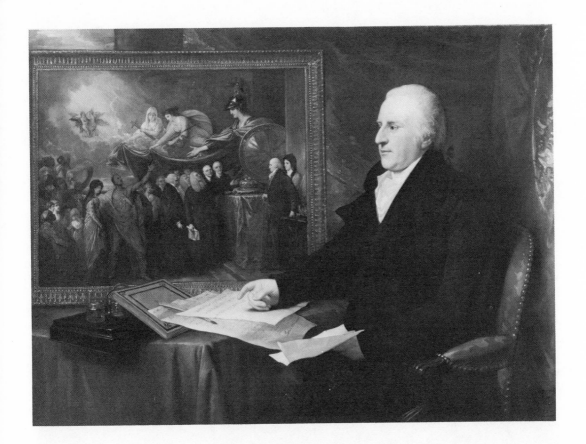

Fig. 131 *Portrait of John Eardley-Wilmot, Esq.*, 1812, oil on canvas, 41³/₈ × 58¹/₄ inches. Yale Center for British Art, New Haven, Connecticut; Paul Mellon Collection.

If *Britannia Receiving the Loyalists* indicates that West sympathized with Americans who opposed the breach with England, his unfinished depiction of the American Peace Commissioners (fig. 132)—with his friend Benjamin Franklin in the center of the composition—suggests his pride in American independence. Moreover, West had planned to paint a whole historical series based on battles of the American Revolution, but he abandoned the project because the war remained such a delicate issue in official British circles.[10]

As the structure of governments shifted in the late eighteenth century, so did West's choice of subject matter. The passionate convictions of his youth were now tempered by modern realities. Issues of patriotism and courage, which had once been unshakable bedrocks of his beliefs, blurred in definition when loyalties were divided. Impersonal panoramas of long-past battles appeared more suitable for a world turned upside down, especially when topics from antiquity had suddenly become suspect in the raw light of a revolutionary era. Almost overnight, the sacrifice and honor of noble Greeks and Romans started to represent outward defiance of the established order. Edmund Burke, Thomas Paine, and Jacques Louis David so successfully recast incidents from the ancient past into allegories of modern revolution that West found a whole range of classical subjects

transformed into messages of protest. As the official painter for the court, he could ill afford to depict subjects that might be construed as overt acts of political defiance.

Intellectual currents were also changing as the revolutionary period ushered in new ideas of freedom, individual rights, and personal dignity. Service to mankind became more appealing than imperial pride; love and piety were more gratifying than sacrificial death. So, West began painting timeless religious and literary subjects that required no polemical opinions. Still hoping to complete the promised commission for Windsor Chapel, West directed his emotional fervor to religious themes, filling his "Revealed Religion" series with much more energy than one finds in his secular history paintings from the same years. The best works of his late career were large Biblical epics such as *Christ Healing the Sick in the Temple* and *Death on a Pale Horse* (figs. 133 and 134).

When Boydell's Shakespeare Gallery opened in the 1790s, West found yet another new field for experimentation. In illustrating scenes from *King Lear* and *Romeo and Juliet* (see figs. 135 and 136), he rekindled much of the lyrical excitement that he once lavished upon dramatic episodes from classical history.

Fig. 132 *American Commissioners of the Preliminary Peace Negotiations with Great Britain,* ca. 1783, oil on canvas, 28³/8 × 36⁵/16 inches. The Henry Francis du Pont Winterthur Museum, Delaware.

Fig. 133 *Christ Healing the Sick in the Temple,* 1815–17, oil on canvas, 120 × 180 inches. Pennsylvania Hospital, Philadelphia.

Fig. 134 *Death on a Pale Horse,* 1817, oil on canvas, 175 × 302 inches. The Pennsylvania Academy of the Fine Arts, Philadelphia.

Before the end of the century, the mantle of history painting had passed to others. Copley had now mastered the grand style, creating impressive epics of modern and medieval history. One of his best, *The Death of Major Peirson* of 1782–84 (fig. 137), is an especially brilliant adaptation of West's dramatic style with its vibrant colors and compelling diagonals. Another American, John Trumbull, also refined and improved his teacher's history-painting formula when West encouraged him to paint the "Revolutionary War" series that he had abandoned. Trumbull began the project in West's London studio around 1785 with his first composition, *The Death of General Warren at the Battle of Bunker's Hill, June 17, 1775* (fig. 138), a dynamic utilization of

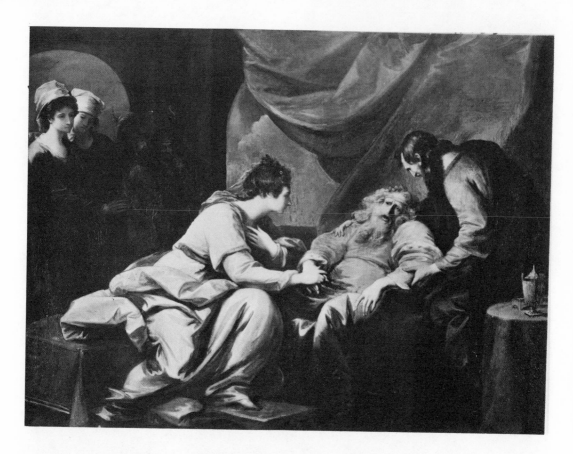

Fig. 135 *Lear and Cordelia,* ca. 1780, oil on canvas, 42¹/₂ × 57 inches. The Henry E. Huntington Library and Art Gallery, San Marino, California.

West's early dramatic formula for grand-style epics. Both Copley and Trumbull adapted West's ideas of "dramatic" and "panoramic" history painting, blending the two formats to fit their own specifications. Their battle scenes of the late 1770s and 1780s pictured a single hero sacrificing his life for a patriotic cause, a foreground audience, frontal lighting, vibrant colors, sweeping diagonals, and specific portraits.

A number of West's American students—Charles Robert Leslie, Samuel F. B. Morse, Mather Brown—also learned the history-painting formula and created their own brands of "dramatic" and "panoramic" compositions. West's American protégés were not the only beneficiaries of his grand-style formula; it soon found adherents beyond the confines of his studio, even beyond the boundaries of the English-speaking world. In France, for example, Jacques Louis David borrowed extensively from West. His large classical epics with their stagelike settings—such as *The Death of Socrates* (fig. 28)—not only resemble theatrical scenes but also have direct ties to specific plays and operas.[11]

During the nineteenth century, the grand-style history-painting formula was stretched and extended by artists in both Europe and America. Emanuel Leutze's *Washington Crossing the Delaware* of 1851 (fig. 139) is certainly a direct descendant

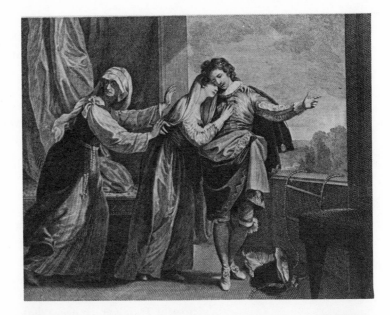

Fig. 136 William Sharp (1749–1824), *Romeo and Juliet,* 1783, engraving after a painting by Benjamin West. Department of Prints and Drawings, The British Museum, London.

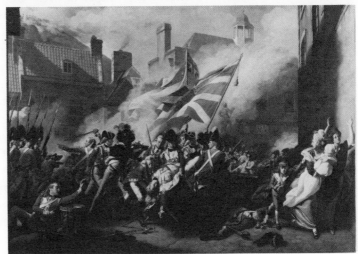

Fig. 137 John Singleton Copley (1738–1815), *The Death of Major Peirson, 6 January 1781,* 1782–84, oil on canvas, 99 × 144 inches. The Tate Gallery, London.

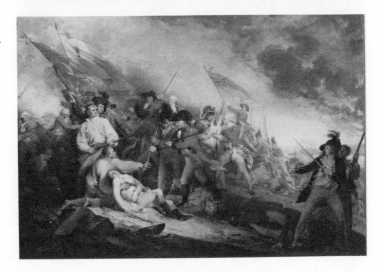

Fig. 138 John Trumbull (1756–1843), *The Death of General Warren at the Battle of Bunker's Hill, June 17, 1775,* 1786, oil on canvas, 24 × 36 inches. Yale University Art Gallery, New Haven, Connecticut; Trumbull Collection.

of West's *Death of General Wolfe*. While the two paintings are alike in scope and drama, they differ in original purpose. Leutze's painting is merely an illustration of a past event, with no suggestion of current allegory, no feeling of personal involvement. On the contrary, West's *Death of Wolfe* conveys a sense of firsthand experience and contains a moral message that relates directly to eighteenth-century interests and concerns. Although Leutze did manage to capture certain aspects of West's operatic splendor, his painting is a patriotic icon, not a dramatic memorial.

❧

The real impact of *The Death of Wolfe* comes from West's ability to encapsulate the ambiance of the late 1760s, an observation perhaps best illustrated by West himself in 1806 when he made a last attempt to paint a death tableau. For his subject he took the final moments in the life of Lord Nelson following his victory at Trafalgar, an event that inspired the same outpouring of public emotion evoked by Wolfe's death at Quebec a half-century earlier. Like Wolfe, Nelson expired at the very moment of triumph, a circumstance that signified the highest measure of patriotic devotion and sacrifice. Perhaps the most striking similarity between the two episodes was that shortly after Nelson died, Parliament announced another national competition, this time to memorialize the hero of Trafalgar.[12]

West painted several versions of Nelson's death. The first (fig. 140), now at the Walker Art Gallery in Liverpool, was designed to be a grand-style drama with all of the compositional devices of his earlier works. The admiral lies on the deck of his ship surrounded by an entourage of officers and seamen in the very kind of operatic finale that West had created in 1770. But somehow the magic had vanished. The old script and dusty scenery—revived after thirty-six years—retains only shadows of the earlier performance. The figures are stiff and colorless, the

Fig. 139 Emanuel Leutze (1816–1868), *Washington Crossing the Delaware,* 1851, oil on canvas, 149 × 255 inches. The Metropolitan Museum of Art, New York, New York; Gift of John Stewart Kennedy, 1897.

Fig. 140 *The Death of Lord Nelson,* 1806, oil on canvas, 70 × 96 inches. Walker Art Gallery, Liverpool, England.

staging false and unnatural, the composition with its extensive array of authentic portraits crowded and disjointed. Whereas Wolfe had expired with the noble and tragic valor of a Caesar, Nelson has fallen with the stunned disbelief of a music-hall comedian.

In 1770, when West decided to transport Wolfe's battlefield death from a wooded hollow attended by two or three men to the center of a "stage" surrounded by thirteen "actors," the use of artistic license brought critical applause. But thirty-six years later, when he moved Nelson's final moments from a tiny space in the belly of a ship to the crowded open deck, he received few commendations. Part of the difficulty came from the altered intellectual climate of the early nineteenth century. Poets of this romantic era rarely equated modern military heroes with the gods of Olympia, and no library of turgid eulogies supported the transition from recorded fact to imaginary allegory. Furthermore, West had been trapped by his desire to foster historical accuracy in art. The painting, therefore, is filled with scrupulous

details carefully gathered from sailors who had been aboard the HMS *Victory* when Nelson died.[13] In many ways, West's commitment to verisimilitude defeated his original aim of creating a heroic memorial. Too much information negates his theatrical format, leaving no clear division between actors and background, no simple dynamic composition. Instead, the canvas is jumbled and disturbing. By being too diligent in his mission as a historian, West lost his distinction as a dramatist.

West's first *Death of Lord Nelson* clearly revealed that the artist could not be a playwright and a reporter at the same time, because an apotheosis and a documentary have conflicting objectives. The former requires exaggeration and imagination, the latter truthfulness and accuracy. West was at once trying to create a eulogy and to record in meticulous detail the participants in a well-documented battle. Not long after he completed his first *Death of Nelson,* the disparity was made emphatically evident. His awakening came after he saw Arthur William Devis's painting of the same subject, a representation of the death scene as it actually occurred in the hold of the ship. But being a valiant hero himself, West refused to admit defeat. Defending his own composition, he told Joseph Farington that there was

no other way of representing the death of a Hero but by an Epic *representation of it. It must exhibit the event in a way to excite awe, & veneration & that which may be required to give superior interest to the representation must be introduced, all than can shew the importance of the Hero.—Wolfe must not die like a common Soldier under a Bush; neither should Nelson be represented dying in the gloomy hold of a Ship, like a sick man in a Prison Hole.—To move the mind there should be a spectacle presented to raise & warm the mind, & all shd. be proportioned to the highest idea conceived of the Hero. No Boy, sd. West, wd. be animated by a representation of Nelson dying like an ordinary man, His feelings must be roused & His mind inflamed by a scene great & extraordinary. A mere matter of fact will never produce the effect.[14]*

In the next two years, West retreated from this lofty but illogical idealism that had once brought him fame and fortune. Now he allowed the two opposite poles of his history-painting formula—allegory and documentation—to separate and reconstitute themselves in two antithetical guises. One was the design for a proposed monument to Lord Nelson (fig. 141), the center of which contains an allegorical painting depicting the admiral's body being transported to heaven by Britannia, Neptune, and a whole host of flying putti and angels. This imaginary vision, which made no pretense of historical reality, was a pure flight of the imagination. Gods of sea and land, symbols of the British

Fig. 141 *Project for the Monument of the Apotheosis of Nelson,* 1812, oil on canvas, 39½ × 29 inches. Yale Center for British Art, New Haven, Connecticut; Paul Mellon Collection.

Empire and of peace and God's benign blessings, leap around the admiral's body, classically wrapped in a shroudlike toga. At the base of the proposed monument, soldiers and citizens mourn, their presence posing a jarring contrast to the mythological fantasy transpiring above. The strangely anachronistic memorial speaks loudly of how far West had moved from his conscientious neoclassicism of the 1760s. In employing the vast array of emblems and allegorical representations, he had totally rejected Shaftesbury's instructions for the classical personification of a hero.

West's other rendition of the Nelson story veered in an entirely different direction. In his final attempt to memorialize Lord Nelson (fig. 142), West pictured the admiral in his "gloomy" stateroom attended by only a few of his officers. Nelson's face is white, his body stiff. In every way the military hero resembles the "sick man in a Prison Hole" that West had scorned a few years earlier. All attempts to "move the mind" or elevate the spirit had vanished, and in their stead survives a lifeless doc-

Fig. 142 *The Death of Lord Nelson,* 1808, oil on canvas, 34$\frac{1}{2}$ × 28$\frac{1}{2}$ inches. National Maritime Museum, Greenwich, London.

ument that recreated the event just as it had happened.

The reversed Hegelian triad suggested by West's three memorials to Lord Nelson presents convincing evidence that the artist had restructured his aesthetic orientation to synthesize the triumphs of his past with the realities of his present. Many works of West's late career followed the two extremes found in the Nelson paintings. Some were spiritual, symbolic, and allegorical; others were naturalistic, well documented, and rational. Missing in most cases was the spark of adventure that characterized his paintings of the 1760s. Frequent attacks of gout and other debilitating ailments of old age, isolation from former friends and colleagues, loss of patronage, the illness and eventual death of his wife—all made West lonely and bitter.

Had he lived only into his mid-thirties, West might be remembered today as a veritable "American Raphael" who, like his Italian Renaissance predecessor, blazed a meteoric path but died long before his brilliant potential could be realized. For a half-century after painting *The Death of General Wolfe,* West continued on, however, a lonely public figure attempting to recapture the challenges and excitement of his youth. In his halcyon days West had been ahead of the tide; he had anticipated

the needs of his patrons and intuited the pulse of the public. It is in this light that he should survive, not as a feeble, eighteenth-century relic who had outlived his time, but as the valiant young hero of Georgian London who translated the cultural, social, and political temper of the moment into sensitive narratives that spoke to a generation steeped in classical rhetoric and theatrical fantasy.

Notes

The following abbreviations are used for archival sources mentioned in the notes:

AAA	Archives of American Art, Smithsonian Institution, Washington, D.C.
APS	American Philosophical Society, Philadelphia, Pennsylvania
HSP	Historical Society of Pennsylvania, Philadelphia
PAFA	The Pennsylvania Academy of the Fine Arts, Philadelphia

The following shortened forms (used hereafter) are for printed reference sources that appear frequently throughout the notes:

Artists, 1700–1799	Whitley, William T. *Artists and Their Friends in England, 1700–1799,* vol. 1 (London and Boston: Medici Society, 1928).
Barockthemen	Pigler, A. *Barockthemen,* vol. 2 (Budapest: Ungarischen Akademie der Wissenschafter, 1966).
Belle Assemblée	*La Belle Assemblée; or, Bell's Court Fashionable Magazine* 4 (1808).
Benjamin West	Alberts, Robert C. *Benjamin West: A Biography* (Boston: Houghton Mifflin, 1978).
DNB	*Dictionary of National Biography*
Farington Diary	Garlick, Kenneth, and Macintyre, Angus, eds. *The Diary of Joseph Farington,* vols. 1–6 (New Haven: Yale University Press, 1978–79).
Life of West	Galt, John. *The Life, Studies, and Works of Benjamin West, Esquire,* 2 vols. (Gainesville, Fla.: Scholars' Facsimiles and Reprints, 1960).
PMHB	*Pennsylvania Magazine of History and Biography*
"Press Cuttings"	"Press Cuttings from English Newspapers on Matters of Artistic Interest, 1686–1835," The Victoria and Albert Museum, London.
Public Characters	*Public Characters of 1805* 7 (1805).

Preface

1. Joel Barlow, *The Columbiad, A Poem* (Philadelphia, 1807), 290.

2. West was so prolific that even in isolating a small segment of his career, I had to ignore certain paintings. In this study I have analyzed only his more important works from the 1760s and early 1770s. I am well aware, however, that during these same years, West painted a number of other theatrical compositions, most based on incidents from classical history. To spotlight each of these would not only have lengthened the manuscript, but would have created a tedious and repetitious text.

Among the recent book-length studies are Dorinda Evans, *Benjamin West and His American Students* (Washington, D.C.: National Portrait Gallery, Smithsonian Institution, 1980); Alberts, *Benjamin West;* and John Dillenberger, *Benjamin West: The Context of His Life's Work with Particular Attention to Paintings with Religious Subject Matter* (San Antonio, Tex.: Trinity University Press, 1977).

3. See, for example, Bernard S. Myers, ed., *McGraw-Hill Dictionary of Art* (New York: McGraw-Hill, 1969), 3: 102. A better and more comprehensive definition may be found in *Encyclopedia of World Art* (New York: McGraw-Hill, 1963), 7:485–94.

4. Joshua Reynolds, *Discourses on Art,* ed. Robert Lavine (New York: Collier Books, 1961), 44, 55.

5. Joshua C. Taylor, *Learning to Look* (Chicago: University of Chicago Press, 1957), 131.

Chapter 1

1. This and all other quotations in the anecdote come from Galt, *Life of West* 2: 46–50.

2. Galt has the wrong date. The correct date is 1759.

3. Joshua Reynolds, *Discourses on Art,* ed. Robert Lavine (New York: Collier Books, 1961), 56.

4. See Leon Battista Alberti, *On Painting,* trans. John R. Spencer (New Haven: Yale University Press, 1956).

5. Rensselaer W. Lee, *Ut Pictura Poesis: The Humanistic Theory of Painting* (New York: W. W. Norton, 1967), 19; Charles Alphonse du Fresnoy, *The Art of Painting [De Arte Graphica],* trans. William Mason and annot. Joshua Reynolds (New York: Arno Press, 1969), 9, 16; Nicolas Poussin, "Observations on Painting," in *From the Classicists to the Impressionists: A Documentary History of Art and Architecture in the Nineteenth Century,* vol. 2, ed. Elizabeth G. Holt (Garden City, N.Y.: Doubleday, Anchor, 1958), 144; Reynolds, *Discourses,* 44; and Anthony Ashley Cooper, Third Earl of Shaftesbury, "An Essay on Painting Being a Notion of the Historical Draught or Tablature of the Judgment of Hercules," *Characteristicks* (London, 1714), 3: 347–91.

6. Fresnoy, *Art of Painting,* 10–11, 15.

7. Garlick and Macintyre, *Farington Diary* 2: 285 (entry 1 January 1795).

8. Benjamin West to Peter Thompson, 23 February 1772, HSP (AAA roll P23/221).

9. Around the same time, Charles Willson Peale portrayed West as a younger and less sophisticated man. The painting is now in the collection of the New-York Historical Society. For more information about West's self-portraits, see Ann C. Van Devanter, "Benjamin West and His Self-portraits," *Antiques* 103 (April 1973); 764–71.

10. Around the same time that West painted *The Artist's Family,* he also created separate portraits of himself and of his wife with their son Raphael. All three of these works are in the collection of the Yale Center for British Art, New Haven, Connecticut. The portrait *Mrs. West and Her Son Raphael* is modeled after the *Madonna della Sedia* by Raphael (Raffaello Sanzio).

11. In 1818 West presented this self-portrait to the Society of Dilettanti, which he had joined in 1792; it is now in the Fogg Art Museum, Harvard University. For a description, see George A. Macmillan, *The Society of Dilettanti* (London: Macmillan, 1932), 79–80.

12. For the best description of West's problems at the Royal Academy, see Alberts, *Benjamin West,* 274–375; and for more detailed information on the issues, see Garlick and Macintyre, *Farington Diary* 3–6: passim.

13. An example of West's debunking may be found in William Hazlitt, "Table Talk" of 1821, published in Robert Wraight, *Hip! Hip! Hip! R.A.* (London: Leslie Frewin, 1968), 44–45. Other critical remarks may be found in William C. Monkhouse, *Masterpieces of English Art* (London: Bell & Daldy, 1869), 51; and W. Burger, *Histoire des Peintres de Toutes les Écoles Anglais* (Paris 1863), 9. His students' attitudes are found in the Thomas Lawrence Papers 4:

263, 274; and in E. Beaumont to T. Lawrence, 13 March 1825, Royal Academy of Arts, London. A discussion of his reputation is found in Alberts, *Benjamin West,* 393–407.

For information on West's life, see Alberts, *Benjamin West;* Dorinda Evans, *Benjamin West and His American Students* (Washington, D.C.: National Portrait Gallery, Smithsonian Institution, 1980); John Dillenberger, *Benjamin West: The Context of His Life's Work with Particular Attention to Paintings with Religious Subject Matter* (San Antonio, Tex.: Trinity University Press, 1977); Grose Evans, *Benjamin West and the Taste of His Times* (Carbondale: Southern Illinois University Press, 1959); and Henry E. Jackson, *Benjamin West, His Life and Work* (Philadelphia: John C. Winston, 1900).

14. Allan Cunningham, *The Lives of the Most Eminent British Painters and Sculptors* (New York: J. & J. Harper, 1831), 2: 52–53.

15. Richard and Samuel Redgrave, *Century of British Painters,* ed. Ruthven Todd (Ithaca: Cornell University Press, 1981), 81.

16. Professor Allen Staley of Columbia University has been working for many years on a catalogue raisonné of West's work, which at the time of this writing is yet to be completed. Staley inherited much of his material from the late Helmut Von Erffa, who spent the better part of his life tracking down paintings by West. A listing of the sale of West's works at the time of his death may be found in George Robins, *A Catalogue Raisonné of the Unequalled Collection of Historical Pictures and Other Admired Compositions of Benjamin West, Esq. Sold by George Robins in the Gallery at Newman Street, May, 1829.* (London, 1829); in U.S. Congress, House, *Letter to the Speaker of the House of Representatives of the United States,* 11 December 1826, H.R. 8; and in West's Gallery, *Catalogue of Pictures and Drawings by the Late Benjamin West* (London, 1824).

17. See Christian Brinton, "Reevaluation of Benjamin West," *Art in America* 26 (July 1938); 137–38; Ella S. Siple, "Art in America: Three Exhibitions of Eighteenth-Century Art," *Burlington Magazine* 72 (May 1938): 238; and Fiske Kimball, *Benjamin West: 1738–1820* (Philadelphia: Philadelphia Museum of Art, 1938). Another exhibition of West's works was held more than two decades later; see *The World of Benjamin West* (Allentown: Pennsylvania Art Museum, 1962).

18. Edgar Wind, "The Revolution of History Painting," *Journal of the Warburg Institute* 2 (Oc-tober 1938): 117–21; Alfred Neumeyer, "The Early Historical Paintings of Benjamin West," *Burlington Magazine* 73 (October 1938): 162–65; and Charles Mitchell, "Benjamin West's 'Death of General Wolfe' and the Popular History Piece," *Journal of the Warburg and Courtauld Institutes* 7 (1944): 20–33.

19. Oliver Millar, *Later Georgian Pictures in the Collection of Her Majesty the Queen* (London: Phaidon, 1969), 1: x.

Chapter 2

1. The most widely circulated original edition was published in London by T. Cadwell and W. Davies in 1820 and has been reprinted several times. Quotations in this book come from Scholars' Facsimiles and Reprints, Gainesville, Florida, 1960. For criticism of the Galt text, see William Dunlap, *A History of the Rise and Progress of the Arts of Design in the United States* (New York: Dover Publications, 1969), 1: 34. Among the many sources that use information from Galt's text as actual fact are Henry E. Jackson, *Benjamin West, His Life and Work* (Philadelphia: John C. Winston, 1900); Dorthea J. Snow, *Benjamin West, Gifted Young Painter* (Indianapolis: Bobbs-Merrill, 1967); Marguerite Henry, *Benjamin West and His Cat Grimalkin* (New York: Bobbs-Merrill, 1947); Grose Evans, *Benjamin West and the Taste of His Times* (Carbondale: Southern Illinois University Press, 1959); Hampton L. Carson, "Life and Works of Benjamin West," *PMHB* 45 (1921): 301–19; and Allan Cunningham, *The Lives of the Most Eminent British Painters and Sculptors,* vol. 2 (New York: J. & J. Harper, 1831). A summary of the Galt biography appears as an appendix to Alberts, *Benjamin West,* 409–12.

2. Quoted in Alberts, *Benjamin West,* 409–10.

3. Frank H. Lyell, *A Study of the Novels of John Galt* (Princeton: Princeton University Press, 1942), 25, 28; and Ian A. Gordon, *John Galt: The Life of a Writer* (Edinburgh: Oliver and Boyd, 1972), 16.

4. In the 1820s Galt became a successful author of novels about his childhood in Scotland. For reviews of the West biography, see Lyell, *Novels of John Galt,* 42.

5. Galt, *Life of West* 1: 20.

6. Ibid., 2.

7. For nineteenth-century biographies of West, see *Belle Assemblée,* 5–12, 52–55, 109–11, 149–

51, 197–98; *Public Characters,* 523–69; and *The Annual Register* (1820): 1163–75. For nine-teenth-century sources that mention of West's link with Lord Delawarre, see *Belle Assemblée,* 5; *Public Characters,* 524; and *Annual Register* (1820), 1163. For West's genealogy, see Letta Brock Stone, *The West Family Register* (Washington, D.C.: W. F. Roberts Co., 1928), 311; and C. T. Barnhill, *Joseph West and Jane Owen* (Ann Arbor: University Microfilms, 1971), 7. I am grateful to Lucy Simler for helping me obtain much of this information.

8. For an anecdote about West's discovery of his Delawarre ancestry, see Cunningham, *Eminent British Painters* 2: 5–6.

9. See Galt, *Life of West* 2: 189–90; Alberts, *Benjamin West,* 180–81; and Dunlap, *Design in the United States* 1: 73.

10. See Galt, *Life of West* 1: 4–5. The inn owned by John West was located on "the Road Leading from Darby to Springfield" and, as one source indicates, was "much frequented by the Duch waggons [sic] to the number of 40 or 50 in a Day." *Chester County Tavern Papers* 4: 114; George D. Smith, *History of Delaware County Pennsylvania* (Philadelphia: Henry B. Ashmead, 1862), 259; and John F. Watson, *Annals of Philadelphia and Pennsylvania, in Olden Time* (Philadelphia: Whiting & Thomas, 1856), 2:80–83.

11. HSP (AAA roll P25/497). John West's role in the abolitionist movement is also mentioned in the William T. Whitley notes, 13: 1667, Department of Prints and Drawings, The British Museum, London.

12. West's meeting with the abolitionists is mentioned in Dunlap, *Design in the United States* 1:60; and his mission to Queen Charlotte in W. Dillwyn to J. Phillips, 4 August 1784, The New-York Historical Society, and in George S. Brookes, *Friend Anthony Benezet* (Philadelphia: University of Pennsylvania Press, 1937), 402–3.

13. Galt, *Life of West* 12: 8–9.

14. The cause of her banishment from the Society of Friends was specifically recorded: "Sarah Pearson, of Marple, a child of believing parents, disowned 12-24-1717 for fornication." See Horace M. Lippincott, "Benjamin West, 1757 C.," *General Magazine Historical Chronicle* 47 (Autumn 1944): 27; and Barnhill, *Joseph West,* 11. Although West was affiliated with the Anglican church in England, he often spoke of his Quaker origins. He is quoted as having said, "I was once a Quaker and have never left the princi-

ple." *PMHB* 6 (1882): 495.

15. For a description of Whitefield's tour of Pennsylvania, see Leonard W. Labaree et al., eds., *The Autobiography of Benjamin Franklin* (New Haven: Yale University Press, 1964), 175–78; Smith, *Delaware County,* 252; and Louis B. Wright, *The Cultural Life of the American Colonies, 1607–1763* (New York: Harper Torchbooks, 1962), 93–94.

16. Galt, *Life of West* 1: 10. These same stories were recalled by West's family members. See, for example, Raphael West to Joseph Hopkinson, 4 December 1823, AAA (roll P88/330–31), and Samuel West to Henry Carey, 2 December 1820, AAA.

17. Galt, *Life of West* 1: 18.

18. In a letter of 1798 West recalled the "morning" of his life "when inocently [sic] sporting on the Banks of those refreshing streems [sic]" of rural Pennsylvania. See *PMHB* 18 (1894): 221.

19. Galt, *Life of West* 1:21. The Wests did have a relative, Edward Penington, whose name was incorrectly spelled by Galt as "Pennington." He was a wealthy Philadelphia judge whose brother-in-law, Samuel Shoemaker, a prosperous merchant, fled to England during the Revolution and spent time with West and his family. See Alberts, *Benjamin West,* 11–12; and "The Diary of Samuel Shoemaker of Philadelphia," HSP.

20. There were several Friends schools in rural Chester County that West could have attended with neighbors or relatives. Or, he could have been enrolled in the academy at New London, founded in 1743 by the Presbyterian minister Francis Alison. Several years later, Alison became a teacher at the College of Philadelphia, where he was still employed when West was there in the late 1750s. See Wright, *American Colonies,* 109; and William J. Frost, *The Quaker Family in Colonial America: A Portrait of the Society of Friends* (New York: St. Martin's Press, 1973), 180–81.

21. See Peter S. Walch, "Charles Rollin and Early Neoclassicism," *Art Bulletin* 49 (June 1967): 123–26; and Ann C. Van Devanter, "Benjamin West's *Death of Socrates:* A New Phase in the Life of a Venerable American History Piece," *Antiques* 104 (September 1973): 436–39.

22. David H. Dickason, "Benjamin West on William Williams: A Previously Unpublished Letter," *Winterthur Portfolio* 6 (1970): 130–31; and Galt, *Life of West* 1: 28–29.

23. Galt, *Life of West* 1: 28.

24. Dickason, "Benjamin West," 131.

25. Galt, *Life of West* 2: 203.

26. Ernst Kris and Otto Kurtz, *Legend, Myth, and Magic in the Image of the Artist* (New Haven: Yale University Press, 1979), 12.

27. Ibid., 13–60.

28. Betty Burroughs, ed., *Vasari's Lives of the Artists* (New York: Simon and Schuster, 1966), 102–4, 136–40, 155–58, 247–99.

29. Galt, *Life of West* 1: 29–31.

Chapter 3

1. Galt's text reads: "Every thing in Pennsylvania . . . was unpropitious to the fine arts. There were no cares in the bosoms of individuals to require public diversions, nor any emulation in the expenditure of wealth to encourage the ornamental manufactures. In the whole Christian world no spot was apparently so unlikely to produce a painter as Pennsylvania." Galt, *Life of West* 1: 16.

2. Carl Bridenbaugh, *Cities in Revolt: Urban Life in America, 1743–1776* (New York: Alfred A. Knopf, 1955), 5, 13–15; and John F. Watson, *Annals of Philadelphia and Pennsylvania, in Olden Time* (Philadelphia: Whiting & Thomas, 1856), 1:211; and Galt, *Life of West* 1: 25–26.

3. As early as the mid-1740s, Pennsylvania Germans were manufacturing musical instruments and forming their own "Musick Clubs." During the winter of 1748–49 the Philadelphia Dancing Assembly began holding its weekly subscription balls for selected members. See Watson, *Annals of Philadelphia* 1: 284; Bridenbaugh, *Cities in Revolt,* 194; and Harvey Wish, *Society and Thought in Early America* (New York: David McKay Co., 1950), 126–27, 130–44, 180–81.

4. Smibert supposedly left forty-one history paintings at his death and Feke is reported to have created a variety of narrative compositions. Among works by these two artists are *The Judgment of Hercules* by Feke and *The Continence of Scipio* by Smibert, both about themes that West would later explore. There were several art collections in colonial Philadelphia, one of the most notable being that of Andrew Hamilton at Bush Hill. See George Vaux, "Extracts from the Diary of Hannah Callender," *PMHB* 12 (1898): 433; Bridenbaugh, *Cities in Revolt,* 404–8; and Alexander Hamilton, *Itinerarium* (New York: Arno

Press, 1971), 124–25, 138–39. For information on Feke, see R. Peter Mooz, "Robert Feke: The Philadelphia Story" in *American Painting to 1776: A Reappraisal,* ed. Ian M. G. Quimby (Winterthur, Del.: Winterthur Conference Report, 1971), 181–216; Henry W. Foote, *Robert Feke* (Cambridge: Harvard University Press, 1930); and Lloyd Goodrich, *Robert Feke* (New York: Whitney Museum of American Art, 1946). On Smibert, see Stephen T. Riley, "John Smibert and the Business of Portrait Painting" in Quimby, *American Painting to 1776,* 159–80; R. Peter Mooz, "Smibert's *Bermuda Group*—A Reevaluation," *Art Quarterly* 33 (Summer 1970): 147–57; and Henry W. Foote, *John Smibert, Painter* (Cambridge: Harvard University Press, 1950).

5. See "Gustavus Hesselius, The Earliest Painter and Organ-Builder in America," *PMHB* 29 (1905): 129–33; Roland E. Fleischer, "Gustavus Hesselius: A Study of His Style" in Quimby *American Painting to 1776,* 127–58; Edgar P. Richardson, "Gustavus Hesselius," *Art Quarterly* 12 (Summer 1949): 220–26; Frederick B. Tolles, "A Contemporary Comment on Gustavus Hesselius," ibid. 17 (Autumn 1954): 271–72; and Christian Brinton, *Gustavus Hesselius, 1682–1755* (Philadelphia: Philadelphia Museum of Art, 1938).

6. David H. Dickason, "Benjamin West on William Williams: A Previously Unpublished Letter," *Winterthur Portfolio* 6 (1970): 131. West remained friendly with Williams for many years, and when the older artist returned to England during the Revolution, West included him as one of the sailors in his *Battle of La Hogue* (fig. 124). For further information on Williams, see William Sawitzky, "William Williams, First Instructor of Benjamin West," *Antiques* 31 (May 1937): 240–42; David H. Dickason, *William Williams, Novelist and Painter of Colonial America* (Bloomington: Indiana University Press, 1970); William H. Gerdts, "William Williams: New American Discoveries," *Winterthur Portfolio* 4 (1968): 159–67; and Edgar P. Richardson, "William Williams—A Dissenting Opinion," *American Art Journal* 4 (Spring 1972): 5–23.

7. Although these paintings are unsigned, they have long been attributed to West because they have been passed down in the family of the sitters until recently given to the Chester County (Pa.) Historical Society. See William Sawitzky, "The American Work of Benjamin West," *PMHB* 62 (October 1938): 446–48.

8. Dickason, "Unpublished Letter," 131.

9. Galt, *Life of West* 1: 60–68. For other evidence of West's involvement in the French and Indian War, see Garlick and Macintyre, *Farington Diary* 4: 1521–22 (entry 15 March 1801).

10. Information on his other works in Lancaster may be found in the Henry manuscripts, HSP (AAA roll P20/679); in Harry M. Tinckom, "Sir Augustus in Pennsylvania: The Travels and Observations of Sir August J. Foster in Early Nineteenth-Century Pennsylvania," *PMHB* 75 (October 1951): 362; and in Sawitzky, "American Work," 437, passim. See also, Watson, *Annals of Philadelphia* 1: 575; and unidentified clipping in the Quaker Scrapbook, HSP (AAA roll P24/37); and a memo from Anne M. Smith, 27 March 1855, Henry manuscripts, HSP (AAA roll P20/679).

11. The full quotation is: "I dined alone & went to tea at Mr. West's. . . . Mrs. Loyd said Her Father George Michael Moser . . . and five other foreigners made up a little Academy for drawing from a living model by lamp light. The room they hired for the purpose was in Gough square, Fleet street. One of the foreigners was Mr. Hide, a German, who afterwards went to Philadelphia, and when Mr. West was a boy gave him some instruction." Garlick and Macintyre, *Farington Diary* 5: 1998–99 (entry 23 March 1803). I was first led to this discovery by a footnote in Alberts, *Benjamin West*, 420. The presence of "Mr. Hide" is further substantiated in another diary notation by Hannah Callender, who commented in 1761 about the paintings of a German minister, "Mr. Hyde," in the Moravian community of Bethlehem. See Vaux, "Diary," 450, 453.

12. For information on Haidt, see Vernon Nelson, *John Valentine Haidt* (Williamsburg, Va.: Abby Aldrich Rockefeller Folk Art Collection, 1966); Garth A. Howland, "John Valentine Haidt, A Little-Known Eighteenth Century Painter," *Pennsylvania History* 8 (October 1941): 304–13; John F. Morman, "The Painting Preacher: John Valentine Haidt," ibid. 20 (April 1953): 180–86; and Monroe H. Fabian, "Some Moravian Paintings in London," *Pennsylvania Folklife* 17 (Winter 1967): 20–23.

13. For a more complete comparison of West's and Haidt's works, see Ann Uhry Abrams, "A New Light on Benjamin West's Pennsylvania Instruction," *Winterthur Portfolio* 17 (Winter 1982): 247.

14. Galt, *Life of West* 1: 36–37.

15. See Ann C. Van Devanter, "Benjamin West's *Death of Socrates*: A New Phase in the Life of a Venerable History Piece," *Antiques* 104 (September 1973): 436–39; Peter S. Walch, "Charles Rollin and Early Neoclassicism," *Art Bulletin* 49 (June 1967): 123–26; and James T. Flexner, "Benjamin West's American Neo-Classicism," *New-York Historical Society Quarterly* 36 (January 1952): 20–27.

16. For further discussion of Haidt's use of statuary and other influences on West, see Abrams, "New Light," 247, 250–51.

17. A play, *The Death of Socrates* by E. Harrison, published in 1756, is recorded by Allardyce Nicoll, *A History of Late Eighteenth-Century Drama, 1750–1800* (Cambridge: Cambridge University Press, 1927), 266. Diderot's outline for the play based on the death of Socrates is in *Traité de la Poésie dramatique* of 1758. See Jean Seznec, "Le Socrate imaginaire" in *Essais sur Diderot et l'Antiquité* (Oxford: Clarendon Press, 1957), 1–22; and Anita Brookner, *Jacques-Louis David* (New York: Harper & Row, 1980), 84–85. For information on William Henry, see Francis Jordan, Jr., *The Life of William Henry of Lancaster, Pennsylvania, 1729–1786* (Lancaster: New Era Printing Co., 1910); and "Biographical Sketch of William Henry of Lancaster County, Pennsylvania," *PMHB* 27 (1903): 91–93. Two decades after West's visit to Lancaster, Henry and his family joined the Moravian church [ibid. 14 (October 1890): xi]. Although it is tempting to speculate that Haidt may have been one link between West, Henry, and the Moravians, there is no factual basis to prove any such connection.

18. Among the artists known to have painted the death of Socrates theme before West are Salvatora Rosa, Charles Alphonse du Fresnoy, and G. B. Cignaroli. See Pigler, *Barockthemen*, 412–13; and miscellaneous information in the Frick Art Reference Library, New York City.

19. Seznec, "Le Socrate imaginaire," 6–7; and Brookner, *Jacques-Louis David,* 37–38, 112.

20. The sophistication of West's *Death of Socrates* suggests that Smith may have influenced the concept and composition of the painting before its completion. As he often traveled to Lancaster, it is highly possible that Smith contacted West while West was still working on the painting. See Bruce R. Lively, "William Smith, The College and Academy of Philadelphia and Pennsylvania Politics, 1753–1758," *Historical Magazine of the Protestant Episcopal Church* 38 (September 1969): 248.

21. The Smith–Penn correspondence is in the Thomas Penn Letterbook, HSP. For Smith's biography, see Horace Wemyss Smith, *Life and Correspondence of the Reverend William Smith, D.D.* (New York: Arno Press, 1972); Albert Frank Gegenheimer, *William Smith, Educator and Churchman, 1727–1803* (Philadelphia: University of Pennsylvania Press, 1943); and Thomas Firth Jones, *A Pair of Lawn Sleeves: A Biography of William Smith (1727–1803)* (Philadelphia: Chilton Book Co., 1972). Among the many accounts of the Smith–Franklin quarrel are James H. Hutson, *Pennsylvania Politics, 1746–1770: The Movement for Royal Government and Its Consequences* (Princeton: Princeton University Press, 1972), "Benjamin Franklin and William Smith: More Light on an Old Philadelphia Quarrel," *PMHB* 93 (January 1969), 109–13, and "Benjamin Franklin and Pennsylvania Politics, 1751–1755: A Reappraisal," ibid. 93 (July 1969): 303–71; Ralph L. Ketcham, "Benjamin Franklin and William Smith: New Light on an Old Philadelphia Quarrel," ibid. 88 (April 1964): 142–63; and *Minutes of the Provincial Council of Pennsylvania* 8: 438–46.

22. Galt, *Life of West* 1: 44–45. See also, William Smith, *Account of the College and Academy of Philadelphia* [1758] (Philadelphia: University of Pennsylvania Press, 1951), 534, passim.

23. There is no documentary proof that West was ever enrolled in the College of Philadelphia. For Smith's educational program, see "A General Idea of the College of Mirania" in *The Works of William Smith, D.D., Late Provost of the College and Academy of Philadelphia* (Philadelphia, 1803), 1: 165–248; W. Smith to R. Peters, 18 July 1754, HSP; and articles in the *Pennsylvania Gazette,* 20 and 27 December 1759.

24. William Smith, *A Charge Delivered May, 1757, at the First Anniversary Commencement in the College and Academy of Philadelphia* (Philadelphia, 1757), 4, 10–11, passim.

25. Excerpted from William Smith, "A Christian Soldier's Duty" (5 April 1757) in *Works* 2: 172, 174–75; *Speech of a Creek-Indian, against the Immoderate Use of Spiritous Licquors* (Philadelphia, 1754), 41, passim; and "Discourse Concerning the Conversion of the Heathen Americans and the Final Propagation of Christianity and the Sciences to the Ends of the Earth" (Philadelphia, 1760), Rare Books Room, Library of Congress.

26. For more complete analysis of this illustration, see Ann Uhry Abrams, "Benjamin West's Documentation of Colonial History: *William Penn's Treaty with the Indians,*" *Art Bulletin* 64 (March 1982): 63–64.

27. For information on these four men, see Gegenheimer, *William Smith,* 95–123; George E. Hastings, *The Life and Works of Francis Hopkinson* (Chicago: University of Chicago Press, 1926); Oscar G. T. Sonneck, *Francis Hopkinson and James Lyon* (New York: Da Capo Press, 1967); Thomas P. Haviland, "Francis Hopkinson and the Grammarians," *PMHB* 126 (1952): 63–70; Charles R. Hildeburn, "Francis Hopkinson," ibid. 2 (1878): 314–24; Edward D. Neill, "Rev. Jacob Duché, The First Chaplain of Congress," ibid., 58–73; and Jacob Duché, *Discourses on Various Subjects . . . ,* 2 vols.: (London, 1790).

28. Francis Hopkinson, "On the Late Successful Expedition against Louisbourg," handwritten copy, The Henry E. Huntington Library and Art Gallery, San Marino, California; printed in *American Magazine* (August 1758).

29. *Pennsylvania Gazette,* 8 November 1759.

30. *American Magazine* (February 1758), 237–38. Written in the margin of this volume in the Rare Books Room, Library of Congress, is Joseph Shippen's identity as author of the poem.

31. Ibid. (September 1758), 607.

32. For information on Wollaston, see Wayne Craven, "John Wollaston: His Career in England and New York City," *American Art Journal* 7 (November 1975): 19–31.

33. Galt wrote that Smith suggested that West paint his portrait in the "style and attitude" of St. Ignatius. A portrait of Smith, painted by West at this time, is now owned by the Historical Society of Pennsylvania. It has been so badly restored and incorrectly repainted that most of West's original work has been obliterated. In an etching made during the nineteenth century by John Sartain, however, we can obtain a fairly clear idea of the oratory pose that may have been copied from the Spanish painting of St. Ignatius described by Galt. Galt, *Life of West* 1: 71–72.

34. West may have chosen this subject because circumstances of the trial resembled Smith's arrest and imprisonment. In the apocryphal Old Testament story, Susanna was falsely accused of adultery and exonerated after Daniel defended her right to present her case before a tribunal. In the same fashion, Smith had been accused of sedition by his enemies in the Pennsylvania Assembly and cleared of the charges after a hearing before George II's Privy Council. It is unfortunate that

we are unable to examine the canvas, which was reportedly lost at sea; it would be helpful to know how West interpreted this subject, which has so few artistic precedents. Galt, *Life of West* 1: 72–73. For information on *Susanna at the Bath* and other paintings illustrating this story, see Pigler, *Barockthemen,* 227–29.

35. See Abrams, "New Light," 257, fn. 21.

36. Thomas Clark Pollock, *Philadelphia Theatre in the Eighteenth Century* (New York: Greenwood Press, 1968), 6–7; and John C. Loftis, *The Politics of Drama in Augustan England* (Oxford: Clarendon Press, 1963), 44, 57–61. See also, Hugh Rankin, *The Theatre in Colonial America* (Chapel Hill: University of North Carolina Press, 1960), 65–71; Pollock, *Philadelphia Theatre,* 7–11; Loftis, *Politics of Drama,* 31–34; and William S. Dye, "Pennsylvania *Versus* the Theatre," *PMHB* 55 (1931): 354–55.

37. *Pennsylvania Journal and Weekly Advertiser,* 27 January 1757.

38. *Pennsylvania Gazette,* 30 August 1759.

39. *Pennsylvania Archives* 3 (1759): 659.

40. *Pennsylvania Gazette,* 8 November 1759.

41. Pollock, *Philadelphia Theatre,* 12.

42. Edgar P. Richardson, "West's Voyage to Italy, 1760, and William Allen," *PMHB* 102 (January 1978): 8–10; and Galt, *Life of West* 1: 84–85.

Chapter 4

1. Galt, *Life of West* 1: 99.

2. For a full description of West's voyage and first weeks in Italy, see Alberts, *Benjamin West,* 29–40.

3. Ibid., 103.

4. For the story of the Albani–Mann correspondence and espionage mission, see Lesley Lewis, *Connoisseurs and Secret Agents in Eighteenth-Century Rome* (London: Chatto & Windus, 1961).

5. The best-known of Mengs's early neoclassical paintings that West might have seen in his studio are *Judgment of Paris* (ca. 1756–57), *Joseph in Prison* (ca. 1756–58), and two versions of *Augustus and Cleopatra* (ca. 1760). Although the paintings resemble the austere historical canvases that Poussin created in Rome a century earlier, Mengs's figures were more sculptural than Poussin's and his compositions more precise and rectilinear. See Thomas Pelzel, *Anton Raphael Mengs*

and Neoclassicism (New York: Garland, 1979), 70–127; and Kenneth Woodbridge, *Landscape and Antiquity: Aspects of English Culture at Stourhead, 1718–1838* (Oxford: Clarendon Press, 1970), 30–50. For the impact of classicism on eighteenth-century English artists in Italy, see Carlo Pietrangeli, "The Discovery of Classical Art in Eighteenth-Century Rome," *Apollo* 117 (May 1983): 380–91.

6. Pelzel, *Mengs and Neoclassicism,* 108–10.

7. For information on Hamilton, see David Irwin, *English Neoclassical Art: Studies in Inspiration and Taste* (London: Faber & Faber, 1966), 31–38, and "Gavin Hamilton: Archaeologist, Painter, and Dealer," *Art Bulletin* 44 (June 1962): 87–102; Robert Rosenblum, "Gavin Hamilton's 'Brutus' and Its Aftermath," *Burlington Magazine* 103 (January 1961): 8–16; and Basil C. Skinner, "Note on Four British Artists in Rome," ibid. 99 (July 1957): 237–38.

8. Galt, *Life of West* 1: 116–17. The anecdote also suggests two of West's own paintings. "Homer" was supposed to have sung verses from Tasso and Ariosto. Before West left Italy, he painted *Angelica and Medoro,* the story of which is first told in a poem by Ariosto, and in 1767 he painted *Rinaldo and Armida* from a story by Tasso.

9. The titles of these paintings are: *Andromache Bewailing the Death of Hector, Hector's Farewell to Andromache, Achilles Lamenting the Death of Patroclus, Achilles Dragging Hector's Body around the Walls of Troy, The Anger of Achilles for the Loss of Brises,* and *Priam Redeeming the Dead Body of Hector.* They were completed over a twenty-year period and purchased by different patrons. Three are now lost and known only through engravings by Domenico Cunego.

10. Galt, *Life of West* 1: 105–6.

11. Quoted in Richard Brilliant, *Arts of the Ancient Greeks* (New York: McGraw-Hill, 1974), xiv–xv.

12. Joel Barlow, *The Columbiad, A Poem* (Philadelphia, 1807), 417.

13. I first discussed these observations in a paper read at the College Art Association annual meeting, Philadelphia, February 1983. See Hugh Honour, "Benjamin West's Indian Family," *Burlington Magazine* 125 (December 1983): 726–33. I wish to thank Mr. Honour for sharing with me his observations on this matter. See also, Alberts, *Benjamin West,* 39–40.

14. Joseph Shippen to Benjamin West, 17 September 1760, PAFA (AAA roll P50/779–81).

15. I wish to thank Dr. William Sturtevant of the Smithsonian Institution for talking with me about the Indians of Pennsylvania and West's method of illustrating them.

16. For details of the operation and West's recovery, see Edgar P. Richardson, "West's Voyage to Italy, 1760, and William Allen," *PMHB* 102 (January 1978): 17–18, 22–23; *Public Characters,* 528; and Alberts, *Benjamin West,* 46–48.

17. It appears that West drew his own self-portrait (fig. 2) at the same time, for it is quite similar in style and medium to the portrait of Kauffmann (fig. 42), both in the collection of Swarthmore College. All of the drawings were probably done in Rome after West met Kauffmann there in 1763. For hints of the romance, see "Autobiography of Charles Willson Peale," typescript, 94, Charles Willson Peale Papers, APS. For information on Kauffmann, see Irwin, *Neoclassical Art,* 51–55; Arthur S. Marks, "Angelica Kauffmann and Some Americans on the Grand Tour," *American Art Journal* 9 (Spring 1980): 5–24; and Peter S. Walch, "An Early Neoclassical Sketchbook by Angelica Kauffman [*sic*]," *Burlington Magazine* 119 (February 1977): 98–108.

18. See John Fleming, "Some Roman Cicerones and Artist-Dealers," *Connoisseur Yearbook* (1959), 24–27; Julia Morgan Harding, ed., *The Journal of Dr. John Morgan of Philadelphia from the City of Rome to the City of London* (Philadelphia: J. B. Lippincott, 1907), 117, passim; and Lewis, *Connoisseurs,* 176–203.

19. Richardson, "West's Voyage," 16–19, 22; *Public Characters,* 529; and Galt, *Life of West* 2: 24–25.

20. Robert Rutherford to Joseph Shippen, 22 April 1763, APS.

21. Very few British officials in Italy trusted Dalton. Horace Mann referred to him as a "sad rogue" who intended to "rob" collectors of their best pieces, and the engraver Robert Strange wrote that during his tour of Italy in the 1760s, Dalton had "haunted" him by obstructing his access to promised commissions. See Horace Mann to Horace Walpole, 19 August 1758 and 1 August 1761 in W. S. Lewis et al., eds., *Correspondence with Sir Horace Mann,* vols. 1–11 (1954–71) of *The Yale Edition of Horace Walpole's Correspondence* (New Haven: Yale University Press, 1937–83), 5: 21, 231, 521–22;

Robert Strange, *An Inquiry into the Establishment of the Royal Academy of Arts to Which Is Prefixed a Letter to the Earl of Bute* (London, 1775), 19–21; and Alberts, *Benjamin West,* 51–52.

22. Galt, *Life of West* 1: 118, 124, 142–44, passim; *Public Characters,* 526–28; and Alberts, *Benjamin West,* 32, 38–39.

23. West's observations about the artists he studied in Italy can be found in two sources: Benjamin West to John Singleton Copley, 6 January 1773, in *Letters and Papers of John Singleton Copley and Henry Pelham, 1739–1776* (New York: AMS Press, 1972), 196; and Franziska Forster-Hahn, "The Sources of True Taste: Benjamin West's Instructions to a Young Painter for His Studies in Italy," *Journal of the Warburg and Courtauld Institutes* 30 (1967): 374. See also, David Alan Brown, *Raphael in America* (Washington, D.C.: National Gallery of Art, 1983), 16–18.

24. It is difficult to fully evaluate the way West studied the old masters, because the paintings he copied are not available for examination. West wrote about these artists many years after he studied in Italy, and his observations most likely reflect the opinions of late eighteenth-century English connoisseurs and critics. Because West was reproducing many of the paintings to send back to Philadelphia, his choice of works to copy depended on his patron's wishes. He did acknowledge, however, to Joseph Shippen that he had been given the liberty to "suit his own taste and turn" in choosing works to reproduce. See Richardson, "West's Voyage," 22.

25. Galt, *Life of West* 2: 168; Forster-Hahn, "Sources of True Taste," 378; and *Copely-Pelham Letters,* 196.

26. Galt, *Life of West* 2: 130–31; Alberts, *Benjamin West,* 225–39; Garlick and Macintyre, *Farington Diary* 3: 703, passim; Forster-Hahn, "Sources of True Taste," 379; and *Copely-Pelham Letters,* 196.

27. West's original painting of *Cymon and Iphigenia* has been lost. Scant information about it can be found in two written sources; one is a description of a drawing sold in a nineteenth-century London sale, the other is Robert Rutherford to Joseph Shippen, 22 April and 21 June 1763, APS (AAA roll P929/911).

28. The parallel between West's friendship with Kauffmann and his painting *Angelica and Medoro* was made by Jules Prown in a talk at the National Portrait Gallery, Smithsonian Institu-

tion, in October 1981.

29. Whitley, *Artists, 1700–1799,*196; Galt, *Life of West* 1: 152–54.

30. Galt, *Life of West* 1: 155–57. An indication that West was influenced by French art appears in *Public Characters,* 530, and *Belle Assemblée,* 7.

31. Denis Diderot, *Salons,* ed. Jean Seznec and Jean Adhemar (Oxford: Oxford University Press, 1975), 1: 196. See also, Robert Rosenblum, *Transformations in Late Eighteenth-Century Art* (Princeton: Princeton University Press, 1969), 3–49; and Michael Fried, *Absorption and Theatricality : Painting and Beholder in the Age of Diderot* (Berkeley and Los Angeles: University of California Press, 1980), 55–57, passim.

32. Diderot, *Salons*, 233.

33. Galt wrote that Pennsylvania governor James Hamilton was in England when West arrived, but there is no other indication that Hamilton was there. See David A. Kimball and Miriam Quinn, eds., "William Allen–Benjamin Chew Correspondence, 1763–1764," *PMHB* 90 (April 1966): 213, 216–19; "Powel–Roberts Correspondence, 1761–1765," ibid. 18 (1894): 37; *Morgan Journal,* 22–23; and T. Penn to W. Peters, 10 August 1763, HSP.

34. A portrait of West (now at the Wadsworth Athenaeum) painted many years later by Thomas Lawrence shows West standing next to one of the Raphael cartoons. See also, John White, introduction in The Victoria and Albert Museum, *The Raphael Cartoons* (London: Her Majesty's Stationery Office, 1972), 5.

35. From Stourhead, West went to Fonthill, Wilton, Salisbury, and Longford before stopping briefly in Reading for the first meeting with his half-brother, Thomas. See Galt, *Life of West* 2: 5; *Public Characters,* 530; and *Belle Assemblée,* 7.

36. Galt, *Life of West* 2: 5; Whitley, *Artists, 1700–1799,* 198–99; William G. Constable, *Richard Wilson* (London: Routledge & Kegan Paul, 1953), 18, 41; Alberts, *Benjamin West,* 58–59; and Garlick and Macintyre, *Farington Diary* 6: 2137 (entry 2 October 1803).

37. For information on early art in England and the English exhibitions, see Ellis K. Waterhouse, *Three Decades of British Art, 1740–1770* (Philadelphia: APS, 1965), 1–48; Whitley, *Artists, 1700–1799,* 185–96; Jean André Rouquet, *The Present State of the Arts in England* (London: Cornmarket Press, 1970); and William Sandby, *The History of the Royal Academy of Arts* (Lon-

don: Cornmarket Press, 1970), 1: 17–43.

38. Before 1760, only two public institutions displayed contemporary British paintings. One was Vauxhall Gardens, the other was the Foundling Hospital. For further information, see Waterhouse, *Three Decades,* 5–10.

39. The Maiden Lane exhibitions remained more closely associated with the Royal Society of Arts and thus lacked the notable names found at Spring Gardens. The original Spring Gardens catalogues are at the Royal Society of Arts, London, but for a listing of the artists, see Algernon Graves, *The Society of Artists of Great Britain, 1760–1791; The Free Society of Artists, 1761–1783, A Complete Dictionary of Contributors and Their Works* (London: Bell and Graves, 1907). See also, Waterhouse, *Three Decades,* 49–62.

Chapter 5

1. For information on Monckton, see *DNB* 13 (1963): 613–14. A meeting between the general and West's brother is recorded by William T. Whitley in his notes, Department of Prints and Drawings, The British Museum.

2. Whitley notes, The British Museum; Ellis K. Waterhouse, *Three Decades of British Art, 1740–1770* (Philadelphia: APS, 1965), 31; Ronald Paulson, *Emblem and Expression: Meaning in English Art of the Eighteenth Century* (Cambridge: Harvard University Press, 1975), 86–87.

3. Catalogue of the Society of Artists of Great Britain, 1764, Royal Society of Arts.

4. Quoted in Horace Walpole, *Anecdotes of Painting in England* (New Haven: Yale University Press, 1937), 4: 113.

5. *Gentleman's Magazine* 34 (May 1764): 223.

6. "Press Cuttings."

7. Quoted in Whitley, *Artists, 1700–1799,* 196. Walpole probably meant Verroccio, not Barroccio.

8. For similar observations, see Helmut Von Erffa, "Benjamin West: The Early Years in London," *American Art Journal* 5 (November 1973): 9–10.

9. For precedents in art, see Pigler, *Barockthemen,* 125–26; Jeffrey Daniels, *Sebastiano Ricci* (Hove, Sussex: Wayland Publishers, 1976), 32–34; and material under that heading at the Frick Art Reference Library. For precedents in the theater, see *Restoration and Eighteenth-Century*

Theatre Research 11 (May 1972): 40, 55.

10. Several studies have been conducted on the iconography of this subject, including Erwin Panofsky, *Hercules am Scheidewege und Andere Antike Bildstoffe in der Neueren Kunst* (Leipzig and Berlin: B. G. Teuber, 1930); E. Tietze-Conrat, "Notes on 'Hercules at the Crossroads,'" *Journal of the Warburg and Courtauld Institutes* 14 (1951): 305–9; and Theodor E. Mommsen, "Petrarch and the Story of the Choice of Hercules," ibid. 16, (1952–53): 178–92.

11. Anthony Ashley Cooper, Third Earl of Shaftesbury, "An Essay on Painting Being a Notion of the Historical Draught or Tablature of the Judgment of Hercules," *Characteristicks* (London, 1714), 3: 390. See also, Stanley Grean, *Shaftesbury's Philosophy of Religion and Ethics, A Study in Enthusiasm* (Athens: Ohio University Press, 1967); and John Andrew Bernstein, "Shaftesbury's Identification of the Good with the Beautiful," *Eighteenth-Century Studies* 10 (Spring 1977): 304–25.

12. Even the facial expressions adhere to the philosopher's dicta. If Hercules "looks on *Virtue*," wrote Shaftesbury, "it ought to be earnestly, and with extreme attention, having some part of the Action of his Body inclining toward *Pleasure*." West's Hercules, covered decorously in fur (not the leopardskin that Shaftesbury suggested), frowns in earnest contemplation, his body turned slightly toward Pleasure. The positioning of Virtue also follows the text precisely, for as Shaftesbury suggested, she stands "with her full poise upon one foot" and her other foot "a little advanc'd and rais'd on a broken piece of rock" to suggest the "rocky way" Hercules must ascend under her guidance. The figure of Pleasure is similarly posed according to the philosopher's instructions, for she lounges seductively at Hercules' feet, wearing the very floral crown that Shaftesbury described. On the other hand, Poussin depicted all three figures standing; Carracci and Pietro da Cortona showed Hercules seated with the goddesses standing; P. G. Batoni depicted Hercules and Vice seated and Virtue standing. See Panofsky, *Hercules,* plates xxvii, xliv, lv. For information on the Matthais painting, see Felix Paknadel, "Shaftesbury's Illustrations of *Characteristics,* "*Journal of the Warburg and Courtauld Institutes* 37 (1974): 295; Shaftesbury, "Essay on Painting," 356, 360, passim.

13. The decision to eliminate such symbolic references must have occurred after West made his initial sketches, because in the only known preliminary drawing, Hercules holds a large club, Virtue has a helmet, and the figure of Vice is surrounded by three putti. I have been unable to find the original version of this drawing, but the Friends Library at Swarthmore College has a photocopy. The drawing was apparently sold in New York in 1768 by Bernard Black Gallery; it is described in the catalogue found in the Art Division of the New York Public Library. The drawing appears to be an amalgamation of Poussin's and Matthais's versions. The former gave Hercules his customary club and incorporated a putto on the side of Pleasure to represent love, while the latter included a number of symbols that Shaftesbury regarded as acceptable.

14. Shaftesbury directed his readers to be original when the subject did not demand "moral" reasons for emulating the traditional iconography. Although Shaftesbury never specified which side the figures should occupy, Matthais, Poussin, and numerous French and Italian artists always followed a similar structure, with Pleasure on the right and Virtue on the left. See Shaftesbury, "Essay on Painting," 386, passim.

15. For more about the relationship between Reynolds, Hogarth, and the "Choice of Hercules" theme, see Paulson, *Emblem and Expression,* 38–43, 80–82.

16. *The Annual Register* (1765), 180–82.

17. For information on Wilkes and the political situation of the early 1760s, see J. Steven Watson, *The Reign of George III, 1760–1820* (Oxford: Clarendon Press, 1960), 67–112; John B. Owen, *The Eighteenth Century, 1714–1815* (New York: W. W. Norton, 1976), 169–79; George Rude, *Wilkes and Liberty: A Social Study of 1763 to 1774* (Oxford: Clarendon Press, 1962); and Jack Lindsay, *1764: The Hurlyburly of Daily Life Exemplified in One Year of the Eighteenth Century* (London: Frederick Muller Ltd., 1959).

18. Von Erffa, "Early Years," 10.

19. For a discussion of Hogarth's narratives, see Ronald Paulson, *Hogarth: His Life, Art, and Times,* 2 vols. (New Haven: Yale University Press, 1971); Frederick Antal, *Hogarth and His Place in European Art* (London: Routledge & Kegan Paul, 1962); Mary F. Klinger, "William Hogarth and London Theatrical Life," *Studies in Eighteenth-Century Culture* 5 (1976): 11–27; and Robert Etheridge Moore, *Hogarth's Literary Relationships* (Minneapolis: University of Minnesota Press, 1948).

20. These and other titles come from the catalogues of the Society of Artists of Great Britain and the Free Society of Artists, 1761–64, at the Royal Society of Arts. Some other theatrical paintings from these early exhibitions were George Dawes's *Oliva and Malvolio in Twelfth Night* and *Catherine and Petrucio in Taming of the Shrew* and Zoffany's *Garrick and Mrs. Cibber in the Character of Jaffier and Belvidera*.

21. See John Sunderland, "Mortimer, Pine, and Some Political Aspects of English History Painting," *Burlington Magazine* 116 (1974): 317–26.

22. Arthur Devis's *Breaking Up Day at Dr. Clayton's School at Salford* (Tate Gallery, London) is an excellent example of the theatrical conversation piece grouped in stiff poses with students and their masters facing the audience as if on stage. Highlighted in the center of the composition is the star student approaching the podium to receive his reward. The entire grouping not only gives the viewers a narrative of the commencement ceremony at Dr. Clayton's School, but also sets up a theatrical scene with leading actors, a chorus, and a hierarchy of participants. For further discussion about conversation pieces, see Paulson, *Emblem and Expression,* 121–36; and Mario Praz, *Conversation Pieces: A Survey of the Informal Group Portrait in Europe and America* (University Park and London: Pennsylvania University Press, 1971).

23. To see the difference between British and Continental interpretations of theatrical themes, compare the writings of Diderot with criticism in the press of the 1760s.

24. David A. Kimball and Miriam Quinn, eds., "William Allen–Benjamin Chew Correspondence, 1763–1764," *PMHB* 90 (April 1966): 221; reprinted in Alberts, *Benjamin West,* 61.

25. Rockingham, a close friend of Edmund Burke's and a strong opponent of Lord Bute, was one of George III's most troublesome detractors. See *DNB* 12 (1963): 1057–59. For details of these early commissions, see Galt, *Life of West* 2: 6–9; Von Erffa, "Early Years," 7–9; and Alberts, *Benjamin West,* 63–64.

26. Franklin was a frequent visitor to the West household, often inviting the younger couple to dine with him and accompany him on outings in the country. He was also godfather to the second West boy, born in 1772, who was named Benjamin after both his father and Franklin. See Benjamin Labaree and William B. Willcox, eds., *The Papers of Benjamin Franklin, 1706–1775* (New Haven: Yale University Press, 1959–), 12: 43, 63, 103, 108; 14: 144, 224, 299, 300; 17: 30–31, 108, 167; 19: 43, 99, 274; 20: 145.

27. Members roster, Royal Society of Arts; *Annual Register* (1820), 1169; Galt, *Life of West* 2: 7; Whitley, *Artists, 1700–1799,* 195; and Alberts, *Benjamin West,* 72.

28. H. Sulger to Mrs. B. West, 15 August 1774, HSP. For more information on West and his students, see Dorinda Evans, *Benjamin West and His American Students* (Washington, D.C.: National Portrait Gallery, Smithsonian Institution, 1980); and William Dunlap, *A History of the Rise and Progress of the Arts of Design in the United States* (New York: Dover Publications, 1969), 1: 79–81.

29. Whitley, *Artists, 1700–1799* 1: 212.

30. "Press Cuttings."

31. Ibid.

32. Ibid.

Chapter 6

1. See David Garrick, *Cymon* (London, 1767) and "The Theatrical Campaign for 1766 and 1767" (London, 1767), Folger Shakespeare Library, Washington, D.C.; Dougald MacMillan, *Drury Lane Calendar, 1747–1776* (Oxford: Clarendon Press, 1938), 229–31; Kalman A. Burnim, *David Garrick, Director* (Carbondale: Southern Illinois University Press, 1961), 16, passim. See also, Roger Fiske, *English Theatre Music in the Eighteenth Century* (London: Oxford University Press, 1973), 294; and Allardyce Nicoll, *A History of Early Eighteenth-Century Drama, 1700–1750* (Cambridge: Cambridge University Press, 1929), 27, 202, passim. The description of West's painting is in Robert Rutherford to Joseph Shippen, 22 April and 21 June 1763, APS (AAA roll P929/911). A painting by West with this title in the Los Angeles County Museum is dated 1773 and does not fit Rutherford's description.

2. For the history of the Licensing Act and the political aspects of early eighteenth-century theater, see John C. Loftis, *The Politics of Drama in Augustan England* (Oxford: Clarendon Press, 1963).

3. Daniel Webb, *An Inquiry into the Beauties of Painting . . . and into the Merits of the Most Celebrated Painters, Ancient and Modern* (London, 1761). I am grateful to Elizabeth Ellis for pointing out this passage to me.

4. John Brewer, *Party Ideology and Popular Politics at the Accession of George III* (Cambridge: Cambridge University Press, 1976), 213.

5. This subject, possibly first explored by Roman sculptors of Herculaneum, was popular in seventeenth-century Holland. See Pigler, *Barockthemen,* 336. For information on the reception of *Pylades and Orestes,* see Galt, *Life of West* 2: 16–17; and Alberts, *Benjamin West,* 73–74. A suggestion that the public initially rejected the painting is found in the notes of William Whitley, Department of Prints and Drawings, The British Museum, and in Sir George Beaumont to Thomas Lawrence, 13 March 1825, Royal Academy of Arts.

6. The original *Castor and Pollux* was then in Madrid, but copies of it were in England. The *Flora* was in Rome with life-size copies in Yorkshire, Norfolk, and Worcestershire. See Francis Haskell and Nicholas Penny, *Taste and the Antique: The Lure of Classical Sculpture, 1500–1900* (New Haven and London: Yale University Press, 1981), 173–75, 216–17.

7. The best published source on British cartoons of the period is M. Dorothy George, *English Political Caricature to 1792: A Study of Opinion and Propaganda* (Oxford: Clarendon Press, 1959).

8. Charles Beckingham, *Scipio Africanus: A Tragedy as Acted in the Theatre in Little-Lincoln Inn Fields* (London, 1718).

9. Among West's predecessors who painted *The Continence of Scipio* were Annibale Carracci, Pietro da Cortona, Giovanni Bellini, Veronese, Dürer, Rubens, Van Dyck, Poussin, Batoni, Ricci, Vien, and Reynolds, to mention only a few. See Pigler, *Barockthemen,* 424–29; and information in the Frick Art Reference Library.

10. West pictured Scipio in a dark-red cloak and Roman tunic seated on a slightly raised throne on the far left. The composition is a deliberate amalgamation of several seventeenth-century sources, from Rubens and Poussin to various renditions by northern artists. Sebastiano Ricci painted seven known versions of *The Continence of Scipio,* one of which West is known to have copied. Venetian artists, who were especially fond of the Scipio theme, possibly selected it because it had appeared often as both a drama and an opera during the early eighteenth century. Sebastiano Ricci and his colleagues may even have designed the scenery for one of the productions. See Michael Levey, *Painting in Eighteenth-Century Venice* (London: Phaidon, 1959), 24–26; and Jeffrey Daniels, *Sebastiano Ricci* (Hove, Sussex: Wayland Publishers, 1976), 2, 35, 46–47, 93.

11. Beckingham, *Scipio Africanus,* 50–56; and Nicoll, *Early Eighteenth-Century Drama,* 89–90.

12. Beckingham, *Scipio Africanus,* 55. As Beckingham was known to have been a strong supporter of the Hanovarians against the Pretender, his reference to Scipio as a benevolent ruler from another land was probably an allegorical reference to either George I or William of Orange. See Loftis, *Politics of Drama,* 79–81; Nicoll, *Early Eighteenth-Century Drama,* 89–90; and Mary E. Knapp, *Prologues and Epilogues of the Eighteenth Century* (New Haven: Yale University Press, 1961), 203.

13. John Brooke, *King George III* (Frogmore, St. Albans: Panther Books Ltd., 1974), 217–20; and Horace Walpole, *Memoirs of the Reign of King George the Third* (Freeport, N.Y.: Books for Libraries Press, 1970), 2: 205, passim.

14. See *Gentleman's Magazine* 35 (January 1765): 6; and "An Epistle to Junius Silanus from Cornelius Scipio" (London, 1769), Library of Congress.

15. Such statements appear in various articles found in "Press Cuttings."

16. The word "poets" in the poem refers to dramatists in the context of the entire prologue, which appears in *St. James Chronicle,* 22–25 February 1766.

17. "Press Cuttings." In the same exhibition, West also submitted *Jupiter and Semele* and *Venus and Adonis,* both of which correspond to theatrical productions: William Congreve's *Semele,* originally produced in 1710 and reopened in 1744 with a new score by Handel; and Colley Cibber's *Venus and Adonis,* which first appeared at Drury Lane in 1714 and was periodically revived throughout the century. See MacMillan, *Drury Lane Calender,* 233. For additional information on these productions, see *Restoration and Eighteenth-Century Theatrical Research* 10 (May 1971): 51; and Nicoll, *Early Eighteenth-Century Drama,* 115, 311.

18. A painting sold at Sotheby's (London) in 1974 said to be West's *Fright of Astyanax* is probably a French painting, possibly by Antoine Coypel. I wish to thank Professor Allen Staley for confirming this matter for me. See also, Dora Wiebenson, "Subjects from Homer's Iliad in Neoclassical Art," *Art Bulletin* 46 (1964): 23–37.

Galt identified the painting purchased by Bishop Newton as the *Parting of Hector and Andromache*. See Galt, *Life of West* 2: 9. A painting with this title, now in the New-York Historical Society, is not the fragment represented in the Newton portrait.

19. See Jean Racine, *Andromache: Tragedy in Five Acts, 1667,* trans. Richard Wilber (New York and San Diego: Harcourt Brace Jovanovich, 1982).

20. Bishop Newton might have commissioned West's *Fright of Astyanax* for similar reasons, perceiving it as a tribute to the Hanoverian rulers with whom he had close ties. See Galt, *Life of West* 2: 9; and *DNB* 14 (1964): 403–5.

21. The columnist for the *Public Advertiser* admired West's *Pyrrhus Brought to Glaucius,* commenting favorably about "the Countenances," the grouping of figures and the management of light and shade. But he wrote, "The Manner is harder than in the other Pictures, the Drapery heavy, and every would-be Critic calls little Pyrrhus' Head of Hair a Mop." "Press Cuttings."

22. A drawing by Louis Cheron, engraved as the frontispiece of the 1727 English edition of Plutarch's *Lives,* depicts the same scene, and probably provided a model for West's background architecture and King Glaucias's contemplative pose. West followed Plutarch by picturing the baby Pyrrhus actually climbing onto Glaucius's knees and the child's Epirian escorts bowing to the king to plead for acceptance of the boy.

23. A notation accompanying an engraving made of *Pyrrhus Brought to Glaucius* in 1811 stated that Drummond had purchased the painting. See Henry Moses, *The Gallery of Pictures Painted by Benjamin West, Esq.* (London, 1811). Another account said that the archbishop admired *Pyrrhus,* and the Bishop of Bristol bought *Elisha Restoring to Life the Shunamite's Son.* See *The Annual Register* (1820), 1169; and *Belle Assemblée,* 15.

24. Galt, *Life of West* 2: 11–13.

25. See Cornelius Tacitus, *The Annals of Imperial Rome,* trans. Michael Grant (London and New York: Penguin Books, 1981), 2: 84, 119; and Allen Staley, "Benjamin West's *The Landing of Agrippina at Brundisium with the Ashes of Germanicus," Philadelphia Museum of Art Bulletin* 61 (Fall 1965/Winter 1966): 10–19.

26. Although this print appeared in a 1768 French edition of the *Annals* of Tacitus it was probably published earlier as a separate engraving, a common practice of the eighteenth century. In West's painting Agrippina's costume, the bow of the boat, the building at the left, and the pose of the figure on the right all appear to be based on this print. One sign that West might have been modeling certain details in his *Agrippina* on the Gravelot print is seen in the difference between the oil sketch of 1766 and the finished painting of 1768, in which Agrippina's head is completely covered just as in Gravelot's engraving. See Peter S. Walch, "Charles Rollin and Early Neoclassicism," *Art Bulletin* 49 (June 1967): 123–26.

27. Hamilton's painting was commissioned a year earlier than West's but not completed until 1771. Since Hamilton was in Italy, it is unlikely that West knew much, if anything, about his painting, unless a sketch made its way back to England. In that case, West might have copied Hamilton, as some have suggested. More likely, however, both copied Gravelot. In fact, Hamilton's painting contains a figure behind Agrippina who strongly resembles the woman in the corner of Gravelot's engraving. To my knowledge, no earlier examples of this exact subject existed, although there are several paintings related to the Agrippina legend. West might have seen one of them by Francesco Desiderio in the collection of Sir John Coote, even though his painting is primarily architectural, with the tiny figures playing a secondary role. See Pigler, *Barockthemen,* 339; and photographs in the Frick Art Reference Library. See also, Staley, "*Agrippina,*" 13; and Ellis K. Waterhouse, "The British Contribution to the Neo-Classical Style in Painting," *Proceedings of the British Academy* 40 (1954): 57–74.

28. West's exhibition pieces were growing gradually in size: *Angelica and Medoro* of 1763–64 is about 3 × 2 feet; *Pylades and Orestes* and *The Continence of Scipio* of 1766 are slightly more than 3 × 4 feet; and *Venus Lamenting the Death of Adonis* of 1768 is 5' 4" × 5' 9½".

29. The proscenium, which was usually separated from the stage by sets of projecting doors, was growing smaller during the eighteenth century, but as prints and paintings of the 1780s reveal, it remained part of the acting area throughout the century. See Allardyce Nicoll, *The Garrick Stage: Theatres and Audience in the Eighteenth Century* (Athens: University of Georgia Press, 1980), 23–24; and Colin Visser, "Scenery and Technical Design" in *The London Theatre World, 1660–1800,* ed. Robert D. Hume (Carbondale and Edwardsville: Southern Illinois University Press, 1980), 66–72.

30. The "marriage" of fine arts and theater really occurred in the 1770s after Garrick brought Philippe de Loutherbourg from France to design scenery for Drury Lane. For a good summary of the innovations in lighting and scenery, see Nicoll, *Garrick Stage,* 102–41; Burnim, *Garrick, Director,* 80–81; and Visser, "Technical Design," 66–118.

31. Staley, *"Agrippina,"* 14; Nicoll, *Garrick Stage,* 145–73; and Burnim, *Garrick, Director,* 76–77. See also, Edgar Wind, "The Sources of David's *Horaces," Journal of the Warburg and Courtauld Institutes* 4 (1941): 124–38.

32. The story of Sejanus comes from Tacitus, *Annals* 6: 12, 17–19, 52–58, 67, and 5: 1–5. See in the Grant translation, 145, 150–51, 169–71, 177, 182–84.

33. Francis Gentleman, prologue in Ben Jonson, *Sejanus* (London, 1752). Garrick's statement is included in Gentleman's introduction to the play.

34. The following historical figures were used as allegorical representations of Lord Bute in addition to those mentioned in the text: Rizzo, Macbeth, Sir Robert Carr, William (or Peter) des Roches, the Bishop of Winchester, Thomas Wolsey, Hubert de Brugh, and Simon de Montfort. In addition, Bute was often symbolized as a large jackboot, a parody of his name (pronounced "boot"). See "The Faces of Lord Bute: A Visual Contribution to Anglo-American Political Ideology," *Perspectives in American History* 6 (1972): 95–116; George, *English Political Caricature,* 122–23; and cartoons nos. 3845, 3867, 3897, 3939, and 4048, Department of Prints and Drawings, The British Museum.

35. The rumor that King George continued to correspond with Bute after the latter was dismissed is not unfounded. See Romney Sedgwick, *Letters from George III to Lord Bute, 1756–1766* (London, 1939); John B. Owen, *The Eighteenth Century, 1714–1815* (New York: W. W. Norton, 1976), 169–96; and Brooke, *King George III,* 173–174.

36. *The Favorite, An Historical Tragedy* (London, 1770). The play was advertised as "an alteration of Ben Jonson's *Sejanus,* to which the editor, for a very obvious purpose, has prefixed an ironical dedication to Lord Bute." See also, *Gentleman's Magazine* 39 (December 1769): 600; and James J. Lynch, *Box, Pit, and Gallery: Stage and Society in Johnson's London* (Berkeley and Los Angeles: University of California Press, 1953), 48, 136.

37. These images are found in varying print sources. See George, *English Political Caricature,* 117–40.

38. Quoted in ibid., 128.

39. These sentiments are expressed in a letter from Drummond to Newcastle, 17 October 1766, Ad. MS 33070, The British Museum. For information on Drummond, see *DNB* 6 (1963): 38–40; and Robert Hay Drummond, *Memoirs of Robert, Archbishop of York, Prefixed to His Sermons* (Edinburgh, 1803–4), xi–xxxix.

Chapter 7

1. The subsequent description of West's first meeting with the king comes from Galt, *Life of West* 2: 20–21.

2. Ibid. 2: 21–22; and see Catalogue of the Royal Academy of Arts, 1769, National Gallery of Art, Washington, D.C.

3. In response to this remark, Galt supposedly answered that "it was, indeed, surprising it should have been neglected by Poussin, who was so well qualified to have done it justice." The association of West with Poussin is significant in light of the king's interests, for the seventeenth-century French master created several didactic narratives that obviously influenced the composition of West's *Agrippina.* Furthermore, Poussin also depicted a portion of the same legend in his *Death of Germanicus.* See Galt, *Life of West* 2: 23; and Allen Staley, "Benjamin West's *The Landing of Agrippina at Brundisium with the Ashes of Germanicus," Philadelphia Museum of Art Bulletin* 61 (1966): 13.

4. Galt, *Life of West* 2: 25–26.

5. Galt also commented on the visit, explaining that the king told West he planned to place the painting "in one of the principal apartments" of the palace, where it would fill an entire wall. Galt, *Life of West* 2: 33. For Peale's account, see "Autobiography of Charles Willson Peale," typescript, 94–95, Charles Willson Peale Papers, APS. I am very grateful to Dr. Lillian B. Miller for helping me obtain this information. See also, Charles Coleman Sellers, *Charles Willson Peale with Patron and Populace* (New York: Scribner's, 1969), 94–95; and Dorinda Evans, *Benjamin West and His American Students* (Washington, D.C.: National Portrait Gallery, Smithsonian Institution, 1980), 37–48.

6. While in Italy, West may have seen (or heard about) the ceiling fresco in the *Salla de Attilio Re-*

golo at the Palazzo del Te, Mantua, which depicted scenes from the life of Regulus. Or, he might have visited the Museo Civico in Verona, where he would have seen two other illustrations of the Regulus legend by an anonymous sixteenth-century artist, one showing the consul taking his oath before the senate in Carthage, the other his return to Carthage from Rome. Savatora Rosa painted *The Death of Regulus by Torture,* which is now in the Virginia Museum of Fine Arts. Most likely, West would have been familiar with *The Departure of Regulus,* painted in 1752 by his friend and adviser Richard Wilson. His composition, however, bears little resemblance to West's interpretation of the subject, for Wilson, whose primary interest was landscape, included only tiny figures of Regulus and his family within an imaginative vista of the Italian countryside. In 1758 the Royal Society of Arts cited "Regulus Taking Leave of His Friends When He Departed on His Return to Carthage" as a fit topic for history painting. The directors, however, decided to award premiums only for British subjects. See *Minutes of the Society of Arts* 3 (1758–59): 154–55, Royal Society of Arts. I wish to thank Mr. David Allan for helping me find this information. For further discussion of the competition, see John Sunderland, "Mortimer, Pine, and Some Political Aspects of English History Painting," *Burlington Magazine* 116 (1974): 325; and for Wilson's *Regulus,* see William G. Constable, *Richard Wilson* (London: Routledge & Kegan Paul, 1953), 159.

7. Havard's play is loosely based on John Crome's drama by the same name, written in 1694. See William Havard, *Regulus, A Tragedy* (London, 1744); Pietro Metastasio, *Attilio Regolo* (written 1740; presented 1750) is translated for the first time into English by John Hoole, *Dramas and Other Poems of the Abbe Pietro Metastasio* (London, 1800). See Allardyce Nicoll, *A History of Early Eighteenth-Century Drama, 1700–1750* (Cambridge: Cambridge University Press, 1929), 83, 334; and Mary E. Knapp, *Prologues and Epilogues of the Eighteenth Century* (New Haven: Yale University Press, 1961), 298–304.

8. The climactic conclusion of both the play and the opera is a scene devoted to Regulus's departure amidst weeping family members and emotional colleagues. In act 3, scene 11 of the opera, the setting is specified as a terrace overlooking the Tiber with "magnificent porticoes" and ships ready for departure for Carthage. Similar scenery (which is also mentioned in *Punica*) appear in the background of West's painting.

9. Silius Italicus, *Punica,* trans. and ed. J. D. Duff (London: Wm. Heineman Ltd. and New York: G. P. Putnam's Sons, 1934), 6: 455–90, 315, 317.

10. John Brewer, *Party Ideology and Popular Politics at the Accession of George III* (Cambridge: Cambridge University Press, 1976), 213.

11. *St. James Chronicle,* 5–7 July 1768.

12. MS. w.b. 467, Folger Shakespeare Library.

13. "Roman Virtues," *Public Advertiser,* 7 January 1769.

14. On the title page of *Quintus Horatius Flaccus* (Birmingham, Eng., 1770), Britannia is seated with a shield, a Union Jack, and her arm around a child, a similar configuration to that in West's *Regulus.*

15. *Public Advertiser,* 26 May 1769.

16. Moser was previously the master of the small London academy attended by West's former teacher John Valentine Haidt (see chap. 3, n. 11). See also, Sidney C. Hutchinson, *The History of the Royal Academy, 1768–1968* (London: Chapman and Hall, 1968), 29, passim. For further information on the founding of the Royal Academy, see William Sandby, *The History of the Royal Academy of Arts* (London: Cornmarket Press, 1970), 1: 40–58; John E. Hodgson and Fred A. Eaton, *The Royal Academy and Its Members, 1768–1830* (New York: Charles Scribner's Sons, 1905), 12–13, 28–32, passim. For West's role, see Alberts, *Benjamin West,* 90–98; and Charles I. Landis, "Benjamin West and the Royal Academy," *PMHB* 50 (1926): 135–38. For the conflicts within the Society of Artists, see William Thompson, *The Conduct of the Royal Academicians While Members of the Incorporated Society of Artists of Great Britain . . .* (London, 1771).

17. West apparently wanted Strange to be admitted to the academy. See Robert Strange, *An Inquiry into the Establishment of the Royal Academy of Arts to Which Is Prefixed a Letter to the Earl of Bute* (London, 1775), 60–141; and Alberts, *Benjamin West,* 92–93.

18. Reynolds was said to have been reluctant to assume the presidency of the Royal Academy because artistic rivalries in London had become so extremely heated. One apocryphal legend credits West with persuading Reynolds to accept the post. See Alberts, *Benjamin West,* 93–94; Galt, *Life of West* 2: 41–44; and James Northcote, *The Life of Sir Joshua Reynolds* (London, 1819), 1: 163–66. For information on Townshend's prints,

see F. G. Stephens and Edward Hawkins, *Catalogue of Prints and Drawings in the British Museum* (London: British Museum, 1883), 4: 458–59, 461–64.

19. West was one of six designated history painters among the founding members. The others were Angelica Kauffmann, Francesco Bartolozzi, Francis Hayman, G. B. Cipriani, and Samuel Wale. He was also named as a "visitor," which meant that he instructed in the school on a rotating basis together with eight other artists (Agostino Carlini, Charles Catton, Cipriani, Nathaniel Dance, Hayman, Peter Toms, Richard Wilson, and Francesco Zuccarelli). See Sandby, *History of the Royal Academy*, 52–56; and Garlick and Macintyre, *Farington Diary* 1: 132 (entry 5 January 1794).

20. "Press Cuttings."

21. Two French illustrators, Joseph Lamorlet and Hubert François Gravelot, depicted the scene, the former in the 1661 English translation of *Punica,* the latter in volume 1 of Rollin's *Ancient History.* Except for picturing the boy and his father at the altar (and Lamorlet's drawing also shows the dead beast), there is little comparison between these illustrations and West's painting, which is more fully detailed. The illustrations may be found in Silius Italicus, *The Second Punic War between Hannibal and the Romans . . .,* trans. Thomas Ross (London, 1661), and Charles Rollin, *Ancient History,* vol. 1 (London, 1789).

22. A pamphlet of 1714 was entitled "Hannibal Not at Our Gates." The popular tract, rumored to have been written by Swift, satirizes current apprehensions of a Jacobite invasion—equating the Pretender with Hannibal's marching on Rome.

23. Walpole to Mann, 6 May 1770 in W. S. Lewis et al., eds., *Correspondence with Sir Horace Mann,* vols. 1–11 (1954–71) of *The Yale Edition of Horace Walpole's Correspondence* (New Haven: Yale University Press, 1937–83), 6: 23, 210–11; and Galt, *Life of West* 2: 207.

24. Benjamin West to John Green, 10 September 1771, AAA.

25. For a discussion of the king's illness, see John Brooke, *King George III* (St. Albans: Panther Books, Ltd., 1974), 531–41.

26. See Alberts, *Benjamin West,* 306–84, for the story of the lost royal patronage; for information on the lost commission, see Jerry D. Meyer, "Benjamin West's Chapel of Revealed Religion: A Study in Eighteenth-Century Protestant Religious Art," *Art Bulletin* 57 (June 1975): 247–65.

Chapter 8

1. Benjamin West to Charles Willson Peale, 21 June 1771, in Lillian B. Miller, ed., *The Selected Papers of Charles Willson Peale and His Family,* vol. 1, *Charles Willson Peale: Artist in Revolutionary America, 1735–1791* (New Haven and London: Yale University Press, 1983), 81. Also found in HSP Collection of the PAFA (AAA roll P28/621–22).

2. The anecdotes appear in Whitley, *Artists, 1700–1799,* 282, and are further elaborated in Whitley's notes found in the Department of Prints and Drawings, The British Museum. A review of the exhibition appeared in the *Gazateer,* 20 May 1771.

3. A fine discussion of the patriotic significance of *The Death of General Wolfe* may be found in Dennis Montagna, "Benjamin West's *The Death of General Wolfe:* A Nationalist Narrative," *American Art Journal* 8 (Spring 1981): 72–88.

4. For information on Murray and Townshend, see *DNB* 13 (1967): 1271–72, and 19: 1051–52; Oliver Warner, *With Wolfe to Quebec* (Toronto and London: Collins & Sons, 1972), 66, 122, 129–31, 189, 197; C. P. Stacey, *Quebec, 1759* (New York: St. Martin's Press, 1959), 6, 84–87, 92–93, 153–55, 161, 175–76; and Horace Walpole, *Memoirs of the Reign of King George the Third* (Freeport, N.Y.: Books for Libraries Press, 1970), 1: 17–18.

5. George Cockings, *The Conquest of Canada; or, The Siege of Quebec, An Historical Tragedy* (London, 1766), preface.

6. "Daphnis and Menalcas: A Pastoral Sacred to the Memory of the Late General Wolfe" (London, 1759), Beinecke Rare Book and Manuscript Library, Yale University.

7. Thomas Young, "A Poem Sacred to the Memory of James Wolfe, Esquire" (London, 1761), 5, 15, Rare Books Room, Library of Congress.

8. J[ohn] P[ringle], *Life of General James Wolfe . . .* (London, 1760), 23, 30–31. See also, J. Clarence Webster, "The First Published Life of James Wolfe," *Canadian Historical Review* (December 1930).

9. West probably heard of the competition for the monument when he was in Italy. See Horace

Mann to Horace Walpole, 13 September 1760 in W. S. Lewis et al., eds., *Correspondence with Sir Horace Mann,* vols. 1–11 (1954–71) of *The Yale Edition of Horace Walpole's Correspondence* (New Haven: Yale University Press, 1937–83), 5: 21, 436. The contest is mentioned in Margaret Whinney, *Sculpture in Britain, 1530 to 1830* (London: Penguin Books, 1964), 138–39, 265; and J. Clarence Webster, *Wolfe and the Artists: A Study of His Portraiture* (Toronto: Ryerson, 1930), 51–52. For contemporary discussion of the memorial, see *Gentleman's Magazine* 29 (November 1759): 549; 30 (April 1760): 201; and 58 (August 1788): 668–69.

10. "Daphnis and Menalcas."

11. By 1770 Townshend was again in the limelight as the controversial Lord Lieutenant of Ireland; see *DNB* 19: 1051–52; and Walpole, *Memoirs* 3: 78–81.

12. The two versions of Penny's painting are at the Ashmolean Museum, Oxford, and at Petworth House, Sussex. See Montagna, "Nationalist Narrative," 74–77; Charles Mitchell, "Benjamin West's 'Death of General Wolfe' and the Popular History Piece," *Journal of the Warburg and Courtauld Institutes* 7 (1944): 30–32; Webster, *Wolfe and the Artist,* 61, and "Pictures of the Death of Major General James Wolfe," *Journal of the Society for Army Historical Research* 6 (January 1927): 30–36; Edgar Wind, "Penny, West, and 'The Death of Wolfe,' " *Journal of the Warburg and Courtauld Institutes* 10 (1947): 159–62; Theodore Crombie, "The Death of Wolfe in Paintings, A Bicentenary Review," *Connoisseur* 144 (September 1959): 56–57; and David Irwin, "James Barry, and The Death of Wolfe in 1759," *Art Bulletin* 41 (December 1959): 330–32.

13. For the best discussion of the four versions, see C. P. Stacey, "Benjamin West and 'The Death of Wolfe,' " *National Gallery of Canada Bulletin* 4 (1966): 1–5. There are several smaller versions of the painting, but they are probably copies made by West's students.

14. West's "revolution in the dressing of figures in historical pictures" is mentioned in *Public Characters,* 539; *The Annual Register* (1820), 1168; and *Belle Assemblée,* 10.

15. See Edgar Wind, "The Revolution of History Painting," *Journal of the Warburg Institute* 2 (October 1938): 117–21; "Benjamin West's Death of Wolfe," *William L. Clements Library Bulletin,* no. 17 (1928); E. Alfred Jones, "The History of a Pic-

ture," *Canadian Magazine of Politics, Science, and Literature* 56 (December 1920): 106–12; Alfred Neumeyer, "The Early Historical Paintings of Benjamin West," *Burlington Magazine* 73 (October 1938): 162–65; Ruthven Todd, "Benjamin West vs. the History Picture," *Magazine of Art* 41 (December 1948): 301–5; Agnes Addison, "The Legend of West's Death of Wolfe," *College Art Journal* 5 (November 1945): 23–25.

16. See Neumeyer, "Early Historical Paintings," 165; and Mitchell, "Popular History Piece," 30–32.

17. For a discussion of eighteenth-century attitudes toward death, see John McManners, *Death and the Enlightenment: Changing Attitudes to Death among Christians and Unbelievers in Eighteenth-Century France* (London and New York: Oxford University Press, 1982).

18. For discussion of the background, see Montagna, "Nationalist Narrative," 77–80; Stacey, "Benjamin West," 4; and *Clements Library Bulletin* 17, n.p.

19. For information on the radiographs and infrared and ultraviolet studies, I wish to thank Michael Pantazzi of the National Gallery of Canada. A rumor that circulated for many years accused West of charging each soldier one hundred pounds for the privilege of being represented in the painting. See Alberts, *Benjamin West,* 105–6; and Stacey, "Benjamin West," 4.

20. The identification of the Indian in West's portrait of Guy Johnson as James Brandt is now somewhat in doubt. For information on the men identified in Woollett's key of 1776 and the expanded key of 1922, see Stacey, "Benjamin West," 3–4; Jones, "History of a Picture," 106–11; *Clements Library Bulletin* 17, n.p.; "Some Notes on the Death of Wolfe," *Canadian Historical Review* 3 (September 1922): 272–78; and "A New Account of the Death of Wolfe," ibid. 4 (March 1923): 45–55. For information about the lives of individual officers identified in the 1776 key, see *DNB* 1 (1967): 1195–96; 21: 472–73; and 22: 549–50.

21. William Smith, *An Historical Account of the Expedition against the Ohio Indians in the Year 1764 under the Command of Henry Bouquet, Esq. . . .* (London, 1766). The book was also printed in Philadelphia in 1765, but only the London edition contains West's illustrations. The original drawings are at the Yale Center for British Art, New Haven, Connecticut.

22. The feathered headdress, beaded pouch, ear-hoops, tomahawk, rifle, and drapery are almost identical—albeit more skillfully executed—to those found in earlier paintings by West. The similarity of the Indian's dress suggests that West either possessed sketches of native costumes or had access to objects that he continued to incorporate into his paintings. One striking feature of the Indian in the *Death of Wolfe* is the intricate pattern of tattoos that cover his body. As such markings were common among the various American tribes, West may have taken them from prints or paintings of Indians in English collections. Or possibly he used a live model, since delegations of Native Americans often visited London during those years. For helpful insights into the role of Indians in West's paintings, I wish to thank Dr. William Sturtevant of the Smithsonian Institution.

23. The Schaak portrait was widely distributed as a mezzotint in the mid-1760s. See J. F. Kerslake, "The Likeness of Wolfe" in *Wolfe: Portraiture and Genealogy* (Quebec: Quebec House, 1959), 17–43; Beckless Willson, "Portraits and Relics of General Wolfe," *Connoisseur* 23 (January 1909): 3–12; and H. Oakes-Jones, "Wolfe and His Portraits," *Journal of the Society for Army* 15 (Spring 1936): 1–4.

24. Among the many examples of this convention in nineteenth-century sculpture is Horatio Greenough's statue of George Washington. West mentioned the use of modern costume during a discussion of a memorial for Lord Cornwallis. Garlick and Macintyre, *Farington Diary* 2: 369–70 (entry 23 July 1795). See also, Mitchell, "Popular History Piece," 32. For information on Marchant, see Samuel Redgrave, *A Dictionary of Artists of the English School* (London: Longmans, Green Co., 1874), 272.

25. Bromley's effusive praise incited a heated debate when the Royal Academy had to decide whether or not to purchase the book for its library. West's detractors complained that Bromley's account was so heavily biased because West himself had dictated the text. As West had similarly used Galt to transcribe his ideas, it is feasible to accept Bromley's remarks as tantamount to West's own explanation of the way he wanted his work perceived. See Robert A. Bromley, *A Philosophical and Critical History of the Fine Arts* (New York: Garland, 1971), 56–59. For the controversy at the Royal Academy, see Charles Mitchell, "Benjamin West's Death of Nelson," in D. Fraser et al., eds., *Essays in the History of Art Presented to Rudolf Wittkower* (London:

Phaidon, 1967), 270–72; and Garlick and Macintyre, *Farington Diary* 1: 164–65 (entry 20 February 1793), and 1: 191 (entry 20 May 1793).

26. T. A. Carter of the Grosvenor Estates assured me that no documents exist to prove that Lord Richard commissioned West. For information on Grosvenor, see *Gentleman's Magazine* 40 (1770): 139, 314–18, 568; *DNB* 8 (1963): 723; A. I. Dasent, *A History of Grosvenor Square* (London: Macmillan, 1935), 30–33; Roy B. Clark, *William Gifford: Tory Satirist, Critic, and Editor* (New York: Columbia University Press, 1930), 10–12; Gervas Huxley, *Lady Elizabeth and the Grosvenors* (London: Oxford University Press, 1965), 4–5; and Nesta Pain, *George III at Home* (London: Eyre Methuen, 1975), 48–50.

27. Information about the Grosvenor holdings in East Florida and Grosvenor's interest in the American trade may be found in "Hints Respecting American Trade" (February 2, 1763), Ad. MS 38335, British Library, reproduced in Thomas C. Barrow, "A Project for Imperial Reform: 'Hints Respecting the Settlement [for] our American Provinces, 1763,' " *William and Mary Quarterly*, 24 (January 1967): 108–26. I wish to thank T. A. Carter of the Grosvenor Estates for the original document of the land grant.

28. For information on Woollett's print, see Alberts, *Benjamin West*, 110; and Mitchell, "Popular History Piece," 32–33.

29. The original of this verse is in the APS manuscript collection. See also, Philip S. Foner, ed., *The Complete Writings of Thomas Paine* (New York: Citadel Press, 1945), 2: 496; and A. Owen Aldridge, "The Poetry of Thomas Paine," *PMHB* 79 (January 1955): 81–99.

Chapter 9

1. Edmund Burke, *A Philosophical Enquiry into the Origin of Our Ideas of the Sublime and Beautiful*, 2d ed. (London, 1787), 95; and Alexander Pope, "An Essay on Criticism," *The Poems of Alexander Pope*, ed. John Butt (New Haven: Yale University Press, 1973), 146. For a study of Burke's theory, see Samuel H. Monk, *The Sublime: A Study of Critical Theories in Eighteenth-Century England* (New York: Modern Language Association, 1935), 84–99.

2. West or the king may have chosen the subject of Chevalier Bayard's death to hang with *The Death of Wolfe* for more reasons than just compositional and didactic similarities. Major Robert

Bayard of New York, who had commanded a regiment of Americans at Quebec and published his memoirs of the victorious battle, criticized West for leaving him out of his painting. See *Gentleman's Magazine* 89: 48; and E. Alfred Jones, "The History of a Picture" *Canadian Magazine of Politics, Science, and Literature* 56 (December 1920). For contemporary popularity of the legend, see *The Annual Register* (1767): 22–23.

3. See Jules D. Prown, *John Singleton Copley* (Cambridge: Harvard University Press, 1966), 2: 275–91; and "John Trumbull as a History Painter" in *John Trumbull: The Hand and Spirit of a Painter,* ed. Helen A. Cooper (New Haven: Yale University Press, 1982), 28–29.

4. Quoted in Horace Walpole, *Anecdotes of Painting in England* (New Haven: Yale University Press, 1937), 4: 115–16. Much of this analysis was presented in a talk by David M. Robb, Jr., entitled "Benjamin West: The Death of the Earl of Chatham," delivered at the annual meeting of the College Art Association in February 1983. I am very grateful to Dr. Robb for sharing his ideas with me.

5. For more on the Penn legend, see Ann Uhry Abrams, "Benjamin West's Documentation of Colonial History: *William Penn's Treaty with the Indians,*" *Art Bulletin* 64 (March 1982): 59–65. The two books that established the apocryphal tale are Parson M. L. Weems, *The Life of William Penn, The Settler of Pennsylvania* (Philadelphia, 1845) and Thomas Clarkson, *Memoirs of the Public and Private Life of William Penn* (London, 1849). For additional information on the painting, see Ellen Starr Brinton, "Benjamin West's Painting of Penn's Treaty with the Indians," *Bulletin of the Friends' Historical Association* 30 (Autumn 1941): 99–159; and Charles Coleman Sellers and Anthony Garvan, *Symbols of Peace: William Penn's Treaty with the Indians* (Philadelphia: Pennsylvania Academy of the Fine Arts, 1976).

6. Information on this treaty is found in letters between Thomas Penn and his deputies in Pennsylvania, Thomas Penn Letterbook, HSP. For a broader survey of the political controversies, see William S. Hanna, *Benjamin Franklin and Pennsylvania Politics* (Stanford: Stanford University Press, 1964); James H. Hutson, *Pennsylvania Poltics, 1746–1770: The Movement for Royal Government and Its Consequences* (Princeton: Princeton University Press, 1972); and Abrams, "*Penn's Treaty,*" 68–69.

7. Abrams, "*Penn's Treaty,*" 69–75. West's identity of his father and half-brother may be found in B. West to W. Darton, 1 February 1805, HSP (reprinted in Sellers and Garvan, *Symbols of Peace,* n.p.) and also appears in B. West to William West, 12 July 1775, *PMHB* 30 (1908): 14.

8. An engraving of the painting, made by John Hall, was sold in Pennsylvania in 1775 and thereafter. West mentioned the print in the letter to his brother in 1775.

9. Roy Strong, *Recreating the Past: British History and the Victorian Painter* (London: Thames & Hudson, 1978), 79–85.

10. See Arthur S. Marks, "Benjamin West and the American Revolution," *American Art Journal* 6 (November 1974): 15–35; Mary Beth Norton, "Eardley-Wilmot, Britannia and the Loyalists: A Painting by Benjamin West," *Perspectives in American History* 6 (1972): 119–31; and Helmut Von Erffa, "Benjamin West at the Height of His Career," ibid. 1 (Spring 1969): 19–27.

11. See Anita Brookner, *Jacques-Louis David* (New York: Harper & Row, 1980), 60–80, passim; and Edgar Wind, "The Sources of David's *Horaces,*" *Journal of the Warburg and Courtauld Institutes* 4 (1941): 124–38.

12. For more information on the competition, West's statement, and other details of *The Death of Lord Nelson,* see Charles E. Mitchell, "Benjamin West's Death of Nelson" in *Essays in the History of Art Presented to Rudolf Wittkower,* ed. Douglas Fraser et al. (London: Phaidon, 1967), 265–73.

13. Ibid., 267

14. Quoted in James Greig, *The Farington Diary* (London: Hutchinson and Co., 1922–28), 4: 155.

Comments on Sources

The Life and Work of Benjamin West

Visual Material

The best way to research West's early history paintings is to study the works themselves, a task hampered by the inaccessibility or loss of many major works. Reproductions and engravings, which never have the impact of the original canvas, have had to suffice in many cases. Unfortunately, this book went to press before Professor Allen Staley's forthcoming catalogue raisonné of West's paintings was completed. Without access to the catalogue, my search for specific information about presumably lost works, preparatory sketches, and other incidental data was limited.

Most of West's history paintings in the Royal Collection cannot be viewed by the general public. Through the kindness of the Lord Chamberlain's Office, I was able to see all of these important works. With few exceptions, the rest of the paintings discussed in this study come from public collections. In Canada, there is the National Gallery of Canada, Ottawa; in England, the Tate Gallery and the Victoria and Albert Museum, London, the Fitzwilliam Museum at Cambridge, and the National Maritime Museum, Greenwich; and in the United States, the Yale University Art Gallery and the Yale Center for British Art, New Haven; the Pennsylvania Academy of the Fine Arts and the Historical Society of Pennsylvania, Philadelphia; the Detroit Institute of Arts; the National Gallery of Art in Washington, D.C.; and the Henry Francis du Pont Winterthur Museum, Delaware.

There are several fine collections of West's drawings. The two largest are in the Pierpont Morgan Library in New York City and the Friends Library of Swarthmore College in Swarthmore, Pennsylvania. West's colonial sketchbook, a treasure of vignettes from his Pennsylvania years, is at the Historical Society of Pennsylvania in Philadelphia, and the small sketchbooks from his Italian trip are at the Royal Academy of Arts in London. Other drawings can be found in the Detroit Institute of Arts; the Henry E. Huntington Library and Art Gallery, San Marino, California; the Victoria and Albert Museum; the Library of Windsor Castle; and at many other museums and libraries around the United States, Canada, and England. Almost all of West's history paintings were engraved, the largest collection of these being in the Department of Prints and Drawings at the British Museum.

Primary Sources, Unpublished

In the vast archival collections of West material in the United States and Britain, only a few documents concern West's life before 1770. The most comprehensive collection is at the Historical Society of Pennsylvania (HSP). In addition to many letters, the HSP has the "extra-illustrated" copy of Galt's biography, which contains fragments of letters and memoranda. A few letters that document West's Italian studies and first years in England may be found at the American Philosophical Society (APS) in Philadelphia, and a few more are in the New York Public Library and Pennsylvania Academy of the Fine Arts (PAFA). Almost all of these letters are on microfilm at the Archives of American Art (AAA), Smithsonian Institution, Washington, D.C., which has branches in Boston, Detroit, New York, San Francisco, and San Marino.

One especially delightful unpublished source is "The Diary of Samuel Shoemaker of Philadelphia, November 7, 1783 to October 5, 1785," at the HSP and the New-York Historical Society. Although these daily entries (written by an old friend of West's from Philadelphia who escaped to London during the Revolution) contain little material that could be used in this book, it does provide a firsthand glimpse into the personalities and actions of West and his family.

English libraries have only fragmentary information about West's early life, but they do have a great deal pertaining to his later years. By far the best source for learning about West's first decade in London is the series of scrapbooks entitled "Press Cuttings from English Newspapers on Matters of Artistic Interest, 1686–1835" in the library of the Victoria and Albert Museum. In the Department of Prints and Drawings of the British Museum are William T. Whitley's clippings and notes, many of which are not published in his two-volume study *Artists and Their Friends in England, 1700–1799*. Catalogues of the Spring Gardens exhibitions and information about the Society of Artists are available at the library of the Royal Society of Arts; letters, mostly about West's later life, can be found at the Royal Academy of Arts, the Royal Archives at Windsor Castle, and the Fitzwilliam Museum, at Cambridge.

Primary Sources, Published

The Life, Studies, and Works of Benjamin West, Esquire by John Galt, published in 1820 in London, and reissued in 1960 by Scholars' Facsimiles and Reprints, Gainesville, Florida, is indispensable for conducting research on West.

Substantiating much of the material in Galt's biography are several essays that were published in journals during the artist's lifetime. They include:

La Belle Assemblée; or, Bell's Court Fashionable Magazine 4 (1808): 5–12, 52–55, 109–11, 149–51, 197–98.

Public Characters of 1805 7 (1805): 523–69.

"The Beauties of the Royal Palaces; or, a Pocket Companion to Windsor, Kensington, Kent, and Hampton Court . . . ," *Windsor Guide*, 1800.

European Magazine and London Review (September 1794): 163–66.

Universal Magazine 3 (May 1805): 87–96, 102–3. A copy is on microfilm, roll P24, AAA.

Biographies published shortly after West's death include Allan Cunningham, *The Lives of the Most Eminent British Painters and Sculptors*, vol. 2. (London and New York, 1831); *The Annual Register* (1820), 1163–75; and *The Georgian Era: Memoirs of the Most Eminent Persons, Who Have Flourished in Great Britain* (London, 1834), 86–90.

A number of diaries and memoirs contain material on West, mostly pertaining to his later years. The most comprehensive is *The Diary of Joseph Farington*, a meticulous compendium of daily entries made between 1793 and 1821 by one of West's students, Joseph Farington. The original diary is at the Royal Archives, Windsor Castle. Excerpts from this multivolume work were first published in 1922 with James Greig as editor (London: Hutchinson and Co., 1922). Beginning in the late 1970s Yale University Press has been issuing the original diary in two-volume sets: volumes 1 through 6, covering the years 1763 through 1804, were edited by Kenneth Garlick and Angus Macintyre and published 1978–79; volumes 7 through 14, covering January 1805 through December 1815, were edited by Kathryn Cave and published 1982–84. Other published diaries, memoirs, and collections of letters with information about West are:

Angelo, Henry. *The Reminiscences of Henry Angelo*. 2 vols. London, 1830; New York: Benjamin Blom, 1969.

Dunlap, William. *The Diary of William Dunlap*. 3 vols. New York: New-York Historical Society, 1931.

————. *A History of the Rise and Progress of the Arts of Design in the United States*. 3 vols. New York, 1834; New York: Dover Publications, 1969.

Dickason, David H. "Benjamin West on William Williams: A Previously Unpublished Letter." *Winterthur Portfolio* 6 (1970): 128–33.

Forster-Hahn, Franziska, "The Sources of True Taste: Benjamin West's Instructions to a Young Painter for His Studies in Italy." *Journal of the Warburg and Courtauld Institutes* 30 (1967): 367–82.

Hart, Charles Henry, ed. "Autobiographical Notes of Matthew Pratt, Painter." *Pennsylvania Magazine of History and Biography* 9 (1895): 460–67.

Kimball, David A., and Quinn, Miriam, eds. "William Allen–Benjamin Chew Correspondence, 1763–1764," *Pennsylvania Magazine of History and Biography* 90 (April 1966): 202–26.

Letters and Papers of John Singleton Copley and Henry Pelham, 1739–1776. Boston: Massachusetts Historical Society, 1914; New York: AMS Press, 1972.

"Letters of Benjamin West." *Pennsylvania Magazine of History and Biography* 18 (1894): 219–22; 37 (1913): 499–502.

Miller, Lillian B., ed. *The Selected Papers of Charles Willson Peale and His Family*. Vol. 1,

Charles Willson Peale: Artist in Revolutionary America, 1735–1791. New Haven: Yale University Press, 1983.

Richardson, Edgar P. "West's Voyage to Italy, 1760, and William Allen." *Pennsylvania Magazine of History and Biography* 102 (January 1978): 3–26.

Sizer, Theodore, ed. "Benjamin West to His Former Pupil John Trumbull." *Yale University Library Gazette* 25 (January 1951): 104–9.

_____. *The Autobiography of Colonel John Trumbull, Patriot-Artist, 1756–1843.* New Haven: Yale University Press, 1953.

Smith, John Thomas. *Nollekens and His Times.* 2 vols. London: Henry Colburn, 1929.

Walpole, Horace. *Anecdotes of Painting in England.* Vol. 4. New Haven: Yale University Press, 1937.

_____. *Correspondence with Sir Horace Mann.* 11 vols. (1954–71), W. S. Lewis et al., eds., of *The Yale Edition of Horace Walpole's Correspondence,* vols. 17–27. 48 vols. to date. New Haven: Yale University Press, 1937–).

Walker, Lewis Burd, ed. *The Burd Papers: Extracts from Chief Justice William Allen's Letterbook.* Philadelphia: Privately printed, 1897.

Whitley, William T. *Artists and Their Friends in England, 1700–1799.* 2 vols. London and Boston: Medici Society, 1928; New York: Arno Press, 1969.

Secondary Sources, Biographical
Over the years there have been a number of book-length studies and articles about West's life. The most recent is *Benjamin West: A Biography* by Robert C. Alberts (Boston: Houghton Mifflin, 1978). It is well researched and quite thorough, with a marvelous bibliography. While it contains valuable information about the Royal Academy and West's relationship with the king, the biographer adds little to the scholarship of West's early history paintings. Other general studies for adult readers are:

Carson, Hampton L. "The Life and Works of Benjamin West." *Pennsylvania Magazine of History and Biography* 45 (1921): 301–19.

Evans, Grose. *Benjamin West and the Taste of His Times.* Carbondale: Southern Illinois University Press, 1959.

Jackson, Henry E. *Benjamin West, His Life and Work.* Philadelphia: John C. Winston, 1900.

Morgan, Charles, and Toole, Margaret C. "Benjamin West: His Times and His Influence." *Art in America* 38 (December 1950): 205–14.

Sherman, Frederic F. "The Art of Benjamin West." *Art in America* 6 (April 1918): 155–62.

Among the children's books about West are:

Hawthorne, Nathaniel. *Biographical Stories for Children.* Boston: Tappan and Dennet, 1842, 7–161.

Henry, Marguerite. *Benjamin West and His Cat Grimalkin.* New York: Bobbs-Merrill, 1947.

Snow, Dorothea J. *Benjamin West: Gifted Young Painter.* Indianapolis: Bobbs-Merrill, 1967.

Secondary Sources, West as an Artist
A few items were published under West's name during his lifetime, including *A Discourse Delivered to the Students of the Royal Academy on the Distribution of the Prizes, December 10, 1792* . . . (London, 1793); "Letters to the Earl of Elgin" in W. R. Hamilton, *Memorandum on the Subject of the Earl of Elgin's Pursuits in Greece* (Edinburgh, 1811); and "To the Committee of the Northern Society for Promoting the Fine Arts" in *Annals of the Fine Arts* 4 (1819): 220–26. In addition, Henry Moses compiled a book of West's engravings, *The Gallery of Pictures Painted by Benjamin West, Esq· Historical Painter to His Majesty and President of the Royal Academy, Engraved in Outline by Henry Moses* (London, 1811).

After West's death in 1820 his works were sold in several auctions. These works are listed in *Catalogue of Pictures and Drawings by the Late Benjamin West,* West's Gallery (London, 1824); and in George Robins, *A Catalogue Raisonné of the Unequalled Collection of Historical Pictures and Other Admired Compositions of Benjamin West, Esq. Sold by George Robins in the Gallery at Newman Street, May, 1829* (London, 1829).

Among the nineteenth-century attempts to redeem West's reputation and explain or defend his works are the *Addresses Delivered by Dr. Thomas G. Morton and John B. Garrett,* published by Pennsylvania Hospital (Philadelphia, 1884); Job Roberts Tyson, *Address before the Washington Art Association* (Philadelphia, 1858); and Raphael Lamar West and Benjamin West, Jr., *Letter to the Speaker of the House of Representatives of the United States,* December 11, 1826 (H.R. 8, 19th Cong., 2d sess., April 12, 1826).

Among the more recent exhibition catalogues of note are *The World of Benjamin West,* Allen-

town Art Museum (Pennsylvania, 1962); *Benjamin West: His Time and Influence,* Amherst College (Massachusetts, 1950); *Benjamin West,* Graham Gallery (New York, 1962); Fiske Kimball, *Benjamin West: 1738–1820,* Philadelphia Museum of Art (1938); and *Copley, Stuart, and West in America and England,* Museum of Fine Arts (Boston, 1976).

Several people have written about specialized areas of West's career. The best study of his contributions as a teacher is Dorinda Evans, *Benjamin West and His American Students* (Washington, D.C.: National Portrait Gallery, Smithsonian Institution, 1980).

Studies of his religious paintings include John Dillenberger, *Benjamin West: The Context of His Life's Work with Particular Attention to Paintings with Religious Subject Matter* (San Antonio, Tex.: Trinity University Press, 1977); *"Revealed Religion," Paintings by Benjamin West* (Greenville, S.C.: Bob Jones University, 1963); Jerry D. Meyer, "Benjamin West's Chapel of Revealed Religion: A Study in Eighteenth-Century Protestant Religious Art" in *Art Bulletin* 57 (June 1973): 247–63; and "Benjamin West's Window Designs for St. George's Chapel, Windsor" in *American Art Journal* 11 (July 1979): 53–64.

Books on West's drawings are Ruth Kramer, *Drawings by Benjamin West and His Son Raphael Lamar West,* and Nancy L. Pressly, *Revealed Religion: Benjamin West's Commissions for Windsor Castle and Fonthill Abbey* (San Antonio, Tex.: San Antonio Museum of Art, 1983).

The late Professor Helmut Von Erffa gathered copious material on West but produced only three articles, all of which were published in *American Art Journal:* "Benjamin West at the Height of His Career," 1 (Spring 1969): 19–27; "Benjamin West Reinterpreted," 81 (June 1962): 630–33; and "Benjamin West: The Early Years in London," 5 (November 1973): 5–14.

Other articles focusing on specific aspects of West's career are:

Abrams, Ann Uhry. "A New Light on Benjamin West's Pennsylvania Instruction." *Winterthur Portfolio* 17 (Winter 1982): 243–57.

Gottesman, Rita. "Copley versus West." *Antiques* 78 (November 1960): 478–79.

Flexner, James T. "Benjamin West's American Neo-Classicism." *New-York Historical Society Quarterly* 36 (January 1952): 5–41.

Hart, Charles H. "Benjamin West's Family: The American President of the Royal Academy of Arts Not a Quaker." *Pennsylvania Magazine of History and Biography* 32 (1908): 1–33.

Marks, Arthur S. "Benjamin West and the American Revolution." *American Art Journal* 6 (November 1974): 15–35.

Neumeyer, Alfred. "The Early Historical Paintings of Benjamin West." *Burlington Magazine* 73 (October 1938): 162–65.

Sermon, Kurt M. "His Sketches Reveal the Scope of Benjamin West's Work as an Artist." *American Collector* 14 (May 1945): 6–7, 19.

Sawitzky, William. "The American Work of Benjamin West." *Pennsylvania Magazine of History and Biography* 62 (October 1938): 433–62.

Todd, Ruthven. "Benjamin West vs. the History Picture." *Magazine of Art* 41 (December 1948): 301–5.

A number of other articles concern West's individual works. Among those dealing primarily with *The Death of General Wolfe* are "Benjamin West's Death of Wolfe" in *William L. Clements Library Bulletin* (University of Michigan) 17 (1928); Charles Mitchell, "Benjamin West's 'Death of General Wolfe' and the Popular History Piece" in *Journal of the Warburg and Courtauld Institutes* 7 (1944): 20–33; Dennis Montagna, "Benjamin West's The Death of General Wolfe: A Nationalist Narrative" in *American Art Journal* 8 (Spring 1981): 72–88; C. P. Stacey, "Benjamin West and 'The Death of Wolfe' " in *National Gallery of Canada Bulletin* 4 (1966): 1–5; and Edgar Wind, "Penny, West, and 'The Death of Wolfe' " in *Journal of the Warburg and Courtauld Institutes* 10 (1947): 159–62.

Essays on *William Penn's Treaty with the Indians* include Ann Uhry Abrams, "Benjamin West's Documentation of Colonial History: *William Penn's Treaty with the Indians*" in *Art Bulletin* 64 (March 1982): 59–65; Ellen Starr Brinton, "Benjamin West's Painting of Penn's Treaty with the Indians" in *Bulletin of the Friends' Historical Association* 30 (Autumn 1941): 99–159; and Charles Coleman Sellers and Anthony Garvan, *Symbols of Peace: William Penn's Treaty with the Indians* (Philadelphia: Pennsylvania Academy of the Fine Arts, 1976).

On *Death on a Pale Horse* there are *Description of Mr. West's Picture of Death on the Pale Horse; or, the Opening of the First Five Seals* (Philadelphia, early 1800s); Fiske Kimball, "Benjamin West au Salon de 1802, La Mort sur le Cheval Pale" in *Gazette de Beaux Arts* 7 (1932): 403–10; and Allen Staley, "West's Death on the Pale Horse" in *Detroit Institute of Arts Bulletin*

58 (1980): 137–49.

Other discussions of individual works include:

Honour, Hugh. "Benjamin West's 'Indian Family.' " *Burlington Magazine* 125 (December 1983): 726–33.

McQuin, A. D. *A Description of the Picture, Christ Rejected by the Jews.* Philadelphia, 1830.

Mitchell, Charles E. "Benjamin West's Death of Nelson." In *Essays in the History of Art Presented to Rudolph Wittkower,* edited by Douglas Fraser et al. London: Phaidon, 1967.

Norton, Mary Beth. "Eardley-Wilmot, Britannia and the Loyalists: A Painting by Benjamin West." *Perspectives in American History* 6 (1972): 119–31.

Rosenblum, Robert. "Benjamin West's 'Eagle Bringing the Cup of Water to Psyche': A Document of Romantic Classicism." *Record of the Art Museum* (Princeton University) 19 (1960): 66–75.

Robinson, John. *A Description of, and Critical Remarks on, the Picture of Christ Healing the Sick in the Temple. . . .* Philadelphia, 1818.

Staley, Allen. "Benjamin West's *The Landing of Agrippina at Brundisium with the Ashes of Germanicus.*" *Philadelphia Museum of Art Bulletin* 61 (Fall 1965/Winter 1966): 10–19.

Art in Europe and America

General Studies
Primary sources for studying eighteenth-century art come in two basic forms other than the paintings themselves: one is the memoirs, essays, and critiques written by individual artists and writers; the other is the lists of paintings in the annual exhibitions. Of the latter, the exhibition catalogues of the Royal Society of Arts (Spring Gardens and Maiden Lane) and the Royal Academy of Arts were most helpful. While not illustrated by pictures nor accompanied by an explanatory text like more modern catalogues, the lists give titles and groupings of pictures more thoroughly than any other source. The works themselves have been published in Algernon Graves, *Royal Academy of Arts: A Complete Dictionary of the Contributors and Their Works from Its Foundation in 1769 to 1904,* 8 vols. (London, 1901); and in *The Society of Artists of Great Britain, 1760–1791; The Free Society of Artists, 1761–1783: A Complete Dictionary of Contributors and Their Works* (London, 1907). These volumes are arranged by the artists' names, and therefore do not give a full picture of individual exhibitions.

Numerous critical and theoretical commentaries were written before and during the eighteenth century. Those with the most direct bearing on this book are:

Bromley, Robert A. *A Philosophical and Critical History of the Fine Arts.* London, 1793: New York: Garland, 1971.

Burke, Edmund. *A Philosophical Enquiry into the Origin of Our Ideas of the Sublime and Beautiful.* London, 1759; New York: Garland, 1971.

du Fresnoy, Charles Alphonse. *The Art of Painting [De Arte Graphica].* Translated into English verse by William Mason with annotations by Joshua Reynolds. London, 1783; New York: Arno Press, 1969.

Reynolds, Joshua. *Discourses on Art.* Edited by Robert Lavine. New York: Collier Books, 1961.

Richardson, Jonathan. *An Essay on the Theory of Painting.* London, 1725; London: Scholar Press, 1971.

Rouquet, Jean André. *The Present State of the Arts in England.* London, 1755; London: Cornmarket Press, 1970.

Shaftesbury, Third Earl of [Anthony Ashley Cooper]. "An Essay on Painting Being a Notion of the Historical Draught or Tablature of the Judgment of Hercules." *Characteristicks* 3. London, 1714.

Webb, Daniel. *An Inquiry into the Beauties of Painting . . . and into the Merits of the Most Celebrated Painters, Ancient and Modern.* London, 1761.

Of all the modern theoretical essays, the most provocative discussion of the ideas behind history painting is Rensselaer W. Lee, *Ut Pictura Poesis: The Humanistic Theory of Painting* (New York: W. W. Norton, 1967). Other, more general studies of neoclassicism and history painting are:

Greenhalgh, Michael. *The Classical Tradition in Art from the Fall of the Roman Empire to the Time of Ingres.* New York: Harper & Row, 1978.

Haskell, Francis, and Penny, Nicholas. *Taste and the Antique: The Lure of Classical Sculpture, 1500–1900.* New Haven and London: Yale University Press, 1981.

Honour, Hugh. *Neo-Classicism*. Harmondsworth and New York: Penguin Books, 1968.

Locquin, Jean. *La Peinture D'Histoire en France de 1747 à 1785*. Paris, 1912; Paris: Association pour la Diffusion de l'Histoire de l'art, 1978.

Rosenblum, Robert. "The Origin of Painting: A Problem in the Iconography of Romantic Classicism." *Art Bulletin* 39 (December 1956): 279–90.

————. *Transformations in Late Eighteenth-Century Art*. Princeton: Princeton University Press, 1969.

The Royal Academy of Arts and The Victoria and Albert Museum. *The Age of Neo-Classicism*. London: Arts Council of Great Britain, 1972.

Wiebenson, Dora. "Subjects from Homer's Iliad in Neoclassical Art." *Art Bulletin* 46 (1964): 23–37.

Wind, Edgar. "The Revolution of History Painting." *Journal of the Warburg Institute* 2 (October 1938): 117–21.

American Colonial Painting

Most of the studies of American colonial painting are in the form of monographs or articles about individual artists, with only a few worthwhile books available. Among the better ones are James T. Flexner, *America's Old Masters* (New York: Viking, 1939); and *American Painting to 1776: A Reappraisal,* edited by Ian M. G. Quimby (Winterthur Conference Report, 1971; Charlottesville: University Press of Virginia, 1971).

Some other interesting general studies are:

American Artists in Europe, 1800–1900. Liverpool: Walker Art Gallery, 1976.

Bizardel, Yvon. *American Painters in Paris*. Translated by Richard Howard. New York: Macmillan, 1960.

Dickson, Harold E. "Artists as Showmen." *American Art Journal* 5 (May 1973): 4–17.

Dillenberger, Jane, and Taylor, Joshua C. *The Hand and the Spirit: Religious Art in America, 1700–1900*. Berkeley: University Museum, 1972.

Flexner, James T. "The American School in London." *Metropolitan Museum of Art Bulletin* 7 (October 1948): 64–72.

Hoopes, Donelson. *American Narrative Painting*. Los Angeles: Los Angeles County Museum of Art, 1974.

Kenin, Richard. *Return to Albion: Americans in England, 1760–1949*. New York: Holt, Rinehart and Winston, 1979.

Richardson, Edgar P. "Old and New England." *Art Quarterly* 8 (1945): 3–15.

Among the more helpful studies on individual artists are:

Brinton, Christian. *Gustavus Hesselius, 1682–1755*. Philadelphia: Philadelphia Museum of Art, 1938.

Cooper, Helen, ed. *John Trumbull: The Hand and Spirit of a Painter*. New Haven: Yale University Press, 1982.

Craven, Wayne. "John Wollaston: His Career in England and New York." *American Art Journal* 7 (November 1975): 19–31.

Dickason, David H. *William Williams, Novelist and Painter of Colonial America*. Bloomington: Indiana University Press, 1970.

Doud, Richard K. "John Hesselius, Maryland Limner." *Winterthur Portfolio* 5 (1969): 129–53.

Foote, Henry W. *John Smibert, Painter*. Cambridge: Harvard University Press, 1950.

————. *Robert Feke*. Cambridge: Harvard University Press, 1930.

Gerdts, William H. "William Williams: New American Discoveries." *Winterthur Portfolio* 4 (1968): 159–67.

Goodrich, Lloyd. *Robert Feke*. New York: Whitney Museum of American Art, 1946.

Jaffe, Irma B. *John Trumbull: Patriot-Artist of the American Revolution*. Boston: New York Graphic Society, 1975.

Howland, Garth A. "John Valentine Haidt, A Little-Known Eighteenth-Century Painter." *Pennsylvania History* 8 (October 1941): 304–13.

Miller, Lillian B. "Charles Willson Peale as History Painter: The Exhumation of the Mastodon." *American Art Journal* 13 (Winter 1981): 47–68.

Mooz, R. Peter. "Smibert's *Bermuda Group*—A Reevaluation." *Art Quarterly* 33 (Summer 1970): 147–57.

Nelson, Vernon. *John Valentine Haidt*. Williamsburg, Va.: Abby Aldrich Rockefeller Folk Art Collection, 1966.

Prown, Jules D. *John Singleton Copley*. 2 vols. Cambridge: Harvard University Press, 1966.

Richardson, Edgar P. "Gustavus Hesselius." *Art Quarterly* 12 (Summer 1949): 220–26.

_____. "William Williams—A Dissenting Opinion," *American Art Journal* 4 (Spring 1972): 5–23.

Sawitzky, William. *Matthew Pratt, 1734–1805.* New York: New-York Historical Society, 1942.

Sellers, Charles Coleman. *Charles Willson Peale, Artist of the Revolution.* 2 vols. Philadelphia: American Philosophical Society, 1947.

_____. *Charles Willson Peale with Patron and Populace.* New York: Scribner's, 1969.

Eighteenth-Century British Art

Among the general studies on British Art of the period are:

Burke, Joseph. *English Art, 1714–1800.* Oxford: Oxford University Press, 1976.

Burger, W. *Histoire des Peintres de Toutes les Écoles Anglais.* Paris, 1863.

Cummings, Frederick, and Staley, Allen. *Romantic Art in Britain: Paintings and Drawings, 1760–1860.* Philadelphia: Philadelphia Museum of Art, 1968.

Gaunt, William. *The Great Century of British Painting, Hogarth to Turner.* London: Phaidon, 1971.

Hermann, Frank. *The English as Collectors: A Documentary Chrestomathy.* New York: W. W. Norton, 1972.

Lipking, Lawrence. *The Ordering of the Arts in Eighteenth-Century England.* Princeton: Princeton University Press, 1970.

Mayoux, Jean-Jacques. *English Painting from Hogarth to the Pre-Raphaelites.* New York: St. Martin's Press, 1972.

Monkhouse, William C. *Masterpieces of English Art.* London: Bell & Daldy, 1869.

Millar, Oliver. *Later Georgian Pictures in the Collection of Her Majesty the Queen.* 2 vols. London: Phaidon, 1969.

Painting in England, 1700–1850, Collection of Mr. and Mrs. Paul Mellon. 2 vols. Richmond: Virginia Museum of Art, 1963.

Paulson, Ronald. *Emblem and Expression: Meaning in English Art of the Eighteenth Century.* Cambridge: Harvard University Press, 1975.

Pye, John. *Patronage of British Art: An Historical Sketch.* London, 1845.

Redgrave, Richard and Samuel. *Century of British Painters.* London, 1866; Ithaca: Cornell University Press, 1981.

Sitwell, Sacheverell. *Narrative Pictures: A Survey of English Genre and Its Painters.* New York: Benjamin Blom, 1972.

Sunderland, John. *Painting in Britain, 1525–1975.* New York: New York University Press, 1976.

Tinker, Chauncey Brewster. *Painter and Poet: Studies in the Literary Relations of English Painting.* Cambridge: Harvard University Press, 1939.

Waagen, Gustav F. *Treasures of Art in Great Britain.* 3 vols. London, 1854.

Waterhouse, Ellis K. *Painting in Britain, 1530–1790.* London: Penguin Books, 1953.

_____. *Three Decades of British Art, 1740–1770.* Philadelphia: American Philosophical Society, 1965.

Whinney, Margaret. *Sculpture in Britain, 1530–1830.* London: Penguin Books, 1964.

For special emphasis on English neoclassicism and related studies, see:

British Artists in Rome, 1700–1800. London: Greater London Council, 1974.

Fleming, John. *Robert Adam and His Circle in Edinburgh and Rome.* London: John Murray, 1962.

Goodreau, David. "Pictorial Sources of the Neo-Classical Style: London or Rome." *Studies in Eighteenth-Century Culture* 4 (1975): 247–70.

Irwin, David. "English Neo-Classicism and Some Patrons." *Apollo* 78 (November 1963): 360–67.

_____. *English Neoclassical Art: Studies in Inspiration and Taste.* London: Faber & Faber, 1966.

Rosenblum, Robert. "The Dawn of British Romantic Painting, 1760–1780." In *The Varied Pattern: Studies in the Eighteenth Century,* edited by Peter Hughes and David Williams. Toronto: A. M. Hakkert, 1971.

Waterhouse, Ellis K. "The British Contribution to the Neo-Classical Style in Painting." *Proceedings of the British Academy* 40 (1954): 57–74.

Among the studies relating to London's eighteenth-century art associations and institutions are:

Hodgson, John Evan, and Eaton, Fred A. *The Royal Academy and Its Members. 1768–1830.* New York: Charles Scribner's Sons, 1905.

Holme, Charles, ed. *The Royal Academy from Reynolds to Millais.* London and New York: The Studio, 1904.

Hudson, Derek, and Luckhurst, Kenneth W. *The Royal Society of Arts, 1754–1954.* London: John Murray, 1954.

Hutchinson, Sidney C. *The History of the Royal Academy, 1768–1968.* London: Chapman and Hall, 1968.

————. *The Homes of the Royal Academy.* London: Royal Academy of Arts, 1956.

Leslie, George D. *The Inner Life of the Royal Academy.* London, 1914; New York: Benjamin Blom, 1971.

Sandby, William. *The History of the Royal Academy of Arts.* 2 vols. London, 1862; London: Cornmarket Press, 1970.

Strange, Robert. *An Inquiry into the Establishment of the Royal Academy of Arts to Which Is Prefixed a Letter to the Earl of Bute.* London, 1775.

Thompson, William. *The Conduct of the Royal Academicians While Members of the Incorporated Society of Artists.* . . . London, 1771.

Wraight, Robert, ed. *Hip! Hip! Hip! R.A.: An Unofficial Book for the Royal Academy's Bicentenary.* London: Leslie Frewin, 1968.

Wood, Henry T. *A History of the Royal Society of Arts.* London: John Murray, 1913.

Studies on prints and printmaking in eighteenth-century Britain and America include:

Adair, Douglass. "The Stamp Act in Contemporary English Cartoons." *William and Mary Quarterly,* 3d. ser., 10 (October 1953): 538–42.

Dolmetsch, Joan D. *Rebellion and Reconciliation: Satirical Prints on the Revolution at Williamsburg.* Charlottesville: University Press of Virginia, 1976.

George, M. Dorothy. "America in English Satirical Prints." *William and Mary Quarterly,* 3d. ser., 10 (October 1953): 511–37.

————. *English Political Caricature to 1792: A Study of Opinion and Propaganda.* Oxford: Clarendon Press, 1959.

————. *Hogarth to Cruikshank: Social Change in Graphic Satire.* London: Penguin, Allen Lane, 1967.

Godfrey, Richard T. *Printmaking in Britain: A General History from Its Beginnings to the Present Day.* New York: New York University Press, 1978.

Hammelmann, Hanns, and Boase, T. S. R. *Book Illustrators in Eighteenth-Century England.* New Haven: Yale, Mellon Center, 1975.

Herdan, Innes and Gustav, eds. and trans. *Lichtenberg's Commentaries on Hogarth's Engravings.* London: Crescent Press, 1966.

Hunter, Kathryn. "The Informing Word: Verbal Strategies in Visual Satire." *Studies in Eighteenth-Century Culture* 4 (1975): 271–96.

Paulson, Ronald. *Hogarth's Graphic Works,* rev. ed. New Haven: Yale University Press, 1970.

Richardson, Edgar P. "Stamp Act Cartoons in the Colonies." *Pennsylvania Magazine of History and Biography* 96 (July 1972): 275–97.

Stephens, Frederick G., and Hawkins, Edward. *Catalogue of Prints and Drawings in the British Museum,* vol. 3 (London: British Museum, 1877); vol. 4 (London: British Museum, 1883).

Wright, Thomas. *Caricature History of the Georges.* London, 1868; New York: Benjamin Blom, 1968.

Of the monographs, special studies, and biographies about West's contemporaries and predecessors in the British art world, the following were most helpful:

Constable, William G. *Richard Wilson.* London: Routledge & Kegan Paul, 1953.

Ford, Brinsley. "A Portrait Group by Gavin Hamilton: With Some Notes on Portraits of Englishmen in Rome." *Burlington Magazine* 97 (December 1955): 372–78.

Hudson, Derek. *Sir Joshua Reynolds, A Personal Study.* London: Geoffrey Bles, 1958.

Irwin, David. "Gavin Hamilton: Archaeologist, Painter, and Dealer." *Art Bulletin* 44 (June 1962): 87–102.

Klinger, Mary F. "William Hogarth and London Theatrical Life." *Studies in Eighteenth-Century Culture* 5 (1976): 11–27.

Marks, Arthur S. "Angelica Kauffmann and Some Americans on the Grand Tour." *American Art Journal* 12 (Spring 1980): 5–24.

Paulson, Ronald. *Hogarth: His Life, Art, and Times.* 2 vols. New Haven: Yale University Press, 1971.

Pressley, William L. *The Life and Art of James Barry.* New Haven: Yale, Mellon Center, 1981.

Rosenblum, Robert. "Gavin Hamilton's 'Brutus' and Its Aftermath." *Burlington Magazine* 103 (January 1961): 8–16.

Sunderland, John. "Mortimer, Pine, and Some Political Aspects of English History Painting." *Burlington Magazine* 116 (June 1974): 317–26.

Stewart, Robert. *Robert Edge Pine: A British Portrait Painter in America.* Washington, D.C.: National Portrait Gallery, Smithsonian Institution, 1979.

Sulton, Denys, ed. *An Italian Sketchbook by Richard Wilson, R.A.* London: Paul Mellon Foundation, 1968.

Waterhouse, Ellis K. *Reynolds.* London: Phaidon, 1973.

Walch, Peter S. "An Early Neoclassical Sketchbook by Angelica Kauffman [sic]." *Burlington Magazine* 119 (February 1977): 98–108.

Eighteenth-Century European Art
There are numerous books and articles about painting in eighteenth-century France and Italy, but only a few of these have direct bearing on West's experiences in these two countries. The following were the best of the general studies for my purposes:

Fried, Michael. *Absorption and Theatricality: Painting and Beholder in the Age of Diderot.* Berkeley and Los Angeles: University of California Press, 1980.

French Painting: The Revolutionary Decades, 1760–1830. Sydney: Australian Gallery Directors Council, 1980.

French Painting, 1774–1830: The Age of Revolution. Detroit: Wayne State University Press, 1975.

Levey, Michael. *Painting in Eighteenth-Century Venice.* London: Phaidon, 1959.

Maxon, John, and Rishel, Joseph J. *Painting in Italy in the Eighteenth Century—Rococo to Romanticism.* Chicago: Art Institute of Chicago, 1970.

Rosenberg, Pierre. *The Age of Louis XV: French Painting, 1710–1774.* Toledo, Ohio: Toledo Museum of Art, 1975.

On the individuals who touched West's life or influenced his work, the following provided the best information:

Brookner, Anita. *Greuze: The Rise and Fall of an Eighteenth-Century Phenomenon.* London: Elek Press, 1972.

Daniels, Jeffrey. *Sebastiano Ricci.* Hove, Sussex: Wayland Publishers, 1976.

Leppmann, Wolfgang. *Winckelmann.* New York: Alfred A. Knopf, 1970.

Ministerio de Cultura. *Antonio Raphael Mengs, 1728–1779.* Madrid: Prado, 1980.

Pelzel, Thomas. *Anton Raphael Mengs and Neoclassicism.* New York: Garland, 1979.

Seznec, Jean. "Diderot and Historical Painting." In *Aspects of the Eighteenth Century,* edited by Earl R. Wasserman. Baltimore: Johns Hopkins Press, 1965.

Eighteenth-Century Social, Political, and Cultural History

Primary Sources
The best way to form a clear picture of the cultural and historical ambience of a period is to read its newspapers, magazines, and other publications that had wide popular circulation. For colonial Pennsylvania, there is the *Pennsylvania Gazette,* an unbeatable source for insight into the daily life of the colony. The *American Magazine,* published between 1757 and 1758 by the College of Philadelphia, was especially important for learning about the intellectual climate of West's years in the provincial capital. Of all the London papers and magazines, I found the *Gentleman's Magazine, Universal Magazine,* the *St. James Chronicle,* and the *Public Advertiser* to be best for my purposes.

Memoirs, letters, sermons, and other contemporary documents also contained relevant information about the thoughts and activities of the period. For colonial Pennsylvania, none are better than those of William Smith, many of them gathered in *The Works of William Smith, D.D., Late Provost of the College of the Academy of Philadelphia,* 2 vols. (Philadelphia, 1803). Others were available in the Reading Room of the Library of Congress and at the Library Company of Philadelphia. Another wonderful source for insights into the ideas of the time is the classic *Autobiography of Benjamin Franklin,* available in

paperback from Signet Books, 1961; and Franklin's letters and papers collected in *The Papers of Benjamin Franklin, 1706–1775,* 24 volumes to date, edited by Benjamin Labaree and William B. Willcox (New Haven: Yale University Press, 1959–).

There are quite a few published diaries from colonial Pennsylvania, the most important for my purposes being Alexander Hamilton, *Itinerarium* (Philadelphia, 1744; New York: Arno Press, 1971); and George Vaux, "Extracts from the Diary of Hannah Callender," *Pennsylvania Magazine of History and Biography* 12 (1898).

Insights into the travels of young Pennsylvanians in Italy around the time of West's visit can be found in *The Journal of Dr. John Morgan of Philadelphia from the City of Rome to the City of London, 1764* (Philadelphia: J. B. Lippincott, 1907).

Glimpses into the life and thought of eighteenth-century London come from the many pamphlets and broadsides that air political opinions, social commentaries, literary criticisms, and a variety of contemporary satires. Many of these can be found in the Rare Books Room of the Library of Congress and in the Folger Shakespeare Library, Washington, D.C.; the Library Company of Philadelphia; the Beinecke Library of Yale University; and the British Museum Library. In each of these collections, especially the latter, I found copies of eighteenth-century dramas, comedies, parodies, and operatic librettos. The original scripts (many of them annotated) provide valuable material about the ties between art and drama in the eighteenth century. An excellent guide for researchers of theatrical themes is the fourteen-volume *Restoration and Eighteenth-Century Theatre Research,* published by Loyola University, Chicago, from 1962 to 1965.

Historical Background: General Studies

Many fine studies have captured the ideological and conceptual background of the eighteenth century. While I consulted many, I found these few general studies to set the mood best:

Gay, Peter. *The Enlightenment: An Interpretation.* Vol. 1, *The Rise of Modern Paganism.* New York: Alfred A. Knopf, 1966.

Hampson, Norman. *A Cultural History of the Enlightenment.* New York: Pantheon, 1968.

Peardon, Thomas P. *Transition in English Historical Writing, 1760–1830.* New York: Columbia University, AMS Press, 1933.

Willey, Basil. *Eighteenth-Century Background:*
Studies on the Idea of Nature in the Thought of the Period. London: Chatto & Windus, 1939.

Colonial Pennsylvania

General impressions of cultural, political, and intellectual life in colonial America can be found in these books:

Bridenbaugh, Carl. *Cities in Revolt: Urban Life in America, 1743–1776.* New York: Alfred A. Knopf, 1955.

Bush, Clive. *The Dream of Reason: American Consciousness and Cultural Achievement from Independence to the Civil War.* New York: St. Martin's Press, 1978.

Christie, Ian R., and Labaree, Benjamin W. *Empire or Independence, 1760–1776: A British-American Dialogue on the Coming of the American Revolution.* New York: W. W. Norton, 1976.

Miller, Lillian B., ed., *In the Minds and Hearts of the People: Prologue to the American Revolution 1760–1774.* Greenwich, Conn.: New York Graphic Society, 1974.

Silverman, Kenneth. *A Cultural History of the American Revolution.* New York: Thomas Y. Crowell Co., 1976.

Wish, Harvey. *Society and Thought in Early America.* New York: David McKay Co., 1950.

Wright, Louis B. *The Cultural Life of the American Colonies, 1607–1763.* New York: Harper Torchbooks, 1962.

The greatest source for trivia and details about colonial Pennsylvania is John F. Watson, *Annals of Philadelphia and Pennsylvania, in Olden Time,* 2 vols. (Philadelphia: Whiting and Thomas, 1856). More recent valuable studies about life in the colony include:

Baltzell, E. Digby. *Puritan Boston and Quaker Philadelphia.* New York: Free Press, 1979.

Bridenbaugh, Carl and Jessica. *Rebels and Gentlemen: Philadelphia in the Age of Franklin.* New York: Galaxy Books, 1965.

Cochran, Thomas C. *Pennsylvania: A Bicentennial History.* New York: W. W. Norton, 1978.

Frost, J. William. *The Quaker Family in Colonial America: A Portrait of the Society of Friends.* New York: St. Martin's Press, 1973.

Hanna, William S. *Benjamin Franklin and Pennsylvania Politics.* Stanford: Stanford University Press, 1964.

Hutson, James H. *Pennsylvania Politics, 1746–1770: The Movement for Royal Government and Its Consequences.* Princeton: Princeton University Press, 1972.

Illick, Joseph E. *Colonial Pennsylvania: A History.* New York: Charles Scribner's Sons, 1976.

Biographies of individuals in colonial Philadelphia who touched West's life include:

Hastings, George E. *The Life and Works of Francis Hopkinson.* Chicago: University of Chicago Press, 1926.

Gegenheimer, Albert Frank. *William Smith, Educator and Churchman, 1727–1803.* Philadelphia: University of Pennsylvania Press, 1943.

Jones, Thomas Firth. *A Pair of Lawn Sleeves: A Biography of William Smith (1727–1803).* Philadelphia: Chilton Book Co., 1972.

Jordan, Francis, Jr. *The Life of William Henry of Lancaster, Pennsylvania 1729–1786.* Lancaster: New Era Printing Co., 1910.

Sonneck, Oscar G. T. *Francis Hopkinson and James Lyon.* New York, 1905; New York: Da Capo Press, 1967.

Smith, Horace Wemyss. *Life and Correspondence of the Reverend William Smith, D.D.* New York, 1880; New York: Arno Press, 1972.

Historical Background: England
The history of late eighteenth-century England has been so well researched with so many excellent scholarly studies, especially related to politics, that by necessity I have limited the following list only to those books that have direct bearing on West and his work.
 Biographies of George III that I found most helpful are:

Ayling, Stanley. *George the Third.* London: Collins, 1972.

Butterfield, Herbert. *George III and the Historians,* rev. ed. New York: Macmillan, 1959.

Brooke, John. *King George III.* Frogmore, St. Albans: Panther Books, 1974.

Watson, J. Steven. *The Reign of George III, 1760–1815.* Oxford: Clarendon, 1960.

Other general studies on the politics, culture, and ideology of the time include:

Clifford, James L., ed. *Man Versus Society in Eighteenth-Century Britain. Six Points of View.* Cambridge: Cambridge University Press, 1968.

George, M. Dorothy. *London Life in the Eighteenth Century.* New York: Capricorn Books, 1965.

Marshall, Dorothy. *Dr. Johnson's London.* London: John Wiley & Sons, 1968.

Owen, John B. *The Eighteenth Century, 1714–1815.* New York: W. W. Norton, 1976.

Plumb, J. H. *England in the Eighteenth Century.* London: Penguin Books, 1950.

Among the specialized studies that address individual problems, these were helpful:

Brewer, John. "The Faces of Lord Bute: A Visual Contribution to Anglo-American Political Ideology." *Perspectives in American History* 6 (1972): 95–116.

Lewis, Lesley. *Connoisseurs and Secret Agents in Eighteenth-Century Rome.* London: Chatto & Windus, 1961.

Lindsay, Jack. *1764: The Hurlyburly of Daily Life Exemplified in One Year of the Eighteenth Century.* London: Frederick Muller, Ltd., 1959.

Rude, George. *Wilkes and Liberty: A Social Study of 1763 to 1774.* Oxford: Clarendon, 1962.

For biographies of John Galt, see:

Gordon, Ian A. *John Galt: The Life of a Writer.* Edinburgh: Oliver and Boyd, 1972.

Lyell, Frank H. *A Study of the Novels of John Galt.* Princeton: Princeton University Press, 1942.

Needler, George H. *John Galt's Dramas: A Brief Review.* Toronto: University of Toronto Press, 1945.

Whatley, C. A., ed. *John Galt, 1779–1979.* Edinburgh: Ramsay Head Press, 1979.

Eighteenth-Century Theater
The classic analysis of early theater in America, *History of the American Theatre,* was written in 1832 by West's student, William Dunlap. More recent studies that pertain to theater in Philadelphia include:

Pollock, Thomas Clark. *Philadelphia Theatre in the Eighteenth Century, Together with the Day Book of the Same Period* (Philadelphia, 1933; New York: Greenwood Press, 1968).

Quinn, Arthur Hobson. "The Theatre and the Drama in Old Philadelphia." *Transaction of the American Philosophical Society,* n.s. 43 (1953): 313–15.

Rankin, Hugh. *The Theatre in Colonial America.* Chapel Hill: University of North Carolina Press, 1960.

Seilhamer, George O. *History of the American Theatre before the Revolution.* Vol. 1. Philadelphia, 1888; Grosse Point: Michigan Scholarly Press, 1968.

There are numerous studies of English theater in Georgian London. I found the following books most helpful for finding the titles of plays, information about playhouses, synopses of plots, and lists of characters:

Burnim, Kalman A. *David Garrick, Director.* Carbondale: Southern Illinois University Press, 1973.

Dent, Edward J. *Foundations of English Opera.* 1928. Reprint. New York: Da Capo Press, 1965.

Hume, Robert D., ed. *The London Theatre World, 1600–1800.* Carbondale: Southern Illinois University Press, 1980.

Knapp, Mary E. *Prologues and Epilogues of the Eighteenth Century.* New Haven: Yale University Press, 1961.

Loftis, John. *The Politics of Drama in Augustan England.* Oxford: Clarendon, 1963.

Lynch, James J. *Box, Pit, and Gallery: Stage and Society in Johnson's London.* Berkeley and Los Angeles: University of California Press, 1953.

MacMillan, Dougald. *Drury Lane Calendar, 1747–1776.* Oxford: Clarendon, 1938.

Nicoll, Allardyce. *A History of Early Eighteenth-Century Drama, 1700–1750.* Cambridge: Cambridge University Press, 1925.

————. *Late Eighteenth-Century Drama.* Cambridge: Cambridge University Press, 1927.

————. *The Garrick Stage: Theatres and Audience in the Eighteenth Century.* Athens: University of Georgia Press, 1980.

Petty, Fred C. *Italian Opera in London, 1760–1800.* Ann Arbor: UMI Research Press, 1980.

Richards, Kenneth, and Thomson, Peter, eds. *The Eighteenth-Century English Stage.* London: Methuen & Co., 1972.

Scouten, Arthur H. *The London Stage, 1729–1747: A Critical Introduction.* Carbondale: Southern Illinois University Press, 1968.

Stone, George Winchester, Jr. *The London Stage, 1747–1776: A Critical Introduction.* Carbondale: Southern Illinois University Press, 1968.

Wyndham, Henry S. *The Annals of Covent Garden Theatre from 1732 to 1897.* London: Chatto & Windus, 1906.

List of Illustrations

Titles are of works in oil by Benjamin West unless otherwise noted.

Index

This book was produced by the Smithsonian Institution Press
Edited by Jane McAllister
Designed by Carol Hare Beehler